REFASHIONING AND REDRESS

REFASHIONING AND REDRESS
CONSERVING AND DISPLAYING DRESS

EDITED BY MARY M. BROOKS AND DINAH D. EASTOP

THE GETTY CONSERVATION INSTITUTE | LOS ANGELES

The Getty Conservation Institute

Timothy P. Whalen, *Director*

Jeanne Marie Teutonico, *Associate Director, Programs*

The Getty Conservation Institute works to advance conservation practice in the visual arts, broadly interpreted to include objects, collections, architecture, and sites. It serves the conservation community through scientific research, education and training, model field projects, and the broad dissemination of the results of both its own work and the work of others in the field. And in all its endeavors, it focuses on the creation and dissemination of knowledge that will benefit professionals and organizations responsible for the conservation of the world's cultural heritage.

Published by the Getty Conservation Institute, Los Angeles

Getty Publications

1200 Getty Center Drive, Suite 500

Los Angeles, CA 90049-1682

www.getty.edu/publications

Ruth Evans Lane, *Project Editor*

Jennifer Boynton, *Manuscript Editor*

Catherine Lorenz, *Designer*

Suzanne Watson, *Production*

Distributed in the United States and Canada by the University of Chicago Press

Distributed outside the United States and Canada by Yale University Press, London

Printed in China

Library of Congress Cataloging-in-Publication Data

Names: Brooks, Mary M., editor. | Eastop, Dinah, editor. | Getty Conservation Institute, issuing body.

Title: Refashioning and redress : conserving and displaying dress / edited by Mary M. Brooks and Dinah D. Eastop.

Description: Los Angeles : Getty Conservation Institute, [2016]

Identifiers: LCCN 2016019987 | ISBN 9781606065112 (pbk.)

Subjects: LCSH: Clothing and dress—Conservation and restoration. | Costume—Conservation and restoration. | Textile fabrics—Preservation. | Museum techniques.

Classification: LCC NK4704.5 .R44 2016 | DDC 746/.0432—dc23

LC record available at https://lccn.loc.gov/2016019987

Front cover: Museum of London staff and volunteers with mannequins dressed for the *Pleasure Garden* display (publicity shot). © Museum of London

Back cover: A Tahitian mourner's costume (see fig. 6.3). © Pitt Rivers Museum, University of Oxford

p. i: An exhibition view of *First Peoples* at Bunjilaka Aboriginal Cultural Centre, Melbourne Museum, Museum Victoria (see fig. 3.1). © Museum Victoria / John Broomfield

p. ii: An exhibition view of *Dressed to Kill* (see fig. 12.2). Photo: National Gallery of Australia, Canberra

p. viii: A mannequin wearing a gown from the 1760s with a Philip Treacy hat (see fig. 14.2). © Museum of London

p. x: Rajiv Gandhi's trousers at the Indira Gandhi Memorial Museum (see fig. 16.3). Photo: Justin Gare, Senior Objects Conservator, Artlab Australia

Illustration Credits

CONTENTS

IX **FOREWORD**
Timothy P. Whalen

XI **ACKNOWLEDGMENTS**

XIII **EDITORS' PREFACE**
Mary M. Brooks and Dinah D. Eastop

1 **INTRODUCTION | INTERACTIONS OF MEANING AND MATTER**
Dinah D. Eastop with Mary M. Brooks

19 **1 | REFLECTING ABSENCE AND PRESENCE**
DISPLAYING DRESS OF KNOWN INDIVIDUALS
Mary M. Brooks

33 **2 | CONSERVING AN AINU ROBE WITHIN THE FRAMEWORK OF JAPAN'S CULTURAL PROPERTY PRESERVATION POLICY**
Mie Ishii

49 **3 | "WRAPPED IN COUNTRY"**
CONSERVING AND REPRESENTING POSSUM-SKIN CLOAKS
AS IN/TANGIBLE HERITAGE
Henry L. Atkinson, Vicki Couzens, Lee Darroch,
Genevieve Grieves, Samantha Hamilton, Holly Jones-Amin,
Mandy Nicholson, and Amanda Reynolds

65 **4 | *KAHU ORA***
LIVING CLOAKS, LIVING CULTURE
Rangi Te Kanawa, Awhina Tamarapa, and Anne Peranteau

79 **5 | PRESERVING AND DISPLAYING ARCHAEOLOGICAL GARMENTS VIA PRESSURE MOUNTING**
Anja Bayer

93 **6 | THE CONSERVATION AND DISPLAY OF THE TAHITIAN MOURNER'S COSTUME AT THE PITT RIVERS MUSEUM, UNIVERSITY OF OXFORD**
Jeremy S. Uden, Heather M. Richardson, and Rachael E. Lee

107 **7 | DRESS IN THE LIMELIGHT**
THE CONSERVATION AND DISPLAY OF ELLEN TERRY'S "BEETLE-WING" DRESS AT SMALLHYTHE PLACE
Emma Slocombe and Zenzie Tinker

121 **8 | MAKING SENSE OF A FRAGMENTARY COAT FOUND CONCEALED WITHIN A BUILDING**
Kathryn Gill

133 **9 | BACK TO BLACK**
CONSERVATION OF A 1900s ENSEMBLE VIA REPLICATION AND WEB DISPLAY (REPLICAR)
Teresa Cristina Toledo de Paula

145 **10 | CONCEPTS IN PRACTICE**
COLLABORATIVE APPROACHES IN DEVELOPING THE BOWES MUSEUM'S FASHION AND TEXTILE GALLERY
Claire Gresswell, Joanna Hashagen, and Janet Wood

159 **11 | A DELICATE BALANCE**
ETHICS AND AESTHETICS AT THE COSTUME INSTITUTE, METROPOLITAN MUSEUM OF ART, NEW YORK
Sarah Scaturro and Joyce Fung

173 **12 | FASHION AS ART**
DRESSED TO KILL: 100 YEARS OF FASHION
Micheline Ford and Roger Leong

187 **13 | RADICALIZING THE REPRESENTATION OF FASHION**
ALEXANDER McQUEEN AT THE V&A, 1999–2015
Claire Wilcox

199 14 | PEOPLING THE *PLEASURE GARDEN*
 CREATING AN IMMERSIVE DISPLAY
 AT THE MUSEUM OF LONDON
 Beatrice Behlen and Christine Supianek-Chassay

213 15 | DRAMATIC EFFECTS ON A STATIC STAGE
 CANTONESE OPERA COSTUMES
 AT THE HONG KONG HERITAGE MUSEUM
 Evita So Yeung and Angela Yuenkuen Cheung

225 16 | CONSERVING DAMAGE
 CLOTHING WORN BY INDIRA GANDHI AND RAJIV GANDHI
 AT THE TIME OF THEIR ASSASSINATIONS
 Kristin Phillips

237 17 | MOVING FORWARD TOGETHER
 Bianca M. du Mortier and Suzan Meijer

251 INDEX

FOREWORD

Timothy P. Whalen, Director
The Getty Conservation Institute

The seeds for *Refashioning and Redress: Conserving and Displaying Dress* were sown when Mary Brooks and Dinah Eastop were preparing the GCI's Readings in Conservation volume *Changing Views of Textile Conservation.* As coeditors of that book, they read hundreds of articles related to textile conservation and engaged in countless discussions with colleagues on the intellectual and practical challenges of conserving and displaying textiles and dress. Through this process, it became clear that textile conservation was a rapidly evolving and increasingly interdisciplinary practice. This understanding helped shape that volume.

Following publication of the Readings volume in 2011, Mary and Dinah felt that the display of dress—how the exhibition of dress provides new and creative ways to explore cultural attitudes, social change, and ever-shifting styles—warranted further examination. They proposed that the GCI publish a collection of specially commissioned papers addressing these themes. Upon reading their proposal, we knew we would have an inspired book to publish.

Refashioning and Redress, with contributions by conservators, curators, designers, makers, and researchers from around the world, addresses a broad range of topics illustrating changing approaches and practices. Linking the practical and the conceptual, the case studies include fashion as spectacle in the museum, theatrical dress, and dress as political and personal memorialization, as well as dress from living indigenous cultures, dress in fragments, and the presentation of dress online.

Mary and Dinah are highly regarded conservators, educators, and scholars based in the U.K. and are long-time colleagues of the GCI. We are grateful to them for their professionalism and unflagging enthusiasm and to the many authors who contributed to this engaging volume. We believe that *Refashioning and Redress* explores an important topic— the conservation and representation of dress—and will benefit conservation and curatorial professionals as well as students of conservation, museology, art, design and social history, and material culture studies.

ACKNOWLEDGMENTS

Mary M. Brooks and Dinah D. Eastop

Many people have contributed to the development of this book, and
we thank them all for their support and input.

We are grateful to the members of our Academic Advisory Panel
for their ready agreement to contribute to this exploration of the inter-
action of conservation and display and for their thoughtful feedback.
The panel comprised Christopher Breward (principal, Edinburgh
College of Art; professor, Cultural History, University of Edinburgh);
Jean L. Druesedow (director, Kent State University Museum, Ohio;
chair, ICOM's International Committee for Museums and Collections of
Costume; previously associate curator in charge, Costume Institute,
Metropolitan Museum of Art); Katia Johansen (independent researcher
based in Denmark; conservator/curator, Royal Danish Collections,
1980–2016); Christine Stevens (library research reserve store manager,
Robinson Library, Newcastle University; former chair, Dress and
Textile Specialists, UK); and Deborah Lee Trupin (textile and upholstery
conservator, Trupin Conservation Services, New York; formerly textile
conservator, New York State Office of Parks, Recreation and Historic
Preservation's Bureau of Historic Sites, Peebles Island).

For helpful advice and practical assistance, we thank the following:
Trustees of the Daphne Bullard Trust, for supporting the mounting of
Captain Foote's costume, York Art Gallery, York Museums Trust, UK;
Lorna Calcutt (program leader, Conservation, West Dean College, West
Sussex, UK); Dr. Anne-Marie Deisser (project coordinator, Heritage Con-
servation and Human Rights, Department of History and Archaeology,
University of Nairobi, Kenya); Professor Amy de la Haye (Rootstein
Hopkins Chair of Dress History and Curatorship, London College of
Fashion); Cathy Hay (historic dressmaker, publisher of the websites
Foundations Revealed and *Your Wardrobe Unlock'd*); Dr. Elsje Janssen
(director of collections, Royal Museum of Fine Arts Antwerp; former
curator of textiles, Rijksmuseum, Amsterdam); Frances Lennard
(professor, Textile Conservation, University of Glasgow); Melissa
Leventon (principal, Curatrix Group, San Francisco); Catherine C.

McLean (senior textile conservator, Conservation Center, Los Angeles County Museum of Art); Dr. Lesley Miller (professor, Dress and Textile History, University of Glasgow; senior curator, Textiles, Victoria and Albert Museum); Bernice Morris (associate conservator, Costume and Textiles, Philadelphia Museum of Art); Bettina Niekamp (head, Textile Conservation, Abegg-Stiftung, Riggisberg, Switzerland); Flavia Parisi (program assistant, ICCROM), Caroline Rendell (textile conservator, UK/France); Teresa Shergold (librarian, West Dean College, West Sussex, UK); Professor Bill Sherman (head, Research, Victoria and Albert Museum); Catherine Smith (senior lecturer, Clothing and Textile Sciences/Ngā Pūtaiao Pūeru, University of Otago, New Zealand); Bre Stitt (Centre for Fashion Curation, London College of Fashion); and Jeff Veitch (technician/photography, Department of Archaeology, Durham University, UK).

Discussions at the Ehemaligentreffen, Abegg-Stiftung (Riggisberg, Switzerland, 2014); the panel "Playing a Role: Noble Representations," Anglo-American Conference of Historians, Institute of Historical Research (London, 2015); and the ICOM Costume Committee Annual Meeting "Exhibitions and Interpretation" (Toronto, 2015) provided fruitful insights. We thank the participants for their comments.

Colleagues at the Getty Conservation Institute (GCI) have continued to provide the exceptional support and encouragement that characterized our experience of editing *Changing Views of Textile Conservation* (Readings in Conservation, 2011). Their positive response to our proposal to open up the debate on the challenges of conserving and displaying dress was much appreciated. Particular thanks are owed to Timothy P. Whalen, director of the GCI, and to Cynthia Godlewski, publications manager at the GCI, for her expert guidance and wise support. We also thank the Getty Publications team: associate editor Ruth Evans Lane, designer Catherine Lorenz, production coordinator Suzanne Watson, and Pam Moffat, who oversaw image acquisition and permission, as well as freelance copy editor Jennifer Boynton.

Our final thanks must go to the thirty-five authors who responded so creatively to our invitation and were willing to engage in different, often collaborative, approaches to thinking about the conservation and display of dress.

EDITORS' PREFACE

Mary M. Brooks and Dinah D. Eastop

Exhibitions of dress provide innovative and visually exciting ways to explore cultural attitudes, design innovations, shifting styles, and social change. Putting dress of whatever kind on a mount for display is a complex and often collaborative process. In this book, we seek to explore the challenges of conserving and displaying dress as a dynamic and interactive process of investigation, interpretation, intervention, and display. The complexity of such interactions and their cumulative effects are examined in a range of case studies that reflect the changing approaches and actions of different times and places.

One way to introduce this book is to explain what led us to recognize that familiar museum procedures are part of ongoing processes of cultural production. For Mary Brooks, it was seeking ways to analyze the complexity of what is happening when a garment is placed on a mannequin. For Dinah Eastop, it was her investigation of the rationales for, and effects of, conservation interventions. These strands led to discussion of the intellectual and practical challenges of conserving and displaying dress. The focus became the dynamic between the applied and the conceptual. We were interested in exploring the complexity of the processes of interpretation embedded and embodied in conserving and presenting garments for public display. To quote Valerie Steele, because "intellectuals live by the word, many scholars tend to ignore the important role that *objects* can play in the creation of knowledge" (1998:327).

Our goal is to reflect a broad range of practice that is multinational, and that includes the perspectives of a variety of professions. We identified case studies for analysis and, with the support of the Getty Conservation Institute, solicited papers that highlight the contingencies of judgment. Approaches considered appropriate at one time or place may be viewed differently at other times and places. Each paper examines the play of contingencies, as one judgment follows another.

This book is neither an introduction to mounting garments for display nor is it a textbook. It is not a historiography or a critical analysis of display practices in museums or a guide to conservation techniques.

These are all important topics on which there is a growing body of literature. Notable examples include the context-transforming journal *Fashion Theory*, edited by Valerie Steele (1997 to date); Alexandra Palmer's critical review of approaches to displaying dress inside and outside the museum (*Fashion Theory* 12, 2008); Lara Flecker's *A Practical Guide to Costume Mounting* (2007); Frances Lennard and Patricia Ewer's *Textile Conservation: Recent Advances* (2010); Judith Clark, Amy de la Haye, and Jeffrey Horsley's *Exhibiting Fashion: Before and After 1971* (2014); and Marie Riegels Melchior and Birgitta Svensson's *Fashion and Museums: Theory and Practice* (2014). This significant and developing body of work amply justifies the observation that a study of fashion exhibition practices can be rich and rewarding (Petrov 2015:278).

In focusing on what happens in practice, we have chosen a material culture perspective, exploring person-object-language interactions over time and place. We decided to use *dress* as a global term rather than *costume* or *fashion*. This limits the morality implicit in defining what "costume" or "fashion" is and frames dress as body covering in social use. The book's title, *Refashioning and Redress*, draws on the power of the prefix *re-* (literally, "again"). *Refashioning* reflects both a certain category of dress that forms part of high fashion, art, and design, and the intellectual and physical processes that take place whenever garments are mounted on a form, of whatever type, and placed on public display in a specific context. *Redress* carries an explicit sense of reengaging, revisiting, and making amends. The conservation measures involved may be interventive, literally "refashioning" items by reordering component parts for the purposes of display, and/or acts of "redress"; for example, encouraging the use of garments outside the traditional boundaries of the museum. The prefix *re-* also has resonance with representation and in "reversibility," one of the dominant ethical ideologies in conservation practice. The book's subtitle, *Conserving and Displaying Dress*, makes explicit the theme of the book: the interaction of conservation and display practices.

We hope this book will be of interest to practitioners and students in disciplines ranging from dress history to social history, from material culture studies to fashion studies, and from conservation to museology. Our aim is to stimulate reflection and discussion. We want to promote awareness of the material, social, and philosophical interactions that are inherent in the conservation and display of dress. We also hope that these papers demonstrate how the conservation and display of dress can be understood as material, social, and conceptual processes in the continuing or cumulative present, and thereby foster informed debate.

REFERENCES

Clark, Judith, Amy de la Haye, with Jeffrey Horsley. 2014. *Exhibiting Fashion: Before and After 1971*. New Haven, CT: Yale University Press.

Flecker, Lara. 2007. *A Practical Guide to Costume Mounting*. Oxford: Butterworth-Heinemann.

Lennard, Frances, and Patricia Ewer, eds. 2010. *Textile Conservation: Recent Advances*. Oxford: Butterworth-Heinemann.

Melchior, Marie Riegels, and Birgitta Svensson, eds. 2014. *Fashion and Museums: Theory and Practice*. London: Bloomsbury.

Palmer, Alexandra. 2008. "Untouchable: Creating Desire and Knowledge in Museum Costume and Textile Exhibitions." *Fashion Theory* 12 (1): 31–63.

Petrov, Julia. 2015. Review of *Exhibiting Fashion: Before and After 1971*, by Judith Clark and Amy de la Haye with Jeffrey Horsley. *Textile History* 46 (2): 276–78.

Steele, Valerie. 1998. "A Museum of Fashion Is More than a Clothes-Bag." *Fashion Theory* 2 (4): 327–36.

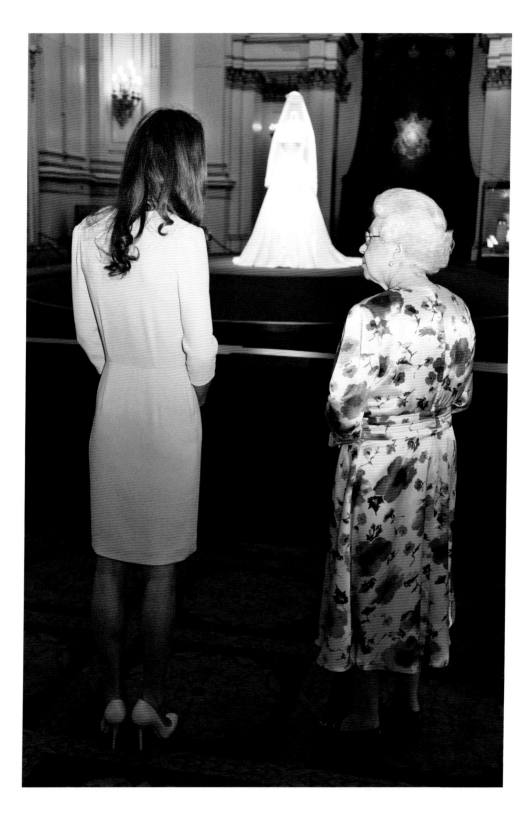

INTRODUCTION | INTERACTIONS OF MEANING AND MATTER

Dinah D. Eastop with Mary M. Brooks

Her Majesty Queen Elizabeth II became, if only briefly, a renowned commentator on the display of dress. She is reported as observing that Catherine Middleton's much-praised wedding dress (designed by Sarah Burton of Alexander McQueen) looked "horrible" and "disturbing" when it was exhibited at Buckingham Palace in 2011.[1] The newly created Duchess of Cambridge described the exhibit, with the tiara and veil floating above the dress on a headless mannequin, as "surreal" (fig. 0.1). Whatever the thoughts of the royal family, the public flocked to see it. This example may be viewed as exceptional in some ways, but it nonetheless draws attention to important features of displaying dress in museum settings: the absent body characterized by the headless mannequin; the intimate association of the dress with its wearer (who, unsurprisingly, finds the representation "surreal"); the disconcerted feelings of an informed viewer; the popularity of an exhibition featuring a dress of both a famous wearer and a famous designer; and a garment that was already widely known due to extensive media coverage.

This example supports the argument that an exhibition is "a field in which three distinct terms are independently in play: makers of objects, exhibitors of made objects, and viewers of exhibited made objects" (Baxandall 1991:36). Each of these agents is active, and the resulting relations are complex, dynamic, and sometimes fraught (Vergo 1989:43–44). In the case of the Duchess of Cambridge's wedding dress, its "makers" would encompass the designer and those who actually assembled the dress, as well as the bride, who "made it" by choosing the design and wearing it with style. Michael Baxandall emphasizes that the activity of each agent is "differently directed and discreetly if not incompatibly structured" (1991:36) and plays a different role. This book highlights the specificities of such interactions, showing that conservators are also active agents in the process.

Refashioning and Redress: Conserving and Displaying Dress seeks to stimulate discussion about the representation of dress, notably but not exclusively within museological practice. The aims are to focus

FIGURE 0.1
The Duchess of Cambridge and Her Majesty Queen Elizabeth II view the former's wedding dress as displayed at Buckingham Palace, 2011. Photo: John Stillwell / PA Archive / Press Association Images

attention on the processes of meaning-making by studying the actions involved in conserving and preparing garments for display or other use, and to demonstrate that the resulting representations arise from a complex process of interaction of intellectual and technical decisions. The latter are informed by historical and practical knowledge and understanding, tempered by the realities of the display context and the exhibition concept and design. The discussion inevitably draws attention to wider issues fundamental to understanding museum collections, such as authorship, authorization, and authenticity (Eastop 2011).

This book explores what is being conserved and displayed, and how. The relationships between conservation interventions and display choices are examined in order to foster debate about decision-making, display, and representation; about the effects of curatorial, conservation, and design decisions on the material evidence of dress; and about the forms, sites, and effects of display. The aim is to stimulate critical discussion about what is being conserved and presented, and to what purpose. The core argument is built on three propositions. The first is that the display of dress involves an interactive process of preservation and conservation, display, and the responses of "users," usually the viewing public. This processual view directs attention away from viewing, conservation, and display as goals in themselves; rather, they are seen as dynamic, interactive processes over time where changes in power, influence, and objectives become more evident and are therefore opened up for analysis. The second proposition is that only by studying individual examples will these interactive processes be identified. The third is that all participants in this process are involved in a dynamic interaction, whether actively or passively. One goal of this book is to create opportunities, which Nayanika Mookherjee and Christopher Pinney (2011) have called a "theoretical space," to encourage critical thinking about these interactive processes.

This introductory paper begins with a discussion of refashioning, focusing on terms used and placing them within a conceptual framework. The relationship between the word (what is written or what is said by way of explanation or commentary) and what is in the world (the materiality of dress in this case) is key to understanding the interactions of conservation and display, and their effects. The processes of display, presentation, and preservation, and thus the specificities of the interaction, are explored in seventeen papers commissioned to reflect a diversity of artifacts, contexts, challenges, and approaches. These wide-ranging case studies include the conservation and display of garments associated with famous wearers and famous designers, as well

as "anonymous" clothing (such as a fragmentary brown wool coat and new forms of academic dress). The case studies demonstrate a breadth of conservation practice, with interventions ranging from object treatments, the making of replicas, and the investigation of museum-held pieces to make new garments, to the revival of once widely practiced techniques and designs.

REFASHIONING

Refashioning means to give a new form (to something), to fashion (make) some thing again or differently, and thus, to make, remake, modify, rework, or alter. Its etymological origins can be found in terms meaning "shape," "manner," and "mode." We have adopted the term to emphasize that some conservation projects and/or displays have the goal and the effect of refashioning. Such refashioning may include significant interventions to remove and replace failing components, as was the case for Grace Kelly's wedding dress of 1956 (Haugland 2006). Its original foundation petticoat had deteriorated so it could no longer hold the skirt in its distinctive bell shape. After extensive documentation of its original materials and construction, the petticoat was detached and replaced with a copy. The original was placed in museum storage, making it more accessible for study, while its replacement enables the stylish shape of the iconic garment to be represented (Eastop and Morris 2010). When considering options for Kelly's wedding dress, curators and conservators were influenced by its on-screen presence. Millions of people had watched the wedding and formed strong views about how the dress should look based on its appearance on black-and-white television screens.

The paper "Dress in the Limelight: The Conservation and Display of Ellen Terry's 'Beetle-Wing' Dress at Smallhythe Place" demonstrates how garments have been remodeled in the past, and how conservation can involve elements of replication. In "Back to Black: Conservation of a 1900s Ensemble via Replication and Web Display (Replicar)," remodeling involved the production of two replicas, in addition to giving a new "form" to both the original garment and the replicas via digital surrogates that were accessible to in-the-round scrutiny online. Digital technology is also enabling new forms of collecting and conserving; for example, the Deliberately Concealed Garments Project uses a website as its primary means of collection, presentation, and dissemination, as well as preservation (Eastop and Dew 2006).

Refashioning, in the sense of presenting as fashionable, is sometimes an explicit goal of display and conservation interventions. "A

Delicate Balance: Ethics and Aesthetics at the Costume Institute, Metropolitan Museum of Art, New York" explains the importance of historical and ongoing links between the Costume Institute and New York's fashion industry. The aim of the Costume Institute is not to display dress as past anachronisms but to convey their effects when first presented to the public as state-of-the-art high fashion. The same point is made in "Fashion as Art: *Dressed to Kill: 100 Years of Fashion*." The team at each institution sought to convey the shock and wonder that innovative, fashionable garments excited when first presented on the catwalk. Each paper also explores the challenges of presenting fashion in the context of institutions dedicated to art.

Reestablishing the remarkable effects of high fashion is also explored in "Peopling the *Pleasure Garden*: Creating an Immersive Display at the Museum of London." In this presentation, historical garments from the museum's collections are complemented by the innovative "wraparound effect" of filmed actors in replica dress who appear to be "walking through" the garden. Modern hats by leading contemporary designers are used to "complete" the ensembles for two reasons: first, because few original headpieces were sufficiently robust for prolonged exhibition, and second, because the outrageous modern hats provide sensational compensation for the missing headwear. The process of conservation also has an important role in achieving the dramatic impact "of fashionable dress [which] carries within it an implicit preoccupation with style and aesthetics" but also "a sense of the ephemeral and the transitory" (Brooks 2010:175).

Refashioning, in the sense of fashioning something differently, can be seen in the treatment of fragmentary garments. In the case of textiles excavated from grave sites, as described in "Preserving and Displaying Archaeological Garments via Pressure Mounting," the fragile remains could not be preserved or presented as three-dimensional garments, but they could be presented in a way that suggested their original design. In this form of refashioning, the pieces were assembled to enable them to be understood as garments while accommodating their fragmentary condition. "Conserving Damage: Clothing Worn by Indira Gandhi and Rajiv Gandhi at the Time of Their Assassinations" introduces more recent material: fragmentary clothes preserved and exhibited in New Delhi as memorials of two prime ministers of India. In this refashioning, the surviving parts of the garments serve as powerful, evocative material metonyms of those who were killed while wearing them.

REDRESS

The term *redress* is used to exploit the pun, the play on words that high-
lights its different but interrelated meanings or applications. *Redress*
can mean "to dress again"; for example, when putting a garment on a
mannequin, taking it off in order to modify the mannequin's shape, and
then putting it back on. Etymologically, *redress* is derived from words
meaning "to straighten," and it can also be defined as "to set right what
is wrong," "to remedy or repair (a wrong or injury)," and "to correct or
adjust the balance." In the context of this book, *redress* draws on its
physical and metaphorical origins, "setting right" both garments and
past wrongs, notably in terms of social justice. An example of physical
reconfiguration is found in "The Conservation and Display of the Tahitian
Mourner's Costume at the Pitt Rivers Museum, University of Oxford."

The effects of the destruction or undermining of indigenous cul-
tural values and practices during colonial and postcolonial eras are now
more widely recognized. The preservation of surviving artifacts, and
the renewal of making and wearing practices, is examined both within
and beyond the museum in "*Kahu Ora*: Living Cloaks, Living Culture"
and "'Wrapped in Country': Conserving and Representing Possum-Skin
Cloaks as In/tangible Heritage." An example of questioning legally
enshrined prejudicial practices to right past wrongs within museum
practice is introduced in "Conserving an Ainu Robe within the Frame-
work of Japan's Cultural Property Preservation Policy."

These examples show that museums have had, and continue to
have, significant roles in how nations are performed and materialized
(Moohkerjee 2011:S12), and that they can play a role in processes of
reconciliation. The Women's Jail, a recently developed heritage site in
Johannesburg, South Africa, provides another example. The curato-
rial team, which included former prisoners, used the display of dress
to reflect women's accounts of their prison experiences and to repre-
sent the distinctive ways apartheid affected women, notably by the
"insidious daily erosions of personal liberties and dignities" (Coombes
2011:S93). The display also sought to widen definitions of acts of resis-
tance (e.g., to encompass refusal to comply with the hated Pass Laws).
Some exhibits were also chosen to reflect the oral and performative
expressions of women's testimony at the Truth and Reconciliation
Commission (ibid.:S98). One installation included a pair of prison-issue
knickers, significant because prison authorities used the inconveniences
of menstruation to humiliate prisoners, and underwear was distributed
only after coordinated acts of defiance.

Each of the jail's six narrow isolation cells is occupied by a representation of a former prisoner who appears in a "talking-head" film to tell the story of an object of particular significance to her from the period just before imprisonment. Nikiwe Deborah Matshoba's wedding dress stands in one cell, the sleeves arranged as if worn but with its shoulders shaped by a coat hanger, all enclosed in transparent plastic, with a video screen above (fig. 0.2). Matshoba (d. 2014), one of the original curatorial team at the Women's Jail, tells the story of this dress. She was released from prison but placed under house arrest, and "banning orders" prevented her from attending her wedding ceremony.[2] This "metonymic curatorial strategy" (Coombes 2011:S100) enables the exhibited garment to stand for Matshoba. Such "embodied exhibitions" are welcomed as instructive and affective for survivors and viewers alike (Mookherjee 2011:S12).

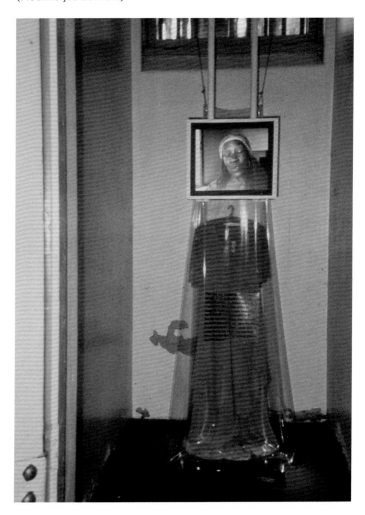

FIGURE 0.2
An installation view of an isolation cell at the Women's Jail showing Nikiwe Deborah Matshoba's wedding dress, Johannesburg, 2005. © Annie E. Coombes 2005

REPRESENTATION

The papers in *Refashioning and Redress* demonstrate the processes and the effects of representation. Representation is an active process, as emphasized in "the *work* of representation" and the "*practices* of representation" (Hall 1997:15; italics added). It is important to recognize that it is the "participants in a culture who give meaning to people, objects and events" (ibid.:3). The production and exchange of meaning—making sense of things—is usually attributed to language, but concepts, ideas, and feelings can also be represented by things, which "'in themselves' rarely if ever have any one single, fixed and unchanging meaning" (ibid.). Each paper in *Refashioning and Redress* demonstrates "how representation actually *works*" (ibid.:2; italics in the original) in the production and circulation of meaning through the conservation and display of dress.

Deciding what to conserve and how, and what to display and how, is contingent on many factors, including available expertise and resources. It also reflects the values attributed to the various characteristics of cultural property, including the material, the social, and the political. Such complexity merits reflection and careful consideration (e.g., Eastop 2009, 2011) but is often taken for granted, neglected, or dismissed as self-evident. "Making Sense of a Fragmentary Coat Found Concealed within a Building" illustrates the interaction of conservation and display measures, and a range of forms of representation, including the creation of a replica garment and image-rich documentation shown on a monitor alongside the coat.

Conservation is now widely understood as "managing change" (e.g., Teutonico and Matero 2003) and encompasses both preventive and remedial elements, including preservation, investigation, and presentation. Each paper describes measures taken to preserve tangible and/or intangible properties and attributes of artifacts and practices, and reports the outcomes of investigations, often based on material, technological, or historical information. Presentation, re-presentation, and representation are fundamental issues that are influenced by conservation and display practices. *Representation*, like *redress*, is an apt term because of its double meaning. *Represent* means "to act or speak on behalf of someone else," or "to set forth with a view to influencing opinion," while *re-present* means "to present again." Thus, representation is the particular way someone or something is described or portrayed, and/or the particular way something takes the place of another thing/person. Like the term *redress*, the two distinct meanings of *represent* and *re-present* are inherently connected and often operate simultaneously.

Exploring the interaction of conservation and display provided the starting point for this book. As a verb, *display* means "to show"; that is, to put something in a prominent place so it may be seen readily. As a noun, it means a "performance, show, or staged event for public viewing, education and/or entertainment." Its etymology reveals two roots: one in an ancient Latin word meaning "to scatter, disperse," and another in a medieval Latin word meaning "to unfold" (and by analogy "to explain"). In every case in this book, *display* has meant unfolding in the literal and material sense (as an action involving physical objects in museum storerooms and conservation studios), as well as the showing and explaining that occurs in the public domain.

The argument here is that conservation and display together constitute a process. The following papers reveal the complexity and diversity of this process, which is circular to the extent that feedback from the outcome of each action modifies the process. The terms *abstraction* and *materialization* are used to reveal commonalities between each of the case studies. Abstraction is taken as verbal or other symbolic exchanges referring to the material or object; materialization is the process whereby these verbal or symbolic exchanges are used to organize changes to the material world. Refashioning and display can be seen as a to-and-fro process of abstraction and materialization that includes periods of rapid change and comparative stasis. The following section shows how the refashioning and display processes respond to social, material, political, and technological change.

CHANGE

Museum practices change over time, with changes in "heritage culture," in technology, and most significantly for this book, in what is required or expected of conservation and display. The effects of radically different conservation and display decisions can be seen in the small but hugely important collection of textiles and dress at the Petrie Museum of Egyptian Archaeology, University College London.[3] The museum's holdings include the Tarkhan Tunic, the remains of a pleated linen garment dated to ca. 2800 BC and known as the "world's oldest dress" (UC28614B). It was found inside out, as though it had just been pulled off the wearer's body, with creases around the armpit and elbow areas. When conservation interventions were made in the late 1970s, the fragile garment was turned inside in. This intervention facilitated the support of the garment and enabled it to be exhibited as it was presumed to have been worn in life as opposed to funerary use (Landi and Hall 1979). A different approach was adopted for the Gurob Sleeves, dated to 1550–1069 BC

(UC8980); such sleeves were made separately and attached to garments as required. Their display mount was determined by the fact that the contemporaneous term for such sleeves meant "that which hangs down." As these sleeves are in excellent condition, they could be mounted with minimal padding, and hanging down, with no attempt to present them as worn on the body (Textile Conservation Centre 1994).

These interventions can be compared with the treatment of the remains of a beaded garment, ca. 2400 BC (UC17743), and that of a sprang cap found on a woman's desiccated head, dated to 30 BC–AD 395 (UC28073). A restoration approach was adopted for the beaded dress. The finds were excavated from a robbed grave that contained a box with the collapsed dress inside; sufficient faience beads survived in good condition for the front of the garment to be reconstructed and mounted on the stylized form of a girl (Seth-Smith and Lister 1995). The fabric covering of the form was chosen to match the skin tone represented in contemporaneous Egyptian wall paintings. In the latter case, the upper parts of the woman's head and face are covered by a sprang cap that had been tied in place. Research showed that, although many similar excavated sprang hats/bags are preserved in museums, this is the only cap to be preserved in place as a head covering. The conservation intervention therefore focused on nondestructive investigations and preservation of the textile in situ (Javér, Eastop, and Janssen 1999).

The challenge of presenting ancient Egyptian garments as worn in life, as if in movement, was addressed in the exhibition *Clothing Culture* at the Whitworth Art Gallery, Manchester, United Kingdom (Pritchard 2006). Many of the textiles, excavated from grave sites, were brittle and incomplete and therefore were displayed lying flat in table cases rather than on mannequins. In her short film "Lady with Ankh Cross," Jane Harris exploited digital technology to show how a fourth-century garment may have looked when worn, representing the interaction of body and garment. The digital portrayal involved designing a narrative through mime and defining the "portrait" of the "wearer," developing specific computer graphic construction/animation processes for the garment, and using motion capture technology to achieve body data. The resulting film provided a key interpretation tool that enabled museum visitors to see the garment "as worn."[4] It also animated the display of the many archaeological fragments, which had to be exhibited in more conventional ways because of their vulnerable condition.

THE BODY

One of the difficulties encountered when discussing the refashioning-display process is the versatility of the term *body*, which can refer to the human body in general, to a particular person's body, or to a defined entity, such as a corporation, among other definitions. Talking of "the body" while observing a body, its physical substitute, or a void introduces the idea that different people may understand different things, possibly based on their own gendered bodily experience; however, the word's versatility, and its capacity for elision, allows for a shared discussion within these differences of view and experience. Novice conservators have been observed to create mounts in their own image. In one example, involving the mounting of ballet costumes, three student conservators were told to create a display form for "their" garment, which they had carefully examined, measured, and documented. Each of the resulting forms reflected their makers' physical shape and proportions. Likewise, the impossibility of escaping from one's own time has been explored (e.g., Finch 1982), and ways of recognizing one's own position, both physically and conceptually, have been analyzed (e.g., Similä and Eastop 2016).

Embodiment is the representation or expression of "something" in tangible form; in other words, it is material or substantial and is capable of being touched or discernible by touch. The verb *embody* means "to be an expression of," or "to give a tangible or visible form to an idea, quality, or feeling." Thus, *embody* means "to manifest, to demonstrate"; synonyms include *incorporate* (literally, "to bring into the body") and *encompass*. Each item of dress introduced in these papers has been made, acquired, conserved, and/or displayed in order to express an idea or a quality or a feeling in tangible form. Restrictions may be imposed on tangible encounters; for example, to reduce the risk of damaging artifacts or lessen contact with harmful contaminants that may be found in some museum collections (Odegaard and Sadongei 2005). Conversely, encounters may be actively encouraged; for example, when working with a community artist (Johnson 2007), by wearing possum-skin cloaks at ceremonies at the University of Melbourne, or by handling ancestral Māori cloaks held in museums.

Embodied knowledge (or enacted knowledge) is also important for conservation, display, and redress, because it helps in understanding the knowledge and skills involved in manufacturing textiles and dress—the interaction between maker and what is made—both in the past and present. Interest in understanding the interdependencies between doing and making, and between material culture and cognition, is growing

and is reflected in several fields, including anthropology, archaeology, and medicine (Van Dyke 2013; Eastop 2014). Understanding the interaction of maker and what is made is important for investigating, preserving, and presenting textiles and dress. It is also essential for maintaining and developing the skills to sustain and revitalize traditions of making and using, and the related ecologies of materials production.

METAPHOR, METONYM, AND PARATAXIS

Clothing relates to the body as both physical and linguistic interactions (metaphor, metonym, and parataxis), thus allowing an almost infinite number of associations of meaning. Meaning-rich links are established in the work of metaphor, which enables connections between different domains by shared understanding of features or properties. Body-based experience and body-based language (via core metaphors) are fundamental to understanding dress and its terminologies. Many metaphors are grounded in bodily experience, and understanding derived from this experience is transferred via metaphor to other domains (Lakoff and Johnson 1980); for example, ideas about time can be linked to the body as follows:

body—back of body—behind—before—"it's behind me"—in the past

As this example demonstrates, metaphors often involve a move from bodily experience to conceptual thinking:

bodily experience ▸ spatial ▸ temporal ▸ conceptual

For our purposes, the word *model* provides a useful example for exploring such metaphoric chains of meaning-making, because its many interrelated (nested) meanings are reflected in the word and in the world, which, in the context of this book, is the interaction of conservation and display. The word *model* is used to describe a person modeling a garment (that is, a catwalk or runway model), a person who poses for artists (a so-called life model), and an object that substitutes for a person, such as a mannequin or dressmaker's dummy. *Model* can also be used for a garment that serves as an exemplar for subsequent versions. A model can also refer to an abstract framework used in designing experiments. These uses are distinct, and their meanings are context dependent, but each of the meanings depends upon the interrelationship of the tropes of metaphor and metonym. The metaphoric associations of the word *model* move between the material and the conceptual:

named person—exemplary body/runway model/life model/
mannequin representation of body (corset/mannequin/
dummy/custom-made mount)—exemplary garment—model as
abstract framework

These interconnections and complexities of world and word help to
explain why the forms used to exhibit dress in museums often excite or
elicit strong responses. As a source of core metaphors, the human body
is an active agent in generating affect, and this was exploited in the
embodied exhibition of dress in the cells of the Women's Jail in Johan-
nesburg. This might be characterized as the "world-word" problem
arising from the intimate links between the world and the words used to
describe experience and, hence, the inherent circularity of analyzing the
workings of such interactions.

Norwegian fashion photographer Sølve Sundsbø exploited ten-
sions between the animate and inanimate mannequin in his images
for the catalogue accompanying *Savage Beauty*, the Metropoli-
tan Museum of Art's 2011 exhibition of the work of British fashion
designer and couturier Alexander McQueen (1969–2010). Sundsbø
photographed Polina Kasina, one of McQueen's favorite models, in a
close-fitting coat of lacquered gold duck feathers that was worn over
a dress with frothing, gold-embroidered skirts[5] (fig. 0.3). Using exten-
sive makeup (cosmetics) and digital retouching, Sundsbø deliberately
blurred the boundaries between the human body and its replica to
"make up" a "mannequin." Kasina's skin was coated with alabaster
acrylic paint, and artificial joints were created by tying string around
her wrists and neck. A stylized mannequin head was digitally substi-
tuted for Kasina's. During the lengthy photographic session, the paint
started to flake, revealing the model beneath the simulacrum imposed
on the living body. Sundsbø relished this as further evidence of the
multiple and ambiguous layers of artifice and reality he had created:
"The human started to break through. She is both artificial and flesh
and blood."[6] As Andrew Bolton, curator of the McQueen exhibition in
New York, observed, "You are not certain whether it is real or fake."[7]
The tension of real/artificial, human/mannequin is explored in "Reflect-
ing Absence and Presence: Displaying Dress of Known Individuals,"
where re-creating each body as a display form emphasizes its loss. In
"Dramatic Effects on a Static Stage: Cantonese Opera Costumes at the
Hong Kong Heritage Museum," photographs are used to connect the
exhibited garments with the renowned performers who once wore the
lavish costumes.

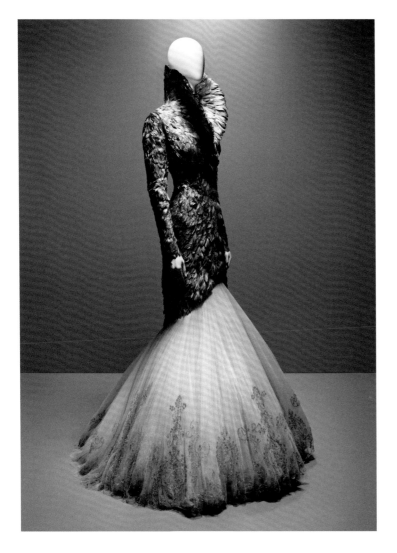

FIGURE 0.3
Model Polina Kasina as a
mannequin wearing an
Alexander McQueen coat
from his autumn/winter
2010–11 collection; image
created by photographer
Sølve Sundsbø. Photo:
Sundsbø / Art + Commerce

"Radicalizing the Representation of Fashion: Alexander McQueen
at the V&A, 1999–2015" draws attention to the many parataxes in the
language of fashion. Parataxis occurs when two terms or concepts are
put together with no explicit conjunction and without either one being
subordinate to the other. In juxtaposing two unconnected or loosely
connected terms, new or unexpected meanings can be generated.
Catwalk models with "made up" faces provide the example in this
paper. "Made up" can be understood as a parataxis that links "makeup"
as cosmetics with "made up" as creation or fanciful or false fabrication.
It is left to the reader to establish the connection, perhaps the creation
of an idealized body or appearance in elite fashion.

ABSTRACTION AND MATERIALIZATION

The workings of metaphor, metonym, and parataxis are important in understanding viewers' responses to displayed garments, because clothing functions as both metaphor and metonym for the body. This introductory paper opened with Queen Elizabeth II telling the Duchess of Cambridge that she found the presentation of her wedding dress "horrible" and "very creepy,"[8] apparently because the ensemble was shown on a headless mannequin. A garment is put on a mannequin and displayed for a reason, and the process involves a sequence of "second guessing." The displayer presumes something about the viewer; namely, that the viewer will recognize the dress and want to see it. The viewer will also have presumed something about the exhibit. In this case, we can assume that the viewer hoped to see the real dress and get a sense of its materials, cut, and effect. So the display, the view, is informed by a series of abstractions based on the general presumptions of both displayer and viewer. A body can lead to feelings of empathy or disgust, showing its affective power. The headless mannequin may have failed to evoke empathy because the viewer (in this case, the Queen) may have had a preconceived idea of how the dress should look, based on her direct experience of viewing the real thing at the wedding ceremony in Westminster Abbey, London.

As explored in "Concepts in Practice: Collaborative Approaches in Developing the Bowes Museum's Fashion and Textile Gallery," the absence of the body can be exploited, allowing free rein to the imagination. The transparent and apparently formless mannequins used to mount dress at the new gallery have been welcomed: the absence of the body seems to evoke more empathy. The careful juxtaposition of portraits and headwear, and the layered arrangement of garments within the showcases, as well as the arrangement of the cases themselves, allows viewers greater scope to imagine the garments as worn and in movement.

Considering the effects of conservation and display on the viewer and/or the wearer extends the context beyond that of the museum into wider socioeconomic and political spheres. For example, exhibitions of McQueen's work must now take his death into account. Managers of heritage sites have to consider income and visitor numbers, both on-site and online. The conservation and display of textiles and dress at the Petrie Museum of Egyptian Archaeology have to be seen within the institution's stated role as a teaching, research, and study collection; its location at University College London; its origins in colonial-era excavations; and its mandate to illustrate the development of culture,

technology, and daily life in ancient Egypt (University College London 1977). Each exhibition and each conservation intervention will help to frame the next exhibition or intervention, thereby contributing to the development of particular cultures of museums or heritage. Punctuations of time, and the effects of different socioeconomic and political contexts, are now more widely recognized. "Moving Forward Together" introduces changes made in the last hundred years in conservation and display practices at the Rijksmuseum, Amsterdam. The title draws attention to changes within the institution and highlights the benefits of collaborative working practices.

The metaphorical power of dress can result in affecting and forceful performance, and may enable viewers to question the authenticity and authority expected of museums and similar institutions.[9] It is no coincidence that the word *matter* covers both physical forms (for example, the three states of matter) and what matters (significance). The following papers show how the abstractions of what matters are materialized through conservation and display practices, and conversely, how the stuff that matters is valued for its intangible attributes (as well as its tangible qualities). Unpacking the process of conservation and display in meaning-making results in an inevitable circularity. Exploring this process can help museum professionals to reflect on their practice and help users of collections to be more critical in their examination of exhibited dress.

NOTES

1. Nicholas Witchell, "Queen overheard criticising Duchess wedding dress display," *BBC News*, July 22, 2011, accessed November 28, 2015, www.bbc.co.uk/news/uk-14257114/. The dress was displayed at Buckingham Palace from July 23 to October 3, 2011.

2. "Nikiwe Deborah Matshoba," South African History Online, accessed February 22, 2015, http://www.sahistory.org.za/people/nikiwe-deborah-matshoba/.

3. University College London Museums & Collections, Petrie Museum of Egyptian Archaeology Catalogue, accessed November 25, 2015, http://petriecat.museums.ucl.ac.uk/.

4. See the research statement by Jane Harris, "Lady with Ankh Cross (4th century A.D. portrait)," University of the Arts London, accessed November 28, 2015, http://ualresearchonline.arts.ac.uk/889/. See also Jessica Hemmings, "Jane Harris: Motion Capture Restoration," January 1, 2007, accessed November 28, 2015, http://www.jessicahemmings.com/jane-harris-motion-capture-restoration/.

5. "Alexander McQueen Autumn/Winter 2010–2011 (Angels & Dæmons)," video, 26:11 min., accessed July 17, 2015, https://www.youtube.com/watch?v=1yUOaXp34tM/. In this video of the collection, the coat of lacquered gold duck feathers appears at 23:10 min.

6. Sundsbø, quoted in Eric Wilson, "A Mannequin in Every Sense," *New York Times*,
 April 13, 2011, accessed July 18, 2011, http://www.nytimes.com/2011/04/14/fashion
 /14ROW.html/.

7. Bolton, quoted in Eric Wilson, "A Mannequin in Every Sense," *New York Times*, April 13,
 2011, accessed July 18, 2011, http://www.nytimes.com/2011/04/14/fashion/14ROW.html.

8. Ross Lydall, "Kate Middleton's wedding dress makes the Royal Family £10 million"
 Evening Standard, July 18, 2012, p. 3.

9. For example, different forms of understanding of authenticity are explored in Dovgan
 Nurse, Eastop, and Brooks 2014.

REFERENCES

Baxandall, Michael. 1991. "Exhibiting Intention: Some Preconditions of the Visual Display
 of Culturally Purposeful Objects." In *Exhibiting Cultures: The Poetics and Politics of
 Museum Display*, edited by Ivan Karp and Steven D. Lavine, 33–41. Washington, D.C.:
 Smithsonian Institution Press.

Brooks, Mary M. 2010. "La conservazione degli oggetti della moda." In *Moda: Storie e storie*,
 edited by M. Giuseppina Muzzarelli, Giorgio Riello, and E. Tosi Brandi, 169–79. Milan:
 Bruno Mondadori.

Coombes, Annie E. 2011. "Witnessing History/Embodying Testimony: Gender and Memory
 in Post-Apartheid South Africa." *Journal of the Royal Anthropological Institute*; special
 issue, *The Aesthetics of Nations: Anthropological and Historical Approaches*, edited by
 Nayanika Mookherjee and Christopher Pinney, S92–112.

Dovgan Nurse, Luba, Dinah D. Eastop, and Mary M. Brooks. 2014. "Authenticity in the Revival
 of Orthodox Ecclesiastical Embroidery in Post-Soviet Russia." In *Authenticity and Rep-
 lication: The "Real Thing" in Art and Conservation*, edited by Rebecca Gordon, Erma
 Hermens, and Frances Lennard, 74–85. London: Archetype.

Eastop, Dinah D. 2009. "The Cultural Dynamics of Conservation Principles in Reported Prac-
 tice." In *Conservation: Principles, Dilemmas and Uncomfortable Truths*, edited by Alison
 Richmond and Alison Bracker, 150–62. Oxford: Butterworth-Heinemann.

———. 2011. "Conservation Practice as Enacted Ethics." In *The Routledge Companion to
 Museum Ethics: Redefining Ethics for the Twenty-First Century Museum*, edited by
 Janet Marstine, 426–44. London: Routledge.

———. 2014. "String Figures Matter: Embodied Knowledge in Action." *Craft Research* 5 (2):
 221–29.

Eastop, Dinah D., and Charlotte Dew. 2006. "Context and Meaning Generation: The Con-
 servation of Garments Deliberately Concealed in Buildings." In *The Object in Context:
 Crossing Conservation Boundaries*, edited by David Saunders, Joyce H. Townsend, and
 Sally Woodcock, 17–22. London: International Institute for Conservation.

Eastop, Dinah D., and Bernice Morris. 2010. "Fit for a Princess? Material Culture and the Con-
 servation of Grace Kelly's Wedding Dress." In *Textile Conservation: Recent Advances*,
 edited by Frances Lennard and Patricia Ewer, 76–84. Oxford: Butterworth-Heinemann.

Finch, Karen. 1982. "Changing Attitudes—New Developments—Full Circle." In *Conservazione
 e restauro dei tessili: Convegno internazionale Como, 1980*, edited by Franceso Perte-
 gato, 82–86. Milan: CISST.

Hall, Stuart, ed. 1997. *Representation: Cultural Representations and Signifying Practices*.
 Buckingham, UK: Open University Press.

Haugland, H. Kristina. 2006. *Grace Kelly: Icon of Style to Royal Bride*. New Haven, CT: Yale
 University Press.

Javér, Anna, Dinah D. Eastop, and Rosalind Janssen. 1999. "A Sprang Cap Preserved on a Naturally Dried Human Head." *Textile History* 30 (2): 135–54.

Johnson, Jessica. 2007. "Collaborative Touch: Working with a Community Artist to Restore a Kwakwaka'wakw Mask." In *The Power of Touch*, edited by Elizabeth Pye, 215–22. London: UCL Publications.

Lakoff, George, and Mark Johnson. 1980. *Metaphors We Live By*. Chicago: University of Chicago Press.

Landi, Sheila, and Rosalind M. Hall. 1979. "The Discovery and Conservation of an Ancient Egyptian Linen Tunic." *Studies in Conservation* 24: 141–52.

Mookherjee, Nayanika. 2011. "The Aesthetics of Nations: Anthropological and Historical Approaches." *Journal of the Royal Anthropological Institute*; special issue, *The Aesthetics of Nations: Anthropological and Historical Approaches*, edited by Nayanika Mookherjee and Christopher Pinney, S1–20.

Mookherjee, Nayanika, and Christopher Pinney. 2011. Preface to *Journal of the Royal Anthropological Institute*; special issue, *The Aesthetics of Nations: Anthropological and Historical Approaches*, edited by Nayanika Mookherjee and Christopher Pinney, Siii–iv.

Odegaard, Nancy, and Alyce Sadongei, eds. 2005. *Old Poisons, New Problems: A Museum Resource for Managing Contaminated Cultural Materials*. Walnut Creek, CA: Altamira Press.

Pritchard, Frances. 2006. *Clothing Culture: Dress in Egypt in the First Millennium AD, Clothing from Egypt in the Collection of the Whitworth Art Gallery, the University of Manchester*. Manchester, UK: Whitworth Art Gallery.

Seth-Smith, Alexandra, and Alison Lister. 1995. "The Research and Reconstruction of a Fifth Dynasty Bead-Net Dress." In *Conservation in Ancient Egyptian Collections*, Postprints of the United Kingdom Institute for Conservation Archaeology Section Conference, London, July 20–21, 1995, edited by Carol E. Brown, Fiona Macalister, and Margot Wright, 165–72. London: Archetype.

Similä, Katriina, and Dinah D. Eastop. 2016. "Positioning: Where You Stand." In *Learning Curve: Education, Experience, Reflection*, Postprints of the Icon Textile Group Spring Forum, London, April 13, 2015, edited by Alison Fairhurst, 10–21. London: Icon.

Teutonico, Jeanne Marie, and Frank Matero, eds. 2003. *Managing Change: Sustainable Approaches to the Conservation of the Built Environment*. Los Angeles: Getty Conservation Institute.

Textile Conservation Centre (UK). 1994. "Conservation Report on 'Gurob Sleeves.'" TCC 1826.3. Unpublished report.

University College London. 1977. *The Guide to the Petrie Museum of Egyptian Archaeology*. London: University College London.

Van Dyke, Ron. 2013. Review of *In Defense of Things. Archaeology and the Ontology of Objects*, by B. Olsen. *Journal of Design History* 26 (2): 224–27.

Vergo, Peter. 1989. "The Reticent Object." In *The New Museology*, edited by Peter Vergo, 41–59. London: Reaktion.

AUTHOR BIOGRAPHIES

MARY M. BROOKS, PhD, FSA, FIIC, graduated from Cambridge University and trained at the Textile Conservation Centre (UK) and the Abegg-Stiftung, Riggisberg, Switzerland. She worked at the M.H. de Young Museum, San Francisco, and York Castle Museum, England, where she co-curated the award-winning *Stop the Rot* (1993–94). She became head of

Studies and Research, Textile Conservation Centre, in 1993, and has since taught conservation, museum studies, and cultural heritage management at York and Durham Universities. She held a Getty Conservation Scholarship (2001) and an Arts and Humanities Research Board (AHRB) Innovation Award with the Victoria and Albert Museum, London (2002–3). She was a Monument Fellow at York Castle Museum (2010–11) and a curatorial researcher for the Kirkgate redisplay project, York Castle Museum (2011–12). She has been guest curator for two exhibitions at the Ashmolean Museum, University of Oxford: *Curious Works: Seventeenth-Century English Embroideries* (2003), and *Eye of the Needle*, showcasing the Feller's collection of seventeenth-century embroidery (2014).

DINAH D. EASTOP, PhD, FIIC, is an accredited conservator with postgraduate training in anthropology (University College London [UCL]). Her focus is on material culture as the interconnection between the material and the social. Her conservation training included internships at the Abegg-Stiftung, Riggisberg, Switzerland, and she worked at the Textile Conservation Centre (UK) in many roles (e.g., as director and senior lecturer) and later in Collection Care, The National Archives (UK). She was founding director of the AHRC Research Centre for Textile Conservation and Textile Studies (UK). Eastop was a visiting international scholar, Grimwade Centre for Cultural Materials Conservation, University of Melbourne, and she has honorary posts at the universities of Glasgow, London (UCL Institute of Archaeology), and Southampton. She works internationally, notably with ICCROM (most recently with CollAsia). Eastop coauthored *Chemical Principles of Textile Conservation* (with Ágnes Tímár-Balázsy) and coedited *Upholstery Conservation: Principles and Practice* (with Kathryn Gill) and *Changing Views of Textile Conservation* (with Mary M. Brooks). She leads the Deliberately Concealed Garments Project (www.concealedgarments.org).

1 | REFLECTING ABSENCE AND PRESENCE
DISPLAYING DRESS OF KNOWN INDIVIDUALS

Mary M. Brooks

Displaying dress in museums is a complex physical process to which curators and conservators have, over many years, devoted great thought and technical skill (Flecker 2007; Amnéus and Miles 2012). Techniques have been developed that satisfy conservation needs while responding to interpretative narratives and designers' concepts. Joanne Entwistle argues that dress is an "embodied practice, *a situated bodily practice* which is embedded in the social world" (2000:325). This paper does not challenge this view but rather seeks to explore what happens when the dress is present without the body that once wore it. The shift from dress worn on the living body, itself a mode of display, to dress displayed on an inert form, which may be realistic or stylized, involves a complex blend of physical, cultural, and social elements. Placing a garment on a mannequin in a museum is a re-bodiment within specific performative frameworks. The malleable garment, echoing the living body it once covered, protected, shaped, and ornamented, is placed upon a fixed form, often created through a process of "reverse engineering." The complexities involved in this (re)construction of the body, merging the boundaries between the original wearer, who may be living or dead and is both absent and present, are intensified when the person who wore the garment is known through paintings, photographs, and written descriptions. This paper explores how this "body," present as a mounted garment contextualized and interpreted by curators, conservators, and designers, functions to represent the person. Two case studies conclude the paper: a nineteenth-century dress worn by a wealthy woman married into the English ruling class, and an eighteenth-century Mughal garment worn by an Englishman of the East India Company.

AMBIVALENT BODIES
The words used to describe the "body" on which garments are displayed are ambivalent terms. *Model* can conflate the animate and inanimate, being both a noun (a model can be a couture garment, or the person who wears and displays garments) and a verb (describing the process

of modeling garments for couture consumers). The word *mannequin* is equally equivocal, being both "an inanimate dressmaker's dummy [and]…a living, breathing woman" (C. Evans 2013:xx). As Caroline Evans notes in her subtle exploration of the fashion show's history, living mannequins become stylized "unreal" bodies as the process of representing dress in such fashion shows makes individuals "disappear from view" (ibid.:8). Mannequins, models, and dummies are also everyday objects used by dressmakers, artists, shops, and museums as functional, substitute bodies. They can be eerily animate, recalling stories of Pygmalion, who fell in love with his own sculpture of a beautiful woman, and Franz's infatuation with Coppélia, the life-size doll created by Dr. Coppelius.[1] They can evoke complex emotions and reactions. Jane Munro, curator of *Silent Partners: Artist and Mannequin from Function to Fetish* (2014–15, Fitzwilliam Museum, Cambridge), observed that mannequins "are just human enough—but there is an impenetrable barrier that can sometimes disturb us. They are silent and inert, but in at least some cases give the impression of a being in which life is not absent, but in abeyance."[2]

ABSENCE AND PRESENCE

Themes of absence and presence and life and death permeate discussions of dress collections and exhibitions. Several well-known critics have used the trope: Valerie Steele described museums as cemeteries for "dead" clothes (1998:334); Elizabeth Wilson observed that dress exhibitions "hint at…the atrophy of the body and the evanescence of life" (1985:1) and show "clothes suspended in a kind of rigor mortis" (Ash and Wilson 1992:15).

Others have voiced concerns about how clothes will be used to evoke individuals. The exhibition *Isabella Blow: Fashion Galore!* (2013–14, Somerset House, London) showed clothes worn by fashion director and muse Isabella Blow (1958–2007).[3] Long before the exhibition, her biographer Lauren Goldstein Crowe discussed what might be lost in displaying Blow's clothes:

> Exhibitions of clothes are notoriously difficult to pull off. Without context, without a human body, they are lifeless things devoid of meaning.…To do her [Blow] justice they will have to find a way to show that she was more than just her collection of clothes. (2011:252)

Co-curator Shonagh Marshall explained how the exhibition addressed this challenge. Conservators balanced preservation

requirements with ensuring that traces of Blow's life were vividly evi-
dent: cigarette holes in her McQueen coat, scuffing on her Givenchy
shoes.[4] Different three-dimensional body forms were used to create
different responses. Traditional dressmaker forms were chosen for
garments by designers promoted by Blow. Bespoke mannequins by
designer Shona Heath were commissioned for Blow's own clothes,
including stylized forms raised high on plinths, elegant legs emerging
from "boxes" to display shoes, detached heads with elongated necks
for Blow's dramatic hats, and figures with abstract faces to focus atten-
tion on the garments.[5] Radically different mannequins were used in
the Circular Saloon, which evoked Blow's family home, with her voice
whispering from the walls. A mask maker, working from photographs,
carved masks of Blow's face, each with a different expression and
"makeup." These were then covered with Perspex masks to "suppress"
the evoked reality.[6] Blow's living presence and absence were held in an
uneasy balance.

SURROGATE BODIES

Garments that protected, shaped, and presented the body in life can
become surrogate bodies in the museum, evoking and memorial-
izing the absent wearer. Such molding may be part of the garment's
original construction, as when a Māori cloak is woven to shape (Hiroa
1925:100–101), or reflect the life of mutable clothing, altered to accom-
modate the requirements of a changing figure, new wearers, or a shift-
ing idea of the fashionable form. Wrinkles recall movement; stressed
areas suggest the bending of a body that strained—or even burst
through—fabric and seams. Scholar Peter Stallybrass demonstrated
how garments evoke memories when he described the effect of wear-
ing a jacket belonging to his late colleague Allon White: "He was there
in the wrinkles of the elbows, wrinkles that in the technical jargon of
sewing are called 'memory'; he was there in the stains at the very bot-
tom of the jacket; he was there in the smell of the armpits" (1993:36).
Changes such as these make garments carriers of individuality created
over time. As Judith Attfield wrote, mending and repairs in an old,
loved garment may create the most poignant link: "He only got to love
the cardigan as it grew old and threadbare, so I darned the holes and
mended the ragged cuffs so it would last a little longer. He died soon
after. The cardigan lies in my jumper drawer…reminding me of his per-
manent absence" (2000:149–50). The Countess of Rosse argued that
evidence of the passage of time was an added dimension in her fam-
ily's dress collection, as such clothes had "that meaning of having been

worn" (de la Haye, Taylor, and Thompson 2005:9).[7] The analogy often drawn between the decaying garment and the deceased person is all too close: "fragmenting clothes…possess a beauty and poignancy which can be likened to human vulnerability" (ibid.:24).

MANNEQUINS IN THE MUSEUM

Exhibitions presenting clothing of one individual or family highlight both the nature of dress and its role in creating and memorializing personality; examples include Romilly McAlpine's collection of Vivienne Westwood (2000);[8] *Fashion & Fancy Dress: The Messel Family Dress Collection 1865–2005* (2006);[9] *Style and Splendour: Queen Maud of Norway's Wardrobe 1896–1938* (2005–6);[10] and *Grace Kelly: Style Icon* (2010).[11] Underpinning these diverse exhibitions is the idea that the clothes will evoke the individual: self-presentation in life may become re-presentation in a different time and context. This powerful sense of identity through the sloughed skin of clothing reflects the intimacy of the body and the dress.

Using some form of support is essential; the garments must be comprehensible as dress in order to carry the meaning selected for a specific display context, whether as a work of art, a design statement, or as representation of previous wearers. The need to display dress on a form is frequently noted. Eleanor Thompson, one of the curators of *Fashion & Fancy Dress*, observed that Lady Rosse's Charles James dress, called *Le coque noir*, "look[ed] like a screwed up ball of black nothingness" in its box.[12] The choice of form and degree of abstraction or realism influences how museum visitors view and understand the garment in the context of an exhibition. This raises complex questions of how the individual is represented in a museum display, particularly given the malleability of some garments. I was once asked to prepare a large-size 1920s flapper dress for display so that it conformed to a thin body— that is, the late twentieth-century idea of the fashionable figure—rather than the generously built body of the original wearer,[13] whose corporeal existence was denied in the temporary modification of the form of her dress.[14]

Choosing a realistic figure with heads and hands may seem the most direct way of evoking the absent wearer, but it has inherent difficulties. Naomi Tarrant brilliantly compared the impact of the 1885 photograph of Harriet Valentine Crocker (1859–1935) wearing formal court dress with its "re-creation" by the Museum of the City of New York (1983:110–11). Although the mannequin, with realistic head, wig, and hands, had been posed to replicate the sweeping curves of Crocker's

dress, headdress, veil, and fan shown in the photograph, the effect of the museum representation now appears forced and unreal.

One approach to avoid such jarring dissonance is to use figures without heads and hands. In *Fashion & Fancy Dress*, the Messel family clothes were displayed on headless, "invisible" forms. No attempt was made to create mannequins that represented specific individuals. Jenny Lister observed that while these mounts were "very effective in focusing attention" on the garments, there were "discomforting views into empty hollows inside through necklines and armholes" (2006:214). Using other stylized figures also presents challenges. In her perceptive review of *Style and Splendour: Queen Maud of Norway's Wardrobe*, Kay Staniland wrote that "all but one outfit was mounted on headless soft torsos," which "could easily be read as the outer skin of a young person" (2006:96). The exception was Maud's 1906 coronation dress, "shown on an imposing but roughly finished rather gaunt sculptured figure sporting a crown atop an all too solid mass of sculpted hair" (ibid.). This was a replica of an actual human figure, with arms and hands. Staniland acknowledged the high cost of "articulated and accessorized display figures" but argued that the stylized approach can cause difficulties: "several visitors [were] having great problems understanding the nature of the 1920s riding habit, constructed for side-saddle wear but to them a strange apparition, floating on a metal pole, legless as well as headless" (ibid.:98). Mixing the stylized and the mimetic also raises questions about the objectives of the choice of mannequins. Was the intention to present Queen Maud's role, conjured up by small photographs throughout the exhibition, or to focus attention on her fashionable clothes?

The stylized forms used in *Grace Kelly: Style Icon* also received mixed reactions. Described as "immobile" and "macabre" by Rhiannon Harries,[15] the white mannequins had hands, feet, and torsos terminating in extended but headless necks. Another reviewer was even more brutal, describing these "abstract replicas" as looking like "the Paris morgue in the 1790s after a hard day's guillotining: 50 poised princesses, who manage to stand upright and show off their aristocratic finery, despite just having lost their heads."[16] The difficulties of an exhibition filled with numerous representations of Grace Kelly's poised and elegantly coiffed head are evident: Which hairstyle and makeup should be chosen? Should a mimetic head be allowed to "age," to match the dates of the dresses? Would a realistic head underline the motionlessness of the mannequins, particularly given that Kelly's moving image is so familiar from her films (Eastop and Morris 2010).[17] The chosen,

stylized forms seem to have been intended to focus attention on the Grace Kelly style rather than on Kelly herself.

DONORS' PERSPECTIVES

Relatively few donors seem to have recorded their wishes about the display of their donated garments, although some living donors clearly do care about how such clothes are represented. Unusually, the Countess of Rosse stated that she wished her family's clothes to be displayed "with 'elegance' and 'flair' and 'peopled' contextually," an interesting combination of the visual and the human (de la Haye, Taylor, and Thompson 2005:11). She also wanted ensembles to be displayed as they had been worn, and threatened to remove her mother's honeymoon outfit if the hat was shown without the dress. The curator commented, "It would seem that her response was emotive as much as curatorial. The ensemble, in its completeness, evoked living memories of her mother, and, in turn, of her mother's absence" (ibid.:22). My own experience of what became a contested museum display indicates the potential for divergence between museum practice and donor expectations. In this case, the donor so disliked the mannequin used to display her outfit that the exhibition was closed.

For the Pritt sisters, in contrast, a museum seems to have acted almost as a surrogate home. Georgina Pritt's moving letters give detailed information about the eighty-two garments donated to York Castle Museum and the family members who wore them. She wrote delightedly: "My yellow dress seems to have attained celebrity," describing in great detail the changes the dress had undergone and hoping that it might be "a minute contribution to the history of dress."[18] There is no record of this dress ever having been displayed, another form of absence in the museum.

MATERIAL POLITICS: LADY CURZON'S PEACOCK DRESS

American Mary Leiter (1870–1906) became Lady Curzon of Kedleston and vicereine of India thanks to her marriage in 1895 to George Curzon, who became viceroy of India in 1898. She engaged fully with the role, undertaking official duties and promoting Indian textile arts and manufacture through her adoption of hybrid European-Indian dresses. Her genius at realizing the symbolic agency of fabric is perfectly demonstrated by her famous "peacock dress," designed for the 1903 Delhi Durbar State Ball celebrating Edward VII's 1902 coronation. This dress was—and remains—a vivid and deliberate statement of intercultural materiality, combining high fashion and political fashioning. Lady

Curzon clearly understood her performative role as vicereine and was adept at communicating through the medium of dress. Because the ballroom had once held Shah Jahan's seventeenth-century peacock throne, symbolizing India, Lady Curzon's ball gown referred to this past empire while asserting the British Raj's power.[19] The silk chiffon fabric had been embroidered with a design of gold peacock feathers in India and then made up as a fashionable two-piece ball gown by the House of Worth in Paris.[20] The eye of each feather is ornamented with an iridescent beetle-wing case (elytra), a traditional Mughal technique that, according to John Oliver Hobbes,[21] reflected Lady Curzon's taste for "elaborately woven or embroidered materials" (1903:46).

Lady Curzon possessed more than one dress that fused British symbols with Indian materials and embroidery. When her "orchid gown," also made at Worth from embroidered Indian fabric, was exhibited in 2013 at the Yale Center for British Art,[22] the curator, Angus Trumble, recorded how "Mary Curzon's ghostly presence" was conjured up and intensified as the mounting of her dress progressed, creating "a vague but growing sense of imminence....[a] gradual re-animation."[23] However, the peacock dress's current display in the Indian Museum at Kedleston Hall,[24] the Curzon family seat, has little sense of such "presence" despite its imperial context. The garment is mounted on a cloth-covered, headless, short-armed mannequin, and its elaborate if tarnished metal thread embroidery, beetle wings, and flowing train edged with three-dimensional flowers[25] suffer in comparison to their vivid depiction in William Logsdail's posthumous portrait of Lady Curzon wearing the same dress (fig. 1.1).[26] Although the portrait is reproduced on the label next to the dress, the painting itself hangs in a nearby corridor, so the two life-size representations must be viewed separately. Lady Curzon's imposing 1.8m (6ft) height is dramatized in the painting but is less evident in the dress, which is displayed in a raised wooden case with numerous struts obscuring visitors' sightlines. Logsdail depicts Lady Curzon's tiny waist and jeweled stomacher, whereas the dress itself has a different bodice decoration, an altered waistline, and an additional fabric insert in the bodice front (fig. 1.2).[27] The "object biography" is evident in the material. The absent body in this apparently mimetic re-creation of Lady Curzon's famous gown may be that of a different person who wore the dress at a later time.

FIGURE 1.1

William Logsdail (English, 1859–1944), *Mary Victoria Leiter, Lady Curzon*, 1909. Oil on canvas, 269.2 × 144.8 cm (106 × 57 in.). Kedleston, National Trust Inventory Number 108822. Kedleston Hall, The Scarsdale Collection (acquired with the help of the National Heritage Memorial Fund and transferred to the National Trust in 1987). National Trust Photo Library / Art Resource, NY

FIGURE 1.2

Detail of Lady Curzon's peacock dress as displayed in a glass case, Kedleston Hall.
Photo: © 2014 Cathy Hay, thepeacockdress.com

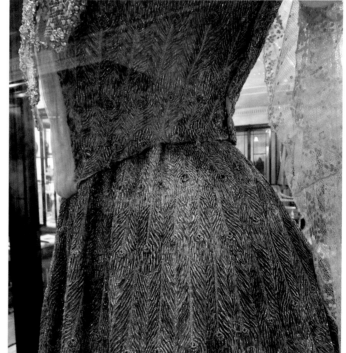

WEARING THE ORIENT: CAPTAIN JOHN FOOTE'S *JAMA*
Between 1761 and 1765, Joshua Reynolds (1723–1792) painted Captain
John Foote (1718–1768) of the East India Company wearing Mughal
clothes.[28] The *jama*—an elegant embroidered cotton robe with side ties,
elongated sleeves, and a long, full skirt—survives, together with the
portrait, in York Museums Trust. Foote's wearing of Mughal garments,
which may have been a gift from an Indian ruler as a *khil'at* (robe of
honor), is a visible adoption of clothing of the "other" and a deliberate
reworking of his Western identity (Crill 2015:11).

Foote is wearing a turban in the portrait, but the mannequin in
the display is headless. It does have arms, however, which were critical
to the presentation, as the curatorial aim was to make a connection
between the two representations. Non-rusting wires inserted into the
center of the soft, silk-covered arms enabled them to be bent slightly,
animating the figure and echoing Foote's pose in the portrait. Padded
rolls at the wrists supported the long sleeves and allowed them to fall
in the gentle folds depicted by Reynolds. Here, the mounted *jama*,
with Reynolds's portrait in the background, are viewed through the
glass of the display case (fig. 1.3), demonstrating both materially and
metaphorically the reflections and refractions characteristic of the
representation of historic dress in museum exhibitions.

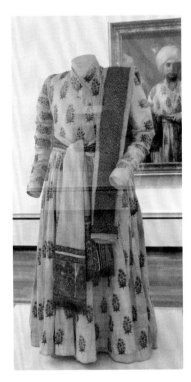

FIGURE 1.3
Captain John Foote's
jama on display in York
Art Gallery, 2011 (YORAG
2003.4). Joshua Reyn-
olds's portrait of Captain
Foote can be seen in the
background, through the
glass case (YORAG 216).
Photo: © Mary M. Brooks.
Image courtesy of York
Museums Trust. http:
//yorkmuseumstrust.org.
uk, CC BY-SA 4.0

The mounting process provided unexpected insights into the prior interactions between the *jama* and Foote's absent body. Conservators aim to display garments with minimum stress, using methods that will reduce the risk of long-term damage. During the mounting process, marked stress wrinkles persisted around the armholes and shoulders even when the mannequin, a traditional male Western tailor's form,[29] was modified to reduce this tension. The reason for this became clear when the mounted *jama* was compared with Reynolds's depiction of the Mughal garment on Foote's body. The same pattern of wrinkles was evident, suggesting that the tight armhole of an Indo-Persian garment was not suited to an occidental body, and that the traditional cut inevitably resulted in stress creases.[30] Despite the apparent fluidity of the garment, it could have been experienced by Foote as constraining: the *jama* may have survived because he rarely wore it.[31] In this case, the conservation mounting process, coupled with evidence from the portrait, provided insights into how the garment might have felt when worn by Foote.

REFLECTIONS

This paper has explored the representation of known individuals through their surviving garments and, in some cases, portraits and photographs. These individuals are often involved in creating the image they present to the world; for example, in their photographic representations. There are relatively few instances where individuals, or their descendants, are involved in the display of their clothing in a museum; when this does happen, it may become a contested interpretation.

Clothing of a known individual may function as a material metonym—and as a memento mori. The more recent exhibitions discussed in this paper have tended to avoid, or to mute, direct mimetic representation, leaving unresolved the issue of what is being represented. The persistent ambiguities that appear to be inherent in the idea of the mannequin, sometimes perceived as hovering between the animate and inanimate, further complicate the transformative process of mounting dress and raise additional questions about this process of representation. Conservation input is vital not only in the "reverse engineering" that re-creates the absent body within specific curatorial and design interpretations but also in understanding and interpreting the changes the garment underwent when it was worn. Such understanding of the nature of the garments can aid understanding of their history and provide insights into their parallel representation in portraits and photographs, thus enhancing interpretation for visitors and making the

mounted dress "just human enough." Nevertheless, the very mutability of textiles and dress means that the challenges of fusing the physical and intellectual when mounting dress for display is highlighted when the garments concerned are those of known individuals.

ACKNOWLEDGMENTS

With thanks to coeditor Dinah D. Eastop; Ffion George, House and Collections manager, Kedleston Hall; Laura Turner, curator of art, York Art Gallery; Cathy Hay, website publisher, *Your Wardrobe Unlock'd*; and Jeff Veitch, Department of Archaeology, Durham University.

NOTES

1. For a version of the Pygmalion story, see Ovid's *Metamorphoses*, 10.243–97, accessed August 24, 2015, http://www.theoi.com/Text/OvidMetamorphoses10.html. The 1870 ballet *Coppélia* was choreographed by Arthur St. Léon, drawing on E. T. A. Hoffmann's story *Der Sandmann*, 1817.

2. Jane Munro, quoted in P. Evans 2014, 21.

3. *Isabella Blow: Fashion Galore!* was presented at Somerset House, London, by the Isabella Blow Foundation and Central Saint Martins. It was curated by Alistair O'Neill and Shonagh Marshall and designed by Carmody Groarke. For more information, see "*Isabella Blow: Fashion Galore!*," Somerset House, accessed July 18, 2011, https: //www.somersethouse.org.uk/visual-arts/isabella-blow-fashion-galore.

4. Shonagh Marshall, "*Isabella Blow: Fashion Galore!* Behind the Scenes Shorts," Somerset House, accessed July 16, 2015, http://www.somersethouse.org.uk/visual-arts/isabella -blow-fashion-galore/behind-the-scenes-shorts.

5. Shona Heath, "Shona Heath—*Isabella Blow: Fashion Galore!*," accessed August 2, 2016, http://blog.courtauld.ac.uk/documentingfashion/2014/03/25/fashion-curator -shonagh-marshall-gives-us-a-tour-of-the-isabella-blow-fashion-galore-exhibition-in -somerset-house/.

6. Shonagh Marshall, "The Mannequins & Shona Heath," Somerset House, accessed July 16, 2015, https://www.youtube.com/watch?v=0j01FsCOKCEface.

7. Anne, Countess of Rosse (née Messel), to John Morley, 1981, Brighton Museum & Art Gallery Archives, Coll/9/d/i (de la Haye, Taylor, and Thompson 2005:11). The Messel Collection of clothing is housed at Brighton Museum & Art Gallery; for more information, see "Fashion and Fancy Dress," Brighton Museum & Art Gallery, accessed July 18, 2011, http://brightonmuseums.org.uk/discover/2015/02/26/fashion-and-fancy -dress-2/.

8. The McAlpine collection, exhibited at the Museum of London (2000), was curated by Catherine McDermott and designed by Tim Hately.

9. *Fashion & Fancy Dress* (2006, Brighton Museum & Art Gallery) was curated by Amy de la Haye, Lou Taylor, and Eleanor Thompson. For more information and images, see University of the Arts London, accessed July 18, 2011, http://ualresearchonline.arts .ac.uk/1729/.

10. *Style and Splendour* (2005–6, Victoria and Albert Museum [hereafter, V&A]) was curated by Anne Kjellberg and Susan North.

11. *Grace Kelly* (2010, V&A) was curated by Jenny Lister.

12. "Fashion and Fancy Dress Curator's Tour"; Eleanor Thompson (curator of costume, Brighton Museum & Art Gallery), interview by Kristen Bailey, *Culture24.org*, accessed March 25, 2016, http://www.culture24.org.uk/art/architecture-and-design/art31270.

13. For a discussion of the failure of museums to display "big frocks" and hence "big women," see Summers 2000: n.p.

14. The mounting followed standard conservation protocols.

15. Rhiannon Harries, review of "Grace Kelly: Style Icon, V&A, London," *Independent*, April 25, 2010, accessed July 16, 2015, http://www.independent.co.uk/arts -entertainment/art/reviews/grace-kelly-style-icon-va-london-1953396.html.

16. Peter Conrad, review of "Grace Kelly: Style Icon," *Observer*, April 18, 2010, accessed July 16, 2015, http://www.theguardian.com/artanddesign/2010/apr/18/grace-kelly -style-icon-exhibition.

17. The mannequin used in the 1956 display of Grace Kelly's wedding dress (1956-51-1a-- d--4b) at the Philadelphia Museum of Art was intended to be a representation of the princess; see introduction, this volume (p. 3).

18. Georgina Pritt to Violet Rodgers, York Castle Museum (YCM), February 8, 1943; YCM 12/41; see Brooks 2012.

19. For a discussion of exchange and appropriation in Lady Curzon's dress, see Thomas 2007:391–93.

20. The dress is in the National Trust Collections (NT 107881); see "The Peacock Dress," National Trust Collections, accessed July 18, 2011, http://www.nationaltrustcollections .org.uk/object/107881.

21. John Oliver Hobbes was the nom de plume of the novelist and journalist Pearl Mary Teresa Craigie. A close friend of Lady Curzon, Craigie attended the Delhi Durbar, reporting on events for papers in London and New York.

22. In *Edwardian Opulence: British Art at the Dawn of the Twentieth Century* at the Yale Center for British Art (New Haven, Connecticut), February 28–June 2, 2013.

23. Angus Trumble, "Edwardian Opulence: 'The Gown,'" *YaleBooks* (blog), May 23, 2013, accessed July 18, 2015, http://yalebooksblog.co.uk/2013/05/23/edwardian-opulence -the-gown-by-angus-trumble/.

24. Lord Curzon divided his "Eastern collection" between the V&A and his Kedleston museum (National Trust 1988:55–56).

25. These flowers, described as camellias or roses, were replaced in the 1950s. For further information, see "Lady Curzon's Peacock Dress," Textile Research Centre, Leiden, accessed June 13, 2015, http://trc-leiden.nl/trc-needles/index.php/component/k2 /item/10514-lady-curzons-peacock-dress.

26. Logsdail's portrait, *Mary Victoria Leiter, Lady Curzon* (1909), is also in the National Trust Collections (NT 108822); see National Trust Collections, accessed July 16, 2015, http://www.nationaltrustcollections.org.uk/object/108822.

27. Alterations include resetting the skirt with gathers around the waist (rather than just at the back) and the 1930s gold brocade fabric insert. Cathy Hay, who made a replica of the dress, observes that some of these alterations appear to be visible in the 1909 portrait and therefore may have been undertaken for Lady Curzon. Other alterations, including the insertion of the brocade fabric, may have been carried out for one of her daughters; see Cathy Hay, "The Peacock Dress Today," *The Peacock Dress* (blog), accessed March 13, 2015, http://thepeacockdress.com/project/the-peacock-dress

-today/. A redisplay of the dress is planned; Ffion George, House and Collections manager, Kedleston Hall, personal communication to author, May 20, 2015.

28. York Art Gallery (YORAG 2003.4). I was commissioned to mount Foote's garments for display in 2011. The surviving *patka* (sash) and shawl differ from those depicted in Reynolds's portrait (YORAG 216).

29. A papier-mâché Proportion Continental Male 9060 was used. The silk undergarment and padded arms were custom-made at the V&A for that institution's display of the ensemble, along with Reynolds's portrait, in *Encounters: The Meeting of Asia and Europe 1500–1800* (2004).

30. The same creases were observed in the display of Foote's *jama* in the V&A exhibition *The Fabric of India*; Dinah D. Eastop, personal communication to author, October 15, 2015.

31. Marcia Pointon noted that the *jama* seemed "remarkably fresh," suggesting it was worn only for special occasions; for example, having a portrait painted (2013:126).

REFERENCES

Amnéus, Cynthia, and Marla Miles. 2012. "A Method for Invisibly Mounting Costume Using Fosshape." *Journal of the American Institute for Conservation* 51 (1): 3–14.

Ash, Juliet, and Elizabeth Wilson. 1992. *Chic Thrills: A Fashion Reader*. Berkeley: University of California Press.

Attfield, Judith. 2000. *Wild Things: The Material Culture of Everyday Life*. Oxford: Berg.

Brooks, Mary M. 2012. "'My yellow dress seems to have attained celebrity': Acquiring and Displaying the Dress and Textile Collection, York Castle Museum, England." Paper presented at Costume Colloquium III: Past Dress—Future Fashion, Florence, Italy, November 8–11. Accessed March 25, 2015. http://www.costume-textiles.com/?page_id=1848.

Crill, Rosemary, ed. 2015. *The Fabric of India*. London: V&A Publishing.

Crowe, Lauren Goldstein. 2011. *Isabella Blow: A Life in Fashion*. London: Quartet.

de la Haye, Amy, Lou Taylor, and Eleanor Thompson. 2005. *A Family of Fashion: The Messels; Six Generations of Dress*. London: Philip Wilson.

Eastop, Dinah D., and Bernice Morris. 2010. "Fit for a Princess? Material Culture and the Conservation of Grace Kelly's Wedding Dress." In *Textile Conservation: Recent Advances*, edited by Frances Lennard and Patricia Ewer, 76–84. Oxford: Butterworth-Heinemann.

Entwistle, Joanne. 2000. "Fashion and the Fleshy Body: Dress as Embodied Practice." *Fashion Theory* 4 (3): 323–47.

Evans, Caroline. 2013. *The Mechanical Smile: Modernism and the First Fashion Shows in France and America, 1900–1929*. New Haven, CT: Yale University Press.

Evans, Pamela. 2014. "Living Dolls." *Cambridge Alumni Magazine* 73: 20–25.

Flecker, Lara. 2007. *A Practical Guide to Costume Mounting*. Oxford: Butterworth-Heinemann.

Hiroa, Te Rangi (Peter H. Buck). 1925. "Evolution of Maori Clothing. Part 6." *Journal of the Polynesian Society* 34 (134): 99–123.

Hobbes, John Oliver [Pearl Mary Teresa Craigie]. 1903. *Imperial India: Letters from the East*. London: T. F. Unwin.

Lister, Jenny. 2006. "Fashion and Fancy Dress: The Messel Family Dress Collection, 1865–2005." *Textile History* 37 (2): 209–16.

National Trust. 1988. *Kedleston Hall*. [London]: National Trust.

Pointon, Marcia. 2013. *Portrayal and the Search for Identity*. London: Reaktion Books.

Stallybrass, Peter. 1993. "Worn Worlds: Clothes, Mourning, and the Life of Things." *Yale*

Review 81 (2): 35–50.

Staniland, Kay. 2006. "Style and Splendour: Queen Maud of Norway's Wardrobe 1896–1938." *Textile History* 37 (1): 95–99.

Steele, Valerie. 1998. "A Museum of Fashion Is More than a Clothes-Bag." *Fashion Theory* 2 (4): 327–36.

Summers, Leigh. 2000. "Sanitising the Female Body: Costume, Corsetry, and the Case for Corporeal Feminism in Social History Museums." *Open Museums Journal* 1: n.p.

Tarrant, Naomi. 1983. *Collecting Costume: The Care and Display of Clothes and Accessories.* London: Allen & Unwin.

Thomas, Nicola J. 2007. "Embodying Imperial Spectacle: Dressing Lady Curzon, Vicereine of India 1899–1905." *Cultural Geographies* 14 (3): 369–400.

Wilson, Elizabeth. 1985. *Adorned in Dreams: Fashion and Modernity.* London/New York: I. B. Tauris.

2 | CONSERVING AN AINU ROBE WITHIN THE FRAMEWORK OF JAPAN'S CULTURAL PROPERTY PRESERVATION POLICY

Mie Ishii

The Ainu are an indigenous people of Russia and the rugged island of Hokkaidō, now part of Japan (Poisson 2002). Ainu culture is distinct from that of Yamato Japan, and Japan's annexation of Hokkaidō after the Meiji Restoration (1868) marginalized the Ainu, who were labeled "former aborigines" in 1899. They were acknowledged by the Japanese government as an ethnic minority in 1997[1] and gained official recognition in 2008. Ekashi Wakka (whose Japanese name was Wakanosuke Akashi) was the Ainu chief of the town of Abuta in southwest Hokkaidō, where there had once been an Ainu settlement. He owned two cotton robes now at the Tokyo National Museum (TNM). They are called *chi uka-uka pu* (*chi* meaning "I" or "my"; *uka-uka* meaning "sew/sewn"; and *pu*, "thing/garment") in Ainu. The robes are a type of garment known as a *rūunpé*, worn for special occasions,[2] and they were assembled from cotton fabrics obtained through trade with Japan and Russia and decorated with appliqué and embroidery. The patterns were embroidered by Ainu women and acted as prayers for the wearer's safety (Chikappu 1994); for example, a whirlpool pattern functioned as a protective talisman (Ogawa 2013:20–39).

Ekashi Wakka's two Ainu robes entered the collection of the Imperial Museum (now called the Tokyo National Museum) in October 1927.[3] The donor was Yorisada Tokugawa (1892–1954),[4] the sixteenth head of the Kishū branch of the Tokugawa family, which ruled Japan during the Edo period (1603–1868). At the Imperial Museum, these robes had been categorized as *dozoku* (local custom, 土俗). The original meaning of *dozoku* was "rural folk custom," but the word subsequently acquired a discriminatory nuance, owing to its connections with colonization, and is no longer used. At the TNM, these items were categorized as Ainu folkloric material; until recently, they were considered to be of little historical or cultural significance and were ineligible for government-funded, full-scale repairs (conservation treatment).

Dr. Nobuyuki Kamba was the second professional specializing in conservation science at the TNM, and he was appointed supervisor of

Conservation and Restoration for the Arts Department in 1998. Kamba was the first to draw attention to the noticeably deteriorating Ainu robes and, in fiscal year 2004, he singled them out for "full-scale repairs" (Kamba 2014:50–51). This essay explores the conservation of one Ainu robe, the first example of government funds being used at the TNM to conserve a robe from a non-Yamato Japanese culture. I introduce legally enshrined views of cultural property in Japan and make comparisons between conservation guidelines in Japan and the West.[5]

JAPAN'S CULTURAL PROPERTY SYSTEM: REPAIR,
FULL-SCALE REPAIR, AND MAINTAIN IN PRESENT CONDITION
Under Japan's Law for the Protection of Cultural Property (henceforth, Cultural Properties Law, or CPL), the act of performing a given process to conserve (*hozon*, 保存) cultural property is called *shūri* (修 理),[6] meaning "repair," and the term has had a specialized definition in the act's administration since the CPL was established in 1950. Toshie Kihara, who works for Japan's Agency for Cultural Affairs, compares this term with the more widely used *shūfuku* (修復), meaning "restoration":

> Since the word *shūfuku* contains two parts—*shū*, which means "to fix," and *fuku*, which means "to put something back to its original condition"—it has a meaning that may be misunderstood to imply "reproducing something," which is not considered the aim of restoration[7] of cultural properties. In contrast, *ri*, the second part of the word *shūri*, means "to judge" and "to correct." So I believe the word *shūri* is more appropriate for the restoration of cultural properties in which the maintenance of the present condition is considered fundamentally important. (Kihara 2011:13–14)

In a wider sense, *shūri* (repair) refers to concepts that correspond to the words *restoration*, *treatment*, and *conservation*. Kamba explains key terms—for example, *honkaku-shūri* (full-scale repair, 本格修理)—as understood at the Tokyo National Museum:

> After a century or so has passed, the long-term deterioration of the materials that comprise an artifact will have progressed further…it will be necessary to once again undertake full-scale repairs. These are repairs that are carried out [… approximately …] once every one hundred years. They are a massive undertaking meant to stabilize the original parts by taking apart the components that constitute the resource or holding. They also entail replacing previous

repairs while reassembling a given work. Accordingly, it is a type of treatment that, in light of the fact that the configuration of the artifact post-repair will differ from its pre-repair state, will be carried out after having undertaken considerable study and preparation.[8]

In summary, a full-scale repair is an intervention that enables cultural property to be preserved and handed down, based on the premise of disassembly, reinforcement, and reassembly undertaken on a hundred-year cycle.

Artifacts encompassed by the CPL include objects designated as important cultural properties and unique national treasures.[9] As of 2014, a total of 154 historic textiles and costumes fall under these headings (146 important cultural properties and 8 national treasures). In addition, there are objects registered as cultural properties at the prefectural and municipal levels. When full-scale repairs are to be undertaken on an important cultural property or national treasure, the Agency for Cultural Affairs is contacted through the prefectural Board of Education and the property's custodian, and relevant government officials and conservators discuss applicable policies and approaches. The CPL stipulates that the state will bear some of the costs of preservation; in cases where costs will be considerable, the national government can provide subsidies.[10]

In Japan, the methods used to repair objects have been passed down alongside the objects themselves over generations; therefore, these methods form the basis for preserving tangible cultural property and, as intangible cultural properties, are also preserved under the CPL.[11] "Since the techniques used to repair and conserve cultural property are themselves cultural property, the Agency for Cultural Affairs also selects restoration techniques and technologies for the manufacturing materials and tools used in restoration that requires preservation. By recognizing individuals and groups that possess these 'selected techniques for conservation,' the Agency aims to preserve and transmit traditional techniques that have been passed down to the present" (Ikeda 2009:59). The Ministry of Education, Culture, Sports, Science, and Technology—which oversees the Agency for Cultural Affairs—references "selected conservation preservation techniques as traditional techniques or craftsmanship that are indispensable to the preservation of cultural property and for which preservation measures shall be taken [with] techniques necessary for handing-down tangible cultural properties to future generations."[12] These encompass conservation techniques as well as the technologies used for the manufacture of necessary tools

and materials, such as brush making (for paper conservation), brocade weaving (for scroll mounting), indigo dyeing, and papermaking. The individuals or organizations possessing such skills are designated as intangible cultural properties and can perform conservation work (Ministry of Culture, Cultural Properties Division 2009).

When full-scale repairs are undertaken at the TNM, the goal is to "stabilize the original parts" and to "exchange [replace] previous repairs" (Kamba 2014:171). There is an inherited system in place for treating a garment or textile selected for full-scale repair. This system entails creating the fabric required for reinforcing weak sections of a garment, using traditional weaving techniques; disassembling the item; removing older repairs and replacing them with new repair materials; and reassembling the garment using Japanese sewing techniques. The principle that the Agency for Cultural Affairs applies when overseeing such a repair is to "maintain the object in its present condition" (*genjō-iji*, 現状維持); that is, "to pass down to this day as much as possible in its present condition and avoid further damage" (Ikeda 2009:63; see also Kobayashi 2012). This guideline is not specified in the CPL but goes back to Tenshin Okakura (1863–1913), an art historian and advocate for heritage preservation who initiated the Ancient Shrines and Temples Preservation law (1879); he is well known in the West as the first curator of Chinese and Japanese art, Museum of Fine Arts, Boston.[13]

Museums in Japan hold many Edo-period kimono that had been donated to temples. When the wearers of kimono died, their families gave the garments to temples as offerings. The kimono were then converted, via patchwork, into monks' stoles or altar cloths. In 1867–70, during the Meiji government's campaign to separate Buddhism and Shinto, many of these temple textiles were returned to public circulation as antiques and refashioned into kimono or art objects for display.[14] Thus, many pre–Meiji era kimono have undergone numerous changes in form and significance: from secular kimono to sacred artifact to antique for sale to cultural property in state-owned collections. The focal point of a kimono is its back, which often features a picturesque design, and the garment would be patched and reconfigured to be seen from the back, often ignoring its original design or construction. Such remodeling is typical of kimono remaking in daily contexts.

In 1952, public funds were first used for the full-scale repair of a kimono designated as an important cultural property (Shiroyama 2012:137–42). Japanese kimono sewing techniques provided the technical foundation for this intervention, and women skilled in that art undertook the restoration (Nakatani and Nakaguchi 1992:103–5).

Kimono were still a part of everyday wear in Japan until the 1970s, and there were many who could sew such garments. Almost without exception, the restoration of kimono held by museums was undertaken by the method described above: undoing the threads with which they were originally sewn; placing new pieces of fabric behind the entire original cloth, or sections that were damaged or missing; sewing the new fabric to the garment to reinforce it; and reassembling the garment, once again by sewing.

Although the guidelines from the Agency for Cultural Affairs require that the object be maintained in its present condition, many reports on kimono restoration record their disassembly (Kawakami 2004). If "maintain in present condition" is interpreted as "maintain the article in the state in which it had been handed down immediately prior to repair," then full-scale repairs predicated on disassembly run counter to that principle. How are we to understand this apparent contradiction between principles and practice? Ayako Kobayashi, of the Fine Arts Section, Cultural Properties Protection Division, Agency for Cultural Affairs, explains the principle to "maintain in present condition" for textiles as follows:

> Repairs for maintaining an object in its present condition, taken
> literally, means to maintain and conserve its present condition (i.e.,
> as they are now) as much as possible. "Present condition" does not
> mean leaving the object partially destroyed, soiled, or damaged.
> Rather, it means thinking about each and every one of the various
> conditions associated with a textile that has come down to the
> present. These would include, for example, the crinkles and stitch-
> ing traces produced when the item was made, its overall shape, its
> tailoring, and scratches and marks from reworking. The pattern of
> these vestiges of use and combination of tears and such constitute
> the history of a textile, and they are thought to have value. Natu-
> rally, in those cases where the physical strength of an item cannot
> be preserved without partial supplements, or when something
> that clearly had been intentionally added at a later time is creat-
> ing a burden of some sort, then the minimum necessary repairs
> will be undertaken and supplemental or unnecessary items will
> be removed. For example, if the lining of a *kosode* was damaged,
> and this was creating problems for the outer material, the lining
> would be removed and then repaired as a separate act of conserva-
> tion. However, it would not be appropriate to perform willful work,
> such as adding new embroidery, gilding, or dye to a missing section

based on uncertain conjectures or without having undertaken adequate study in advance. Actions that go too far—in other words, doing excessive repair work—run contrary to the intrinsic purpose of making repairs. They cannot afford to do harm to the innate character and originality of the textile. (Kobayashi 2012:125; my translation)

Thus, according to Kobayashi, to make repairs with the intention of maintaining a work in its present condition means just that: to maintain the work as it is now, to the greatest extent possible. A textile's present condition represents its history, such as when it was made as well as traces of its use. Kobayashi offers as an example the removal of the lining of a garment, an act premised by disassembly that runs counter to the fundamental principle to maintain in present condition. From this it follows that the principle of maintain in present condition, as understood by the Agency for Cultural Affairs, does not mean fundamentally maintaining an object as is. Instead, the principle can be seen as a starting point for conservation, much like the principle of reversibility promoted in the United Kingdom in the 1960s. Similarly, after a period of debate in the 1990s, "reversibility" is now understood not as a principle per se, but rather as "possible to redo" and/or "not having a permanent impact on the work" (Oddy 1999:1–6). The starting point in Japan was the artifact's disfigured (i.e., reworked) form, which needs to be maintained in present condition. In Japan, a cultural inheritance system has made it possible to repair objects handed down by previous generations repeatedly, informed by such ideas as "re-making" and doing full-scale repairs on clothing. Western conservation approaches and conservation ethics began spreading to Japan from ca. 2000; their influence can be seen, for example, in Kobayashi's remarks about "originality" (Japan Society for the Conservation of Cultural Property 2008).

CONSERVATION GUIDELINES FOR THE AINU ROBE

The guidelines and methods to be used for full-scale repairs at the TNM are debated among staff from the Conservation and Restoration Department, curators, and outside conservators. Because this was the first instance of a full-scale repair being undertaken on an Ainu robe, it will have an impact on conservation guidelines for Ainu folkloric materials in the future. Although the robe is not a designated cultural property, Dr. Toshikazu Sasaki, cultural property examiner and specialist in Ainu folklore studies at the Agency for Cultural Affairs, took part in the discussion.[15] His role was to represent Ainu perspectives and to advise on culturally appropriate approaches to conserve Ainu material.

Sasaki, who had been section head of the folkloric materials office at the TNM, was the first to point out that the name of the robe's wearer had been recorded and that the garment was of high research value. Furthermore, he viewed the small holes and weak areas that had developed when the garment was worn as evidence of use and did not want them reinforced. From the painstaking piecing and embroidery of this *chi uka-uka pu*, it was clear that the wearer's female relatives had worked together to sew (*uka-uka*) the garment (*pu*), and Sasaki identified the sewing thread as an important component. Accepting that the sewing thread was intrinsic to its cultural value, the following guidelines were developed for the conservation of this robe, which was reentering the repair cycle more than one hundred years after its creation:

1. Only sections where the materials have conspicuously deteriorated will be supported with new material. Removing these support materials will return the robe to its original state (in terms of materials present). Conservation materials and methods will be used that permit any treatments to be redone.
2. No reinforcement will be applied to evidence of use, such as holes that developed during the years when the robe was worn or stitches that came loose because of wear.
3. The stitching itself is an important part of manufacturing information so sewing threads will not be cut.
4. Information about the materials used and work done on the robe will be collected and documented.

MATERIALS, TECHNIQUE, AND CONDITION

The robe is composed of sixteen pieces of cotton fabric of five cloth types and measures 1192 × 1260mm (fig. 2.1). The fabric of the main garment pieces was roughly cut, with the edges left unfinished. The pieces were sewn together using approximately 10mm long running stitches (*ieshinin'ninu* in Ainu). The appliqué was made by sewing cotton or silk fabrics, with raw edges neatly folded over, with either white cotton or bark fiber thread. The whirlpool pattern functions as a kind of "evil eye." The protective thorn patterns and protrusions (*oho-yanke* in Ainu, meaning "two protrusions"), made by running a thread slightly over the edge of the patterns to fix them in place, are characteristic features of Ainu design (Ogawa 2013:20–39).

The robe had evidently been made and worn with great care, and it was assembled from well-used fabrics. While the robe was dusty, it

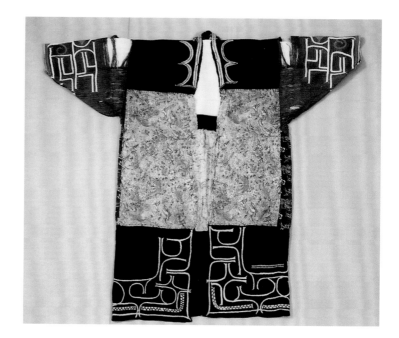

was not noticeably stained. The brown cotton fabric of both sleeves was conspicuously torn, with particularly severe damage where the sleeves joined the main body of the robe. The extensive fiber deterioration was due to the use of an iron mordant in the dyeing process, as well as repeated mechanical action, such as folding and refolding the sleeves. The collar had stretched, presumably distorted in use. A gap had formed at the shoulder opening of the collar, and some embroidery threads had become detached.

CONSERVATION

In the official Japanese context, "repairing" is a method for conserving a historic kimono, and this act is an extension of living kimono culture; hence, if deemed necessary, fabric may be specially made for conservation use. As noted earlier, this is because the system for conserving tangible cultural property includes intangible cultural techniques (such as weaving) and the resultant products. The conservation of the Ainu robe required a support fabric made of fine, plain-weave cotton with selvages, of the same fabric width as the sleeve. Akira Shimura was commissioned to hand-weave the fabric, which I then dyed brown using a light- and water-fast direct dye.

The sleeves were unlined, and the newly woven support fabric could be applied without disassembly and in keeping with the shape of the sleeves (fig. 2.2). Frayed warp threads were carefully

straightened, one or two threads at a time, and were then stitched to
the support fabric using fine polyester thread. There were two reasons
for selecting polyester thread: first, the stitching would be unnotice-
able; second, despite its fineness, the polyester thread would last
longer than a fine, natural fiber thread, such as silk, even if it came into
contact with fibers dyed with iron-containing mordant. Color-matched
cotton support fabric camouflaged gaps in the collar-shoulder open-
ings, where the fabric had stretched. Gold embroidery threads that
had come loose were realigned and stitched in place using fine, light
brown polyester thread. Because the robe had been embroidered after
it was assembled, conducting the repairs in the usual way (i.e., disas-
sembling the garment) would have required undoing the embroidery.
This would have been a major intervention and would have affected
the integrity of the robe itself; preserving evidence of the maker's
hand was considered important.

STORAGE AND DISPLAY OF THE AINU ROBE
The Ainu robe was not folded into *tatōshi* (kimono wrapping paper), the
traditional storage configuration for kimono, because this would have
necessitated folding the sleeves. Rather, the robe was double-folded

from the hem, with the sleeves spread out; placed on a tray; and put into a custom-made storage box. For photo documentation, the robe was temporarily mounted on a vertical, T-shaped stand made for kimono display. For a TNM exhibition on conservation (fig. 2.3), the robe was displayed on a slanted, fabric-covered board, indicating that even after conservation treatment, a garment may not be stable enough to be hung in a conventional manner.[16] Conservation input at the display phase was also a change in standard practice at the TNM. The temperature and relative humidity of the display case were maintained (RH 50% ±5% and 20°C ±5°), with lighting below 50 lux.

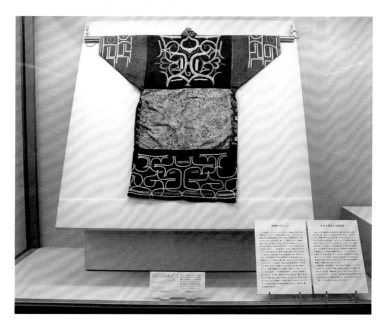

FIGURE 2.3
The Ainu robe (K27890) as displayed in Tokyo National Museum, 2005. Photo: Department of Conservation and Restoration. Courtesy the Tokyo National Museum

DISCUSSION

In Japan, the repair of kimono as cultural properties is informed by Japanese kimono making and has been carried out since the 1950s under the supervision of the Agency for Cultural Affairs. The governing principle has been to maintain in present condition; this is carried out by government funding under the name of "full-scale repair," based on disassembly, reinforcement, and reassembly. While the TNM has been collecting costume since it was established, no garments outside the cultural sphere of Yamato Japan (which excludes Ainu) had undergone government-funded, full-scale repair until this robe the early 2000s. At that point, when conservation management of museum collections began in earnest, appropriate personnel were assigned to conservation positions, and garments requiring repair were identified, based on the

extent of deterioration. The governing principle of conservation as pre-serving an object's original form, viewed as its ideal state, is now com-plemented by respect for transformations; for example, through wear, tear, and renewal. This change arose from consideration, and sometimes adoption, of conservation principles newly introduced from the West.

The Japanese concept of intangible cultural properties has also spread worldwide. In 2003, UNESCO formulated the "Convention for the Safeguarding of the Intangible Cultural Heritage."[17]

Conservation ethics for museum collections have broadened to encompass a diversity of interpretation. For example, Miriam Clavir (now conservator emerita at the Museum of Anthropology, University of British Columbia, Canada) was confronted with a dilemma: Should artifacts be loaned to indigenous peoples of Canada to maintain their living cultures, despite the consequent physical changes (deterioration) to those objects? The artifacts at the museum embodied elements that were becoming fossilized as historical evidence of the past and that were changing "along with living culture" as they were handed down for future generations (Clavir 2002:249). Clavir argues that conservation practices had to change to respect both aspects as intrinsic features of these museum holdings. When considering full-scale repair of cos-tume at Japanese museums with this principle in mind, it is clear that removing old repairs and replacing them with new materials made with traditional manufacturing techniques, and reinforcing original parts with traditionally made materials, puts museum holdings in the category of living culture. This is the distinctive characteristic of the Japanese sys-tem for the inheritance of cultural properties.

While acknowledging this important and influential tradition, it was also necessary to identify appropriate conservation guidelines for performing full-scale repairs on the Ainu robe, as it was not a garment associated with Yamato Japanese culture, for which the legislation had been designed. After the appointment of a conservation professional in 1998, the criteria for significance assessment when conserving an artifact were widened to include its material and condition, as well as its historical, social, and artistic values. Hence, attitudes and policies changed to accommodate the conservation of wider categories of col-lection or use, responding to the needs of both equality and cultural specificity. The Japanese heritage system was designed to preserve Yamato Japanese national identity; strictly speaking, it does not extend to other resident cultures, including Ainu. This case study marks an important transition: a national museum preserving collections in its care by adopting a flexible approach to state-authorized categories,

which are now understood to reflect ideas of cultural superiority that have dominated value judgments in the postcolonial era.

In keeping with the mandate of the Agency for Cultural Affairs to maintain in present condition, it was necessary to develop guidelines that would respect Ainu culture. The treatment of the robe therefore did not involve disassembly. Also, the treatment was undertaken to enable the newly added support materials to be removed without loss of material evidence; the robe would simply be returned to its damaged state. Rather than using commercially available fabric, a specific, handwoven cloth was produced for the support material; this incorporated the principle of ensuring the continuity of traditional skills, in this case weaving, one of the cultural properties of Yamato Japan. However, if the "maintain in present condition" principle is examined more closely, it is clear that other methods are possible, including conservation technologies that would have made fewer modifications. The robe could have been stored and displayed on a flat support (which would reduce direct handling); customized, padded supports could have been placed inside the robe, which then would have been put in a pressure mount; or it could have been stored in an oxygen-free environment to control the oxidation of iron-mordant dyed materials.

CONCLUSION

The principles of conservational ethics evolve over time and may be contested and questioned. What do we value? What do we want to leave for the future? What are the thoughts and opinions of the successors to the cultures that museum collections represent, and which we have a professional duty to respect? Who decides? Those responsible for preserving cultural property develop systems to sustain these assets, respecting local customs, traditions, and precedents. Comparing practices in other nations (e.g., Kite 1995), it is evident that there are experiences that fall outside the existing cultural heritage framework in Japan, for example, those described by Clavir (2002). Suggestions about how to hand down cultural heritage can be adopted from these diverse experiences, making it possible to adjust approaches and methods to accommodate alternative assessments of significance. Cultural custodians, government officials, and private conservators (including myself) had in-depth discussions about full-scale repair for this Ainu robe, for which there was no precedent in Japan.

A National Ainu Museum is being built in Hokkaidō (scheduled to open in 2020),[18] and it may soon be possible to undertake the conservation of Ainu garments informed directly by the wishes of the

Ainu. It is inevitable that issues and complications will occasionally arise in situations where the principles that form the foundation of conservation ethics in the West and in Japan appear contradictory. Exploring the specificities of these situations can provide welcome opportunities for debate, and hence exploration and elucidation. The Japanese approach to cultural property, which acknowledges that handing down something from the past to the future is not solely a matter of physical evidence, is an important message.

ACKNOWLEDGMENTS

I express deep gratitude to the following, each of whom provided guidance and support for this study: Dr. Nobuyuki Kamba, former director, Conservation and Restoration Department, Tokyo National Museum; Yūko Tsuchiya, supervisor, Conservation and Restoration Department, Tokyo National Museum; Hokkaidō University Professor Emeritus Dr. Toshikazu Sasaki; and Akira Shimura of Kasuyama Co., Ltd. The idea for this article arose from discussion with Dinah D. Eastop and Mary M. Brooks and from a course I attended in 2010 (Conservation Methodology: Exploring the Relationship between Theory and Practice) at West Dean College, United Kingdom. The course was initiated by Helen Hughes, Historic Interiors Research and Conservation, and based on ICCROM's Sharing Conservation Decisions program.

NOTES

1. アイヌ文化の振興並びにアイヌの伝統等に関する知識の普及及び啓発に関する法律 / Act on the Promotion of Ainu Culture, and Dissemination and Enlightenment of Knowledge about Ainu Tradition, Act No. 52, May 14, 1997. Japanese Law Translation, accessed May 25, 2015, http://www.japaneselawtranslation.go.jp/common/data/outline/h09Zzk00520101je2.0.htm.

2. Dr. Toshikazu Sasaki, personal communication to author. Dr. Sasaki is an authority on Ainu studies and the driving force behind the plan to build an Ainu cultural museum (Sasaki 2004).

3. The institution was called the Imperial Museum from 1872 to 1947, after which it became the Tokyo National Museum. The Ainu robe discussed in this paper is museum number K27890. The museum's register gives no information on how the robe was collected. Ekashi Wakka's other robe in the museum is K27888.

4. Yorisada Tokugawa was a friend of Motohiro Nijō (1839–1928). Nijō assembled the Ainu folklore collection now at the TNM, which comprises one thousand items from the Dōdabō collection. Nijō was involved in the development of Hokkaidō and head of the Hokkaidō Association, and he founded the Kazoku Ethnological Association in 1902.

5. Being bilingual (English/Japanese) and having studied and worked in Japan, the United Kingdom, and the United States, I understand the nuances of conservation principles in both Japan and the West.

6. CPL, chap. 3, subsection 3. Protection article 34. Law for the Protection of Cultural Property, Series of Instruments for Protecting Cultural Property (3). The English text was published by the Japan Center for International Cooperation in Conservation, National Research Institute for Cultural Properties, Tokyo.

7. The Japanese text uses "cultural property repair," meaning (from the context) conservation; however, the translation uses the word *restoration* (Kihara 2011). *Repair* is not a common word to describe an act for protecting cultural property in English; thus, it seems that the translator chose the word *restoration*. However, as the Japanese government uses the word *shūri*, as explained in Kihara's paper, *shūri* may be better translated as "repair" for this official document.

8. CPL, 6:12–13. My translation from the Japanese.

9. CPL, 6:6. CPL chap. 3, article 27, "Designation."

10. CPL, 6:12. CPL chap. 3, article 35, "Subsidy for Management or Repairs."

11. CPL, 6:37; CPL 6:81. CPL chap. 4, "Intangible Cultural Property."

12. CPL, 6:81.

13. Okakura was assistant to Ernest Fenollosa (1853–1908), an American art historian. Fenollosa, during his years at Tokyo Imperial College, helped found the Bijutsuin (Japan Academy of Fine Arts). The Bijutsuin Kokuhou Syurisho (美術院国宝修所 Bijutsuin Treasure Repair Center), a branch of the association, was the first institution in Japan to focus on conservation techniques.

14. The robe (*kesa*; *kāṣāya* in Sanskrit) of a Buddhist priest is made from discarded fabric. Eventually such robes become rectangular stoles made of stylized patchwork or darned fabrics. The family of a deceased woman would donate her most valued possession (her clothing) to a temple, either in the form of kimono (often sold for cash) or in the form of a patchwork *kesa* or *uchishiki* (altar frontal, or altar cloth).

15. See note 2, above.

16. The exhibition, titled 東京国立博物館コレクションの保存と修理展 (Conservation and restoration of the collection of Tokyo National Museum), ran from October 18 to November 27, 2005.

17. UNESCO, "Text of the Convention for the Safeguarding of the Intangible Cultural Heritage," General Conference of UNESCO, September 29–October 17, 2003, Paris, accessed May 24, 2015, http://www.unesco.org/culture/ich/index.php?lg=en&pg=00006.

18. Agency for Cultural Affairs, "A Basic Plan for a Museum Where a Space Symbolizes Ethnic Conviviality," 2013 (my translation). Dr. Toshikazu Sasaki (see note 2, above).

REFERENCES

Chikappu, Mieko. 1994. アイヌ文様刺繍の心 [Ainu design and the heart of embroidery]. Tokyo: Iwanami Shoten.

Clavir, Miriam. 2002. *Preserving What Is Valued: Museums, Conservation, and First Nations*. Vancouver: UBC Press.

Ikeda, Hitoshi. 2009. 日本の紙文化財の保存と修理 [Preservation and restoration of paper cultural properties in Japan]. In 和紙の保存の国際研修 2008 [International course on conservation of Japanese paper 2008]. Tokyo: Tōkyō Bunkazai Kenkyūjo.

Japan Society for the Conservation of Cultural Property. 2008. 文化財の保存にたずさわる人のための行動規範 [Codes of conduct for those involved in the conservation of cultural properties]. Tokyo: Japan Society for the Conservation of Cultural Property.

Kamba, Nobuyuki. 2014. 博物館資料の臨床保存学 [Practical conservation studies of museum materials]. Tokyo: Musashino Bijutsu Daigaku Shuppankyoku.

Kawakami, Shigeki. 2004. 染織の修理 [Repair of textiles]. 日本の美術 453 [*Art of Japan 453*]. Tokyo: Shibundo.

Kihara, Toshie. 2011. 日本おける絵画修理の理念 [Principles of the restoration of paintings as cultural property established in Japan]. In 第 33回文化財の保存および修復に関する国際研究集会 [The 33rd international symposium on the conservation and restoration of cultural property]. Tokyo: Tōkyō Bunkazai Kenkyūjo. English trans., 13–14.

Kite, Marion. 1995. "The Conservation of a 19th-Century Japanese Ainu Barkcloth Kimono and the Papyrus Wrappings from a 3rd-Century Egyptian Bottle." In *Starch and Other Carbohydrate Adhesives for Use in Textile Conservation*, edited by Pippa Cruickshank and Zenzie Tinker, 25–27. London: UKIC Textile Section.

Kobayashi, Ayako. 2012. 染織品保存修理の理念 [Principles regarding the preservation and repair of textiles]. In 染織技法の伝統と継承―研究と保存修復の現状 東京文化財研究所 [The 35th international symposium on the conservation and restoration of cultural properties, tradition and transmission of textile techniques: current state of research and conservation, September 3–5, 2011, National Research Institute for Cultural Properties, Tokyo, and Tokyo National Museum], 121–26. Tokyo: Tōkyō Bunkazai Kenkyūjo. English abstract, 127–28.

Ministry of Culture, Cultural Properties Division. 2009. 文化財を伝える　伝統の名匠　選定保存技術 [Handing down cultural property: masters of tradition; selected conservation techniques]. 保持者・保持団体 [Holders and holding associations]. Tokyo: Bunkachō Bunkazaibu.

Nakatani, Michiko, and Chie Nakaguchi. 1992. 染織文化財の修復について [On the restoration of textiles]. In 歴史的に見た染織の美と技術 [The techniques and aesthetics of textile through history], edited by Kisuke Kashiwagi, 103–5. Tokyo: Maruzen.

Oddy, W. Andrew. 1999. "Does Reversibility Exist?" In *Reversibility—Does It Exist?*, edited by W. Andrew Oddy and Sara Carroll, 1–6. London: British Museum.

Ogawa, Sanae. 2013. アイヌ民族もんよう集―刺繍の刺し方・裁ち方の世界― [Ainu embroidery design: embroidery technique and the world of cutting]. Toya: Utara Ainu Bunka Kyōkai.

Poisson, Barbara A. 2002. *The Ainu of Japan*. Minneapolis: Learner.

Sasaki, Toshikazu. 2004. アイヌ絵誌の研究 [Studies on Ainu pictorial documents]. Chiba: Sōfūkan.

Shiroyama, Yoshimi. 2012. 染織文化財を伝える - 修理の現場から [Transmitting textile cultural property: from the conservation studio]. In 染織技法の伝統と継承―研究と保存修復の現状 東京文化財研究所 [The 35th international symposium on the conservation and restoration of cultural properties, tradition and transmission of textile techniques: current state of research and conservation, September 3–5, 2011, National Research Institute for Cultural Properties, Tokyo, and Tokyo National Museum], 137–42. Tokyo: Tōkyō Bunkazai Kenkyūjo. English abstract, 143–44.

AUTHOR BIOGRAPHY

MIE ISHII, who is bilingual (English/Japanese), studied art history and aesthetics at Keio University in Tokyo and is a specialist in textile conservation, working in Japan and internationally. She trained at the Textile Conservation Centre/Courtauld Institute of Art, London (1995–98), and worked in the Textile Conservation Department, Metropolitan Museum of Art,

New York (1998–2000). Since returning to Japan in 2000, she has undertaken conservation commissions from national museums, providing first hand understanding of heritage preservation laws and the conservation policy of Japan. Since 2016 she has been associate professor at National Saga University, Faculty of Art and Regional Design.

3 | "WRAPPED IN COUNTRY"
CONSERVING AND REPRESENTING POSSUM-SKIN CLOAKS AS IN/TANGIBLE HERITAGE

Henry L. Atkinson, Vicki Couzens, Lee Darroch,
Genevieve Grieves, Samantha Hamilton, Holly Jones-Amin,
Mandy Nicholson, and Amanda Reynolds

> It's a gift back to the next generation [i.e., a return gift]. It's not ours to have and to keep.[1]

Possum-skin cloaks continue to be essential aspects of culture for Aboriginal peoples of southeast Australia. This paper provides a historical context for possum-skin cloak-making and its recent revival. It describes their continuing cultural significance by outlining the display, interpretation, and conservation of three generations of cloaks in the *First Peoples* exhibition at the Bunjilaka Aboriginal Cultural Centre, Melbourne Museum, Museum Victoria (MV). It also introduces a cloak made specifically for ceremonial functions at the University of Melbourne (UoM).

The conservation and preservation strategies recently developed and implemented at MV and the UoM contribute to the continuing development of strong cultures. The possum-skin cloaks exhibited at MV highlight approaches to working with communities to develop content about, to display, and to preserve cultural material. The cloak at the UoM is the first of its kind to be placed in storage with traditional academic gowns, and a specific protocol was developed to inform its use and care, as well as strategies for future treatment. The large number of authors for this paper proclaims and reflects the collaborative processes undertaken by Elders, artists, curators, conservators, and collection managers to conserve and represent these significant aspects of southeast Aboriginal culture.

HISTORY AND USE OF POSSUM-SKIN CLOAKS
In pre-European times, possum-skin cloaks were an intrinsic part of life and death; people were buried in them and were thus "wrapped in their Country." Cloaks were used in daily life to stay warm and dry in the cold climate of southeast Australia, and for ceremonial purposes and meetings. Also, women drummed on cloaks as part of *corroboree*, gatherings where Aboriginal people share song, dance, story, and important

cultural knowledge. A cloak was made for a child when she or he grew too heavy to be carried, and the expectation was that the garment would be retained until death. The cloak was enlarged as the child grew up, manifesting the person's life story and marking pivotal events, such as initiatory rites of passage, marriage, and the birth of children. In this way, the cloak became powerfully connected with an individual, a truly biographical object, with marks and symbols added as life unfolded (Couzens forthcoming).

According to Elder Aunty Phoebe Nicholson:

> Possum skin rugs were also used for medicinal purposes such as covering the head and body over a hot coal fire of smoking gum leaves and other medicinal herbal plants while it permeated into an inhalant, or just lying in the warmth of the sun and wrapping up in the possum skin cloak on top of smouldering green gum leaves over coals to heal colds and other illnesses.[2]

Cloaks were valuable trade items and formed the basis of some of the first intercultural exchanges in southeast Australia. They were sought after by the early European immigrants and traded for imported goods. Pastoralist, squatter, and ethnohistoric accounts record that thousands of skins were sold, and there were once thousands of cloaks belonging to both Aboriginal people and to incomers (Cahir 2005). Historic cloaks are now very rare: only four nineteenth-century possum-skin cloaks and one decorated pelt have been identified as extant.[3] The two cloaks preserved at MV are introduced below.

Cloaks today are designed and utilized in much the same way, with their use extended to naming days, "Welcome to Country" ceremonies, and birthing. *Country* is a term used by Aboriginal people to refer to the land to which they belong, and their place of Dreaming. *Dreaming* is a Western term used to describe the Aboriginal spirituality system. The Dreaming encompasses all the cultural values, laws, and knowledge passed down through song, dance, painting, and storytelling to each generation. During a "Welcome to Country" ceremony, young manna gum (*Eucalyptus viminalis*) leaves are placed on the embers of a fire to create smoke. An Elder, dressed in a cloak, smokes both themselves and the cloak before commencing the ceremony. The oils in the leaves emanate and cleanse the area of bad spirits and those that visitors may bring with them. Once the area is cleansed, all visitors are safe to travel through Country.

MANUFACTURING TECHNIQUES

The manufacture of a cloak is a very labor-intensive process (Couzens forthcoming). Brushtail possums (*Trichosurus vulpecula*) remain the most common source of pelts.[4] Possums were hunted by men, and the pelts were stretched and cured by both men and women. Handmade wooden pegs were used to stretch the skins onto oblong pieces of flattened bark (Couzens forthcoming; Dawson 1881:9; Smyth 1878:271). Oblong scars attributed to the removal of bark from the brown stringybark tree (*Eucalyptus baxteri*), slabs, and wooden pegs have been found at three separate rock art shelters in Gariwerd National Park in Western Victoria, suggesting that these shelters were sites for processing skins (Gunn 2009:23–30; Jones-Amin, Nicholson, and Ewen 2014).

Skins were trimmed and dried by the fire, with the smoke and bark sap tanning the skin (Dawson 1881:9; Reynolds et al. 2005:17). The skins were thinned while secured to the bark by scraping with a sharpened shell or stone implement (Smyth 1878:271). Diagonal lines were scratched with sharpened mussel shells into skins to make them soft and pliable; animal fat and ocher were later applied to enhance the design and maintain flexibility, as well as for preservation (Reynolds et al. 2005:17). The skins were arranged to form a rectangle and then sewn together using kangaroo sinew or reed string. The sinew was obtained from kangaroo tail or hind leg and was chewed to break it down into thin threads (Couzens forthcoming); the reed string was handmade from river and/or bush reeds, hair, grasses, and so on. An adult-size cloak might comprise up to eighty-seven skins (Jones-Amin, Nicholson, and Ewen 2014). In later times, cloaks were decorated with significant designs; for example, motifs specific to a person's clan, distinguishing where they were from and telling the story of Country, family, and creation.

However, manufacturing techniques have changed. Possums are now a protected species in Australia, and tanned skins are procured from New Zealand, where the possum is an introduced species and a pest. Despite this change, contemporary acts of cloak-making remain expressions of cultural identity and maintain connections with the Ancestors.

CONTEMPORARY CLOAKS

The making of possum-skin cloaks ceased for almost a hundred years. Only a handful of nineteenth-century cloaks are known to survive (Reynolds et al. 2005:1, 10); of these, two are in the collections of Museum Victoria. In the late 1980s, Val Heap (Yorta Yorta) and Uncle

Wally Cooper (Yorta Yorta, Moidaban) made undecorated cloaks for the Koorie Heritage Trust in Melbourne, and Gayle Maddigan (Wamba Wamba, Wertigkia, Dhudhuroa, Nyeri Nyeri) later made a decorated cloak.[5] These cloak-makers were followed by others, including Kelly Koumalatsos in the early 1990s (Wergaia, Wamba Wamba).[6]

This recent cultural reclamation and the revitalization of possum-skin cloak-making in southeast Australia are a form of conservation and a representation of tangible and intangible heritage. The movement was born from an encounter that Vicki Couzens (Gunditjmara Keerray Woorroong) had with the Lake Condah cloak at Museum Victoria.[7] Following is a brief description that outlines the experiences of artists Couzens, Lee Darroch (Yorta Yorta, Mutti Mutti, Boon Wurrung), Treahna Hamm (Yorta Yorta), Maree Clarke (Mutti Mutti, Yorta Yorta, Boon Wurrung, Wemba Wemba), and Mandy Nicholson (Wurundjeri) and acknowledges the important contributions of many others.

Couzens's journey began in 1999 when she viewed the nineteenth-century Lake Condah cloak (*kooramook* in Gunditjmara) at the museum and had a powerful physical and spiritual experience that connected her to the Ancestors who made this cloak. Couzens later spoke to Lee Darroch, saying: "We need to make copies of those old cloaks.... Their message, our story, is to return the cloaks to our People, to reclaim, regenerate, revitalize and remember. To remember what those cloaks mean to us and tell the stories of our People and Country" (Couzens forthcoming). Couzens and her sister Debra sought guidance from their father, Elder Ivan Couzens, to reproduce the Lake Condah cloak, while Treahna Hamm and Darroch went to Uncle Henry Atkinson (Wolithiga Elder) and the Yorta Yorta Council of Elders for permission to reproduce the Maiden's Punt cloak.[8] The artists then undertook research with the assistance of many people and government agencies, including Museum Victoria and Arts Victoria. They also sought knowledge from other Elders to ensure that their replicas were as close to the originals as possible.

These artists have since shared their knowledge of cloak-making with communities throughout southeast Australia. They traveled around Victoria, working with community representatives and artists from thirty-eight language groups to produce community cloaks, which were showcased at the Melbourne 2006 Commonwealth Games Opening Ceremony (Couzens and Edmonds 2008:783–84). Since 2006, possum-skin cloak-making and cloak-wearing have become firmly reestablished as a cultural practice across Victoria; more recently, the practices have spread to other southeast groups within Canberra, New South Wales, and South Australia.

Through these experiences, new materials and techniques have been developed. For example, the use of sinew and bone to sew the pelts together declined after Aboriginal people were forced to live in church-run missions and/or on government-run reserves, where rights and freedoms were strictly limited and the speaking of native languages and the practice of cultural traditions were often forbidden. Today, waxed cotton or synthetic thread and metal needles are used. The tanned skins from New Zealand are too soft to withstand traditional decoration tools, so designs are often burnt into the skin and painted with ocher or acrylics.[9]

TANGIBLE AND INTANGIBLE ASPECTS
OF POSSUM-SKIN CLOAK REVIVAL

Over the past fifteen years, spiritual healing has been at the center of Couzens's and Darroch's work. While they teach the practical aspects of cloak-making, it is the experience of intergenerational sharing, connecting to culture and to others, that is fundamental. Gaining knowledge, learning language, telling stories, and singing songlines[10] is what brings about healing in all participants (Couzens forthcoming). Cloaks represent so much more than "material culture" to Aboriginal people in the southeast. They are a powerful means of enhancing dignity and self-esteem for individuals and communities, in sometimes overwhelming ways.

These tangible and intangible aspects of possum-skin cloaks are currently manifested in the care and presentation of the cloaks displayed at MV and the ceremonial cloak at the UoM. Elders, artists, curators, conservators, university staff, and collection managers have worked together on the display, interpretation, and preservation of the cloaks in these institutions. The following case studies provide details of the processes and outcomes.

HISTORIC CLOAKS AT MUSEUM VICTORIA

Historic and contemporary *biganga* (possum-skin cloaks in Yorta Yorta) are prominent in the *First Peoples* exhibition at MV. Throughout the displays, cloaks represent significant material culture: they are depicted in a range of ceremonial and everyday contexts through photographs and films; in the artwork of William Barak (Wurundjeri, Nurungaeta) (ca. 1824–1903); as a record of important clan symbols; on interactives; and as textured designs on wall panels.

During the development of the exhibition, it was essential that each cloak was treated with the deepest cultural respect. Caroline

Martin, manager of the Bunjilaka Aboriginal Cultural Centre, was key to this process; she was determined to consult, engage, and collaborate with communities of Victoria throughout the process. Four Yorta Yorta Elders—Uncle Henry Atkinson, Uncle Alf "Boydie" Turner, Aunty Zeta Thompson, and Uncle Donnie Briggs—worked with conservator Samantha Hamilton during the preparation of the historic biganga for display and on plans for long-term storage. The Elders also guided the interpretation of the biganga by working closely with the lead curator, Genevieve Grieves, to create a seven-minute film that highlights the cloak's connection to Country and to people and explains the meaning of the designs while contextualizing the art of possum-skin cloak-making. Meanwhile, Darroch worked closely with the senior curator, Amanda Reynolds; the assistant curator, Kimberley Moulton; and conservator Hamilton on the interpretation and display of her contemporary cloaks.

The cloaks were displayed in two sections of the *First Peoples* exhibition: Wrapped in Country, within the "Wominjeka" (welcome) section; and Coming Together, within the "Our Story" section (fig. 3.1). Coming Together features two generations of contemporary biganga made by Darroch, and these parent and child cloaks focus on the stories and places of Yorta Yorta people; they are displayed in a glass case between two sections of the exhibition and are referenced by both.

FIGURE 3.1
The possum-skin cloak display in the "Our Story" section of the *First Peoples* exhibition at the Bunjilaka Aboriginal Cultural Centre, Melbourne Museum, Museum Victoria.
© Museum Victoria, John Broomfield

Wrapped in Country connects Darroch's cloaks to a grandparent cloak, the nineteenth-century biganga known as the Wolithiga, or Maiden's Punt cloak. Wolithiga was found near the punt on the Murray River, land that is traditional to the Wolithiga, who hunted, fished, gathered, and lived on both sides of the Dhungala (or Murray) River. (Maiden's Punt is located on the Murray River, near Echuca.) This rare biganga is one of only two existing intact cloaks from Victoria; the other is the Lake Condah cloak. MV purchased Wolithiga from the R.E. Johns Estate in 1853. It measures 2510 × 2045mm and is made from eighty-two panels stitched together, most of which are decorated.

The Wolithiga biganga is structurally stable but fragile. It has dehydrated, and it is brittle, torn, and worn. It has lost skin sections with many previous old repairs as well as matted fur with more losses. X-ray fluorescence identified the presence of mercury, arsenic, lead, and bromine on the surface of the skin and fur (Goodall 2012).[11] Based on the fragility of the biganga, it was decided that it would be laid fully extended within a new display case and new storage crate, supported on a tailor-made handling-cum-storage mount. This was a great contrast to its previous folded display and storage within a smaller case and cardboard box.

The Elders further stipulated that the historic biganga and kooramook should always be on display for community viewing and access, regardless of concerns about associated degradation. It was agreed that the cloaks would be rotated on a five-year basis, but this aspect needs further discussion with the Gunditjmara community. It was also agreed that the biganga would be displayed under light levels guided by Bruce Ford's microfade testing on possum-skin cloaks held by the National Museum of Australia (Ford and Smith 2011).

During deliberations about the condition of the biganga, the Elders unanimously agreed that minimal cleaning should be undertaken, that the old repairs be left in place, and that no new repairs should be performed for aesthetic purposes by either community members or conservators in the present or the future. However, they approved the humidification and flattening of creased edges that were the result of past museum practices. The Elders spoke in detail about the intangible qualities of the cloak and their responsibilities as its current custodians and accepted the invitation to assist in the preparation of the biganga for display. After the new display case and support had been manufactured, the Elders returned to Melbourne, where they were briefed about working with the detected hazardous substances and wore appropriate personal protective equipment. They placed the cloak on the support

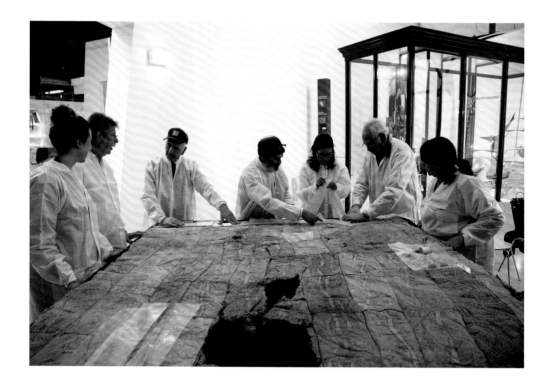

FIGURE 3.2

Museum staff and Elders undertaking conservation of the Maiden's Punt (Echuca) cloak, a historic Yorta Yorta cloak (X016274), for the *First Peoples* exhibition. © Museum Victoria, John Patten

and assisted with the localized humidification and the relaxing and flattening of the folded and creased edges (fig. 3.2). They also secured the cloak (by stitching with cotton thread between the original stitches) to the support, enabling its safe display at an angle of 15 degrees from the horizontal. Aunty Zeta helped with conservation documentation by marking the added stitch locations on a large A3 photograph. The entire process with the Elders was thoroughly recorded through audio, visual, and written documentation. Specific cultural protocols, storage instructions, and a preservation plan were created and incorporated into the biganga's conservation record in MV's collections database. After a cleansing smoking ceremony, the Elders helped the collection managers install the biganga in its new home and played a significant role in its future preservation. Feelings of ownership, connection, and gratitude were shared by all participants (Hamilton 2013).

THE CONTEMPORARY BIGANGA AT MUSEUM VICTORIA

A contemporary piece in the MV collection, Darroch's Echuca biganga (2005), was selected to connect the historic biganga with contemporary practice. Senior curator Reynolds asked Darroch if she would loan one of her children's cloaks to display alongside the adult cloak in order to convey intergenerational knowledge transfer. Darroch agreed but

later telephoned to say that she wanted to donate a *yalka Yorta Yorta biganga* (children's cloak) to the museum in recognition of the *First Peoples* project. To paraphrase Darroch: "then you will have the child, adult and grandparent cloaks all together—as they should be." This was a defining moment, because visitors to *First Peoples* learn that the grandparent cloak (Wolithiga) survived invasion, massacres and desecrations, missionaries, and the banning of indigenous languages and cultural practices. The biganga survived to seed many more generations.

Based on the structural stability, interpretation, and representation of Darroch's contemporary adult and child biganga, they were mounted on tailor-made soft-sculpture forms, secured by stitching. This way, the audience would see how they were worn. It was also documented that Darroch or her direct descendants were to be consulted about any future conservation or preservation needs. These biganga are now part of community-based preservation plans, designed to ensure the most appropriate form, both culturally and materially, of long-term preservation.

THE CONTEMPORARY CLOAK AT THE UNIVERSITY OF MELBOURNE
The UoM cloak was commissioned in 2012 to commemorate the sesquicentennial of the founding of the Melbourne Medical School. It was given to the school on behalf of the Wurundjeri people, the original custodians of law and owners of the land upon which the UoM is sited. The cloak, gifted by its maker, the Wurundjeri artist Mandy Nicholson, depicts symbols linked to Wurundjeri Country (fig. 3.3). It was commissioned for ceremonial use at the university (fig. 3.4), and its long-term storage, use, and condition monitoring were not initially considered. After six months of use, advice was sought, and the cloak arrived at the Grimwade Centre for Cultural Materials Conservation (GCCMC) at the UoM in good condition, neatly folded five times and squeezed into a small (A4-size) cardboard box (Jones-Amin, Nicholson, and Ewen 2014).

A protocol was developed by Mandy Nicholson and conservator Holly Jones-Amin in consultation with university staff. The cloak is now stored with the university's academic gowns, and its use is managed jointly by Murrup Barak (Melbourne Institute for Indigenous Development, Indigenous Development, UoM) and the Senior Graduations Office. It was important that the protocol be clear, practical, and concise, because it was uncertain whether there would be additional input from the GCCMC after the protocol was written and the cloak was returned to the university's storage. The protocol encompasses use, care, and repair of the cloak, using standard museum practice to enable

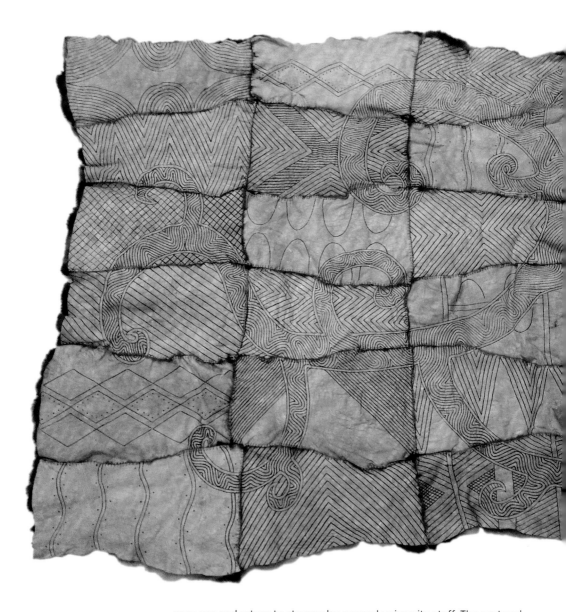

FIGURE 3.3

The possum-skin cloak commissioned in 2012 by the University of Melbourne from Wurundjeri artist Mandy Nicholson. Photo: Holly Jones-Amin

easy use and return to storage by general university staff. The protocol is respectful but also pragmatic; it gives guidance for wearing the cloak, about what to do if it rains or if insects are found, and about conservation repair. The protocol states that, to avoid food stains and residues, cloak wearers are discouraged from eating and drinking. Nicholson states that alcohol should not be consumed while the cloak is worn, because "it would be disrespectful to drink alcohol while wearing a symbol of Aboriginal culture such as the cloak." The cloak is a reversible garment and can be worn with the images outermost or, in wet weather, with the water-resistant fur outermost.

The benefits that the cloak provides for cultural identity are acknowledged and welcomed, and the physical changes resulting from use of the cloak are accepted as inevitable. Conservation thinking informs the beginning of the cloak's existence as a garment to be worn rather than as an exhibit. The protocol, which is working well, identifies conservation as responsible for condition assessment and advice on storage, while any repair to the cloak will be in the hands (literally and metaphorically) of Nicholson and her descendants. In August 2015, Professor Ian Anderson wore the cloak in East Arnhem Land when conferring the degree of Doctor of Laws *honoris causa* on the Gumatj leader

FIGURE 3.4

Professor Ian Anderson with Professor Megan Davis, who is wearing the possum-skin cloak made by Mandy Nicholson; 2012 Narrm Oration, University of Melbourne. Photo: Peter Casamento

Galarruy Yunupingu. The cloak was transported by Qantas airline as carry-on luggage because of a written request supported by the protocol and condition report.

CONCLUSION

The models of collaboration developed at MV and the UoM have endorsed the future involvement of and responsibility for conservation to descendants of the cloak-makers. For Aboriginal peoples of southeast Australia, possum-skin cloaks represent a continuation of cultural practice linked to identity, spirituality, and connection to Country. The current revitalization of cloak-making and the collaborative conservation and preservation strategies outlined above support the continuing development of strong culture, both tangible and intangible.

It is important to recognize that there are different forms of "conservation." State-endorsed institutions often preserve culture by collecting, conserving, storing, and displaying objects. Aboriginal communities preserve or sustain culture by ensuring that the next generation has the knowledge, skills, and resources to practice culture (Reynolds 2006:105–12). In each case outlined above, the custodianship of significant cultural material is shared by many: Elders, artists, users, curators, conservators, and collection managers. Such collaborative approaches to preserving and sustaining Aboriginal cultural heritage highlight the outcomes of these two ways of coming together and have seen important aspects recognized, respected, and upheld. In Uncle Henry's words: "One could say the new cloaks are as priceless as the originals and as important for younger generations as anything they will encounter in this a modern world—they are never far from their culture and heritage. This venture encompassed the meetings of many peoples of varied backgrounds, cementing the understanding that even though we are different, we are as one."

NOTES

1. Reynolds et al. 2005:58.

2. Aunty Phoebe Nicholson, personal communication to Amanda Reynolds, August 2013.

3. Sculthorpe (2015:244, 262n4) refers to seven cloaks (six cloaks and the single decorated pelt). Investigations undertaken for this paper have identified five nineteenth-century possum-skin cloaks (four plus the pelt) in museum collections:

 Maiden's Punt (Echuca) cloak, a Yorta Yorta cloak collected in 1853, Museum Victoria, Australia (Register entry, n.d. X016274, Cloak, Australia, Northeast (Victoria), Registered);

 Lake Condah cloak, a Gunditjmara cloak collected in 1872, Museum Victoria,

Australia (Register entry, n.d. X016275, Cloak, Australia, Northeast (Victoria), Registered);

Cloak, Museum of Ethnology, Berlin, Germany;

Decorated possum pelt, 19 × 34cm, collected in New South Wales before 1868, British Museum, Oc.4571, donated by William Henry Blackmore;

Cloak, 1839–40, National Museum of Natural History, Smithsonian Institution, E-5803-0.

Investigations also confirmed that the collection of the Museo Nazionale Preistorico Etnografico "Luigi Pigorini" (Luigi Pigorini National Museum of Prehistory and Ethnography), Rome, Italy, does not possess a possum-skin cloak. Luigi Pigorini, Museo Nazionale Preistorico Etnografico "Luigi Pigorini," personal communication to authors, Rome, Italy, February 2015.

4. Possums are nocturnal arboreal marsupials. To some people, they are important totems; to others, they are an important source of food and clothing.

5. There are more than 250 language groups in Aboriginal Australia. People identify themselves in a variety of ways, including clan groups and language groups of their ancestry.

6. Chris Keeler, personal communication, February 28, 2015.

7. Register entry, n.d. X016275, Cloak, Australia, Northeast (Victoria), Registered. KE EMu catalogue module, MV.

8. Register entry, n.d. X016274, Cloak, Australia, Northeast (Victoria), Registered. KE EMu catalogue module, MV.

9. A comparable effect can be seen in the current revival of Russian Orthodox embroidery (see Dovgan Nurse, Eastop, and Brooks 2014:74–85).

10. A songline is a track across the land, sky, or sea following a journey of a Creation Ancestor. Songlines are recorded in Creation stories, songs, paintings, and dance. A knowledgeable person is able to navigate across the land by repeating the words of the songs describing the location of landmarks, water holes, and other natural phenomena. By singing the songs in the appropriate sequence, indigenous people navigate vast distances. Australia contains an extensive system of songlines, many passing through multiple Aboriginal countries.

11. Presumed to be residue from pesticides applied after acquisition.

REFERENCES

Cahir, David. 2005. "Dallong–Possum Skin Rugs: A Study of an Inter-Cultural Trade Item in Victoria." *Provenance: The Journal of the Public Record Office of Victoria* [Australia] 4: 1–6.

Couzens, Vicki. Forthcoming. "'*Kooramook yakeeneeyt*—Possum Dreaming': Reconnecting Communities and Culture: Telling the Story of Possum Skin Cloaks." PhD diss., Royal Melbourne Institute of Technology.

Couzens, Vicki, and Fran Edmonds. 2008. "The Reclamation of South-East Australian Aboriginal Arts Practices." In *Crossing Cultures: Conflict, Migration, and Convergence; The Proceedings of the 32nd International Congress of the History of Art*, edited by Jaynie Anderson, 781–85. Parkville, Australia: University of Melbourne.

Dawson, James. 1881. *Australian Aborigines*. Melbourne: George Robertson.

Dovgan Nurse, Luba, Dinah D. Eastop, and Mary M. Brooks. 2014. "Authenticity in the Revival of Orthodox Ecclesiastical Embroidery in Post-Soviet Russia." In *Authenticity and Replication: The "Real Thing" in Art and Conservation*, edited by Rebecca Gordon, Erma Hermens, and Frances Lennard, 74–85. London: Archetype.

Ford, Bruce, and Nicola Smith. 2011. "Lighting Guidelines and the Lightfastness of Australian Indigenous Objects at the National Museum of Australia." In *Preprints of the 16th Triennial Conference of ICOM Conservation Committee, Lisbon, Portugal, September 19–23*, edited by Janet Bridgland, 19–23. London: James and James.

Goodall, Rosemary. 2012. "X 016274, Cloak, Australia, Northeast (Victoria), Registered, KE EMu conservation module." Museum Victoria.

Gunn, Robert G. 2009. "Wooden Artefacts from Gariwerd Rockshelters, Western Victoria." *Australian Archaeology* 68: 23–30.

Hamilton, Samantha. 2013. "Conservation Community Consultation during the Bunjilaka Redevelopment Project at Melbourne Museum." Paper presented at "Contexts for Conservation," the Australian Institute for the Conservation of Cultural Material Conference, Adelaide, South Australia, October 23–25. Accessed August 2, 2016. https://aiccm.org.au/sites/default/files/docs/NatConf_2013/NatConf_2013PubsFinal/8.%20Community%20consultation%20during%20the%20Bunjilaka%20redevelopment%20project.pdf.

Jones-Amin, Holly, Mandy Nicholson, and Shaun Ewen. 2014. "A Protocol of Use and Preservation of a New Traditional Possum Skin Cloak Used in University Ceremonies." In *ICOM-CC 17th Triennial Conference Preprints, Melbourne, September 15–19*, edited by Janet Bridgland. Paris: International Committee for Conservation.

Reynolds, Amanda J. 2006. *Keeping Culture: Aboriginal Tasmania*. Canberra: National Museum of Australia Press.

Reynolds, Amanda J., Debra Couzens, Vicki Couzens, Lee Darroch, and Treahna Hamm. 2005. *Wrapped in a Possum Skin Cloak: The Tooloyn Koortakay Collection in the National Museum of Australia*. Canberra: National Museum of Australia Press.

Sculthorpe, Gaye. 2015. "Drawing on Country." In *Indigenous Australia: Enduring Civilisation*, edited by Gaye Sculthorpe, John Carty, Howard Morphy, Maria Nugent, Ian Coates, Lissant Bolton, and Jonathan Jones, 242–55. London: British Museum.

Smyth, Robert Brough. 1878. *The Aborigines of Victoria*. Melbourne: Government Printer.

AUTHOR BIOGRAPHIES

HENRY L. ATKINSON, a Wolithiga Elder and a former spokesperson for the Yorta Yorta Council of Elders, has advocated for the rights of the Yorta Yorta in Native Title claims and government policy. He was raised in Echuca and has strong ties to his Country. He is currently a consultant and lecturer at Deakin University and formerly at Monash University. Atkinson has served on many committees, including Museum Victoria's Aboriginal Cultural Heritage Committee and the Australian government's Indigenous Repatriation Committee. He co-curated and was active in the preservation of the historic Yorta Yorta possum-skin cloak at Museum Victoria.

VICKI COUZENS is a senior possum-skin cloak-maker, teacher, artist, language and culture researcher, curator, and writer from Gunditjmara Keerray Woorroong Country in Western Victoria. For the past fifteen years she has passionately learned and taught the sacred southeastern cultural tradition of making, wearing, and healing through possum-skin cloaks, and her work is held in several national and international collections. She has been instrumental in the cultural reclamation and regeneration of language, cultural practices, ceremony, and creative traditions. Her writings are featured in community and academic forums, and she is an influential teacher and mentor.

LEE DARROCH is a Yorta Yorta, Mutti Mutti, and Boon Wurrung woman who has lived on Raymond Island, Gippsland Lakes, for the past twenty-eight years. She is an artist, senior cloak-maker, and cultural worker, and her artwork is inspired by the need to continue cultural, spiritual, and artistic practices. Darroch has run her own business, Gurranyin Arts, for over twenty years. She feels guided in her art by the Old People who have gone before us and by her Elders today. Darroch hopes to leave a rich legacy for her children and others, so that the Dreaming will continue in an unbroken line.

GENEVIEVE GRIEVES is a Worimi woman. She is currently a lecturer in the Indigenous Studies Program, University of Melbourne, and is pursuing her doctorate on memorialization and frontier violence. Grieves was lead curator of the *First Peoples* exhibition at Melbourne Museum. She previously worked with the Koorie Heritage Trust (Melbourne) in oral history, family history, and digital archiving, and developed the Mission Voices website. She creates video art and was a researcher, field producer, and online-content developer for the First Australians film project. Grieves wrote and directed *Lani's Story*, a documentary that won numerous awards.

SAMANTHA HAMILTON is an object conservator at Museum Victoria, currently completing her doctorate ("Best Practice in Conservation Programs for Remote Aboriginal Communities") at the University of Melbourne. She has worked both nationally and internationally and in private practice. Awards include a Mellon Fellowship, an Australian National University Scholarship, a Norman MacGeorge Scholarship, and a University of Melbourne PhD Fieldwork Grant. Hamilton is a committee member for the Museums Accreditation Program of Museums Australia (Victoria) and is coordinator for the Exhibition Special Interest Group of the Australian Institute for the Conservation of Cultural Material.

HOLLY JONES-AMIN is a senior conservator at the University of Melbourne's Grimwade Centre for Cultural Materials Conservation (GCCMC). She is a foundation lecturer and tutor for the Masters of Cultural Materials Conservation program,\ and manages the Objects consultancy program. She holds degrees in archaeology and conservation and has extensive experience working as a conservator in Australia, the Middle East, and Southeast and central Asia. Jones-Amin has specialist skills in the treatment of archaeological objects from indigenous and world cultures. Her research interests include the degradation and stabilization of porous archaeological ceramics and how cultural belief systems are respected in museum settings.

MANDY NICHOLSON is a Wurundjeri artist (the Wurundjeri being the traditional custodians of the land on which the University of Melbourne is located). She has worked in various media, including ceramics, printmaking, clothing, sculpture/carvings, and public art installations. She specializes in two-dimensional painted works and launched her business, Tharangalk Art, in 2000. Nicholson holds an honors degree in indigenous archaeology, with a minor in geology. She is currently a project officer and Woiwurrung language specialist at the Victorian Aboriginal Corporation for Languages (VACL), assisting with the revival of the thirty-eight indigenous language groups of Victoria.

AMANDA REYNOLDS was senior curator of the "Our Story" section in the international award–winning *First Peoples* exhibition (2013, Museum Victoria). A writer and storyteller, she specializes in community-based collaborative curatorial models and culturally based creative healing programs. Committed to the flourishing of storytelling and cultural practices,

she contributes to caring for the homelands and songlines of the southeast. Projects include possum-skin cloak healing, resource coordinator for Banmirra Arts; co-curator of *Garrigar-rang: Sea Country* (2014, Australian Museum); curator of *Living Democracy* (2008, Museum of Australian Democracy); and curator of *First Australians: Gallery of Aboriginal and Torres Strait Islander Peoples* (2001, National Museum of Australia).

4 | *KAHU ORA*
LIVING CLOAKS, LIVING CULTURE

Rangi Te Kanawa, Awhina Tamarapa, and Anne Peranteau

Museums preserve and display collections as material evidence of the past and the present, and these activities take place within current power structures. Museums can be characterized as microcosms of dominant sociopolitical attitudes and activities; for example, many of these institutions have colonial legacies. Recently, indigenous peoples have voiced alternative perspectives on history and knowledge production, creating a "cultural interface" (Nakata 2007). Museums and conservation practice can provide mechanisms for redress by articulating and embodying different histories and current power relations. One of the most empowering aspects of Māori[1] museum practice is enabling the reconnection and restoration of *taonga* (cultural treasures)[2] and customary knowledge with their communities of origin. This paper introduces and explains the reconnection and restorative approaches adopted for the exhibition *Kahu Ora, Living Cloaks* at the Museum of New Zealand Te Papa Tongarewa (hereafter Te Papa).[3]

MUSEUMS, TAONGA, AND LIVING COLLECTIONS
Museum policies and procedures can be perceived as barriers to Māori needs; in some respects, traditional museum practice and Māori aspirations are opposed, leading to tensions that can remain unresolved and difficult to navigate. Thus, the contested knowledge space of museum practice can be emotionally charged and confrontational, but it can also open up exciting possibilities. Restoration of cultural pride, knowledge, and practice is an important issue, and it has implications for access to collections as well as for their use, conservation, and display.

In New Zealand (called Aotearoa by the Māori), the establishment of museums was closely associated with international exhibitions designed to display the abundance of colonized lands and their commercial potential. The resulting "trophy-style" displays were characterized by densely arranged objects with no indication of original context, status, or the human relationships they embodied (and continue to embody) (McCarthy 2007). Museums became places of instruction in

Pākeha (European) ways of knowing, displaying traditional Māori dress in a way that belied the survival of Māori as a living culture.

The 1980s were pivotal years during which issues of representation were recognized as significant and the care of collections was reclaimed and redirected to show "that Maoridom is a living culture, and that our *taonga* express us as a people with a past, a present and a future" (Tamarapa 1996:162). For the museum sector, the watershed event in the era of redress was the *Te Māori* touring exhibition of 1984–86. A stronger presence within the museum enabled Māori to assert traditional knowledge, interpretations, and values, and to work with the taonga held there. A 1987 Court of Appeal ruling brought Article II of the Treaty of Waitangi to bear on all state-owned enterprises, including museums, and directed bicultural partnership in both governance and collections' stewardship (C. Smith and Scott 2009). Conservation was seen as fundamental to preserving indigenous collections, especially in storage improvement, materials research, and physical stabilization; the importance of training Māori conservators was also recognized. Calls were made for consultation and community empowerment, notably at the Taonga Maori Conference in 1990 (Cultural Conservation Advisory Council 1992), while conservation publications focused on structural stabilization (see, for example, Barton 1986; Scott 1988).

The role of museums in providing access to ancestral taonga for descendants, makers, and researchers is vital for "living collections" and "living traditions." Challenges to the notion of "living taonga" are matched by its potential for active transformation. Underlying the premise that museums have a responsibility to preserve cultural knowledge by caring for collections is a belief that the objects themselves should be preserved unaltered. This frequently means a "hands-off" policy and, hence, the oft-perceived tension between access and preservation:

> For many indigenous peoples, preservation is much more than physical cleaning and conserving the "authentic" artefact. The vitality and expressions of a living culture are important in the modern world, and this should be reconciled with treasures stored in passive repositories and hidden away in museum cupboards, shelves and cabinets. (Hakiwai 2007:46)

Continuity of practice is now acknowledged as an important issue in heritage conservation, and Te Papa recognizes the value of direct, hands-on access to cultural heritage and has adapted its policies accordingly (e.g., H. Smith 2009). The concept of taonga well illustrates

the nature of living heritage; it clearly expresses the importance of con-
tinuity as a key characteristic and reflects the specific practices associ-
ated with the care of such heritage (Wijesuriya 2007:69).

Restoration can apply not only to objects but also to a culture's
potential and well-being. Being subject to colonization can convince
people of their limitations,[4] but this can be overcome when they
develop a sense of empowerment and renewal through experience of
their *mana* (Royal 2007). *Mana* in this sense is the creative potential
within a person, an understanding of deep personal values, ethics, and
sense of place in the world, *mātauranga Māori*.[5] In a museum context,
the revival of customary practices and maintenance of cultural knowl-
edge is a form of redress and liberation, restoring people's rights to
control and manage their own cultural heritage.[6]

KAHU ORA, LIVING CLOAKS

The 2012 exhibition *Kahu Ora, Living Cloaks* (and its accompanying pub-
lication, *Whatu Kākahu/Māori Cloaks*, edited by Tamarapa, 2011) was the
culmination of five years of work that combined the Māori knowledge
of senior weavers from Te Roopu Raranga Whatu o Aotearoa (National
Collective of Māori Weavers in New Zealand) and the science-based
research of Māori textile scholars. Throughout the exhibition's develop-
ment, weavers were acknowledged as activators, knowledge holders,
and hands-on researchers who required access to taonga in order to
regenerate practical, customary knowledge. This collaboration began
in 2007 with the Whatu Kākahu project, the principal aim of which was
to identify Māori cloaks in public collections and thereby enhance the
practice and knowledge of Māori customary weaving. The exhibition's
title—*kahu* (cloak) and *ora* (life)—demonstrated interactions of past and
present and reflected the vitality of Māori cloak-weaving, an art form
that continues to innovate. It sought to convey the fundamental core
and depth of *mātauranga* inherent in living cultural practice.

The Whatu Kākahu project demonstrated what could be achieved
through encouraging meaningful access to museum collections. Dur-
ing the project, senior Māori weavers shared their knowledge about
and their responses to the *kākahu* (cloaks) at Te Papa, advised on the
selection of exhibits (Tamarapa 2011:15), and, along with scholars, art-
ists, and writers, contributed essays on cloak-weaving. Kākahu formerly
relegated to an anonymous existence in museum storage were recog-
nized as embodiments of familial connections. Personal recollections
and observations that surfaced when viewing ancestral taonga were
recorded, notably any associations with family history. Each experience

demonstrated the vibrancy of knowledge generated by the presence of these kākahu.

This collaborative process promoted *mātauranga* (Māori knowledge, practices, customs, and belief), supported scientific investigation, and honored relationships with weavers past and present. These multidimensional perspectives respected Māori values and sensitivities, demonstrating the importance of preserving and encouraging Māori cloak-weaving as a precious, living form of art for present and future generations. The themes and perspectives explored in the Whatu Kākahu project were given full expression in *Kahu Ora, Living Cloaks*, which aimed to reassert Māori cultural agency. A weavers' studio formed the conceptual heart of the exhibition, enabling the public to engage with weavers directly (fig. 4.1). Each month a local group demonstrated weaving and displayed examples; for many visitors, these interactions proved far more meaningful than reading museum labels or watching the audiovisual content.[7]

Customary cloak-weaving is considered the highest form of Māori fiber arts because it requires great skill and extensive knowledge of Māori history, protocols, and values, and because it demonstrates the interrelationship between natural and cultural domains. Cloaks woven from natural materials such as *muka*, a fiber processed from the *harakeke* leaf,[8] are especially esteemed because of the plant's cultural

FIGURE 4.1
Visitors in *Kahu Ora, Living Cloaks* engaging directly with weavers in the exhibition's weavers' studio. Courtesy the Museum of New Zealand Te Papa Tongarewa

FIGURE 4.2
Peter Love, a *kaumatua*
(respected elder) of the
Te Ati Awa iwi, wearing
a *kahu kuri*, or dog-skin
cloak (ME002053).
Courtesy the Museum
of New Zealand Te Papa
Tongarewa

and spiritual associations. Although no longer worn every day, kākahu
still represent personal prestige, honor, and ancestral connection
(fig. 4.2): they are taonga that embody physical and spiritual protection.
As explained by the late master weaver Erenora Puketapu-Hetet, "weav-
ing is endowed with the spiritual essence of the Māori people" (1989:2).

The *Kahu Ora* exhibition questioned the dichotomy of preservation
versus access by encouraging the community to inform conservation
activities, and these discussions of treatment goals and strategies within
and beyond the museum have enabled indigenous perspectives to
shape conservation practice (e.g., Te Kanawa 1990). Māori conservators
have extended their work to outreach activities, helping communities to
take control of heritage management outside the museum (e.g., Bloom-
field 2008). The *Kahu Ora* exhibition narrative, developed in consultation
with source communities, provided interpretive guidance to inform

conservation decisions. The four cloaks introduced below illustrate the conservation approach, where the objectives of cultural reproduction are supported by respecting and preserving historic taonga.

CONSERVATION AND DISPLAY

Conservation is intertwined with museum display and thus extends beyond physical stabilization to interpretation and presentation. Significance assessments provide the basis for conservation decision-making at Te Papa, with minimum intervention generally preferred. Understanding the materials, technology, and deterioration processes is fundamental and draws on the expertise of makers and on instrumental analysis; conservation therefore provides one arena for integrating Māori and Pākeha (that is, European) knowledge systems. The following case studies focus on Māori cloaks that were mainly functional, worn wrapped around the body, and highly valued as taonga. Most are roughly oblong, subtly shaped in the weaving process. Many have decorative *taaniko* (borders) in finer twined work with feather adornment, thrums of fiber and leaf, and/or strips of dog-skin fur.

Harakeke (*Phormium tenax*) was used extensively in traditional Māori culture; almost all forms of clothing were made with it, in fiber (*muka*) or leaf form. Muka was extracted from the leaf with a mussel shell, plied over the thigh to produce both warp and weft threads, with single fibers often used as weft threads. Some cloaks lack ply in the warp threads, giving the muka fibers between the weft rows a wave-like appearance. The twining "stitch" (*whatu*), both single and in pairs (*whatu aho tahi*) and double pairs (*whatu aho rua*), interlocks the warp (*whenu*) and makes up the numerous weft (*aho*) rows. The weft rows form the foundation (*kaupapa*) of the cloak, and adornment is added either during the weaving process or afterward. For example, feathers or thrums (in dyed leaf or fibrous form, called *Hukahuka* and *Pokinikini*, respectively) are incorporated during the weaving process, while dog-fur strips are stitched on after the foundation is woven.

Cloaks of the eighteenth and early nineteenth centuries usually feature only three colors of muka: undyed, plus two colored with natural dyes. Red brown was made by soaking muka in the bark of the *tanekaha* tree (*Phyllocladus trichomanoides*) and then rubbing it with warm wood ash. Black was made by soaking muka in the bark of various trees—the *hinau* (*Elaeocarpus dentatus*), the *manuka* (*Leptospermum scoparium*), and the *kanuka* (*Kunzea ericoides*)—and then submerging it in an iron-rich mud (*paru*). Somewhat later, a golden-yellow dye was produced by soaking muka in a tannin solution of the

shrub *raurekau* (*Coprosma areolate*) (G. Smith and Te Kanawa 2008). Māori incorporated imported dyed wool into borders and the edging of cloaks (for example, as supplementary wefts or pom-poms) or stitched into the foundation weave.

Measuring 2.9 × 1.35m, a *kaitaka*, a loan item deposited at Te Papa (TMP 9928), was the largest cloak in the *Kahu Ora* exhibition. It had been damaged by light and discolored from prolonged display in a private collection during which artifacts had been laid on top of it. These artifacts, including a greenstone weapon (*mere*), had protected the underlying parts of the cloak from light exposure, leaving pale "shadows" of the objects visible against the darker, more photooxidized surrounding areas. The differential color change provided evidence of a long-standing relationship between taonga, and because this evidence was considered significant, it was retained: no attempt was made to reduce or disguise the differential discoloration. While some discoloration or soiling can be of evidential value, it can also be viewed as damage; for example, extensive dye bleed on another cloak was traced to a basement flood and treated to reduce "tide-line" staining (Peranteau 2013).

Almost every cloak selected for display in *Kahu Ora* incorporated black-dyed muka fiber. For many years, the presence of this vulnerable black fiber has restricted the display of objects and ultimately the connectivity of the cloaks with both museum visitors and those affiliated with these taonga. Concern about the stability of these fibers led to a collaborative research program to investigate consolidants (G. Smith and Te Kanawa 2008; Te Kanawa 2005), drawing on science (via instrumental analysis of materials) and on indigenous knowledge of dyeing processes. The embrittlement and the discoloration of the fibers to golden brown (Daniels 1999) were shown to be caused by oxidation of the carboxylic groups in the fiber, resulting in the production of acetic acid; fiber deterioration was further catalyzed by dyeing with iron tannate. Options for consolidation were investigated, and the application of a 1% w/v vaporized solution of sodium alginate strengthened the fiber and reduced the production of acid. Further research is underway to analyze the efficacy of this treatment, particularly in terms of strength, color retention, and acidity levels.

As expected, the most fragile cloak in the exhibition was a *pihepihe* (ME015675), a rain cloak/cape made with a foundation of black-dyed muka completely covered with black-dyed *harakeke* leaf tags. In storage, it lay surrounded and covered with detached leaf tags (that is, short leaf strips) and black fiber dust. Despite the cloak's fragility, the

adornment was thick and the foundation remained intact. Consolidation was not appropriate in this case, as more damage could result from the handling necessary to isolate each of the many tags, and it was understood that *Kahu Ora* might provide a one-time opportunity to show this *pihepihe*. Too fragile to be displayed as worn, the cloak was mounted on a cloth-covered board, interleaved with a thin, smooth, archival card, and secured to the board with small "croquet" pins constructed of coated, extruded steel of 1mm diameter. A template was made to aid the pinning process; by gently separating the tags, it was possible to record the position of the top three weft rows. The markings for these weft rows were transferred to the mount, and then pairs of small holes were drilled into the mount. The cloak was laid on the archival card, and the template guided the insertion of pins between the warp (*whenu*) and under one of the three marked weft (*aho*) rows and into the holes. Detached leaf tags were then removed from the cloak and retained for research purposes.[9] When displayed at an angle of 15 degrees from the horizontal, the cloak's fragile, deteriorated condition was not obvious: the *pihepihe* appeared complete and intact. Following exhibition, there was no visible change in the cloak's condition. The archival card was used as a support under the cloak while it was carefully eased back into its storage drawer.

A *kahu kuri* (or dog-skin cloak, WE001591) was one of five such cloaks exhibited. They were the most prestigious type of cloak, worn only by chiefs and gifted as symbols of *mana*, marking transactions, alliances, and exchanges. *Kuri* (the Polynesian dog) were prized companions and "many had whakapapa or genealogy that was recited right alongside that of their kaitiaki (guardians)" (Wallace 2011:54). *Kuri* were extinct by the 1870s, and most dog-skin cloaks are dated pre-1850, before large-scale colonial settlement of New Zealand. Fashioned from muka and strips of fur, the cloaks have a foundation (*kaupapa*) of densely weft-twined fibers.[10] The foundation was flexible and lacked ingrained soiling, accretions, or applied coloration. Although the short, curled collar strips were stiff and slightly brittle, the cloak could be handled safely with an overall support. The fur was covered with fine, dark gray soiling that reduced the contrast between the brown and cream furs. There was evidence of past pest activity (moth casings and grazed areas), and the fur felt harsh and somewhat "chalky." Residues of insecticides, which were widely used in the past, are sometimes present in "ethnographic" collections, and they can be a serious health hazard (Odegaard and Sadongei 2005). In this case, X-ray fluorescence (XRF) analysis did not indicate the presence of arsenic- or mercury-based pesticides.[11]

Where their condition permitted, historic feathered cloaks and contemporary cloaks were displayed on headless mounts, called rib forms (fig. 4.3).[12] The mounts were designed so that they could be adjusted for each cloak, providing a stylized representation of how the garments might have looked when worn. A *Kahukiwi* cloak (ME002056)—completely adorned with feathers (mainly from the kiwi, but also from the *tui, kaka, moho pereru, kereru*, and peacock) and woven with shaping rows (*aho poka*) to accommodate the wearer's shoulders and buttocks—serves as an example of mounting on a rib form (fig. 4.4). A template was made of the cloak to reduce unnecessary handling during mount preparation and adjustment. The rib form was constructed from 44mm wide strips of polypropylene, evenly spaced around an oval-shaped piece of sealed medium-density fiberboard (MDF) and attached to an upright steel pole. The MDF was padded with Ethafoam and covered with napped, black nylon fabric. Long, flexible metal "spokes" (2mm diameter) enabled the size and contour of the support form to be adjusted to accommodate cloaks of different shapes. The top edge of the cloak was attached with staple-like pins (resembling croquet hoops) placed carefully between warp (*whenu*) and immediately under weft

FIGURE 4.3
A rib-form mount.
Courtesy the Museum
of New Zealand Te Papa
Tongarewa

FIGURE 4.4
A *Kahukiwi* cloak
(ME002056) on the rib-
form mount. Courtesy the
Museum of New Zealand
Te Papa Tongarewa

(*aho*) stitches, and then pierced into the padded oval board. The pins were covered by the feathers and could not be seen. It was once common practice to attach cloaks to display mounts with hook-and-loop fasteners such as Velcro. The loop strip was stitched to the underside of the top edge of the cloak, with the hook strip secured to the mount. As the fasteners can become an almost permanent fixture, there has been a move away from this method at Te Papa to the use of so-called croquet pins. Insertion and removal of the pins requires careful handling, but it is a quick and simple method for temporary display.

CONCEPTS OF "CONTINUITY"

As noted earlier, the current approach to conservation in New Zealand enables individuals and communities, particularly those connected via a shared culture, to embrace taonga. The focus on preserving the physical integrity of artifacts for future generations by restricting handling (and sometimes display) can also restrict the present generation from such embrace. Recognizing the importance of taonga in maintaining cultural identity, Te Papa has changed its practices to enable some cloaks in the collection to be used for *pōwhiri* (welcoming) and repatriation ceremonies. Although the effects of such use, from a conservation perspective, may be considered undesirable (e.g., feathers can be dislodged by being affectionately stroked), ways of reducing such risks have been developed, including minimizing the number of cloaks lent, or facilitating their safe handling by providing cloaks with cushioned underlays. As a principal concept in sustaining Māori cultural heritage, it is now expected that these *taonga* will embrace their people, as much as their people will embrace them.

The origins of Te Papa are rooted in colonialism, but contemporary agendas pursue self-determination, sovereignty (*rangatiratanga*), and cultural revitalization/liberation. For Māori, keeping taonga "warm" (present, relevant, alive) in the consciousness of communities is an important role of *kaitiaki* (custodians). Museum professionals are considered *kaitiaki* of this knowledge, and their role is to assist in its maintenance and development; they must act as conduits for *kaupapa*, the regeneration of customary knowledge, values, and practices, within the museum and beyond. For almost two decades, a popular and effective outreach program headed by Te Paerangi National Services has presented community workshops on conservation. These workshops take place in the community environment, often on a *marae* (a Māori tribal meeting place), where *pōwhiri* and *mihi whakatau* (introductions) are respected. Participants are encouraged to bring taonga for condition

assessments and are given assistance and advice on, for example, storage methods and materials.

Accepting the validity of indigenous knowledge systems, practices, and values, and being prepared to reevaluate notions of restoration, conservation, and access, can lead to emancipatory change. Māori weavers believe that it is necessary to develop meaningful, long-term relationships with museums in order to achieve such change. Museum professionals can serve as co-agents for social and cultural emancipatory change, leading to better understanding of the contested grounds of museum philosophy and practice. The creative potential inherent in *mātauranga Māori* opens up a future for knowledge development in which museum professionals should play a role. The dynamic politics of cultural sovereignty and changes within contemporary Māori society can help foster new concepts for a museum practice centered on people.

NOTES

1. Māori are the indigenous people of Aotearoa (as the Māori refer to New Zealand).

2. Taonga are highly valued objects, knowledge, practices, places, resources, and cultural aspects that link to ancestral history, customs, spiritual beliefs, and worldview. They are tangible and intangible continuums of what is uniquely Māori, imbuing a sense of cultural identity and belonging.

3. This coauthored paper reflects three perspectives. Awhina Tamarapa, as lead curator of the exhibition *Kahu Ora, Living Cloaks*, introduces a curatorial view, complemented by conservators Anne Peranteau and Rangi Te Kanawa (the assigned conservator of Māori descent for the exhibition).

4. As explained by Charles Royal (Te Ahukaramū), "Creative Potential: The Vision and Concept Underpinning the Strategy of Ngā Pae o Te Māramatanga," in the seminar Ngā Pae o Te Māramatanga, March 27, 2013.

5. Royal refers to three aspects of *mana*, derived from the teachings of Māori *tōhunga* (scholar) and respected elder Māori Marsden: *mana atua* (deepest values), *mana tupuna* (what flows to you from your ancestors), and *mana whenua* (a person's sense of place in the world). See also Royal 2007.

6. See note 4, above, and Smith and Winkelbauer 2006.

7. Visitor feedback indicated that people enjoyed the experience with the weavers the most.

8. *Harakeke* (*Phormium tenax*) was used to make cordage as well as garments. Although it is a leaf fiber (a monocotyledon from the genus *Hemerocallis*), European traders thought the fibers looked like linen (which is made from bast fibers derived from the stems of flax, a dicotyledonous species), and it is therefore often referred to as New Zealand flax.

9. Sampling from taonga is avoided. Analysis is usually undertaken on material that has already detached.

10. The methods by which the skins were preserved by Māori remain unknown. Colonial observer William Colenso recorded skins stretched on frames sheltered from sun and

rain; the use of tannins or oils (known to have been harvested for other purposes) has been hypothesized (Wallace 2011). The shrinkage temperature of one sample was recorded as 58°C, which would seem to rule out use of vegetable tannins; further research is required.

11. A Bruker Tracer SD-III, a handheld XRF device.

12. Penny Angrick presented a poster, "A Rib Form for Māori Cloaks," at the 3rd International Mountmakers Forum, April 26–27, 2012, Field Museum, Chicago.

REFERENCES

Anderson, Atholl, Judith Binney, and Aroha Harris. 2014. *Tangata Whenua: An Illustrated History*. Wellington: Bridget Williams.

Barton, Gerry. 1986. "The Conservation of the Māori Birdman Kite in the Auckland Museum, New Zealand." In *Symposium 86: The Care and Preservation of Ethnological Materials*, edited by Robert Barclay, M. Gilberg, J. C. McCauley, and T. Stone, 186–91. Ottawa: Canadian Conservation Institute.

Bloomfield, Tharron. 2008. *"Pupuru te mahara*—Preserving the Memory: Working with Māori Communities on Preservation Projects in Aotearoa, New Zealand." In *Preprints of the 15th Triennial Conference of ICOM Conservation Committee, New Delhi, September 22–26*, edited by Janet Bridgland, 144–49. New Delhi: ICOM-CC/Allied Publishers.

Cultural Conservation Advisory Council. 1992. *Taonga Maori: Proceedings of a Conference, November 18–27, 1990*. Wellington: Department of Internal Affairs/Te Tari Taiwhenua.

Daniels, Vincent. 1999. "Factors Affecting the Deterioration of Cellulosic Fibres in Black-Dyed New Zealand Flax (*Phormium tenax*)." *Studies in Conservation* 44: 73–85.

Hakiwai, Arapata. 2007. "The Protection of Taonga and Māori Heritage in Aotearoa (New Zealand)." In *Decolonising Conservation: Caring for Māori Meeting Houses outside New Zealand*, edited by Dean Sully, 45–58. Walnut Creek, CA: Left Coast Press.

Heikell, Vicki. 1995. "The Conservator's Approach to Sacred Art." *WAAC Newsletter* 17 (3): 1–2. Accessed August 13, 2015. http://www.cool.conservation-us.org/waac/wn/wn17/wn17-3/wn17-310.html.

McCarthy, Conal. 2007. *Exhibiting Māori: A History of Colonial Cultures of Display*. Wellington: Te Papa Press.

Nakata, Martin. 2007. "The Cultural Interface." *Australian Journal of Indigenous Education* 36: 7–14.

Odegaard, Nancy, and Alyce Sadongei, eds. 2005. *Old Poisons, New Problems: A Museum Resource for Managing Contaminated Cultural Materials*. Walnut Creek, CA: Altamira Press.

Peranteau, Anne. 2013. "Gellan Gum as a Material for Local Stain Reduction." In *Conserving Modernity: The Articulation of Innovation; Preprints of the 9th North American Textile Conservation Conference (NATCC)*, San Francisco, November 12–15, 72–85. [San Francisco]: NATCC. CD-ROM.

Puketapu-Hetet, Erenora. 1989. *Maori Weaving*. Auckland: Pitman.

Royal, Charles. 2007. "The Creative Potential Paradigm Emerging in iwi/Māori Communities." Keynote address at "Tranzform: Te Tinihanga," the Library and Information Association of New Zealand Conference, Rotorua, New Zealand, September 10. Accessed July 5, 2016. http://www.lianza.org.nz/sites/default/files/royal_charles_creativepotential.pdf.

Scott, G. 1988. "A Maori Cloak." *Conservation News* 35: 10–11.

Smith, Catherine, and Marcelle Scott. 2009. "Ethics and Practice: Australian and New Zealand

Conservation Contexts." In *Conservation: Principles, Dilemmas and Uncomfortable Truths*, edited by Alison Richmond and Alison Bracker, 184–96. Oxford: Butterworth-Heinemann.

Smith, Catherine, and Heike Winkelbauer. 2006. "Conservation of a Māori Eel Trap: Practical and Ethical Issues." In *The Object in Context: Crossing Conservation Boundaries*, edited by David Saunders, Joyce H. Townsend, and Sally Woodcock, 128–32. London: International Institute for Conservation.

Smith, Gerald, and Rangi Te Kanawa. 2008. "Some Traditional Colorants of Maori and Other Cultures." *Chemistry in New Zealand* 72 (4): 127–31.

Smith, Huhana. 2009. "Mana Taonga and the Micro World of Intricate Research and Findings around Taonga Māori at the Museum of New Zealand Te Papa Tongarewa." *Sites*, n.s., 6 (2): 7–31.

Tamarapa, Awhina. 1996. "Museum Kaitiaki: Maori Perspectives on the Presentation and Management of Maori Treasures and Relationships with Museums." In *Curatorship: Indigenous Perspectives in Post-Colonial Societies*. Proceedings of Commonwealth Association of Museums Symposium, May 1994, Victoria, British Columbia, 160–69. Ottawa: Canadian Museum of Civilization.

———. 2009. "Te Māori 25th Year Anniversary." *Te Papa* (blog), September 9, 2009. Accessed February 24, 2015. http://blog.tepapa.govt.nz/2009/09/09/te-maori-25th-year -anniversary/.

———, ed. 2011. *Whatu Kākahu/Māori Cloaks*. Wellington: Te Papa Press.

Te Kanawa, Rangi. 1990. "Conservation of Māori Textiles." *AICCM Bulletin* 16 (3): 57–69.

———. 2005. "Consolidation of Iron Tannate Dyed *Phormium tenax* Fibres Using Zinc Alginate." MSc diss., Victoria University of Wellington.

Wallace, Patricia. 2011. "*Ko te Pūtaio, te Ao o nga Tupuna*: Ancestral Māori Scientific Practice." In *Whatu Kākahu/Māori Cloaks*, edited by Awhina Tamarapa, 45–60. Wellington: Te Papa Press.

Wijesuriya, Gamini. 2007. "Conserving Living Taonga: The Concept of Continuity." In *Decolonising Conservation: Caring for Māori Meeting Houses outside New Zealand*, edited by Dean Sully, 59–70. Walnut Creek, CA: Left Coast Press.

AUTHOR BIOGRAPHIES

ANNE PERANTEAU is textile conservator at the Museum of New Zealand Te Papa Tongarewa, where she assesses and treats objects from the Māori, Pacific, and History collections in preparation for display and loan. Prior to moving to New Zealand in 2008, she trained and worked in the United States. She received her MSc in fine art conservation from Winterthur/University of Delaware in 2004. Peranteau is a member of the American Institute for Conservation (AIC), New Zealand Conservators of Cultural Materials (NZCCM), and the International Council of Museums, Committee for Conservation (ICOM-CC).

AWHINA TAMARAPA (New Zealand Māori tribal affiliation: Ngāti Kahungunu, Ngāti Ruanui, Ngāti Pikiao) has extensive museum experience, having contributed in various roles for more than twenty years. She is currently a curator Māori at the Museum of New Zealand Te Papa Tongarewa and has also been a concept developer and collection manager. Recent projects include editing *Whatu Kākahu/Māori Cloaks* (2011, Te Papa Press). She was lead curator for *Kahu Ora, Living Cloaks* (2013). Her most recent exhibition project was as lead curator for the Ngāti Toa Rangatira iwi exhibition *Whiti Te Ra! The Story of Ngāti Toa Rangatira*. Tamarapa has a BA in anthropology from Victoria University of Wellington and a BML in Māori law and

philosophy from Te Wānanga o Raukawa. She is currently completing an MA in museum studies at Massey University, New Zealand.

RANGI TE KANAWA (New Zealand Māori tribal affiliation: Ngāti Manipoto) is a textile conservator working part-time at the Museum of New Zealand Te Papa Tongarewa, specializing in Māori textiles. She also works with historical and contemporary Māori, European, and Pacific textiles. Her childhood instruction in traditional Māori weaving from her late mother and grandmother instilled in her an interest in weaving, conservation, and research. Te Kanawa has a BSc in the conservation of cultural materials, Canberra University, Australia, and she interned in England at the Textile Conservation Centre, Hampton Court Palace, and at the British Museum (1992). She completed an MSc at Victoria University of Wellington (Te Whare Wānanga o te Ūpoko o te Ika a Māui). Her thesis focused on the stabilization of iron-tannate-dyed black *harakeke* (*Phormium tenax*) (2005).

5 | PRESERVING AND DISPLAYING ARCHAEOLOGICAL GARMENTS VIA PRESSURE MOUNTING

Anja Bayer

Garments from archaeological contexts are often incomplete and very fragile. They can be challenging to exhibit, and considerable conservation work may be necessary to achieve both long-term preservation and effective display. The textiles may need to be supported (e.g., by sandwiching between layers of protective fabric), and further losses due to handling may be expected to occur. Some garments must be mounted flat on a board and held in place with glazing—so-called pressure mounts—a method that addresses both preservation and display.

In this paper I explore pressure-mounting techniques and discuss the rationale for their use. I introduce the construction of and materials used for pressure mounts and consider their advantages and disadvantages for display. I also discuss possibilities for enhancing the viewers' experience of pressure-mounted textiles. Although this paper focuses on excavated garments, pressure mounting may also be relevant to garments that are fragmentary, fragile, or have open seams.

The work discussed below was performed at the Abegg-Stiftung, an art historical institute founded by Werner and Margaret Abegg in 1961 in Riggisberg, Switzerland, to promote understanding of the history of textile design and technology. Pressure mounting has been undertaken at the Abegg-Stiftung for more than fifty years, and the system was developed to meet the needs of a wide range of textile objects. The Abegg-Stiftung has a number of originally three-dimensional garments, of different cultures and dates, preserved in pressure mounts; it has also mounted textile objects for other institutions.

Herein I discuss the pressure mounting of various fragmentary, excavated textiles. An eleventh-century dalmatic forms the core case study. The dalmatic (a T-shaped ecclesiastical vestment) had been lifted with other liturgical vestments from the tomb of Saint Godehard and until recently was preserved in a tightly packed bundle in the saint's shrine in Hildesheim Cathedral, Germany. The other case studies—a seventeenth-century doublet and hose, a late antique Egyptian silk

tunic, and a central Asian garment—are introduced as comparators, to demonstrate the versatility of pressure mounting.

BASIC COMPONENTS OF PRESSURE MOUNTS

A pressure mount that meets contemporary conservation standards has as its base a rigid board, which is covered first with padding materials and then with a display fabric. The historic textiles are laid directly onto this cloth-covered padded board. A glazing layer on top holds the fragments in place when the board is lifted from horizontal to vertical, and all the layers are held together securely by a frame or by clamps (e.g., "mirror clips").[1] Pressure mounting is readily reversible, and because the fragments are secured between the padded base and the glazing, further support (e.g., stitching) is seldom necessary. Small differences in depth, such as seams, hems, and fastenings, may be accommodated within the soft padding or by adjustments to the padding itself, such as extra layers and/or layers with "cutouts." Even the rigid base can be adapted; for example, by carving out areas of greater depth.

Many different conservation standard materials have been used for pressure mounting, and they vary by institution and conservator. The choice is influenced by availability, workability, and the importance of certain material characteristics in a particular environment (Tétreault 1993, 1994; Kataoka 2010). The base can consist of cardboard, aluminum, synthetic materials, or wood, and the padding can be formed by soft fabrics such as fleecy cotton or felts and fleeces of natural or synthetic origin. Any smooth fabric appropriate for display is a possible option for the finishing layer. The choice of glazing material is limited to glass or acrylic sheet (polymethyl methacrylate, or PMMA),[2] and each material has advantages and disadvantages. Glass, for example, is inert, has an easy-to-clean surface, has a higher stiffness, and is available in larger sizes; however, it is heavier than PMMA and more brittle. It is also more temperature sensitive than PMMA, which can lead to deposits of fatty acids on the inside of the glass (Bayer 2012). These deposits need to be removed, to prevent a blurry appearance of the textile. The deposition of fatty acids has not been reported on the less temperature-sensitive PMMA. Compared to glass, PMMA is lighter in weight and less likely to break; however, it is only available in smaller sizes, its surface is easily scratched, and it is electrostatic.[3] Furthermore, PMMA has a much higher tendency to bow in larger sizes, which must be taken into consideration when constructing pressure mounts.

For many years, conservators at the Abegg-Stiftung used wooden boards for the bases; cotton flannelette as the padding layer; and

cotton, linen, or silk display fabrics under glass. However, an increased awareness of the possible long-term catalytic effects of storage and display materials on museum objects kept in closed environments led to changes in the choice of materials. Blockboard with a near neutral pH and low formaldehyde emission rate is used instead. The materials' characteristics and interactions—for example, acid emissions of wood, or fatty acid deposits on glass—have been monitored and evaluated for negative influences on the historic objects. No adverse results have been detected, even on early mounts (Niekamp 2012).

The bases are shaped according to the textile to be mounted. Because large pieces of glass tend to sag (and very large pieces tend to bow), the blockboard is pre-tensioned for larger formats to achieve an even pressure between board and glass. Pre-tensioning in the vertical direction is now undertaken for boards measuring more than 1m in height, and it is increased by 5mm for each additional 0.5m. The pre-tensioned board is stabilized by braces (struts) screwed onto the back of the tensioned (arched) board. Stronger support, necessary for larger boards, is achieved by braces of laminated wood that are cut to fit the arched shape of the board before they are screwed onto its reverse. The design of an optimum, large-size pressure mount requires more experience and research.[4] The glazing used at the Abegg-Stiftung is white glass, which prevents color distortion when viewing the mounted textile; the glass has an antiglare preparation that allows for an extremely clear, undisturbed view of the exhibit.[5]

MAKING FRAGMENTARY PRESSURE-MOUNTED GARMENTS MORE COMPREHENSIBLE

Different approaches have been used to make fragmentary garments in pressure mounts comprehensible to general viewers. There are two common challenges (disregarding technical restrictions) faced by museum professionals: first, making sense of areas of loss, and second, showing the relationship between the front and back of a garment. This front-back relationship can be articulated around either a horizontal axis or a vertical axis. In the former, the axis is formed by the horizontal line across the shoulder area of the garment. In the latter, the relationship is based on a standard view of the garment as worn, with the front and back articulated on the vertical axis, as if the wearer had turned around. Both forms of arrangement have pros and cons, and the choice depends on practical, aesthetic, and didactic issues.

One advantage of pressure mounting is that changes in interpretation or preference can be accommodated quite easily, depending on the

object's state of preservation, by lifting the glazing layer and removing fragments and camouflage underlays (usually held in place by the glazing layer). The following four case studies explore different ways of presenting excavated garments in pressure mounts.

EXPLOITING THE HORIZONTAL AXIS

The first example is the mounting in 1978 of a fragmentary, early seventeenth-century doublet and matching hose[6] (Flury-Lemberg 1988:263–65) (fig. 5.1). The fragments include thick braids woven with metal threads; many of the doublet's thread-wrapped buttons (with wooden cores) are also extant. The mount was padded to accommodate these thicker components, enabling the fragmentary garments to be secured safely in the pressure mount. Lacunae in the doublet's collar, center

FIGURE 5.1
Fragments of an early seventeenth-century doublet and hose, as mounted in 1978 (Service cantonal d'archéologie, Genève, GV86–OBJET 2). © Abegg-Stiftung (CH-3132 Riggisberg 2013). Photo: Hans Kobi

back panels, and skirt tabs were camouflaged with color-matched, custom-dyed cloth, which made it easier for the viewer to understand the cut (shape) of the doublet. The fragments were arranged on a single board, with the doublet fragments placed above the hose fragments, on a horizontal axis. When the mount is displayed vertically, the back of the doublet is upside down, with the front and the hose in an "as worn" orientation.

A late antique Egyptian silk tunic, preserved in a very fragmentary condition with large areas of loss, was mounted in 1990 (fig. 5.2).[7] Small details in the processing and the layout of the fabric's pattern enabled it to be identified as a sleeved garment that had been woven in one piece. When worn, the pattern was upright on both the front and back; the neck opening is formed by a slit at the pattern change. When these

FIGURE 5.2
Fragments of a late antique Egyptian silk tunic (3945), as mounted in 1990. © Abegg-Stiftung (CH-3132 Riggisberg 2013). Photo: Christoph von Viràg

fragments were being conserved, the inversion of the pattern and the weaving technology of the fabric were assessed as more significant than its format as a garment. The decision was made to indicate the original shape of the fragmentary tunic on the mount using a layer of a fine, semitransparent silk fabric (crepeline). The custom-dyed crepeline was laid on the padded, cloth-covered board, filling the gaps between the fragments and joining them optically. Parts of the crepeline were extended to the edge of the board to suggest the garment's missing elements/sections, such as its sleeves and the length of the tunic.

EXPLOITING THE VERTICAL AXIS

A different result was achieved when mounting a garment from Central Asia preserved in twelve fragments of two silk fabrics woven with gilded leather strips (Schorta 2004).[8] The fragments were vacuumed and humidified to be unfolded and realigned as much as was practical. No section of the garment has been preserved in its original three-dimensional shape: parts of the front, sleeves, and the neck opening are missing, and the back also has a central area of loss. Even though the shape was reconstructed and fragments of the front and back were reassembled, the option of a three-dimensional reconstruction was rejected because of the poor state of preservation of the two fabrics: the silk with its gilded leather strips is degraded, damaged, and torn. The textile could not be supported adequately by stitching or a sandwiching technique.

When placed on a single board, with one half upside down, the fragmentary garment was difficult to read. The invisible neck opening of this presentation seemed to enhance this problem. The fragments of the front and back of the garment were assembled on one board for a photograph, but for the pressure mount they needed to be divided on separate boards (figs. 5.3, 5.4) because of the garment's large size: its maximum dimensions are 2.97 × 2.22m. The garment's appearance is much easier to understand when the front and back fragments are separated, with each in the expected orientation for viewing. The areas of loss caused more difficulties, especially on the front. In some areas, the left and right front sides overlapped; in others, both parts are lost, creating a confusing situation for the viewer. The conservator decided to use partial underlays of color-matched cotton fabric to camouflage losses (the same as the doublet, discussed above). Most camouflage patches were placed under areas of loss within one fragment. On the front, the right side (the lower flap of which, when it had been worn, was covered by the left side), was almost completely "reconstructed"

FIGURE 5.3
Fragments (front) of a garment from Central Asia (5176, 5285, 5423), as mounted for display, 2002. © Abegg-Stiftung (CH-3132 Riggisberg 2013). Photo: Christoph von Viràg

FIGURE 5.4
Fragments (back) of a garment from Central Asia (5176, 5285, 5423), as mounted for display, 2002. © Abegg-Stiftung (CH-3132 Riggisberg 2013). Photo: Christoph von Viràg

with the cotton fabric; in contrast, the left side still looked fragmentary, with the cotton fabric only infilling areas of loss within the fragment. This helps the viewer recognize both the shape of the right-side piece and the double-breasted shape of the front as a whole. Establishing how much (or how little) needs to be added to ensure that the infills support but do not disturb the view of the ancient textile is a process of trial and error.

THE DALMATIC OF SAINT GODEHARD

The grave garments of Saint Godehard (died 1038) were enshrined, together with other remnants of his tomb, in 1132 at Hildesheim Cathedral. The shrine was opened in 2009 for conservation purposes, and the garments were documented and treated at the Abegg-Stiftung (Schorta 2010). The bundle of the saint's vestments contained fragments of a dalmatic, a chasuble, and shoes, as well as items that could not be identified. The weak fragments of the dalmatic were surface-cleaned, using gentle vacuum suction, and humidified so that they could be unfolded and flattened to enable documentation. Fragments from both the front and back of the dalmatic were in a relatively sound condition and complete enough to be treated and mounted for exhibition. The dalmatic is finished with *clavi* (decorative stripes) and has a tablet-woven fringe at the left side seam, reaching from the lower hem into the curve of the armpit. It also has trimming fabrics on the inside along the lower hem, the hem of the left side slit, and at the hems of the sleeve ends and the neckline. No construction seams remain, except for small parts of the shoulder seam.

The fibers of the main silk fabric and the trimmings are degraded to a light beige hue in the best-preserved areas, which, though brittle, retain a certain silky sheen. The monochrome pattern with griffins and panthers is easier to see in these areas. Other areas exhibit all shades between beige and dark brown; in the darker areas, the silk powders readily. The front of the dalmatic, being less fragmentary and generally lighter in color, is better preserved than the back. The bottom left corner is missing, as is the left shoulder area and the upper parts of the sleeves. A huge oblong had been cut away (fig. 5.5), perhaps as early as the twelfth century, presumably to serve a reliquary function.

A stitched support might have been possible, but only for the better-preserved parts of the garment. Sandwiching the fragments between layers of transparent fabric was considered inappropriate in this case, as the woven pattern would have been obscured and the more degraded parts would have continued to shed silk-fiber dust. It was evident that preservation would only be achieved with a pressure mount, which would enable safe handling of the fragments with the least risk of further loss. It was decided to put the front and the back of the dalmatic on separate boards, which reduced the size and weight of each mount, improved their stability, and increased display options.

The major disadvantage of this mounting is that the two-dimensional display makes it difficult for viewers to understand how the dalmatic may have looked when worn. Certainly, the cut of the dalmatic

is evident, and the mount does not disguise the fact that many parts
are missing or irregular in shape. The large oblong loss, considered
historically significant, is also evident. Nevertheless, an unprepared
viewer may struggle to recognize the displayed fragments as a liturgical
vestment. The outlines could have been indicated by a crepeline under-
lay, as with the mount of the Egyptian silk tunic (see fig. 5.2), or with
a cotton fabric ending at the seamline, as on the front of the central
Asian garment (see fig. 5.3). Another technique—lines of running
stitches along seamlines and hemlines—had been explored in the past
for enhancing understanding of fragmentary patterns by continuing
essential outlines in gaps between fragments.[9]

However, for Saint Godehard's dalmatic, each of these options was
rejected. The crepeline was dismissed because placing and replacing
brittle fragments on it would have resulted in more loss, as fibers could
easily be caught in the crepeline's open weave (this is not an issue
with the smooth silk of the display fabric). Cotton fabric infills or out-
line stitching were also rejected because the formerly straight outlines
of the dalmatic, like hems or the folded lines from seam allowances,
were now irregular due to different states of preservation, making it

FIGURE 5.5
Fragments (front)
of Saint Godehard's
dalmatic (Dommuseum
Hildesheim, D 2009-4b),
as mounted for display,
2014–15. To make the
vestment comprehensible
to viewers, a drawing of
the deduced garment
structure was included on
the exhibition label.
© Abegg-Stiftung (CH-
3132 Riggisberg 2013).
Photo: Christoph von
Viràg

impossible to find the "right" line to follow. Furthermore, deciding which color to choose and which gaps to fill becomes almost impossible when reconstructing a garment from hundreds of fragments.

It was decided not to integrate a reconstruction into the mounting of the dalmatic, thus avoiding the risk of having to open the mount and remove what, in the future, may be considered an unsatisfactory intervention. Instead, to help viewers recognize and value the vestment, a reconstruction drawing of the cut and the pattern was added to the exhibition label (see fig. 5.5). A drawing could also be added onto the glazing. This would make any later changes or adaptations easier, because the textile fragments themselves would remain almost untouched.

The garment is more than 1.32m in height, and it required the pretensioning of the boards for the pressure mount to achieve an even pressure over the whole area. Each board was covered with two layers of thick cotton flannelette ($580g/m^2$). The upper layer of flannelette was cut out where the dalmatic has trimmings, and both layers were cut away to accommodate the fringe, resulting in a padding that varied according to the different heights of the fragments. The fringe required special treatment: the much entangled loops are very brittle and broke at the slightest touch. Furthermore, the mass of loops has considerable volume and needed space in the padding to avoid being compressed between the board and the glazing. Therefore the loops required some form of consolidation in order to reduce loss of material during the handling and transport of the pressure mount to Hildesheim.[10]

The padded boards were covered with a silk display fabric, and the fragments were arranged on the cloth-covered boards. Extraneous particles were lifted off, and the glass was carefully placed on top and fixed with clamps. Each pressure mount was lifted to the vertical as soon as possible to minimize stress on the textile fragments caused by the weight of the glass. The conserved dalmatic was displayed in the 2014 exhibition *Hülle und Zier: Mittelalterliche Textilien im Reliquienkult* (Wrapping and adornment: medieval textiles in the cult of relics) at the Abegg-Stiftung. The experience of displaying Saint Godehard's dalmatic in a pair of pressure mounts confirmed that the garment is not easy to understand on its own, but that the drawing offers enough supplementary information to make it more readily comprehensible. In March 2015 the vestment was returned safely to Hildesheim, where the reverse of the dalmatic is now on display in the newly built Dommuseum Hildesheim (Hildesheim Cathedral Museum) (fig. 5.6).

FIGURE 5.6
On the right are
fragments (back) of
Saint Godehard's
dalmatic (Dommuseum
Hildesheim, D 2009-4b),
as displayed at Dom-
museum Hildesheim.
© Dommuseum
Hildesheim. Photo:
Florian Monheim

CONCLUDING REMARKS

One of the most significant results of the decision to preserve garments within pressure mounts is that they will not be presented in their original, three-dimensional form. However, a garment's constituent textiles will be preserved (that is, they will be flatter and cleaner) and, once mounted, the risk of further loss is reduced. The dimensions of the displayed textile may currently be limited by practical considerations (as mentioned above), but progress in technology will increase the range of possibilities. A pressure mount may not be appropriate if the fabric of a historic object is well preserved and a support treatment can be implemented to return a garment to its three-dimensional form. For viewers, understanding a garment in a museum setting is greatly enhanced if it can be shown close to its original shape, as worn. However, in instances where garments survive in a fragmentary and very fragile condition, pressure mounting provides an effective option for both conservation and display.

ACKNOWLEDGMENTS

For editorial advice and fruitful discussion, I thank Mary M. Brooks, Dinah D. Eastop, Bettina Niekamp, and Caroline Vogt. For images, I thank Christoph von Viràg and Dommuseum Hildesheim. For rediscovering the location of Hans von Kaunitz's garments, I thank Catherine Depierraz.

NOTES

1. See in Kienzler, Niekamp, and Petzold 2004:52, fig. 11; Depierraz and Vogt 2010:117, fig. 8.
2. Colloquially, acrylic glass, Perspex, or Plexiglas.
3. New materials with hardened and antistatic surfaces are now available.
4. Scientifically based parameters were developed during K. Neuser's research for her BA thesis (2009) at the Abegg-Stiftung for the remounting of a large (1.7 × 4.55m) late antique hanging (Riggisberg, Abegg-Stiftung, inv. no. 4185); Kötzsche 2004.
5. A list of materials and suppliers for pressure mounting is available from the author.
6. Grave garments of Hans von Kaunitz (died 1608), Service cantonal d'archéologie, Genève (Archaeological Service of the Canton of Geneva), inv. no. GV86–OBJET 2, exhibited at the archaeological site of the Cathédrale Saint-Pierre, Geneva.
7. Riggisberg, Abegg-Stiftung, inv. no. 3945; Flury-Lemberg 1995:26–43, cat. no. 3; Schrenk 2004:180–84, cat. no. 61.
8. Riggisberg, Abegg-Stiftung, inv. nos. 5176, 5285, 5423; Otavsky and Wardwell 2011:222–27, cat. no. 82.
9. See, for example, the presentation of fragmentary textiles from Central Asia in the permanent exhibition at the Abegg-Stiftung (inv. no. 4864 or 4865/5066); Schorta 1998:67, fig. 30; 69, fig. 32.

10. The area for the fringe was specially adapted by removing the padding from the board; it was therefore necessary to coat the exposed wood with a barrier layer of Lascaux 498 HV (aqueous dispersion of an acrylic resin) and a layer of undyed cotton fabric. The fringe was consolidated using a method informed by Maria-Theresia Worch's work (2002), complemented by my tests on the concentration of the consolidant. The fringe was treated with a 0.3% v/v solution of Plextol D360 (aqueous dispersion of an acrylic resin) in ethanol. As the fringe is free-hanging within the pressure mount, its top edge was sewn onto a 50mm strip of nylon net; the net is held in place by the pressure mounting between the dalmatic and exhibition fabric. Two smaller fragments of the dalmatic's main fabric, which had been successfully unfolded but were impossible to handle without loss, were consolidated in the same way as the fringe.

REFERENCES

Bayer, Anja. 2012. "Deposits on Exhibition Glass Discussed Using the Example of the Pressure Mount of the 'Liber Linteus' in the Archaeological Museum of Zagreb." *Vjesnik Arheološkog Muzeja u Zagrebu* 45 (1): 61–67. Accessed June 19, 2015. http://hrcak.srce.hr/file/150358.

Depierraz, Catherine, and Caroline Vogt. 2010. "Das Juliusbanner der Stadt Biel: Spurensuche und Konservierung." In *Restaurierung–Restauration–Restauro–Restoration 2: Schweizer Fallbeispiele*, 77–84, 117 (ill.). Bern: Bundesamt für Bevölkerungsschutz, KGS. Accessed June 19, 2015. http://www.bevoelkerungsschutz.admin.ch/internet/bs/fr/home/themen/kgs/publikationen_kgs/forum_kgs/archiv_forum_2007-11.parsys.39434.downloadList.43314.DownloadFile.tmp/forum16print.pdf.

Flury-Lemberg, Mechthild. 1988. *Textile Conservation and Research*. Bern: Abegg-Stiftung.

———. 1995. *Spuren kostbarer Gewebe*. Riggisberger Berichte 3. Riggisberg: Abegg-Stiftung.

Kataoka, Masumi. 2010. "A Study of the Microenvironment within Pressure Mounts." In *Textile Conservation: Advances in Practice*, edited by Frances Lennard and Patricia Ewer, 245–54. Oxford: Butterworth-Heinemann.

Kienzler, Corinna, Bettina Niekamp, and Laura Petzold. 2004. "Caring for Historic Textiles and Costumes." *Orientations* 35 (4): 48–52.

Kötzsche, Lieselotte. 2004. *Der bemalte Behang in der Abegg-Stiftung in Riggisberg: Eine alttestamentliche Bildfolge des 4. Jahrhunderts*. Riggisberger Berichte 11. Riggisberg: Abegg-Stiftung.

Neuser, Katharina 2009. "Ein grossformatiger, spätantiker Behang: Evaluierung der Unter-Glas-Montage." BA thesis, Abegg-Stiftung/Bern University of Applied Sciences.

Niekamp, Bettina. 2012. "Grossformate ziehen um: Der Transport spätantiker, unter Glas montierter Wandbehänge." *Restauro* 118 (2): 12–19.

Otavsky, Karel, and Anne E. Wardwell. 2011. *Mittelalterliche Textilien II: Zwischen Europa und China*. Textilsammlung der Abegg-Stiftung Band 5. Riggisberg: Abegg-Stiftung.

Schorta, Regula. 1998. "Beobachtungen zu frühmittelalterlichen Webtechniken." In *Entlang der Seidenstrasse: Frühmittelalterliche Kunst zwischen Persien und China in der Abegg-Stiftung*. Riggisberger Berichte 6, 43–94. Riggisberg: Abegg-Stiftung.

———. 2004. "A Central Asian Cloth-of-Gold Garment Reconstructed." *Orientations* 35 (4): 53–56.

———. 2010. *Die Stoffe in den Hildesheimer Schreinen: Zu Textilien im Reliquienkult und zu Luxusgeweben im hochmittelalterlichen Europa*. Cologne: Sigured Greven-Stiftung.

Schrenk, Sabine. 2004. *Textilien des Mittelmeerraumes aus spätantiker bis frühislamischer Zeit*. Textilsammlung der Abegg-Stiftung Band 4. Riggisberg: Abegg-Stiftung.

Tétreault, Jean. 1993. *Guidelines for Selecting Materials for Exhibit, Storage and Transportation*. Ottawa: Canadian Conservation Institute. Accessed August 2, 2016. https://forma-caompr.files.wordpress.com/2010/02/guidelines-for-selecting-materials.pdf.

———. 1994. *Display Materials: The Good, the Bad and the Ugly*. In *Exhibitions and Conservation*, edited by Jo Sage, 79–87. Edinburgh: Scottish Society for Conservation and Restoration. Accessed June 19, 2015. http://www.iaq.dk/papers/good-bad-ugly.htm.

Worch, Maria-Theresia. 2002. "Wenn Nähen unmöglich wird…" In *Historische Textilien: Beiträge zu ihrer Erhaltung und Erforschung*, edited by Sabine Martius and Sibyll Russ, 67–76. Nuremberg: Germanisches Nationalmuseum.

AUTHOR BIOGRAPHY

ANJA BAYER, Diplom Konservatorin/Restauratorin FH, 2002, Abegg-Stiftung/Bern University of Applied Sciences, Switzerland. Her thesis focused on technical analyses and documentation of medieval textile finds from a fifteenth-century bishop's tomb in Basel Cathedral. She has worked as a private textile conservator. In 2004 she worked for the Victoria and Albert Museum, London, on the conservation and mounting of Diaghilev ballet costumes. She has been a textile conservator at the Abegg-Stiftung since 2005. Since 2009 she has lectured at the Abegg-Stiftung and the Swiss Conservation-Restoration Campus (CRC).

6 | THE CONSERVATION AND DISPLAY OF THE TAHITIAN MOURNER'S COSTUME AT THE PITT RIVERS MUSEUM, UNIVERSITY OF OXFORD

Jeremy S. Uden, Heather M. Richardson, and Rachael E. Lee

The Tahitian mourner's costume preserved at the Pitt Rivers Museum (PRM), University of Oxford, was collected in 1774 during Captain Cook's second voyage[1] and has been displayed for many years with, as will be shown, some modifications. The costume was acquired by Reinhold and George Forster, the expedition's naturalists. In 1776, the Forsters gave Oxford University part of their collection, which was transferred to the PRM in 1886. The collection was accompanied by a handwritten "Catalogue of Curiosities sent to Oxford," with numbered items starting with "OTaheitee and the Society Isles" and including the mourning dress. The numbers in the catalogue correspond with those on handwritten labels on the objects.

This paper introduces the Tahitian mourner's costume and recent research into its display history in the PRM, as part of the museum's 2015 redisplay of its Cook voyage collections. This redisplay focuses on the material culture of the Pacific contemporary with the mourner's costume and the peoples encountered during Cook's first (1768–71) and second (1772–75) voyages. Research into the costume informed its conservation and display, which were designed to ensure long-term preservation while providing a more accurate representation of its original form and effect. The display of the costume and the long-term preservation of its constituent parts were identified as problematic by conservators Jeremy Uden and Heather Richardson; in-depth investigation was then undertaken by Uden.[2] This led to remounting, informed and implemented by Rachael E. Lee, a costume-mounting specialist. The joint authorship of this paper reflects the collaborative nature of the work.

THE PRM DISPLAY OF THE TAHITIAN MOURNER'S COSTUME
The Tahitian mourner's costume has existed in at least three forms at the PRM: as collected in 1774 (phase 1); as assembled for display between 1972 and 2010 (phase 2); and as mounted for redisplay in 2015 (phase 3).

A Tahitian mourner's costume is a layered ensemble of different components, and the PRM's artifact, as it exists today, consists of nine items. The first items are two differently colored barkcloth *tiputa* (poncho-like garments). According to the "Catalogue of Curiosities," three *tiputa* were worn by the chief mourner, "one over the other, beginning with the white, the red next & the brown overall" (see Coote, Gathercole, and Meister 2000:186). The red *tiputa* appears to be lost, but the thick, almost felted, white garment (item 1) and the papery, brown-dyed garment (item 2) survive. A barkcloth apron (item 3) backed with matting made from pandanus[3] leaves was worn over the *tiputa*. Small, brown, coconut-shell disks, possibly representing stylized turtles, were sewn onto the apron's front.

A feather cloak (item 4) was worn on the back, made of bundles of feathers from the Polynesian imperial pigeon (*Ducula aurorae*), with some frigatebird feathers (*Fregata* sp.). The feather bundles were tied across two parallel lengths of coconut-fiber cord, like rungs on a ladder. A long length of this basic structure was wound around and tied together to create the shape of the cloak. The feathers were split down the center of the shaft so they moved and shimmered along with the mourner.

The hat (item 5) of pandanus matting has an attached barkcloth cape decorated with strips of red, yellow, and black barkcloth. Bindings of barkcloth (item 6) with narrow spirals of plaited human hair are wound, turban-like, around the top of the hat, which is topped with a headdress of black feather bundles (item 7). The chief mourner donned a mask (item 8) made from pearl shells (*Pinctada* sp.) with a fringe of tropicbird feathers (*Phaethon lepturus*). From this was hung a breastplate (item 9), made from black-stained wood ornamented with five pearl shells, and an attached apron made from thousands of small pieces of shell. The shell components are tied together using fine coconut-fiber thread, which passes through a hole drilled in either end of each shell piece.

SIGNIFICANCE

The significance of the ensemble is not fully understood and may never be. At the time of its collection, its meaning may have been deliberately hidden from all but priests and the social elite in Tahiti. Reinhold Forster wrote that "after the death of a person of some note, one of the next relations puts on a kind of masquerade dress, called by them *Hèva*, which is very remarkable, as well on account of its curious workmanship, as the strange assemblage of its parts and extraordinary appearance"

([1778] 1996:277). It is now generally agreed that such costumes were worn by the chief mourner in an elaborate ceremony marking the death of a high-ranking member of society, in particular a chief of one of Tahiti's districts. Accompanied by attendants, their skin blackened with charcoal, the chief mourner would patrol the dead chief's territory, carrying a sword edged with shark's teeth and warning of his advance by rattling pearl-shell clappers. If the chief mourner caught anyone, he would maim or even (so it is said) kill them. He was not considered responsible for his actions because, as chief mourner, he was mad with grief. The mourning ceremony disrupted daily life, and this disruption spread to other districts. Eventually, neighboring chiefs would bring the mourning period to an end with a performance of ritualized combat.

The materials used to make the chief mourner's garments rein-forced the dead chief's social status and his *mana* (power and author-ity). The materials and resources required for the ceremony and the chief mourner's clothing were probably attainable only by those with the highest social status. Such powerful and expensive materials served to transfer the costume's wearer from *noa*, the ordinary state, to a *tapu*, or sanctified state, allowing him (or possibly her) to assume the chief mourner's persona. Pacific scholar Adrienne L. Kaeppler writes that "to behold the chief mourner was to experience the intangible made visible" (2007:123).

Pearl shell was a precious resource obtained by Tahitians from the Tuamotus, a group of islands several hundred miles away, and each shell had the value of a pig. The shell apron, or *parae*, was particularly sacred. According to nineteenth-century missionary William Ellis, creat-ing an apron was a "sacred work; emblems of intercourse with the gods were required to be placed in front of the *parae* when it was made" (1829:413). Across Polynesia, feathers are associated with creation myths and therefore linked with divinity. The tropicbird and frigatebird feathers, used in large quantities in the costume, were immensely valu-able commodities. Feathers of red and yellow were associated with the creator god Ta'aroa, and the ownership of barkcloth dyed with these colors was restricted to Tahiti's elite families. Human hair, used in the headdress bindings, was also sacred, as it came from the head, a *tapu* (sacred or forbidden) part of the body. The act of braiding and plait-ing, of both hair and the coconut fiber used for the costume's ties and cords, was itself a sacred activity in which prayers were bound into the costume's construction. Awareness of these intangible properties of the components of the mourner's costume played an important part in our decision-making during conservation and mounting. Our aim was to

make the costume appear as "unearthly" and spectacular as it does in contemporary illustrations.[4]

The existence of petroglyphs representing the mask and breast-plate in two sacred Tahitian sites, both restricted to high-ranking members of society, demonstrate the historical importance of the mourner's costume in Tahitian society. One suggestion is that the mask and breast-plate together may be a "ship of the dead" motif, with the shell apron representing the sea (D'Alleva 1997:208–9). In many Pacific cultures, it is understood that the soul has to travel after death to a place where it is able to enter the underworld. On Tahiti, this was Mount Temehani on Ra'iatea, which required travel over the sea (Henry 1928:564). The mask and breastplate could also represent the tropicbird feather–fringed helmet (*fau*) of a Tahitian warrior-priest dressed for combat (Henry 1928:293–94).

At the time of Cook's first voyage,[5] Tahitians would not trade mourner's costumes; however, they were recorded (fig. 6.1). Joseph Banks, the expedition's naturalist, participated as one of the attendants in a mourning ritual, naked and with blackened skin. By 1774, social and religious changes meant that the red feathers brought to Tahiti on Cook's second voyage matched the exchange value of mourning

FIGURE 6.1
Illustration of a dancing girl and a chief mourner by Tupaia, a priest/navigator from Ra'iatea who sailed with Captain Cook to New Zealand and Australia on the first voyage (1768–71). British Library, London. © The British Library Board, Add. 15508, f. 9b

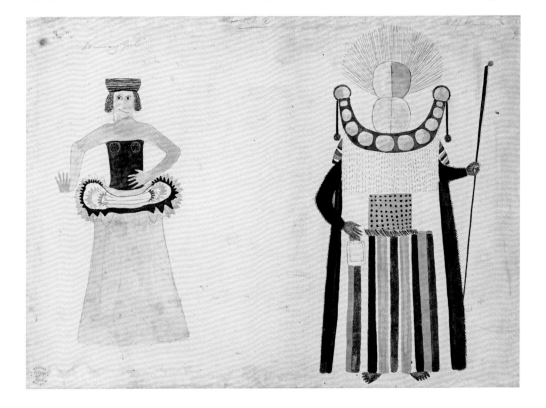

costumes, making them available for trade. According to George Forster ([1777] 2000:362), some ten costumes were collected, of which the PRM's example is arguably the most complete.

THE MOURNER'S COSTUME IN OXFORD

The Forsters' collection, including the mourner's costume, was displayed at the Ashmolean Museum immediately after its arrival, being seen in 1777 by Thomas Bugge, a visiting Danish scientist (see Pedersen and de Clerq 2010:124–25). After a period in storage in the nineteenth century, the collection was transferred to the PRM in 1886 and was on display there by 1900 (phase 1). Photographs taken in 1952 show the mourner's costume mounted on what appears to be an easel. Interestingly, when the British Museum's mourning costume was dismantled in 1966 by chief conservator H. J. Gowers, it too was found to have been mounted on an easel, probably onboard ship soon after its acquisition (Cranstone and Gowers 1968:141).

In 1970 the PRM marked the bicentenary of Cook's Pacific voyages with a special exhibition (Coote 2005), and extensive work was carried out on the costume by the museum's technicians. Photographs were taken of these preparations, during which tears in barkcloth were

FIGURE 6.2
A front view of the mourner's costume as displayed between 1972 and 2010 (phase 2). © Pitt Rivers Museum, University of Oxford (1886.1.1637)

stitched closed and missing sections of the shell apron were replaced with pieces of Perspex. The costume was remounted onto a wooden pole that had a small crosspiece, to give some shape to the shoulder area. After the exhibition was dismantled, a modified version of the mount was used for the costume's permanent display in a case on the museum's lower gallery (phase 2). The case had been installed early in the twentieth century, and its size restricted the manner in which the objects, including the mourner's costume, could be displayed (fig. 6.2).

DISMANTLING THE COSTUME

The Cook voyage display was dismantled in 2010. The mount was actively damaging the costume, and the garments were brought to the conservation studio so that a controlled dismounting could take place, with each step documented. The original mounting had also been inaccurate, with the mask placed far too low. There is an eye-slit in one of the lower shell plates, and when the ensemble is correctly positioned, most of the mask towers above the wearer's head. The wooden "breastplate" should be placed just under the chin, while the pearl-shell apron falls over the upper chest. This also corresponds to contemporaneous illustrations, such as those drawn by William Hodges, an artist on Cook's second voyage. These show the chief mourner, with the "halo" of the tropicbird feather–fringed headdress, as a tall, unearthly figure.[6]

The costume was dismantled piece by piece, beginning with the mask, breastplate, and apron, and working through to the barkcloth layers. Several issues were resolved during this process, as it became possible, for the first time in many years, to access the original Forster labels on the objects with numbers corresponding to those in the "Catalogue of Curiosities." For example, the red-dyed *tiputa* forming the second layer was found to be Forster No. 16 and therefore not part of the mourner's costume. Its addition was explained in a note written by curator Peter Gathercole at the time of the 1970 bicentenary exhibition: "We are deficient in some pieces of tapa, which I could probably make up from our own collection."

Dismantling the headdress (item 7) raised several points for discussion. The barkcloth and hair bindings around the hat (item 5) and the feather headdress above them needed to be removed for conservation, as the hair had been badly damaged by insects. We expected the feather headdress to lift off in one piece, but as removal began, we found it comprised seven feather bundles, four separate and three tied together. These were attached to the headdress with a loosely twined barkcloth string. Tahitians used bundles of feathers during religious

ceremonies, so it is perhaps not surprising to find them incorporated into the mourner's costume. We did not want to remove the bindings if they were in their original configuration, but further investigation showed that the hat bore a large label written by Edward Evans (underkeeper at the Ashmolean Museum) before the transfer to the PRM in 1886. The bindings must have been detached in order to paste the label onto the hat, so we felt confident that we too could remove them. These bindings (two shorter pieces and one section more than 5m long) were simply unwound from the hat.

The "Tamow, or headdress of platted hair" (No. 40 in the "Catalogue of Curiosities") had not been recorded since 1776. In 1994, A. E. D'Alleva had noted skeins of plaited hair as part of the costume (1997:562), and it was suggested that this "missing" object might have been incorporated under the headdress bindings. Unwinding the bindings did indeed reveal this headdress, or *tamau*, which is made entirely of plaited human hair, as worn by high-ranking Tahitian women during dance ceremonies. This headdress may have been given to the Forsters by Poiatua, daughter of Reo, the Bora Bora regent of the island of Ra'iatea (Coote and Uden 2013:245). Again, it was clear that the *tamau* had been removed from the headdress to enable the Ashmolean label to be pasted onto the hat, so we felt we could remove it as well. It is difficult to say why the *tamau* had been incorporated into the mourner's costume.[7] We were able to establish it was not an original part, because it was not big enough to go back in position once the hat had been reshaped. For this reason, it was not included in the phase 3 remounting.

CONSERVATION

The overall aim of the conservation treatment was to stabilize and strengthen damaged elements, such as the feather cloak, and to make them robust enough to display. Barkcloth elements were surface-cleaned where possible. Previous conservation repairs made with thread were removed, and tears were stabilized with Japanese tissue paper adhered with sodium alginate paste. Most damage had occurred at the point of the neck opening where the *tiputa* (the poncho-like garments) had been unsupported on the mount. The 1970 Perspex additions, still considered acceptable as a conservation gapfill, were retained. The bindings and the feather cloak required the most treatment. As mentioned previously, the hair had incurred much insect damage, and many of the fine plaits were unraveled and tangled. The ends were untangled, wound back around the central

core, and adhered to the underlying barkcloth with a very small dot of adhesive.[8] The PRM has a second mourner's costume headdress (of unknown history) on which the bindings appear to be in their original configuration, resembling a turban. In the "Catalogue of Curiosities," the headdress is described as a "turband"; therefore, this appearance was re-created by winding the longer section of binding around the hat and securing it at the front with the shorter pieces. The bindings were sewn in this position with cotton thread so that they could be lifted on and off the hat without having to be unwound.

ISSUES IN MOUNTING

At the PRM, objects are layered within museum cases, primarily in typological groupings, highlighting the use of particular materials and techniques. This compact arrangement creates a visually stimulating resource and is notably different from the style of most other museum displays. Perhaps because of the density of the PRM's displays, however, rare and significant pieces such as the mourner's costume have previously lacked visual impact. Moreover, the PRM's original cases restricted display options. Until recently, the mourner's costume had only been shown at a maximum height of 2m, distorting its presentation and providing unsatisfactory scope for interpretation.

Space restrictions, coupled with the misinterpretation of components of the ensemble, meant that past presentations of the mourner's costume were inaccurate. The use of an easel as a mount in the early 1900s (phase 1) and a wooden pole with a crosspiece in the 1970s (phase 2) are understandable choices; for example, the crosspiece would have helped to support the shoulders. However, these mounts failed either to support the costume adequately or to show the feather cloak from the front. We considered modern T-bar mounts, which can accommodate the often untailored and loosely fitted construction of ethnographic material and are well suited for displaying such garments. We also explored "flat mounting" methods, which can give the appearance of garments "as worn" (Stephens 2001). These methods remain useful as safe ways to mount ethnographic dress; however, we wanted a three-dimensional presentation for the mourner's costume, even though the approach is atypical for sensitive ethnographic materials.

The methods adopted for the display of the mourner's costume (phase 3) were based on mounting practices more often used in displays of fashionable dress, notably those deployed by the Textile Conservation team at the Victoria and Albert Museum, London (Flecker 2007). This approach is first and foremost preventative, aiming to

minimize stress on garments on long-term display. Consequently, such techniques require modifying mannequins or making bespoke mounts with the aim of creating a realistic body form that reflects the proportions, height, and profile of the original wearer. Historical accuracy and visual impact are also important. Although the mourner's costume presented display challenges, it was agreed that this approach, with its added emphasis on the visual aesthetic, could be adopted while also upholding conservation ethics. In previous displays, the costume was presented in the manner used widely for flat textiles. The new mount, in a new, purpose-built display case, presents the costume in a completely three-dimensional form. This display aims to demonstrate, to a greater extent than before, the composition, scale, function, and "otherworldly" impact of this unique ensemble (fig. 6.3).

Assessment and initial reassembly of the mourner's costume took place during discussions between curator Jeremy Coote, the conservation team, and display technicians Chris Wilkinson and Alan

FIGURE 6.3
A front view of the mourner's costume as mounted in 2015 (phase 3). © Pitt Rivers Museum, University of Oxford (1886.1.1637)

Cooke. A team of four was required for the reassembly. All of the items could not be fastened or held in the desired positions at the preparatory stages, and the mounting process helped to determine weaknesses and areas of strain within each material and construction type and to identify where additional support was needed. At this stage, the costume's full height could only be estimated; exact dimensions could not be determined until the final choice of mount was made and the mounting process had begun.

It was crucial for the finished mount to be strong, stable, and padded appropriately to support the weight of the fragile costume effectively not only over a lengthy period of display but also with a view to its potential for future loan. A reinforced buckram (stiff cloth) male torso was chosen to form the central support for all nine components of the costume. The torso has several advantages: it is easily adaptable, its height is adjustable, and the buckram is inexpensive. The form is braced inside the shoulder and neck areas to provide extra strength where the costume's weight is distributed. The padding, which softens the form and defines a body shape, is made of graded layers of polyester wadding secured with a stretch jersey covering. Additional structures were fixed onto this basic framework (fig. 6.4). Soft underpinnings made of silk, undyed plain-weave cotton, Reemay, and Rigilene were added to support all parts of the costume. These were cut exactly to the irregular shape of each of the two *tiputa* and the barkcloth apron to aid their drape and arrangement as they were layered on top of one another.[9] Interleaving a firm yet flexible underpinning reduced friction considerably and, hence, limited potential abrasion of the layered *tiputa*. Custom-made underpinnings acted as a barrier between the feather cloak and the pandanus hat with its attached barkcloth cape.

Two key adaptations were made to the framework. Articulated "arms" and a reinforced neck-plate were added, enabling the feather cloak, pearl-shell mask, and breastplate to be displayed accurately for the first time. Because the feather cloak was considered the most fragile element, the torso was broadened to accommodate its width as well as that of the barkcloth *tiputa*. A discrete armature of aluminum tube with 6mm aluminum sculpture wire was fixed beneath the shoulder line of the torso at each side and encased within soft "arms" made from undyed plain-weave cotton and polyester wadding. This articulated arm mechanism prevents strain and allows the feather cloak to be "worn" safely by supporting the shoulders. It also helps the public to understand the cloak because the lengths of feathered bundles can hang as if from the wearer's wrists, as shown in contemporary illustrations.[10]

FIGURE 6.4
A front view of the mount for the mourner's costume showing underpinnings (phase 3). © Pitt Rivers Museum, University of Oxford (1886.1.1637)

As noted above, the pearl-shell mask and the wooden breastplate had previously been mounted too low. At the correct height, the wearer would have been able to see through the eye-slits while remaining fully masked. A bespoke steel bracket was fixed vertically onto a reinforced aluminum plate inserted between the mount's "neck" and "head." Additional steel fixings, custom-made to support the mask and breastplate, were bolted securely onto the bracket when assembling the full costume. The mounted costume is 2.6m tall, estimated to be the equivalent of a 1.82m (6ft) tall man when wearing the mask (see fig. 6.3). Establishing the correct height of the mask and breastplate was fundamental to representing the immense scale and composition of the costume. The new case was designed to enable it to be shown in its entirety (as we now deduce it to be) and, probably for the first time

since it was acquired by the Forsters in 1774, the costume is displayed as it was intended to be worn.

CONCLUSION

The process of remounting the Tahitian mourner's costume required us to adopt a delicate balance between support and interpretation, based on identifying and analyzing material, visual, and archival evidence.[11] The objective was to present the ensemble as accurately as possible, in a way that was also visually arresting and engaging for diverse audiences, without compromising the integrity of its materials and structure. The process of developing this new presentation provides a useful precedent for reevaluating interpretation methods at the PRM. Knowledge gained through conservation enabled the costume to be remounted "as worn" for the first time in more than two hundred years. At the start of this collaborative project, team members agreed that the mount should enhance the size and imposing appearance of the costume but not detract from its original materials and intangible attributes. The mount was made to be as unobtrusive as possible, particularly the structural mechanisms required to support the pearl-shell mask and the breastplate. We hope that this representation of the Tahitian mourner's costume will prove beneficial to visitors' appreciation and understanding of this powerful and awe-inspiring ensemble.

NOTES

1. Cook's second voyage was commissioned by the Admiralty to look once again for Terra Australis Incognita. Cook made vast sweeps across the Pacific, visiting Tahiti, Tonga, New Caledonia, and South Georgia, demonstrating that the supposed southern continent did not exist in any of its most frequently predicted locations.
2. The Clothworkers' Foundation awarded a Conservation Fellowship to Jeremy Uden, senior conservator, Pitt Rivers Museum, for research into PRM objects collected on Cook's first and second voyages.
3. *Pandanus* sp., a genus of palmlike trees.
4. For example, the sketch by Sydney Parkinson entitled *A Tupapow in the Island of Otaheite* (Joppien and Smith 1985:109, no. 1.45).
5. Cook's first voyage was a joint Royal Navy/Royal Society expedition to observe the 1769 transit of Venus from Tahiti and to gather evidence concerning the existence of the supposed southern continent.
6. For example, *A Toupapow with a corpse on it, attended by the chief mourner in his habit of ceremony*, engraved from a drawing by William Hodges and published in Cook's *Voyage towards the South Pole* (Cook 1777, plate 44).
7. The presence of plaited hair on the headdress may have suggested that the two were related.
8. Mowilith 50 (polyvinyl acetate).

9. The additional tiputa was Forster No. 16 and therefore definitely not part of the mourner's costume. It was not included in the phase 3 display.

10. For example, the pencil sketch *Dress of the Chief Mourner* by Herman Diedrich Spöring (British Library, Add. MS 23921, f.32; Joppien and Smith 1985:111, no. 1.48).

11. For a stop-frame animation of the mounting of the Tahitian mourner's costume, see http: //conserving-curiosities.blogspot.co.uk/2016/02/tahitian-mourners-costume-mounting .html. Accessed August 2, 2016.

REFERENCES

Cook, James. 1777. *A voyage towards the South Pole and round the world, performed in His Majesty's Ships the "Resolution" and "Adventure," in the years 1772, 1773, 1774, and 1775....* 2 vols. London: W. Strahan and T. Cadell.

Coote, Jeremy. 2005. "'From the Islands of the South Seas, 1773–4': Peter Gathercole's Special Exhibition at the Pitt Rivers Museum." *Journal of Museum Ethnography* 17: 8–31.

Coote, Jeremy, and Jeremy S. Uden. 2013. "The Rediscovery of a Society Islands Tamau, or Head-dress of Human Hair, in the 'Cook-Voyage' Forster Collection at the Pitt Rivers Museum—and a Possible Provenance." *Journal of the Polynesian Society* 122 (4): 233–55.

Coote, Jeremy, Peter Gathercole, and Nicolette Meister. 2000. "'Curiosities sent to Oxford': The Original Documentation of the Forster Collection at the Pitt Rivers Museum." *Journal of the History of Collections* 7 (2): 177–92.

Cranstone, Bryan A. L., and H. J. Gowers. 1968. "The Tahitian Mourner's Dress: A Discovery and a Description." *British Museum Quarterly* 32 (3/4): 138–44.

D'Alleva, A. E. 1997. "Shaping the Body Politic: Gender, Status, and Power in the Art of Eighteenth-Century Tahiti and the Society Islands." PhD diss., Columbia University.

Ellis, William. 1829. *Polynesian Researches.* London: Fisher, Son & Jackson.

Flecker, Lara. 2007. *A Practical Guide to Costume Mounting.* Oxford: Butterworth-Heinemann.

Forster, Johann George. (1777) 2000. *A Voyage round the World.* Edited by Nicholas Thomas and Oliver Berghof. Honolulu: University of Hawai'i Press.

Forster, Johann Reinhold. (1778) 1996. *Observations Made during a Voyage round the World.* Edited by Nicholas Thomas, Harriet Guest, and Michael Dettelbach. Honolulu: University of Hawai'i Press.

Henry, Teuira. 1928. *Ancient Tahiti.* Bernice P. Bishop Museum Bulletin 48. Honolulu: Bernice P. Bishop Museum.

Joppien, Rüdiger, and Bernard Smith. 1985. *The Voyage of the "Endeavour," 1768–1771, with a Descriptive Catalogue of All the Known Original Drawings of Peoples, Places, Artefacts and Events and the Original Engravings Associated with Them.* Volume 1 of *The Art of Captain Cook's Voyages.* New Haven, CT: Yale University Press (Paul Mellon Centre for Studies in British Art/Australian Academy of the Humanities).

Kaeppler, Adrienne L. 2007. "Containers of Divinity." *Journal of the Polynesian Society* 116 (2): 97–130.

Pedersen, Kurt Møller, and Peter de Clerq, eds. 2010. *An observer of observatories: The journal of Thomas Bugge's tour of Germany, Holland and England in 1777.* Aarhus, Denmark: Aarhus Universitetsforlag.

Stephens, Morwena. 2001. "The Research and Proposed Conservation of the Barkcloth Elements of a Tahitian Chief Mourner's Costume." In *Barkcloth: Aspects of Preparation, Use, Deterioration, Conservation and Display*, edited by Margot M. Wright, 56–70. London: Archetype.

AUTHOR BIOGRAPHIES

RACHAEL E. LEE received a BA (Hons) in costume interpretation from Wimbledon College of Art (UK) in 2008. After graduating, she worked as a costume maker for the film and television industry. Lee joined the Victoria and Albert Museum (V&A), London, in 2010 as a costume mounting specialist. She completed the V&A's assistant conservator program in 2014, focusing specifically on conservation of the museum's collection of dress. Lee has created bespoke mounts for exhibitions, including *Hollywood Costume* and *Alexander McQueen: Savage Beauty*. She continues to collaborate with the Pitt Rivers Museum, designing and making mounts for ethnographic costume.

HEATHER M. RICHARDSON has been a conservator at the Pitt Rivers Museum, University of Oxford, since 2001, and head of Conservation since 2008. She received a BA (Hons) in conservation and restoration from De Montfort University (now the University of Lincoln, UK) in 1998. During her final studies, Richardson undertook an internship at the Royal British Columbia Museum, Canada, where she researched her dissertation, "Totem Poles: Treatments and Ethical Issues Involved in Their Conservation." Richardson has held a Historic Scotland ethnographic conservation internship at the Marischal Museum, University of Aberdeen, and an Andrew W. Mellon Fellowship at the National Museum of the American Indian, Smithsonian Institution. She has worked at the Royal Albert Memorial Museum, Exeter, and the British Museum, London. Richardson is an Accredited Conservator-Restorer (ACR) with a specialty in ethnographic conservation.

JEREMY S. UDEN is deputy head of Conservation, Pitt Rivers Museum, University of Oxford, where he has worked since 2008. He trained first as a biologist before training as a conservator at Cardiff University in 1996. After graduating, Uden held a Historic Scotland ethnographic conservation internship at the Marischal Museum, University of Aberdeen. This was followed by positions at the Ashmolean Museum, Horniman Museum, Auckland Museum, and Royal Albert Memorial Museum, Exeter. He held a Clothworkers' Foundation Conservation Fellowship, during which he conserved and investigated the Cook voyage collections at the Pitt Rivers Museum.

7 | DRESS IN THE LIMELIGHT

THE CONSERVATION AND DISPLAY OF ELLEN TERRY'S
"BEETLE-WING" DRESS AT SMALLHYTHE PLACE

Emma Slocombe and Zenzie Tinker

The shimmering green "beetle-wing" dress worn by Ellen Terry in Henry Irving's production of *Macbeth* is an iconic theatrical costume.[1] From the late 1870s, Terry was Britain's leading Shakespearean actress, considered to embody the qualities of beauty and immersive poetic experience admired by champions of the aesthetic movement.[2] Writer Henry James proclaimed "Miss Ellen Terry is 'aesthetic.'"[3] When Terry stepped onto the Lyceum Theatre stage as Lady Macbeth on opening night, December 29, 1888, her iridescent dress illuminated by gaslight, she was greeted by gasps from an audience comprising the leading critics, writers, and artists of fashionable London society. Among them was artist John Singer Sargent, who was inspired to paint her full-length portrait, *Ellen Terry as Lady Macbeth* (Adam 1926:211–12),[4] depicting the actress in her beetle-wing dress, holding a crown aloft at the moment when Lady Macbeth makes herself queen (fig. 7.1). Sargent's portrait defines not just this performance but the pinnacle of Terry's acting career. This paper explores how an understanding of the visual relationship between the beetle-wing dress and the portrait, combined with material investigation of the dress and archival research, was essential to the conservation and redisplay of the costume in Terry's home, Smallhythe Place (fig. 7.2).

SMALLHYTHE PLACE
In 1899 Terry bought Smallhythe Place, a sixteenth-century timber-framed farmhouse in Kent, England, as her country retreat. Mindful of her own legacy, Terry turned Smallhythe into a repository for the scripts, costumes, and playbills of her long professional career, all carefully dated and annotated in her own hand (Slocombe 2011). Following Terry's death in 1928, it was transformed into the Smallhythe Memorial Museum and Theatre by her daughter, theater director Edy Craig. Craig arranged the interior with mementoes of her mother's career, creating a costume room for Terry's more famous dresses. The National Trust acquired Smallhythe Place in 1939 because of its importance to British theater history.

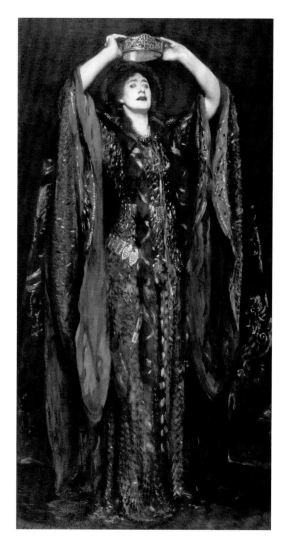

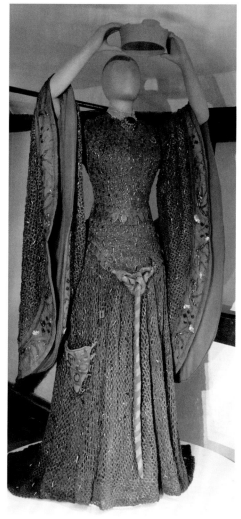

FIGURE 7.1
John Singer Sargent
(American, 1856–1925),
*Ellen Terry as Lady
Macbeth*, 1889. Oil on
canvas, 221 × 114 cm
(87 × 45 in.). London,
Tate Gallery, N02053.
Photo: Tate, London /
Art Resource, NY

FIGURE 7.2
The reconserved beetle-
wing dress as displayed
at Smallhythe Place, 2011.
Photo: © Zenzie Tinker
Conservation Ltd.

THE COSTUME COLLECTION

The extensive nineteenth-century theatrical costume collection at Smallhythe Place includes more than 250 items, many worn by Terry and Irving at the height of their Lyceum Theatre acting partnership. Terry's costumes survived repeated stage use, although significant items, such as the beetle-wing dress, were eventually retired. From the 1930s, they were displayed almost continuously in the costume room (Barratt 2011:3). The 1999 condition survey of the costume collection revealed that the beetle-wing dress had become very weak structurally, despite the introduction in 1984 of a large, glass-fronted display case and light control. The incremental effect of alterations, repairs, and restoration treatments over many decades, combined with long-term display on poor-quality mounts, had resulted in distortions to the original dress and the loss of many of the beetle-wing cases that gave the dress its character (ibid.). This was most evident when the dress was compared with the vibrant, sinuous costume painted by Sargent one hundred years earlier. The completion of a 2002 project to create an on-site, purpose-designed costume store and to stabilize the stored collection—including conservation surveys, repacking, and transferring most of the costume to this dedicated store—meant attention could focus on a new display centered on the beetle-wing dress.

DRESS IN THE LIMELIGHT

The 2007 project Dress in the Limelight had two aims: first, to improve the structural stability of the beetle-wing dress so it could be safely redisplayed and recognized by visitors as the iconic dress painted by Sargent; and second, to reconnect the display of Terry's costume to her stage career, imbuing it with some of the atmosphere of theatrical performance. Curator Emma Slocombe, a member of the Smallhythe Place project team, investigated the history of the Lyceum Theatre production of *Macbeth* and the dress's creation and use, in tandem with physical examination of the dress by a team of textile conservators led by Zenzie Tinker. Each strand of research informed the other; for example, exploring the dress's documentary history helped team members understand the findings of the physical examination and enabled them to date the phases of alteration, which in turn informed the conservation and display proposal. To ensure that the new exhibition reflected Terry's performance as expressed in Sargent's portrait, we investigated the staging of the original production of *Macbeth* and performed comparative analysis of the surviving Lady Macbeth costume and accessories with evidence in the painting.

DESIGNING LADY MACBETH'S COSTUME

Irving commissioned costume for Lyceum Theatre productions from designer Charles Cattermole. Set in the eleventh-century, Irving's *Macbeth* followed the nineteenth-century theatrical convention for historically accurate costume (Cumming 1978:54). Cattermole's designs for tunics and cloaks for the male cast[5] were informed by eleventh- and twelfth-century costume illustrated in books such as J. R. Planché's *History of British Costume* (1847). Terry's copy of this book, now in the Smallhythe Place library, can be linked to the production year of *Macbeth* through her handwritten annotation "invaluable = E.T. = 1888." Her underscore on a passage describing green as the color of "a warrant dress for a queen"[6] indicates Planché was a source of inspiration for the beetle-wing dress (Slocombe 2011:10). Terry, as a lead performer, developed her own costumes with Alice Comyns Carr, her personal designer, and had these made by Mrs. Nettleship, her dressmaker (Cumming 1987:70). The celebrated artists and designers in Terry's circle—such as the aesthetic architect (also her children's father) Edward Godwin and the pre-Raphaelite painter Edward Burne-Jones—influenced her approach to visual design. Although working to a historical period, as agreed with Irving, and with an understanding of his plans for the play's overall atmosphere, Terry's approach may explain the difference between her costumes and those of the rest of the cast. As Oscar Wilde quipped, "Lady Macbeth seems an economical house-keeper, and evidently patronizes local industries for her husband's clothes and servant's liveries; but she takes care to do her own shopping in Byzantium" (quoted in Manvell 1968:198).

The beetle-wing dress was the first of three dresses Comyns Carr designed for Terry as Lady Macbeth. Terry had seen emerald wing cases from the Asian beetle *Sternocera aequisignata* trimming a dress worn by Lady Randolph Churchill and told her designer about it (Terry 1908). Comyns Carr stated that her vision was "to make the dress look as much like soft chain armor as I could, and yet have something of the scales of a serpent" (Adam 1926:211–12). Making up her gown from a pattern for a thirteenth-century dress in Eugène Viollet-le-Duc's *Dictionnaire raisonné du mobilier français*, she added the beetle wings and Celtic designs later as she did not think the dress brilliant enough (Cumming 1978:56–58). She recalled that "Nell…would jib at fashions she fancied might interfere with the freedom of her movements when acting," and the final construction of green crochet applied over a green silk ground appears to combine this practical requirement with Terry's aesthetic design choices (Cumming 1987:73). An engraving of

four gothic sculptures, attributed to Viollet-le-Duc, inserted into Terry's working copy of Irving's 1888 printed script for *Macbeth*, shows how the final dress design referenced one particular historical costume. Terry drew a large ink cross above the figure of Clotilde, queen of the Franks, in a long gown with elongated sleeves, a hip-level belt, and a crown with double-braided plaits, just as Terry's own gown was designed, accessorized, and painted by Sargent (Slocombe 2011:10).

UNDERSTANDING LADY MACBETH'S COSTUME

The costume was first examined in detail by Tinker in 2006. Reuse and lengthy display meant the dress had lost much of its drama. It consisted of a knitted bodice, crochet sleeves (lined with trimmed plain-weave silk), and a crochet skirt lined with a plain-weave silk underskirt trimmed at the hem, as well as a second, separate bodice; additional sleeve linings; eleven detached pieces of crochet; a detached, cotton-faced hem measuring more than 5m; and many detached beetle wings. Original accessories, including a spectacular bejeweled velvet cloak, costume jewelry, a belt, and a hanging scabbard and knife, had survived in varying condition.

Examining the dress on a mannequin and comparing it with both the painting and with William Grove's photographs of Terry wearing her costume onstage indicated that substantial alterations had taken place. Analysis of the components established that the beetle-wing dress in its surviving form had been created from at least two other costumes: both the silk underskirt below the crochet skirt and the sleeve linings have a different weave structure than the lining remains inside the bodice waist. The National Trust conservation records showed that these linings had been reconstructed during the late 1980s treatment to make the dress more complete for display. The sleeves had been altered to make them shorter and less full, and the decorative borders had been applied to the inside edges rather than the outside. These findings informed the unpicking and photography of the main components and the creation of several visual maps of the dress (figs. 7.3, 7.4). These helped the curator understand the phases of alteration that the conservators were uncovering and how the surviving elements of the original dress related to the nineteenth-century visual records.

One of the most obvious differences between the dress and its contemporary images was the lack of the famous trailing hemline that Terry so favored. Describing another of Comyns Carr's dresses to Mrs. Nettleship, Terry stated: "the yellow dress must not be too correct remind Mrs Comyns Carr about the length—it must be too long behind for grace must not be left out for all the archiology [*sic*] in the world"

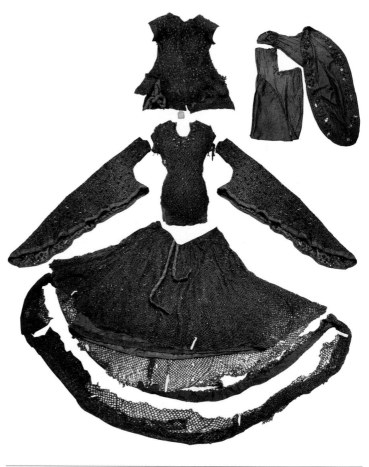

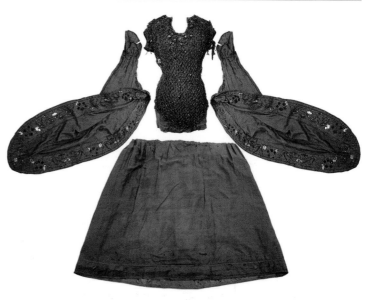

FIGURE 7.3
Visual map of dress components, before retreatment. Photo: © Zenzie Tinker Conservation Ltd.

FIGURE 7.4
Visual map of the remaining components of a deduced second dress. Photo: © Zenzie Tinker Conservation Ltd.

(Cumming 1978:58). The current skirt appeared substantially shorter than in the images, and when the mannequin was set at Terry's height (1.67m, or 5ft 5in), the hem would have barely touched the stage. Among the many detached patches of crochet was what appeared to be a nearly complete faced hem, and it was assumed this had been cut from the dress when it became too damaged to repair. The costume had been worn in 150 performances of *Macbeth* during the first run (Holroyd 2008:199), many times during Terry's famous 1889–1907 American tours, and in theatrical fetes, galas, and performances at the Smallhythe Place Memorial Theatre.

Because crochet construction does not retain stitch marks and gathers in the same way as woven fabrics, it can be a challenge to understand previous alterations. The crochet along the cut bottom edge of the skirt and the detached hem had to be scrupulously examined, checking off each seam against each potential corresponding seam and counting the crochet stitches between them. The size of the crochet stitches was compared, as was possible correspondence between light damage and wear lines. It was eventually concluded that the detached hem had not come from this skirt but from another dress, probably the same one as the second bodice. The fragmentary linings in the surviving dress indicated that the removed underskirt and the second set of sleeve linings had also come from this second bodice/dress. Although a second costume is not mentioned in any contemporary accounts, the two bodices are differently styled, and the second bodice presumably once had its own skirt attached.

STABILIZING LADY MACBETH'S COSTUME

The six-panel crochet skirt was too weak to be reattached to the bodice without full support, and a custom-dyed nylon net seemed in keeping with its structure. First, however, the many holes needed to be strengthened and infilled in an aesthetically acceptable way. Again, the crochet construction demanded a unique stabilization approach. Many different colors of stranded cotton were sampled and combined in trial crochet; then, where we had confidence in the skirt's original structure, we repaired the holes by re-crocheting. Stranded cotton blended well with the original silk and metal tinsel thread, while the different thread is identifiable as a conservation treatment. The repaired skirt was then supported onto the dyed nylon net using staggered, vertical fixing lines of stitching, as well as stitching through each original seam. To ensure that the tension of the stretchy crochet and the nylon net corresponded exactly, the stitching was worked with the skirt hanging vertically over

the conservation net while supported against an internal padded structure. The strengthened skirt still had large and obvious missing sections, particularly at the lower edge. After we established that the detached crochet hem was not from the existing skirt, we still had to address the issue of how to restore the length of the dress. We painstakingly analyzed the detached crochet patches, noticing that several with diagonal lines or seams could be relocated fairly accurately along the skirt's bottom edge. One fragment had the remains of the original folded hem. This, together with knowledge of Terry's height and measurements from contemporary photographs, enabled the correct dress length to be reestablished, and replacement crochet patches were worked to complete missing sections.[7] Rather than working the patches directly into the existing crochet (as had been done with the holes in the main skirt), we placed them in the correct location but attached to the conservation net support alone. This provides good visual infill while leaving the hemline restoration patches physically unconnected to the original surrounding crochet. Given the supposition involved, this choice seemed more ethically appropriate; it allowed the restoration of the original double-folded hemline visible in contemporary photographs, and it provided the dress with its correct weight and aesthetic sweep.

The construction of the lined, trimmed sleeves was more complex than that of the skirt. After a false start—that is, an attempt was made to conserve them in their altered shape—we realized that a section of crochet had been removed from the center of each sleeve to reduce the size. When the repair stitching was opened up, the shape of the sleeves suddenly became more obvious. We were able to recover the original shape by following clues in the seams of the embroidered sleeve trimmings and laying them around the edge of the opened crochet sleeves. As with the missing skirt hem sections, new sections of crochet were inserted behind to re-create the long, sweeping sleeves seen in the nineteenth-century images. We made trial sleeves to check the accuracy of the assumed length and fullness. The fuller sleeve meant that insufficient sleeve trimming remained; this was infilled with dyed silk and a simple line of embroidery worked on either side of the border to carry the viewer's eye more easily over the untrimmed replacement sections. More accurate sleeve linings were re-created from dyed silk.

Technical examination of original and repair threads indicated that the center back skirt seam and several other seams were probably later alterations, but without any evidence of what had existed on the original garment, these seams were left intact. Because thread analysis

had not been conclusive, and some alterations appeared to have been worked in the same thread as the original construction, it was impossible to feel fully confident of each repair phase. When the waist of the supported skirt was regathered prior to reattachment, the sweep of the back of the skirt could more easily be reinterpreted, and this center back seam appeared to be completely wrong. However, comparison of the cut edges of the gathered crochet at the skirt top with what remained of the original still stitched to the bodice confirmed that these matched up correctly. This was puzzling. How had the sweeping train been achieved without adding in more skirt at the waist? By opening up the back seam and imagining the insertion of another panel of crochet, cut in half to create two additional triangular half-panels, the correct sweep of the train could be created without altering the position of the top edge of the skirt in relation to the bodice. This interpretation of the skirt was accepted as very likely, but with no physical evidence remaining, we decided to insert the two triangles in dyed net rather than crochet. This allowed the back seam to hang in its assumed correct position while not being misleading.

The original appearance of the beetle-wing dress was an influencing factor when agreeing on the level of finish for the conserved costume and its redisplay. Terry described her costumes to her daughter:

> They are superb, especially the first one: green beetles on it, and such a cloak! The photographs give no idea of it at all, for it is in its colour that it is so splendid. The rich dark red hair is fine. The whole thing is Rossetti–rich stained-glass effects. (Terry 1908:307)

After discussion, a more restorative approach was taken with the many detached beetle-wing cases. Split or broken cases were repaired using a colored Japanese tissue support secured with a wheat starch/rabbit-skin glue. Wing cases that had two drilled holes were assumed to be from the dress, as they matched those still attached, while those with one hole (or none) were assumed to have been donated. (Smallhythe and beetle-wing cases had become synonymous, and the National Trust had previously accepted donations of them.) The dress looked quite bare, and it was evident that more than the surviving number of double-hole beetle-wing cases would be needed to rectify this. About two hundred wing cases were added to the dress, a combination of one-hole cases and cases in which a hole was drilled using a small, handheld rotary tool (a Dremel). Stranded cotton thread was used to distinguish these from the original cases, which had been sewn with silk thread.

The remains of the original belt, consisting of Celtic-inspired cast-metal shapes on a woven backing, were too short to snake around the waist and hips of the costume. Missing areas could not be hidden by the cloak during display, as had been done previously. Leaving large undecorated areas was not visually acceptable, so missing elements were replaced with polyester casts from the originals, colored to look like metal.

DISPLAYING LADY MACBETH'S COSTUME

Terry believed that Sargent's portrait, exhibited at the New Gallery[8] in 1889, "suggested…all that I should convey in my acting as Lady Macbeth" (Terry 1908:305–6), and she inserted a review of "the most discussed picture of the season" in one of her *Macbeth* scripts.[9] Terry's direct reference to the connection between her performance and Sargent's portrait informed the decision to display the dress in a pose as similar as possible to that in the painting. Working closely with mannequin display specialists H&H Sculptors, London,[10] we devised a fiberglass mannequin torso that reflected this pose, with a removable arm, head, and crown for ease of mounting. The angle of the upstretched arms had to be softened slightly to avoid overstretching the sleeves; working with a toile enabled a good compromise to be achieved without putting the dress through the stress of the fittings. The angled arms of the mannequin also provided good long-term support for the sleeves, necessary because of their weight and large size relative to the small size of the armholes and the vulnerability of the shoulder area. Because it was not clear if the sleeves had ever been attached to the bodice itself, they were retained as distinct elements, separate from the dress. They may have been attached to an undergarment, with the capped armhole of the bodice fitting over in the manner of armor. The sleeves were attached to the mannequin by stitching their support linings directly to the mannequin's fabric covering. Keeping the sleeves as separate elements also reduced the weight-load on the still-fragile dress. Terry disliked corsets and boning in both her everyday dress and stage costumes, and this dress perhaps epitomized her view of the perfect stage costume. Comyns Carr's design achieved the soft, elegant body shape, without the tightness or the rigidity of boning, through the stretchy knitted and crocheted construction and an internal bodice of silk stockinette. This was reflected in the soft but firm supportive underpinnings attached to the mannequin to give the dress the correct line when mounted.

On the final page of her *Macbeth* script, Terry had inserted "How I sketched Mrs Siddon's Shoes: A visit to Miss Ellen Terry's Dressing Room," an account of a behind-the-scenes visit during her performance.

The anonymous author describes the "confusion with dresses and robes, and slippers strewn about the room" into which Terry walks, wearing her beetle-wing dress, to greet the author with the exclamation, "Is this not a lovely robe?"[11] This scene provided the inspiration for the exhibition concept, designed by Easy Tiger Creative, London.[12] A new display was conceived, installed behind a full-length glass screen positioned in the center of the costume room. This enabled the project team to work within the material and spatial constraints of Smallhythe, a historic building with Grade II*[13] designation that restricts alterations.

The first half of the display re-created the atmosphere of Terry's dressing room, using some of her furniture and trunks, including her makeup box, and original costumes and props from *Macbeth*. Beyond a velvet curtain, the display is focused on the beetle-wing dress, slowly rotating on a stage-like plinth (see fig. 7.2). Behind this is a film of an actress on the Smallhythe Theatre stage wearing a contemporary version or modern interpretation of the dress, reenacting Terry's movements in her performance as Lady Macbeth.[14] The abstract style of the mannequin's head and arms was intended to enable the viewer to focus on the form of the original dress and allow comparison with a facsimile of the Sargent portrait without the visual disruption that might be caused by replica accessories or a more naturalistic body form. To show the dress in its full splendor, the red velvet cloak, described by Terry and included in the Sargent portrait, was not presented along with it. The cloak was instead incorporated into the static dressing room scene. The exhibition was supported by contextual material from the *Macbeth* productions, including Terry's annotated script and Lady Macbeth's dagger and jewelry.

CONCLUSION

In its approach to the conservation and redisplay of her most iconic costume, the Dress in the Limelight project sought to understand and apply something of Terry's spirit as "the painters' actress," who expressed her creativity through performance shaped by "the painter's beauty of line, harmony and rhythm."[15] The project was also a rare opportunity to explore the relationship between a nineteenth-century dress and its contemporaneous painted manifestation; the Sargent portrait proved to be an accurate representation. Combined with Smallhythe Place's rich collections of the material legacy of the 1888 performance of *Macbeth*, this enabled the design history of the surviving beetle-wing dress to be understood and that knowledge to be applied to the restoration of its deduced original form. The conservation, remounting, and exhibition

enabled the splendor of the beetle-wing dress and its stage impact to be made visible once again, despite the constraints of creating a contemporary display environment in a modest-sized room in Terry's historic home and the dress's inherent fragility. Irving and Terry had sought to challenge traditional staging and characterization in their performance of *Macbeth*, and this divided their audience. However, audiences and theater critics alike were united in recognizing that "the revival will leave its mark in stage history by reason of the beauty of its setting…and the fascinating unconventionality of Lady Macbeth as modernized by Miss Ellen Terry,"[16] a view realized today through the re-presentation of this remarkable dress.

ACKNOWLEDGMENTS

The National Trust is grateful to the organizations and individuals who supported the Dress in the Limelight project financially. The authors are grateful to Sue Medway, Paul Meredith, and Susannah Mayor, Smallhythe Place; Siobhan Barratt, regional conservator; the team at Zenzie Tinker Conservation (Hazel Arnott, Katharina Mackert, who created the visual maps, Geoffrey Major, Rachel Rhodes, Christobel Sambrook, Janet Wood, and Natalia Zagorska-Thomas); Professor Denis Salter, McGill University, Montreal, Quebec; and Veronica Isaac, Victoria and Albert Museum, London, for their support and expertise.

NOTES

1. *Macbeth. A Tragedy by William Shakespeare*, as arranged for the stage by Henry Irving and presented at the Lyceum Theatre, London, 1888. See the photograph of Ellen Terry as Lady Macbeth by Window & Grove (1888), National Portrait Gallery, London (NPG Ax131311), accessed November 1, 2015, http://www.npg.org.uk/collections/search /portrait/mw135908/Ellen-Terry-as-Lady-Macbeth-in-Macbeth.
2. Defined by critic Walter Pater as a "poetic passion, the desire of beauty, the love of art for art's sake" (1873:252).
3. From the July 1879 article in *Nation* (Manvell 1968:146; Cumming 1987:67).
4. Tate Gallery, London, N02053.
5. For illustrations showing Cattermole's costumes for the male cast, see Lyceum Theatre, *Souvenir of Macbeth*, London, 1888 (National Trust Collection, Smallhythe Place).
6. It is unclear what Planché understood by the term "warrant dress."
7. For more information about and images of the crochet infills, see "Featured Case Study: The Lady Macbeth Beetlewing Dress," Zenzie Tinker Conservation, accessed November 27, 2015, http://www.zenzietinker.co.uk/work/case-study-beetlewing/.
8. Owned by J. Comyns Carr, husband of Alice Comyns Carr.
9. Unsigned review, *Times*, May 3, 1889. There are no page numbers on the cutting, which is adhered to the blank pages at the back of the script.

10. H&H Sculptors (http://www.handhsculptors.com/), specialists in the production of bespoke costume mannequins.
11. "How I sketched Mrs Siddon's Shoes: A visit to Miss Ellen Terry's Dressing Room," *Pall Mall Gazette*, January 11, 1889.
12. Easy Tiger Creative (http://www.easytigercreative.com/) is an interpretation design agency in London.
13. The Grade II* listing gives legal protection from developments that might damage or destroy its inherent architectural and landscape character.
14. The dress was made by Caroline Ebrecht, University of Arts, Dresden, in 2008. She aimed "to create a version of the Ellen Terry beetle-wing dress, using modern affordable materials but trying to capture the magical expression of the original." Susannah Mayor interviewed Ebrecht and quoted her in a project-update interpretation panel in 2009.
15. Robertson (1931:55), quoted by Cumming (1987:68).
16. *World*, January 2, 1889, reprinted in *Era*, January 26, 1889, p. 21. Theatrical reviews were anonymous at this time. A number of reviews were collated following individual publication and reprinted together in the *Era* under the title *"Macbeth" at the Lyceum*.

REFERENCES

Adam, Eve, ed. 1926. *Mrs. J. Comyns Carr's Reminiscences*. London: Hutchinson.
Barratt, Siobhan. 2011. "Thousands of Iridescent Beetle Wings." *National Trust Arts, Buildings, Collections Bulletin* (Summer): 3.
Cumming, Valerie. 1978. "Macbeth at the Lyceum 1888: A Late Nineteenth-Century Approach to Theatre Costume." *Costume* 12 (1): 53–63.
——. 1987. "Ellen Terry: An Aesthetic Actress and Her Costumes." *Costume* 21 (1): 67–74.
Holroyd, Michael. 2008. *A Strange Eventful History: The Dramatic Lives of Ellen Terry, Henry Irving, and Their Remarkable Families*. London: Chatto and Windus.
Manvell, Roger. 1968. *Ellen Terry*. London: Heinemann.
Pater, Walter. 1873. *The Renaissance*. 4th ed. London: Macmillan.
Robertson, Walford G. 1931. *Time Was*. London: Hamish Hamilton.
Slocombe, Emma. 2011. "Lady Macbeth at the Lyceum." *National Trust Historic Houses and Collections Annual* 5: 4–11.
Terry, Ellen. 1908. *The Story of My Life*. London: Hutchinson.

AUTHOR BIOGRAPHIES

EMMA SLOCOMBE, BA, MA, AMA, FSA, is a National Trust curator based in East Sussex and Kent, United Kingdom. Formerly a regional curator with a portfolio including Smallhythe Place, she is now project curator at Knole, Kent, one of the largest medieval and Jacobean houses in England. In addition to general curatorial duties, she is leading research into the history of Knole's interiors and collections, currently focusing on the picture and furniture collection. Slocombe has a special interest in costume and textiles and has published her research into the history of seventeenth-century royal state furniture at Knole and the sixteenth-century embroidery collection at Hardwick Hall, Derbyshire.

ZENZIE TINKER, BA (Hons), ACR (UKIC), trained as a conservator under Ksynia Marko in London and was awarded the Museums Association Certificate in Textile Conservation in 1991 (Trevor Walden Prize). She chaired the UKIC Textile Adhesives Group. She was costume

conservator at the Museum of London (1991–98) and senior conservator at the Victoria and Albert Museum, London (1998–2003), where she worked on costume for the British Galleries project. Since 2003 she has been founding director and lead conservator at Zenzie Tinker Conservation Ltd. in Brighton, United Kingdom.

8 | MAKING SENSE OF A FRAGMENTARY COAT FOUND CONCEALED WITHIN A BUILDING

Kathryn Gill

This paper focuses on the ways that curatorial and conservation decisions affect the preservation and presentation of the material evidence of a fragmentary garment. It has two core propositions: first, that it is helpful to understand conservation as investigation, preservation, and presentation; and second, that when displaying historic items of dress, conservation measures are inextricably linked to modes of representation. Conservation needs affect the options for display, and display preferences likewise inform the choice of conservation options. This interaction is explored via an object-based study.

The fragmentary remains of a man's wool coat were discovered within a building in Maldon, Essex, United Kingdom. There is little documentation about how it was discovered and how it came to Colchester Castle Museum, also in Essex. The earliest written record is dated 1942, when the coat was acquired by the museum (COLEM 1942.175).[1] This documentary evidence refers to the coat's discovery, walled up in a chimney, suggesting it may have formed part of a cache deliberately concealed within the building. The practice of concealing garments within the structure of buildings was widespread, and various motives have been proposed (Swann 1969, 1996; Harrison and Gill 2002). Some garments appear to have been intentionally damaged prior to concealment (Duffield 2004). One sleeve of the Maldon Cache coat is missing, but there is insufficient evidence to establish whether this was deliberate damage. Insect activity seems to have been responsible for large areas of loss in the coat's collar and skirts. The surviving sleeve has been altered by the insertion of a large gusset and the addition of a premade cuff from another garment, presumably to extend the usable life of the coat.

Despite these losses and alterations, enough of the outer fabric and front fastening remains to provide clear evidence of the coat's original cut and construction. The coat has a high, round neckline, a small, standing collar, flared skirts without a waistline seam, and a center front fastening of thread-wrapped buttons (fig. 8.1). These features indicate

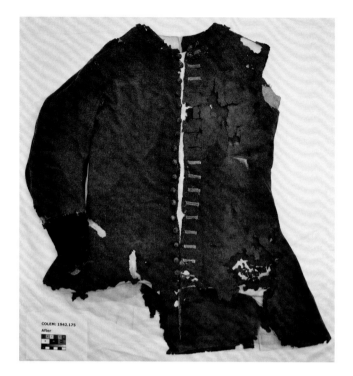

FIGURE 8.1

The fragmentary coat, after conservation (COLEM 1942.175). Photo: © Kate Gill Textile and Upholstery Conservation Services. Reproduced with kind permission of Colchester and Ipswich Museum Service

that the coat's original components are comparable with fashionable European menswear of the early eighteenth century, possibly earlier. The thread-wrapped buttons have proved to be of a previously undocumented form. The coat's damaged condition means that it is possible to see parts of its inner construction that would not normally be visible. These factors make the find significant for the history of dress, particularly as a primary source for understanding methods and materials of construction.

DEVELOPING A PRESERVATION STRATEGY

Curatorial and conservation decisions affect the way the material evidence of an artifact is preserved and presented. The conservation and display strategy developed for this rare garment resulted from a discussion of options between curatorial and conservation specialists.[2] The curator's initial brief was to prepare the fragmentary coat for display alongside archaeological finds in a temporary exhibition called *Buried! Hidden Secrets from the Past*, at Colchester Castle Museum (July 2011–January 2012). The curator was keen to present the coat as an archaeological find while also suggesting how it may have looked when worn; for example, by revealing the shape of the coat's crumpled and fragmentary collar and skirts.

As the conservator, my main priority was to make the fragmentary and fragile garment safe for temporary display, long-term storage, and occasional study, bearing in mind the curatorial preference for exhibiting it in 2011–12. Following my initial, brief condition assessment in March 2010, it was clear that, even after conservation treatment, the coat would remain too fragile to be displayed in any way other than unbuttoned, lying flat and near horizontal.[3] Further discussions between conservation and curatorial specialists ensued, and it was proposed that the materials and construction details temporarily revealed during conservation treatment would be recorded, and that templates would be made of all surviving fragmentary panels of the coat. The overriding aims of the object-based study were to provide a better understanding of the coat's cut and construction, including the thread-wrapped buttons, and to generate information that could enhance future research and display of the fragmentary and fragile garment.

INVESTIGATION

The aim of documentation was to record and retain information about the materials, cut, and construction, including alterations and evidence of wear from the coat's original production and use through to rediscovery in the museum's storage. The investigation was undertaken during the conservation treatment to minimize handling. This was necessary because of the coat's physically unstable, three-dimensional nature and complex structure, which comprises a variety of materials in a multilayered construction. The results of the investigation and conservation interventions were documented in writing, digital images, and line drawings, including accurate, scaled-down drawings of the shape and dimensions of the coat panels. This was achieved by transferring to graph paper the numerous dimensions that had been recorded during investigation and conservation.[4] A similar approach had been used with an early seventeenth-century linen doublet found in the Reigate Cache (Stanton 1995; Eastop 1999).

Investigation included analysis of weaves, buttonholes, and seam stitching as well as thread-wrapped buttons and their method of attachment to the coat. Comparison with published examples (Pietsch and Stolleis 2008:305, fig. 282; Piechatschek 2008) suggested the center front buttons are of a previously unrecorded form, and I conducted an in-depth study to identify the thread-wrapping technique. Because the buttons were too fragile to handle, the majority of the study was based on information that could be gleaned from photographic images, which served, to a degree, as surrogates. Each button was photographed in

the round with a digital camera. Observations about construction and technique were recorded directly onto large-scale printed images. The image sequences enabled study of the effects of thread-wrapping in practice, without having to touch the buttons. The images were annotated in colored inks to help determine the number of thread revolutions. Studying the buttons during conservation was subsequently supported by a learning-by-doing process, which included making large-scale models of the buttons. Time-lapse photography was used to record the actions of the thread-wrapping (Gill 2015, figs. 12–15; Gill forthcoming).

OBJECT RECORD

The brown-colored wool coat is in a fragmentary and altered state. However, as mentioned above, enough of the original outer fabric remains to provide clear evidence of the coat's original cut, construction, and shape. Despite the coat's crumpled and fragile condition, which prevented full access to all areas of the garment for examination and measurement, it was possible to make accurate patterns of most surviving outer fabric elements (Gill 2015, fig. 4). Determining the original cut of the one surviving sleeve was problematic due to two significant alterations: the insertion of a gusset, and the addition of a preconstructed cuff. Unfortunately, no evidence could be found to determine the length of the original sleeve or how the sleeve end was originally finished. There is also no surviving evidence to confirm whether the collar was originally constructed from a single piece of cloth or from pieces seamed together. With the exception of the upper section of the collar, which is folded inward (suggesting it was once lined), all edges of every wool panel are cut and unhemmed, as expected of fulled wool garments. All original seams of the outer fabric panels and linings are secured with a single row of running stitches. The lower edge of the collar is placed on top of (i.e., overlapping) the front panel and is attached with spaced, overcast stitches (fig. 8.2).

The coat was once fully lined, including the sleeve. This was deduced from the only surviving part of the original lining, which is a long, narrow strip of cloth forming the buttonhole facing. The buttonhole stitching is worked through both layers of fabric, confirming that this lining was part of the original construction. It is possible that the same fabric was used to line the whole coat. The coat's collar was also probably lined originally; however, no lining survives. It is possible that the coat included stitched and stiffened interlinings, in particular in the collar and shoulder areas, to help shape them (North and Tiramani

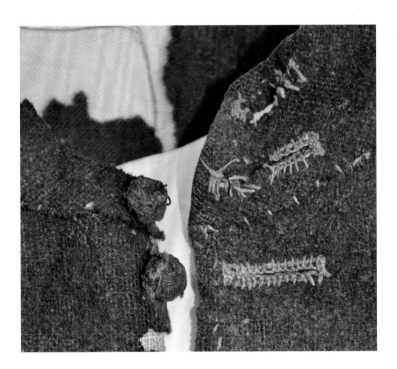

FIGURE 8.2
Detail showing the coat's
original collar, two but-
tons, and three button-
holes (COLEM 1942.175).
Photo: © Kate Gill Textile
and Upholstery Conserva-
tion Services. Reproduced
with kind permission of
Colchester and Ipswich
Museum Service

2011:9). The interlinings of the button and buttonhole areas have sur-
vived and are partially visible through areas of loss in the outer fabric
and linings. The button interlining comprises a long, narrow strip of
cloth folded in half lengthwise that lines up with the cut edge of the
coat's front opening. A small portion of the buttonhole interlining has
survived because it is secured and protected by the buttonhole stitches.

Seventeen buttons at the center front of the coat are part of the
(deduced) original construction. Each button comprises a wood core
wrapped with waxed thread and decorated with two loops of metal-
wrapped thread. The metal thread was functional as well as decorative.
When the button was stitched to the coat, the metal decoration was
threaded onto the anchor thread, preventing the anchor thread from
slipping back through the hole in the button's wood core.

The wrapping method used for the buttons is unusual. Investigation
continues, but at this stage the wrapping technique is characterized as
a variation of the Turk's head knot, in which a single thread with four
interwoven strands, arranged with five bights worked over a rounded
core (roughly hemispherical in shape), forms a pentagon pattern that is
visible on the top face of each button. The pattern is formed by the five
bights and results from the initial wrapping path being repeated until
the wood core is completely covered by the thread (Budworth [1999]
2001:170).

There are nineteen buttonholes, each approximately 26mm wide. Seventeen of the buttonholes are horizontally cut, with each side of the cut reinforced with ten to fourteen stitches, with a stitch bar at either end. The lowest two are false buttonholes, in that each comprises a row of simple chainlike stitches with no cut, making them intentionally nonfunctioning. The coat's center back and side seams are also reinforced with a buttonhole stitch bar. Each 10mm wide bar straddles the seam, reducing strain; this reinforcement stitching performs the same function as the bars worked at each end of the cut buttonholes at the center front.

The cuff is not thought to be part of the coat's original construction. It comprises a wool plush outer fabric that is fully lined and interlined. The cuff was originally fastened with four buttons: one button remains partially intact, and fragments of thread from the remaining three buttons survive. Because of its fragmentary condition, it is not possible to determine the structure of the decorative thread that once covered the button's wood core. The buttons appear to be secured in the same way as the buttons on the coat front. The buttonhole stitching is neatly executed with a very fine thread and small stitches. In marked contrast, the cuff is held to the sleeve with a row of large, overcast stitches and a row of running stitches. Wool plush did not come into general use until the latter part of the mid-eighteenth century, confirming that the cuff is a later addition (Hodgkins and Bloxham 1980:4).

The extant materials of the coat are listed in Table 1; key observations are summarized below. The original coat and sleeve outer fabric, the patches and sleeve gusset, and one replacement lining are all plain-weave, brown-colored, fulled wool with thread counts ranging between 8 to 14 threads per 10mm, the lining being the finer (and having the higher thread count). Another replacement lining and the original coat buttonhole facing are of 2/2 twill-weave, brown-colored wool. In contrast to the buttonhole facing, which is of fulled wool and has only 11 to 12 threads per 10mm, the lining is much finer, with 20 to 22 threads per 10mm. The replacement cuff outer fabric is a dyed purple plush with a wool pile and a linen/hemp ground-weave. The original interfacing beneath the center front buttons is plain-weave white linen, as are the linings of the sleeve and replacement cuff. All three linens share the same thread count, 12 to 13 threads per 10mm. The original buttonhole interfacing at the center front is a 2/2 twill-weave fabric with a thick, softly spun cotton weft (12 threads per 10mm) and a finer, more tightly spun cotton/linen warp (22 threads per 10mm). All the buttons on the coat and the cuff appear to have wood cores, probably boxwood. In

addition, the buttons all have metal-wrapped thread decoration comprising metal strips wrapped in S-direction around a fine linen thread, which in turn is wrapped around a thicker linen thread with a brown wax-based coating. The thread wrapping the original coat buttons is a bast fiber yarn (flax or hemp), colored with a brown wax-based coating. Fiber fragments on the cuff buttons suggest the thread wrapping the button cores is dyed orange silk floss with a net-type overlay structure of dyed purple plied silk thread. The thread used to construct the cuff buttonholes appears to be a dyed dark purple silk. All finishes and fibers have been characterized by visual examination and not by instrumental analysis.

Location on coat	Color and fiber type	Weave type	Thread count	Other comments
Coat & sleeve outer fabric	Brown, fulled wool	Plain weave	9–10 per 10mm	Approx. 2mm thick. Original
Coat inlay patch	Brown, fulled wool	Plain weave	9–10 per 10mm	Approx. 2mm thick. Later addition
Sleeve gusset panel	Brown, fulled wool	Plain weave	8–9 per 10mm	Approx. 1mm thick. Later addition
Cuff outer fabric	Purple dyed plush with wool pile and linen/hemp ground	Plain weave	10–11 per 10mm	Later addition
Coat, buttonhole facing	Brown, fulled wool	2/2 twill weave	11–12 per 10mm	Possibly the original lining fabric
Coat linings, front panel	Brown, napped wool	Plain weave	14 per 10mm	Some, perhaps all, later additions
Coat linings, back panel	Brown, wool	2/2 twill weave	20–22 per 10mm	
Coat linings, back panel patch	Brown, wool	Plain weave	18–20 per 10mm	
Sleeve lining	White, linen	Plain weave	12–13 per 10mm	Later addition (?)
Cuff lining	White, linen	Plain weave	12–13 per 10mm	Original to cuff or later addition (?)
Coat, buttonhole interfacing	White, cotton/ cotton and linen	2/2 twill weave	22 per 10mm (warp) 12 per 10mm (weft)	Original
Coat, interfacing beneath row of buttons	White, linen	Plain weave	12–13 per 10mm	Original
Coat button, wrapping-thread	Flax/hemp with a brown wax-based coating	2 S-ply		Original
Coat button, metal-wrapped thread	Metal strips wrapped in S-direction around a fine linen thread; in turn, wrapped around a thicker linen thread with a brown wax-based coating		Metal strips-copper wire (?) (possibly silvered originally)	Original
Coat button, core	Wood, probably box-wood			The wood is hand-turned. Original
Cuff button, core	Wood, probably box-wood			The wood is hand-turned. Possibly original to cuff
Cuff button, wrapping threads	Dyed orange floss silk to wrap wood core. Dyed purple plied silk to create detached buttonhole net			Probably original to the button addition
Cuff button, metal-wrapped thread	Metal strips wrapped in S-direction around a fine linen thread; in turn, wrapped around a thicker linen thread with a brown wax-based coating		Metal strips-copper wire (?) (possibly silvered originally)	Possibly original to the button
Cuff, buttonhole	Dyed dark purple silk		Thread structure not accessible for examination	Original to cuff

TABLE 1. Coat materials: original and later additions. All stitching threads examined were 2 S-ply flax or hemp, of various thicknesses.

INTERVENTIONS

The principles of "minimum intervention" and "reversibility" informed the conservation approach. The treatment approach was to retain as much material evidence as possible of the coat's long existence, from production, use, and alteration to disposal and discovery; to recognize alterations as significant; and not to camouflage losses. Loose soiling that had accumulated during storage of the coat (i.e., post-excavation) was removed; however, no attempt was made to remove the cement-like soiling associated with the time the coat was walled up in the chimney and therefore considered evidential. Contact humidification techniques were applied to the linings and outer fabric to ease distortions, with the exception of the creasing in the surviving elements of the collar, which provided evidence of wear from use. The aim was not to completely remove creases that had occurred during the coat's concealment, but to relax them sufficiently to reveal the shape of the coat's skirts.

The aim of the support treatment was to secure extant cloth fragments and reconnect them across expanses of loss. This was achieved by stitching to discrete panels of color-matched conservation-grade net. The net's semitransparent qualities enabled areas of loss to remain evident, while areas covered by the net remained visible. This subtle support system was also applied to the missing shoulder elements and enabled the net panels to be stitched together to re-create the original seamline. In turn, this enabled the re-formed shoulder to be supported in the correct shape with the aid of customized, padded forms. The coat was provided with a bespoke, padded, removable support form, which also helped further reveal its shape.

PRESENTATION

Presenting the fragmentary coat and the results of technical analyses was considered important for the exhibition, and a multimodal approach was developed. A mount board covered with a napped fabric was custom-made to support the fragmentary remains of the coat during the temporary exhibition; like the support form, the mount was also designed to serve the needs of subsequent long-term storage and study. So the coat could be readily seen during the exhibition, the board was held at an angle of approximately 20 degrees from the horizontal on a wedge-shaped plinth. The angle was the steepest slope possible at which the coat could be displayed without slipping down, although the display case's interior dimensions also affected the presentation.

This static display was complemented by a dynamic, image-rich PowerPoint presentation installed alongside the coat (fig. 8.3), which

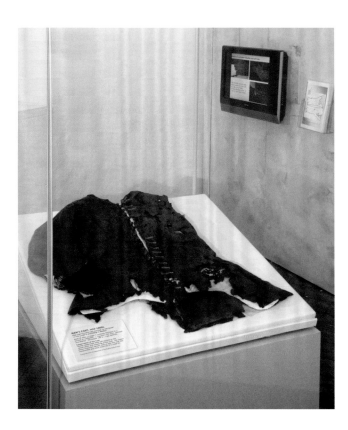

showed the processes of investigation, documentation, and decision-
making, as well as the practical challenges of the conservation treat-
ment. It included detailed images of the materials and construction
elements that were only temporarily revealed during the conservation
process, such as coat linings, seam stitching, and the positioning of the
collar in relation to the neckline. The presentation also included images
and line drawings of areas concealed by the display mount, such as the
coat's back panels (Gill 2012).

As noted above, the thread-wrapping technique of the center front
buttons was revealed by close study during the conservation treat-
ment, combined with subsequent, practice-based reconstructions. This
provided sufficient data to make a set of models, illustrating the wrap-
ping techniques at different stages. The various processes involved
in the button study were made available in PowerPoint format to
facilitate better understanding of button construction for future exhibi-
tions. Some aspects of this information have recently been made more
widely available.[5]

A replica of the coat was made to increase exhibition options
and enhance understanding of its cut and construction. The aim of

replication was to create a copy of the coat in the present configuration when last worn, rather than when first made. A toile (made of fine cotton fabric) provided an opportunity to see the cut of the coat in three dimensions. The replica coat comprised back and front panels, fully lined with two different fabrics, and a complete collar. It also included a full set of buttons and buttonholes and two fully lined sleeves, incorporating the gusset and cuff additions. When mounted on a mannequin and displayed alongside the original coat, the replica can be viewed from all angles, buttoned or unbuttoned. The replica gives the museum visitor an impression of how the original coat may have looked when last worn,[6] assisting with interpretation of the "real thing" (Gill 2015).

CONCLUSION

This paper introduced the outcomes of detailed documentation and practice-based research in understanding the cut and construction of a man's coat, and notably of its center front, thread-wrapped buttons. The exhibition of the fragmentary original and the replica, accompanied by the image-rich PowerPoint presentation, allowed visitors different forms of access. Information revealed by conservation and replication contributed to the dating of the coat in its various forms and shed light on the events in its life, from its original manufacture to its point of rediscovery. Image-based documentation enhanced the way information about materials, construction, and conservation interventions was reported and enabled different stages in the life of the garment to be explored and presented.

Garments undergo changes, but they are often presented in their fashionable form rather than in the later, as-found states that show wear, tear, use, and alteration. The multimodal approach adopted for the Maldon Cache coat has reduced the risk of damage to a fragile find while presenting much primary evidence in a user-friendly format. The ways in which the information has been presented enable a range of interpretations, as do the reversible interventions. This project evolved through dialogue between professionals and by taking a pragmatic approach, working within real-life constraints of time, budget, and site availability for display (in this instance, a stand-alone case and space nearby for a wall-mounted monitor to show the image-based presentation).

The conservation and replication phases of this project have revealed much valuable information about the coat and its construction. It would be interesting to undertake further research—for example, about the removal of the coat from the cache site—to see whether the

discovery was reported in local newspapers or to a local historical society. In addition, fiber analysis of the plush cuff fabric and comparative examples may help in dating this later addition. Dye analysis may reveal that the coat was a different color when new; perhaps it was blue, like the child's wool doublet from the Abingdon Cache (Eastop 2010; Hayward 2010). Historians of dress may identify comparable garments in other collections and in prints, paintings, and sculptures. The detailed, object-based investigation reported here, and recorded in the image-rich conservation records, provides the basis for lively, multimodal displays and for further research and different interpretations.

ACKNOWLEDGMENTS
I would like to thank Danielle Sprecher, former costume curator, Philip Wise, Tom Hodgson, and Ciara Canning of the Colchester and Ipswich Museums for permission to publish. Special thanks are due to Dinah D. Eastop for her advice on various aspects of this project.

NOTES

1.	Danielle Sprecher, then costume curator, Colchester and Ipswich Museums, personal communication to author, March 19, 2010.
2.	Danielle Sprecher, Laura Sorenson, Ciara Canning, Dinah D. Eastop, and myself.
3.	For more images, see "A Man's Fragmentary 17th-Century Coat: Conservation, Documentation and Replication," Kate Gill Textile and Upholstery Conservation Services, accessed December 10, 2014, http://www.kategillconservation.co.uk/portfolio/man%E2%80%99s-fragmentary-17thc-coat-conservation-documentation-and-replication.
4.	Kathryn Gill, "Replica-Making and Informed Compromise: The Case of a Seventeenth-Century Man's Coat." Poster presented at the conference 'The Real Thing?': The Value of Authenticity and Replication," December 6–7, 2012, University of Glasgow, United Kingdom, accessed December 10, 2014, http://www.gla.ac.uk/media/media_276748_en.pdf.
5.	See note 3, above.
6.	See note 3, above.

REFERENCES

Budworth, Geoffrey. (1999) 2001. *The Ultimate Encyclopedia of Knots & Ropework*. London: Anness Publishing.

Duffield, Miriam. 2004. "Interpreting Evidence of Wear and Deliberate Damage in Four Deliberately Concealed Garments." MA diss., University of Southampton.

Eastop, Dinah D. 1999. "Decision Making in Conservation: Determining the Role of Artefacts." In *International Perspectives on Textile Conservation*, edited by Ágnes Tímár-Balázsy and Dinah D. Eastop, 43–46. London: Archetype.

——. 2010. "The Conservation of Garments Concealed within Buildings as Material Culture in

Action." In *Everyday Objects: Medieval and Early Modern Material Culture and Its Meanings*, edited by Tara Hamling and Catherine Richardson, 145–56. Farnham, UK: Ashgate.

Gill, Kathryn. 2012. "Images Can Speak Louder than Words: Communicating Conservation Effectively." *Studies in Conservation* 57, Supplement 1: In "24th Biennial IIC Congress: The Decorative: Conservation and the Applied Arts," special issue, S114–21.

———. 2015. "Sharing Evidence: Documentation, Conservation, and Replication of a Man's Wool Coat with Thread-Wrapped Buttons." *Textile: Journal of Cloth and Culture* 13 (1): 4–29.

———. Forthcoming. "The Investigation and Replication of Some Rare Thread-Wrapped Buttons" (working paper). *Craft Research*.

Harrison, Anna, and Kathryn Gill. 2002. "An Eighteenth-Century Detachable Pocket and Baby's Cap Found Concealed in a Wall Cavity: Conservation and Research." *Textile History* 33 (2): 177–94.

Hayward, Maria. 2010. "A Shadow of a Former Self: Analysis of an Early Seventeenth-Century Boy's Doublet from Abingdon." In *Everyday Objects: Medieval and Early Modern Material Culture and Its Meanings*, edited by Tara Hamling and Catherine Richardson, 107–18. Farnham, UK: Ashgate.

Hodgkins, Vera, and Christine Bloxham. 1980. *Banbury and Shutford Plush*. Oxford: Banbury Historical Society.

North, Susan, and Jenny Tiramani. 2011. *Seventeenth-Century Women's Dress Patterns, Book 1*. London: Victoria and Albert Museum.

Piechatschek, Nadine. 2008. "Die Posamentenknöpfe des 17. Jahrhunderts." In *Kölner Patrizier- und Bürgerkleidung des 17. Jahrhunderts: Die Kostümsammlung Hüpsch in Hessischen Landesmuseum Darmstadt*, edited by Johannes Pietsch and Karen Stolleis, 373–78. Riggisberg: Abegg-Stiftung.

Pietsch, Johannes, and Karen Stolleis, eds. 2008. *Kölner Patrizier- und Bürgerkleidung des 17. Jahrhunderts: Die Kostümsammlung Hüpsch in Hessischen Landesmuseum Darmstadt* [Cologne patricians' and citizens' clothing of the 17th century: The Hüpsch costume collection in Hessian Landesmuseum Darmstadt]. Riggisberg: Abegg-Stiftung.

Stanton, S. 1995. "A Seventeenth-Century Linen Doublet: The Development of a Strategy for the Documentation, Preservation and Display of a Rare Item of Working Class Dress." Diploma diss., Courtauld Institute of Art/Textile Conservation Centre.

Swann, June. 1969. "Shoes Concealed in Buildings." *Northampton County Borough Museums and Art Gallery Journal* 6: 8–21.

———. 1996. "Shoes Concealed in Buildings." *Costume* 30 (1): 56–69.

AUTHOR BIOGRAPHY

KATHRYN (KATE) GILL, FIIC, ACR, FHEA, is a freelance conservator, lecturer, and researcher, notably of textiles and dress. She is a specialist in upholstery conservation and image-based documentation, and she coedited *Upholstery Conservation: Principles and Practice* (2001). Following training in the conservation of textiles and upholstery at the Textile Conservation Centre, England, she set up the upholstery conservation section at the Metropolitan Museum of Art, New York, where she was senior conservator for seven years (1984–91). She became senior conservator and lecturer at the Textile Conservation Centre, University of Southampton (1998–2009), combining practical conservation with research and teaching. She is external advisor, conservation of furniture and related objects courses, West Dean College, England (2008 to date).

9 | BACK TO BLACK
CONSERVATION OF A 1900s ENSEMBLE
VIA REPLICATION AND WEB DISPLAY (REPLICAR)

Teresa Cristina Toledo de Paula

The challenges of preserving and displaying a late nineteenth-century black mourning dress (bodice and skirt) were the focus of a fifteen-month project in 2010–11 known as Replicar. Outcomes included making replica garments and the creation of a website devoted to the ensemble. The project highlights significant issues in the interrelationship of textile conservation, the display of historic dress, and the dissemination and reception of university-led, object-based research.

The Replicar project was developed after the descendants of the Countess of Pinhal, Anna Carolina de Melo Oliveira de Arruda Botelho (1841–1945), asked to borrow her mourning dress. The collection of the Museu Paulista at the Universidade de São Paulo, Brazil, includes the bodice and skirt (museum number 3147) that had been worn by the countess (fig. 9.1). The widow of a farm owner, she managed the Casa do Pinhal, a large coffee plantation. The black mourning dress is important as a memorialization of the countess and as a representation of the history and influence of Brazil's coffee plantations, which were sustained by the work of enslaved Africans and, after the abolition of slavery in 1888, by indentured immigrant workers. The decision to create replicas of the mourning garments, for permanent display in the countess's bedroom at the Casa do Pinhal, was part of a strategy to enhance both conservation and access, because the dress is too fragile for open display.

While this was the first replication of historic dress to be undertaken as a research project within a museum context in Brazil, the textile conservation team was familiar with similar work, notably the *Patterns of Fashion* series of books by British clothing historian and designer Janet Arnold (1932–1998). As a specialist in textile conservation, I led a multidisciplinary team of other specialists, including dress historians, dressmakers, embroiderers, and skilled weavers as well as graduate students (Paula 1998; 2006a; 2006b; 2012). Three research institutes supported the replication project through their expertise and the use of their laboratories.[1]

The initial phase of the project consisted of historical research, the characterization of materials and manufacturing techniques, and

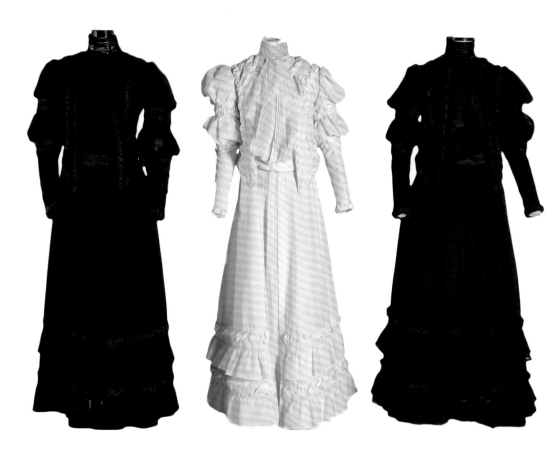

FIGURE 9.1
The three dresses (left
to right): the original
mourning dress (3147);
the white canvas replica;
and the black replica,
made for display in
the countess's room
in the Casa do Pinhal.
© The Museu Paulista,
Universidade de São
Paulo. Photo: José Rosael

the construction of prototype replicas of the bodice and skirt in white
canvas. The second phase involved constructing the replica of the
mourning dress for permanent display at the Casa do Pinhal. The third
phase was the exhibition of both the original and replica garments.
Here, I broke with tradition and chose an online, interactive mode
of dissemination.

The option of wider public exhibition via online display of the count-
ess's garments and of the processes of replication was made possible
using technology, known in Brazil as a hotsite, that is typically employed
by automobile manufacturers.[2] The Replicar hotsite was developed over
a six-month period by auto industry web designers who were hired to
apply the same technology to the representation of the mourning dress.
Ideas and criteria for content emerged from discussions with the web
designers; I edited photographs, X-radiographs, and research reports,
and I explained technical details about the making of the replicas. Public
dissemination via the hotsite was complemented by the wide distribu-
tion of a compact disk that contained all the hotsite content.[3]

CONSERVATION AND ITS NATIONAL, REGIONAL,
AND INSTITUTIONAL CONTEXTS

Impermanence is part of everyday life in the southern hemisphere, and it can be one of the most difficult concepts to deal with in the so-called majority world,[4] once referred to as the "developing world." Both long-term planning and implementation remain a challenge in all fields of work, and few institutions in Brazil are able to develop and sustain long-term projects that conform to international standards of excellence. Within this context, the Museu Paulista has supported innovative new research possibilities, and such innovations have been transmitted to and practiced by many other institutions in the country (e.g., the Museu Afro-Brasileiro in Salvador).

The Museu Paulista, a social history museum, is one of the most visited sites in Brazil and one of São Paulo's largest museums. It has served as the national center for textile conservation since 1993, responsible for the dissemination of best practices and research and the training of students and staff from private and public institutions all over Brazil. However, neither the Museu Paulista nor its textile conservation team had previously been involved with the production of replicas. In 2010–11, the Replicar project enabled the team to introduce new conceptual perspectives and explore new technological approaches. Now, years after the project's completion, it is possible to evaluate its effects and its novelty in the virtual display of textiles and dress.

The Countess of Pinhal was born in 1841 in São Carlos, Brazil, and died in 1945, when she was 104 years old. She became countess by marriage in 1863 and lived in the Casa do Pinhal (Pine House), then one of the largest coffee plantations in Brazil, with her husband and twelve children. After she was widowed in 1901, she adopted mourning dress for the rest of her life, as did most women at that time. One of her black dresses, donated to the Museu Paulista at an unrecorded date, is the focus of this study.

In the first decade of the 1900s, when the imposing building that would later house the Museu Paulista was being built in São Paulo, the city was undergoing a rapid transformation as thousands of immigrants arrived to work, following slavery's end in the previous decade. Contemporaneous trade records refer to locally made fabrics and trimmings, to imported goods (mainly from France), and to catalogues and magazines that brought news of European fashion to "distant South America," including exclusive mourning dresses (as illustrated in Taylor 2009). The countess's black dress, probably made in the late nineteenth century, consists of two separate garments: a boned bodice, and a

matching skirt. They are predominantly of a black-dyed wool fabric, with cotton and silk parts; both garments are constructed with hand- and machine-stitching and are embroidered. Nontextile components include metal clasps and boning (baleen, often referred to as whale bone, but actually thin plates from the palates of certain whales). The condition of the dress was, and remains, very fragile, probably because of the black-dyeing processes, which can lead to inherent and irreversible damage. Safe handling of the garments is difficult and, for preservation reasons, their display is not recommended.

CONSERVATION PRACTICE,
AND A FAMILY'S UNEXPECTED REQUEST
The Count of Pinhal contributed to the development of several other farms, to the founding of banks, and to the construction of railroads. The Casa do Pinhal, which comprises a main house, a forest, and the plantation, has been a designated part of Brazilian Heritage since 1987, and it has an important collection of documents about the so-called golden age of coffee plantations in Brazil. The house has been restored and was opened to the public in 2015.

When the Countess of Pinhal's descendants asked if they could borrow her mourning costume for display inside the Casa do Pinhal, they presented the museum with a challenge. It is important to highlight two issues here. First, at the time, none of the Museu Paulista's textile collection was on display—despite almost daily requests from visitors and staff to make these collections available—due to conservation concerns related to inappropriate environmental conditions. Second, because the countess's dress is preserved in an irreversibly fragile condition, fundamental questions about what constituted "best prac-tices" in conservation arose. I understood best practices to mean ensur-ing the long-term preservation of textile objects; that is, ensuring that future generations have access to the actual textiles.

A simple refusal, however, was not appropriate. The descendants were making a reasonable request that highlighted some of the museum's core goals, including promoting accessibility, showing the collection's relevance, and sharing it in appropriate contexts. Could a compromise be identified? Which policies and practices could be imple-mented, bearing in mind that we might set precedents that would be followed by other museums across the country? The family's request presented an opportunity to highlight textiles in a country where textile collections are few and less valued than other collections and where textile and dress research is incipient and often considered too specific

or dismissed as a "woman's thing," even within an academic and scientific environment. Should that opportunity be wasted?

The current Brazilian museum context, with regard to day-to-day conservation work, resonates with the observation made by British scholar Professor Lou Taylor:

> Artefact-based dress history practice…has its own disciplines which are no less rigorous than those demanded by academic institutions but they are clearly of a different nature. Professional skill and knowledge comes from library, archive and oral history research but above all from handling and examining dress in careful detail. Most dress curators have at one time mended, ironed, wrapped, folded, rolled and cleaned clothes and textiles in their charge and mounted them painstakingly in frames or on display stands. All this requires patient and gentle care. Much of this could fairly be described as traditional "woman's work" and as collections built up in the post-war period [that is, post-1945], this work has indeed been largely undertaken by women specialists. (2012:331)

We recognized that this was an opportunity to make a significant difference both within and beyond the "heritage sector," as well as a significant contribution to the permanence of textiles and dress, both materially and conceptually. This unexpected request was met with an equally unexpected response: with the descendants' support, including a generous budget, and in a spirit of exploration, the Replicar project began.

REPLICATION IN WHITE AND BLACK

Arnold's *Patterns of Fashion* series, published between 1972 and 2008, inspired the proposal put to the countess's descendants, and these volumes and other works on object-based research (e.g., Brooks 2000) pointed the way forward. However, we discovered little on the topic of making replicas, although Renée Dancause's article (2006) was very helpful. It soon became evident that it would be difficult to undertake detailed observation of the black fabric. The poor condition of the dress, which restricted handling, likewise made examination and documentation harder. The black color presented the first major challenge (and one that we did not find reported in the literature) and forced an exploration of alternative approaches. We discovered that simply changing the colors of some digital images of the dress (via a basic Windows computer tool) made examination much easier.[5] We decided to make a "study replica" of the skirt and bodice from white canvas. These white

fabric prototypes enabled close study of details, which helped later with the making of the black replica.

One difficulty encountered during the production of the white prototype replica was the interpretation of measurements taken from the fragile dress. Lack of experience played a role. Although the first mannequin had been custom-made for the white replica, when it arrived, the dress did not fit the dummy. After much discussion, and with the assistance of a specialist in haute couture, we realized that the problem lay in the distribution of the cloth across the mannequin's back. We deduced that the countess had become slightly hunched over during her long life. A new dummy with a hunched posture was ordered, and it worked well. We also noted that the bodice and skirt had been handled more than we had expected or wished.

The next difficulty was identifying and reproducing the black wool fabric. We consulted specialists to identify the materials and technique used to produce the fabric and searched other museum collections on the web. Fabrics for mourning dresses were varied and sometimes distinguished different phases of mourning (Taylor 2009). It is humbling to note that, even with all the available resources, we could neither explain fully nor reproduce a technique used fewer than 125 years ago. The possibility of reproducing the fabric on a historic loom was investigated, as was replicating its "wavy" effect by calendering a ready-made wool fabric. Each attempt was unsuccessful. Once again we had to ask ourselves, what exactly did we want replicated? As Jill Morena states, "Reproducing an original garment can reveal the limits of authenticity, revealing what is there and what is not there and what can never be recovered: the 'true' original garment" (2014:129).

Our main concern was the quality of the information communicated to those who would view the dress at the Casa do Pinhal: we wanted visitors to gain a feeling for the countess's taste in dress, her wealth, and her femininity. We decided to make the replica using a wool fabric similar to that of the original dress. From New York, we imported 8m of a very similar cloth, which was later hand-embroidered in São Paulo to very good effect. For the concealed parts and the stitching, we chose the most resilient materials in order to make the replica garments sufficiently robust for open display.

AN UNEXPECTED OUTCOME:
ONLINE, INTERACTIVE DISPLAY VIA A HOTSITE
It has been a few years since the replica mourning dress was transferred to the countess's descendants and the Replicar team was disbanded.

If not for the Replicar hotsite, it is likely that the project would have been mentioned only occasionally as another successful endeavor of the museum's textile conservation department. Although Replicar and its hotsite were originally conceived as twin projects, they have had different trajectories. Replicar achieved its objective—the display of the replica dress at the Casa do Pinhal—while the hotsite, initially a complementary and experimental tool, has developed into a completely independent form of online display.

The process of replicating the countess's bodice and skirt generated a large and diverse set of documentation, including dozens of computer-aided drawings (CorelDRAW); handmade drawings and templates; textile and fiber test samples; photographs; images from microscopy, X-radiography, and tomography; weekly reports; and a bibliography. Transporting the dress for instrumental analysis required three trips, each involving security and insurance. We also maintained contact with the countess's descendants, and the textile conservation workroom was visited by weavers, artists, fashion designers, and researchers from within the university and beyond. These visits affected the museum's routine and increased staff curiosity about the work being done in textile conservation. Eventually, there was internal, institutional pressure to mount a temporary exhibition of all the documentation, including the white prototype replica and the black replica, as well as the original garments.

In the final months of the Replicar project, I continued to wonder about the proposed temporary exhibition because of the many practical and ethical challenges of display (Andrade 2006; Palmer 2012; Taylor 2012). Could the extremely fragile black garments be displayed safely? Could the details be made visible when they were illuminated at 50 lux maximum and behind glass? Would the public understand the display and the project? I concluded that the garments should not be exhibited in a traditional museum display.

By chance and serendipity, a search for a new car led me to an interactive website (a hotsite) where all of the automobile's features could be viewed in a 360-degree rotation. The idea of applying this technology to the Replicar project emerged: an online display of the bodice-and-skirt ensemble as a three-dimensional object. The website's designers, a company called WOMB, were initially surprised to be contacted, but they welcomed the proposal of transposing the technology from automobiles to museum artifacts. We worked with the designers for nearly six months, including taking the garments to a specialized photographic studio (fig. 9.2) and filming each team

FIGURE 9.2
The skirt of the original mourning dress (3147) being prepared at the photography studio. The mannequin was turned eighteen times to create eighteen pictures for the hotsite, providing enough images for the 360-degree rotation tool. © The Museu Paulista, Universidade de São Paulo. Photo: José Rosael

member talking about the project. Emphasis was placed on enabling online users to control their examination of the ensemble: circling it in 360 degrees, inspecting sections with the zoom facility, and exploring explanations and scientific reports (fig. 9.3). A two-minute film of the team member narratives, which included footage of the moment when the countess's descendants first saw the original dress, the white replica prototype, and the black replica together, provided a welcome personal dimension.

There was no guarantee that the hotsite would work as planned. We also recognized that the online presentation of such object-based research might not attract interest in Brazil. Fortunately, the outcomes exceeded every expectation. Within a few days, museums in Brazil and other Portuguese-speaking countries were discussing the website and

praising its creativity, innovation, cohesion, functionality, design, and comprehensive presentation of object-based research.[6]

Another significant indicator of the impact of the Replicar website was the number of e-mails sent to the museum asking for courses on replication, fashion design, textiles, and textile conservation. Any reservations about the lack of the "real tangibility" of a traditional, object-based research presentation (such as an on-site exhibition and printed articles) were reported only within the museum itself.[7] Visitor feedback confirmed the huge potential audience for the presentation of museum objects online, especially for achieving a virtual presentation of the three-dimensional character of dress (see Loker, Ashdown, and Carnrite 2008). Online display can make fragile museum objects, which can never be safely displayed, more widely available and accessible.

FIGURE 9.3

Replicar's hotsite page showing the interactive circles. Clicking on a circle reveals more information and images about that specific part of the dress. © The Museu Paulista, Universidade de São Paulo, and the Casa do Pinhal

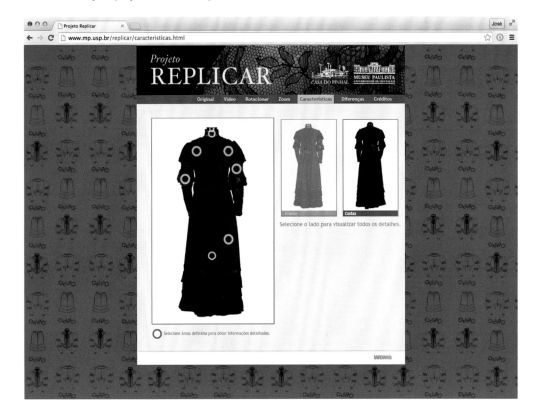

CONCLUSION

The Replicar project and its hotsite provided opportunities to chal-lenge and extend museum practice in Brazil; both were assessed as very effective, surpassing initial expectations and bringing new knowledge and incentives to conservation work at the Museu Paulista. Both the research and its outcomes highlight significant issues about the interrelationship of conservation, display, and the public dissemination of object-based research within the academic setting of Brazil's leading university. A hotsite, usually designed for the transitory launch and marketing of products, became a longer-lasting tool and a valued ally for enhancing the preservation and understanding of historic textiles and dress, and thus for the permanence of textiles and dress, and for textile conservation, in Brazil.

ACKNOWLEDGMENTS

This paper and the Replicar hotsite would not exist without the team of specialists who worked on the replicas. I particularly thank Dr. Rita Andrade, dress historian at Universidade Federal de Goiás; WOMB's team; and the Canadian Conservation Institute library, for supplying a copy of Renée Dancause's paper. Special thanks are owed to Sonia (in memoriam) and Fernão Bracher, the descendants of the countess.

NOTES

1. For X-radiography and tomography, the Instituto de Radiologia, Hospital das Clínicas, Universidade de São Paulo; for fiber and fabric analysis and data available online, Instituto de Pesquisas Tecnológicas/IPT; and for fiber and dye analysis, SENAI–Têxtil.

2. In Brazil, a hotsite is a website prepared as a marketing tool, e.g., for product launches, events, new product editions, or services. They differ from ordinary websites only in the communication strategy used in their conception. Hotsites usually have greater visual appeal and are focused on a specific audience, and they encourage interactivity.

3. "Projeto Replicar," Museu Paulista, CD (ISBN 978-85-64842-00-7).

4. I first read the expression "majority world" in a publication by David Larsen, editor of Africa Media Online, http://www.africamediaonline.com, accessed June 25, 2015. I started using this term to describe the majority of the countries on earth, which have also been called "developing countries" or "third world countries."

5. Similar observations have been made when examining digital X-radiographs; that is, changing between negative and positive images affects what can be seen easily. This technique was applied later in the project for analyzing the X-radiographs and tomog-raphy images of the garments (O'Connor and Brooks 2007).

6. In 2013 the museum published a book that highlighted the most popular news items about it from the past fifty years. It included an article from one of Brazil's largest newspapers about the Replicar project (Duarte 2013).

7. The Conselho Nacional de Desenvolvimento Científico e Tecnológico (CNPq), the national council for scientific research and development in Brazil, did not consider the Replicar hotsite and CD as research outcomes, stating that the work was "too specific." As a result, my fellowship was not extended.

REFERENCES

Andrade, Rita. 2006. "Undercover: Culture and Materiality of Our Costumes and Fabrics." In *Tecidos e sua conservação no Brasil: museus e coleções / Textile Conservation in Brazil: Museums and Collections*, edited by Teresa C. T. de Paula, 258–62. São Paulo: Museu Paulista, Universidade de São Paulo.

Arnold, Janet. 1977. *Patterns of Fashion 2: 1860–1940*. New York: Drama Book Publishers.

Brooks, Mary M., ed. 2000. *Textiles Revealed: Object Lessons in Historic Textiles and Costume Research*. London: Archetype.

Dancause, Renée. 2006. "Reconstruction, Reproduction, Replication, Re-creation: Synonyms in the Costume History and Textile Conservation Literature? A Matter of Perspective." Proceedings of the textiles sessions of AIC's 34th annual meeting. *Textile Specialty Group Postprints* 16: 41–53. Providence, RI: AIC.

Duarte, Marcelo. 2013. "Museu Paulista apresenta réplica do vestido da Condessa de Pinhal." In *Cara de São Paulo: retrospectiva de 50 notícias selecionadas sobre o Museu Paulista e Museu Republicano "Convenção de Itu" no cinquentenário de sua incorporação à Universidade de São Paulo*, edited by Eduardo L. Vidal and Dorival Pegoraro Jr., 63–65. São Paulo: Museu Paulista, Universidade de São Paulo.

Loker, Suzanne, Susan Ashdown, and Erica Carnrite. 2008. "Dress in the Third Dimension: Online Interactivity and Its New Horizons." *Clothing and Textiles Research Journal* 26 (2): 164–76.

Morena, Jill. 2014. "Definitions of Authenticity: A Study of the Relationship between the Reproduction and Original *Gone with the Wind* Costume at the Harry Ransom Center." In *Authenticity and Replication: The "Real Thing" in Art and Conservation*, edited by Rebecca Gordon, Erma Hermens, and Frances Lennard, 119–30. London: Archetype.

O'Connor, Sonia, and Mary M. Brooks. 2007. *X-Radiography of Textiles, Dress and Related Objects*. Oxford: Butterworth-Heinemann.

Palmer, Alexandra. 2012. "Untouchable: Creating Desire and Knowledge in Museum Costume and Textile Exhibitions." In *History/Curation*, vol. 1 of *Textiles: Critical and Primary Sources*, edited by Catherine Harper, 161–85. London: Berg. Previously published in *Fashion Theory* 12, no. 1 (2008): 31–63.

Paula, Teresa C. T. de. 1998. "Inventando moda e costurando história: pensando a conservação de têxteis no Museu Paulista/USP" [Making fashion and sewing history: thinking about textile conservation at the Museu Paulista/USP]. MA diss., Universidade de São Paulo. Accessed June 25, 2015. http://www.teses.usp.br/teses/disponiveis /27/27143/tde-08082001-105338/pt-br.php.

———, ed. 2006a. *Tecidos e sua conservação no Brasil: museus e coleções / Textile Conservation in Brazil: Museums and Collections*. Portuguese-English. São Paulo: Museu Paulista, Universidade de São Paulo.

———. 2006b. "Tecidos no museu: argumentos para uma história das práticas curatoriais no Brasil" [Textiles in museums: arguments for a history of curatorial practices in Brazil]. *Anais do Museu Paulista* 14 (2). Accessed August 2, 2016, http://www.scielo.br/scielo .php?script=sci_issuetoc&pid=0101-471420060001&lng=en&nrm=isohttp://www.scielo .br/scielo.php?script=sci_issuetoc&pid=0101-471420060002&lng=en&nrm=iso.

———. 2012. "A gestão de coleções têxteis nos museus brasileiros: perspectivas e desafios" [Management of textile collections in Brazilian museums: perspectives and challenges]. In *Actas do I Encontro Luso-Brasileiro de Conservação e Restauro*, edited by Gonçalo Sousa and Eduarda Vieira, 52–62. Porto: Universidade Católica Portuguesa.

Taylor, Lou. 2009. *Mourning Dress: A Costume and Social History*. London: Routledge.

———. 2012. "Artefact-Based Approaches: Display and Interpretation." In *History/Curation*, vol. 1 of *Textiles: Critical and Primary Sources*, edited by Catherine Harper, 302–35. London: Berg. Previously published in Lou Taylor, *The Study of Dress History* (Manchester, UK: Manchester University Press, 2002).

AUTHOR BIOGRAPHY

TERESA CHRISTINA TOLEDO DE PAULA received a BA in history (1981), an MA (1998), and a PhD (2004) at the Universidade de São Paulo. She received her postgraduate degree in museology (1988, FESP), and an Independent Art Fellowship for Advanced Training at the Textile Conservation Centre, United Kingdom (Samuel Kress Foundation, 1993). She has worked in museums in São Paulo since 1981. Since 1989 she has been a conservator at the Museu Paulista, Universidade de São Paulo, and was head of conservation (2012–14). She organized the first scientific textile conservation event in Brazil and edited the resulting bilingual publication. Since 2013 she has been a permanent researcher at the Instituto de Estudos Avançados, Universidade de São Paulo.

10 | CONCEPTS IN PRACTICE
COLLABORATIVE APPROACHES IN DEVELOPING THE BOWES MUSEUM'S FASHION AND TEXTILE GALLERY

Claire Gresswell, Joanna Hashagen, and Janet Wood

The Bowes Museum, in the north of England, is a French chateau–style building designed for John Bowes and his French wife, Joséphine, to house their collection of fine and decorative art. John and Joséphine amassed most of their collection in Paris in the mid-nineteenth century, buying tapestries, furnishing textiles, and needlework from the sixteenth to eighteenth centuries. Later additions include garments and dress accessories, quilts traditionally made in northeast England, and the Blackborne lace collection. A new, permanent gallery developed for the collections of textiles and dress opened in 2010, and it has been praised for its innovative approach to display, mounting, and interpretation. The gallery's success has been attributed to the quality of the collections and the close collaboration between the professionals involved, notably between curator, designers, and conservators. These specialists formed a small, experienced, multidisciplinary team, characterized by close engagement with the conceptual and practical issues of presenting historic dress in a museum setting and an energy-generating enthusiasm that fostered a flow of ideas. This paper discusses the gallery development, presenting the perspectives of curator Joanna Hashagen, designers Claire Gresswell and William Daykin of Blue, and Janet Wood, the conservator for costume mounting.

A CURATORIAL PERSPECTIVE: FIRST STEPS IN COLLABORATION
Twin forces drove the development of the new gallery: public demand, and curatorial ambition to create an innovative Fashion and Textile Gallery following the closure of the previous Costume Gallery.[1] This ambition was fueled by the growing relationship with Blue, a small design team that had worked on temporary textile exhibitions at the Bowes for more than a decade.[2] Good designers are inspirational, encouraging the client to dream, and lively debates took place right from the start as the brief was discussed and new ideas explored. The design brief reflected our shared ambitions:

The new galleries will be truly innovative in design. They will be spectacular, using the latest display ideas, and serious by providing easy access to study collections. The aim is to present textiles and dress in an exciting way that can be enjoyed by the general visitor and the specialist alike, catering for both individuals and groups to study the collections. (Hashagen 2007:1)

Unlike many other museum artifacts, textiles and dress do not hold their three-dimensional shape on their own, offering a display challenge for curator, designer, and conservator. Modes of display are therefore particularly potent in representing or assigning meaning and value to textiles and dress in museum settings. The main curatorial objective was to find ways of presenting each garment so it would look as beautiful as possible, without any distractions, while suggesting, as far as practicable, how and where it had been worn or used. Faced with this challenge, Hashagen (as curator) and Gresswell (as 3-D designer) worked together on every aspect of the design process, sitting side-by-side, surrounded by images of the exhibits or sometimes with actual objects. Gresswell sketched all the objects to scale to help understand the possible visual interplay between them. Questions were posed about what was significant about each piece, what could be said about it, and how it should be presented. These debates facilitated a close working relationship, invigorated the design process, and fostered wild ideas and tangible outcomes. Such free exploration of curatorial and display perspectives created a new methodology that redefined the way textiles, garments, and other objects are exhibited, displayed, studied, and interpreted.

A DESIGNER'S PERSPECTIVE: MEANING-MAKING THROUGH NEW WAYS OF PRESENTATION AND INTERPRETATION

An exhibition will fail if viewers cannot make meaning out of what they see and hear. Creating a gallery that allows visitors to make informed meaning, rather than telling them what that meaning is, requires a different design solution. We realized that we wanted to give visitors a sense of the gallery as people centered. There are, after all, few objects that are more personal, intimate, and expressive about their users than textiles and dress. The main aim in creating the Fashion and Textile Gallery was to promote deeper public appreciation of the collection and widen access via new ways of presentation and interpretation. Our objective was to produce a gallery that gave visitors the freedom to attribute meaning to the objects, and we worked to develop a gallery

that stripped interpretation back to the essentials. We also wrestled with what we meant by interpretation and what we thought was essential.

We explored different modes of representation by visiting both museums and high-end retail displays. These visits stimulated much debate, and we found ourselves asking why many displays seemed lifeless despite faultlessly designed installations. We concluded that much of this "dead" feeling arose from the mannequins, which, whether lifelike or stylized, created an unnatural effect. If this effect is intended as part of the design, it can, of course, be exploited. However, as our aim was to convey some sense of the original wearer, we concluded that we needed to avoid using mannequins.

We were intrigued to find some of the fine shops in Bond Street (a fashionable part of London) emulating museum display techniques; that is, high-value items were presented beautifully in stunningly lit, individual showcases. Not only did these shop windows provide enticing platforms for the presentation of clothes and accessories but their design left viewers in no doubt of the quality and attention to detail in the making of each item. These displays exploited illumination to highlight objects, rather than the dull, overall lighting "wash" sometimes used by chain-store retailers. High-end retailers would devote a whole window to a very few items, each displayed as though it had nothing to hide, confident in its styling and quality, calling for viewers' full attention and time. Some display designers had chosen to focus the shopper's eye even more keenly by masking off much of the window to frame a single item or outfit.

The cues we took from these effective retail-design solutions inspired the concept for the new gallery, which would use the pared-back simplicity of large glass structures to greet visitors with a stunning "window" onto fashion and textiles. We felt that it was imperative for visitors to engage with the exhibits the moment they entered the gallery, thus supporting curatorial and interpretive objectives. We wanted visitors to feel a connection with the exhibits, so the collection would be relevant and relatable for them, and this process of interpretative engagement required a different approach. Rather than first presenting seventeenth- or eighteenth-century material, we decided to begin with more-recent items, such as those dating from the 1960s. We considered that visitors were more likely to be able to say "I wore something like that" or "I've seen photos of mum [or granddad] in one of those," thus orienting themselves in time and place. Moving back slowly in time from the 1960s to the 1600s while walking through the gallery also helps

FIGURE 10.1
The current display in the Fashion and Textile Gallery begins with the 1960s and moves back in time to the 1600s. Film monitors are located at the end of the glass "arms." © The Bowes Museum

visitors apply what they know, whether first- or secondhand, to a more remote history (fig. 10.1).

Our visits to the British Galleries at the Victoria and Albert Museum (V&A), London, were also very influential. We saw the benefit of displaying objects from different collections together—for example, textiles with furniture—because the interrelationship or dialogue created by such groupings informs visitors about the tastes, skills, and values of the originating society. We decided that we could achieve a similar effect by introducing paintings from the Bowes collection into the displays. The paintings would provide a mirror into past eras, reflecting the culture in which the textiles and dress were created and used. This form of immersive display was a more effective way of creating context than lengthy text panels.

A FLEXIBLE SOLUTION: LARGE GLASS STRUCTURES AND LAYERED OBJECTS

Blue aimed to design a gallery in which all the activities of the museum's textile department could take place: permanent and temporary display spaces, storage and study areas, and space to examine textiles and dress. A modern, multifunctional look was achieved by working in

harmony with the architecture of the nineteenth-century museum rather than fighting it. We exploited the division of space created by the five sandstone columns (each 5m high) that run the length of the gallery, dividing it in two. The main exhibition area on one side of the gallery is opposite a large glazed space known as the Glass Cube (fig. 10.2). Each of the flexible temporary display spaces on either side has audiovisual equipment allowing large-screen projection. The floor-to-ceiling display wall is a completely flexible unit, perfect for fashion accessories.[3] Installations can be mounted in these units without technical assistance, opening up the space for use by nonmuseum staff.[4] The second temporary exhibition space has four dress cases for designer-in-focus display,[5] supported by large-screen projections of film footage. Alternatively, this flexible space can be unified for a larger exhibition utilizing the design wall, the dress cases, and the Glass Cube together.

The main displays are in the five, large, purpose-built glass structures that extend like arms across the width of the gallery, creating bays between them.[6] These cases, which can present an average of fifty objects "layered" together, enable visitors to see each object from all sides. Visitors can look through and between the glass "arms," and the effect of seeing real people moving among the collection provides a human scale and brings an illusion of movement to the garments. Designed for maximum flexibility—nothing is permanently fixed or

FIGURE 10.2
The Glass Cube in the Fashion and Textile Gallery. © The Bowes Museum

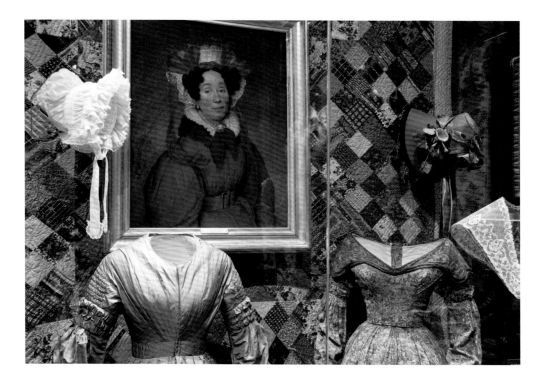

FIGURE 10.3

Detail of the display of 1830s and 1840s dress and accessories. Augustine Cochet's *Portrait of a Woman* of 1833 (BM506) is displayed against a patchwork quilt made of dress fabrics from 1820 to 1846 (1990.10.2). Note the lace fichu on a Perspex mount hanging at the appropriate height.

© The Bowes Museum

screwed down—the system enables layering and hanging of objects together at appropriate heights.[7] For example, lace collars can be shown at shoulder height on a curved mount, as if on a body, giving visitors a clear understanding of how such accessories would have been worn (fig. 10.3).

Hanging contemporaneous painted portraits next to actual garments of a similar style and date creates a link in the viewer's mind between the exhibited dress and the person represented in the painting, while again giving the viewer an idea of how the garment may have been worn. Such links can create a meaningful and even intimate relationship between the museum visitor, the sitter (that is, the person in the portrait), and the garment. This is a much more visitor-friendly form of interpretation than simple illustrations printed on a graphic panel, and the added impact arises as much from the physicality of the oil-painted surface and the gilded frame as from the image of the sitter. The portrait adds life and personality to the clothes. This display scheme enables the contextual interplay of garments, accessories, and paintings, making their place in history more tangible. We were also excited that the backs of the paintings were visible, in the same way that other objects were viewable from different perspectives, and felt this was an honest and direct approach.[8]

Film monitors at the end of each glass arm show a range of images (see fig. 10.1), such as fashion plates or photographs, that provide further context. More importantly, we used archive films or clips from BBC costume dramas for pre-1900 material, to show how clothes would have looked in movement, because the fluid nature of textiles is so much more evident in film. A garment in wear is clearly different in form from the indeterminate shape of the same garment in a drawer or stored in a box. Moving images make the interpretation of these physically complex objects possible, while conventional still images and words reinforce the "dead" or static feel often associated with the use of mannequins. Film can also express how a garment will change the wearer's posture and movement, and perhaps even social ease. Thus, the constrained movement characteristic of late Victorian dress can be contrasted with the more liberated, relaxed gait and posture of the 1920s or with the sense of freedom (whether real or not) that came from wearing a minidress, hot pants, or kaftan in the 1960s.

One of the more challenging objectives was to explain how and why body shape changes over time, and we found that using digital media in conjunction with historical objects proved to be an effective solution. One film shows costumier Luca Costigliolo dressing a woman in a reproduction 1872 outfit, from chemise and drawers up to her outer layers: "When he [Luca] is done, she looks as if she has stepped out of a James Jacques Tissot [sic] painting."[9] The film was extremely popular with visitors throughout the opening year and is now available to a wider audience via the museum's website.[10] We also commissioned close-up films of the textiles and dress in each display case. Moving slowly over the surface of fine embroidery or lace, these films encouraged visitors to look closely at the textiles, to appreciate their beauty and the technical skill needed to create them.

The strategy for the gallery included a further objective: creating enhanced access to the museum's large and significant study collections, which attract regional, national, and international researchers. The Glass Cube (see fig. 10.2) provides a unique multipurpose space for study and accessible storage, particularly for quilts and lace (the collections most in demand).[11] Curators, conservators, students, and volunteers may use the Cube for workshops and talks or as a work space for preparing exhibitions, with all activities being visible to the general visitor. Alternatively, it can be used as a highly dramatic showcase. The Glass Cube places all the functions of the textile department at the heart of the gallery and encourages interaction between curators, conservators, volunteers, and visitors. Sometimes visitors try

to enter the space, which can be slightly disruptive, but most people read the signs explaining the Glass Cube's functions. There have also been some interesting interruptions and encounters, one of which led to an exhibition on Savile Row tailoring.[12] Many visitors enjoy seeing curators, conservators, and volunteers in action, even if they're just stacking empty boxes. Delicate tasks—for example, maneuvering hard-to-handle objects—are usually undertaken before the gallery opens.

MAKING STRATEGIC CHOICES: MANNEQUINS, MOUNTING,
AND CONSERVATION

One of our pivotal decisions, taken while developing the overall design concept for the gallery, was rejecting the use of both mannequins and dressmakers' stands. We concluded that using mannequins of any style inevitably and instantly dictates how the viewer "reads" the garment. It is impossible for mannequins to do other than introduce a fake presence into real artifacts—they are impostors. We also recognized that textiles and clothing are designed to move in far more complex ways than many other objects, responding to the myriad movements of the wearer's body. As noted above, using mannequins creates a dead feeling, exactly the opposite effect of garments on a living, human body.

We needed an unobtrusive mounting solution to allow the textiles and garments to have their own voice, and the development of transparent acrylic mounts was the solution. These mounts gave the curator a way to expose the inside of garments and thereby almost to "deconstruct" the object for viewing. All curators and conservators know the thrill of studying the inside of a garment, but it is rare for museum visitors to see this internal material evidence. The transparent torsos allow visitors to see labels, stitching, and construction; for example, the lining and center back opening in the dress on the right (see fig. 10.3). This is an example of the physical informing the intellectual: the chosen form of mounting enabled more to be seen and studied during a standard museum visit.

Conservators Caroline Rendell and Janet Wood were the third element in the interdisciplinary collaboration, and they played a key role in achieving the display's objectives, most significantly in the design of acrylic see-through mounts for both flat and three-dimensional pieces. Rendell concentrated on remedial conservation interventions and creating mounts for flat textiles and lace,[13] while Wood focused on garment mounting, interpretation, and display. Object selection was made with the conservators. Some items had been conserved for previous exhibitions, while others, important to represent the collection,

needed little or no remedial conservation intervention. Each textile was surface-cleaned before mounting, and some were wet-cleaned and given support treatment. Each piece was assessed at an early stage with regard to its proposed display so that any additional conservation needs or changes to the mounting style could be accommodated. More-vulnerable items that had not yet been conserved were placed in the drawers in the Glass Cube. Detailed conservation assessments were essential in establishing which pieces would be suitable for display on acrylic torsos and mounts. The limited number of body shapes meant that responsible choices had to be made, and not every item in the initial selection was used. The apparent simplicity of these display methods placed the objects at the center of attention.

MOUNTING GARMENTS ON TRANSPARENT ACRYLIC MANNEQUINS
Museums have often used fiberglass and papier-mâché forms, cut away to just below the edges of a garment, but the forms always remain visible inside even if painted or covered with fabric.[14] In our view, every costume display should have an element of magic. It was part of the conservators' role to capture the spirit of the gallery design in the mounting of each ensemble by developing "invisible," transparent display forms. To achieve this, the conservators liaised with the expert acrylic mount maker Roy Mandeville.[15] Creating a custom-made acrylic torso for each garment would have been prohibitively expensive, so two new generic torso shapes were designed.[16] These were loosely related to body silhouettes created by contemporaneous corsetry. Bowes 1, a tiny, flat-chested torso (bust 745mm; waist 435mm) worked well for dresses from the early 1800s, early 1900s, and the 1960s, while Bowes 2, a high-busted, small-waisted torso (bust 860mm; waist 590mm) was suitable for mid-nineteenth-century garments. Some larger twentieth-century dresses and men's and children's costumes were mounted on adapted acrylic shop mannequins.[17]

Once we cut away any acrylic visible beyond the edges of a garment, we discretely applied polyester wadding to each torso to create the historically correct profile and provide essential support. Adding this padding to the slippery acrylic was a challenge: in order to ensure the mount remained invisible, the padding could only be added to areas that visitors could not see. We created finely woven cotton (cambric) covers for each basic torso design to give a firm base for the wadding. These covers were cut away according to the needs of each garment, although where cutting away might have destabilized the structure of the cover, it was tensioned with fine fishing line

FIGURE 10.4
The skillful bias cut and inventive design of this 1932 satin-backed silk crêpe evening gown (1976.20.9) is shown to its full potential on the acrylic mount, which gives the correct line over the hips. © The Bowes Museum

(which was invisible against the acrylic). The line was passed through strategically placed small holes drilled in the torso's shoulders, waist, and sides. Analysis of the cut and construction of each garment was crucial, enabling the dress to be subtly repositioned without stressing the garment or disrupting its original appearance (fig. 10.4). Regular, close communication between designer, curator, and conservator was essential before any padding was added, with detailed analysis of the best angle for displaying each garment in the showcase. Positions were adjusted to enable padding to remain invisible or to be masked by falling shadows.

CONCLUSION

The success of the Fashion and Textile Gallery depended on three interpretive elements, with each element designed to engage the visitor, promote deeper enjoyment and understanding of the exhibits, and preserve the collection for the long term. First, the layered views of the cases themselves, and the layering of objects within the cases (made possible by the flexible display system), generated visual and contextual interplay. Second, the addition of original paintings created a sense of time and place, while films showed dress in movement. Third, the use of discrete transparent mounts gave visitors the opportunity to see inside the garments; this has proved to be one of the most popular aspects of the display.

An overt focus on design can push the collection into the shadows, leaving visitors busy engaging with the exhibition display rather than with the objects. In this instance, the designers cut back the display structure so that the design solutions disappeared, the reverse of many installations where the design can be the most noticeable element. The philosophy of optimizing flexibility has proved highly successful, and it goes much deeper than merely enabling an easy changeover of exhibits, necessary for both access and conservation. Because the gallery can be used in different ways, visitors are immersed in a space that combines all aspects of the textile department's activities: study, cataloguing, and conservation. The Glass Cube dissolves the traditional barrier between visitors and museum staff in the same way that the transparent acrylic mounts have removed the distracting presence of mannequins.

Innovations in the Fashion and Textile Gallery have improved public access and understanding, raised the stakes in the display of textiles and dress, and received international recognition[18] and regional and national awards.[19] We hope that this account of our redisplay strategy has demonstrated that new ways of presentation, and facilitating other

forms of access to collections, can not only be visually stunning but also flexible and functional for the preservation, display, interpretation, and study of textiles and dress.

NOTES

1. The first Costume Gallery was opened in 1976 by Queen Elizabeth, the Queen Mother (née Elizabeth Bowes-Lyon, 1900–2002), who was a descendant of John Bowes (1811–1885) and a lifelong supporter of the museum. Its closure in 2005 caused a public outcry, which helped convince the museum that a new gallery for dress and textiles was an essential part of a major redevelopment scheme.

2. Blue designed the following exhibitions and associated catalogues: *People & Patterns* (1996); *North Country Quilts* (2000); and *Fine & Fashionable: Lace from the Blackborne Collection* (2006).

3. This 600mm deep space was created using the highest-quality shop fittings. Both horizontal and vertical supports can be moved and acrylic fronts slotted in where necessary.

4. For example, fashion design tutors in nearby colleges can easily display student projects based on our exhibitions in these spaces. Student visits have increased dramatically as a result.

5. The temporary fashion exhibition program has become increasingly important, attracting new audiences and giving the museum a higher profile.

6. These enclosures are 3m high, 4m long, and 1.4m wide.

7. Metal bars are hooked over the top frame of the glass ceilings. These slide along rails in two directions so they can be positioned anywhere on a grid system. Rods or wires hung from these bars enable objects to be displayed at any height. As these are easy to unhook, no technicians are required.

8. Unseen elements, such as magnets, were used to support the minimal label stands and small-object mounts. The custom-made, energy-saving LED lighting system of movable, flexible-necked spotlights is attached by magnets. The lighting system and reusable hooks and rods are off-the-shelf shop fittings, making this a sustainable system. Lighting design was by Fusion XL Ltd., United Kingdom.

9. Review by Melinda Watt (2010:14), associate curator, European Sculpture and Decorative Arts, supervising curator, Antonio Ratti Textile Center, Metropolitan Museum of Art. Jacques Joseph Tissot became known as James Tissot by 1854.

10. The film was shown on a full screen in the gallery for the first year before the display wall was installed in 2011; "The Art of Dressing in the 1870s," accessed August 2, 2016, http://thebowesmuseum.org.uk/Collections/ExploreTheCollection/Galleries /FashionTextileGallery.

11. The Glass Cube measures 6 × 6 × 5m. It has floor-to-ceiling racking for boxes with drawers below, four movable plan chests for lace, and a central unit to accommodate large textiles. Twenty quilts hang in the center; each can be lowered on remote-controlled bars.

12. *Henry Poole & Co., Founder of Savile Row: The Art of Bespoke Tailoring and Wool Cloth* (2013).

13. The flat textiles needed very little conservation treatment. The "honest display" approach allowed the backs of mount boards and objects to be visible, aiding the

interpretation of the object. For example, an eighteenth-century tapestry fragment was supported by stitching onto an acrylic stretcher covered in washed linen. Because it was free-hanging in the display, visitors could see the colors of all the weft threads on the tapestry's back.

14. The cutaway mannequins were inspired by the fiberglass figures used at Brighton Museum & Art Gallery, United Kingdom, and the papier-mâché forms made by Carmen Lucini for the exhibition *Sous l'Empire des crinolines (1852–1870)*, Palais Galliera, Paris (2008–9). Flecker discusses Perspex mounts and buckram figures that can be cut away (2013:209).

15. Roy Mandeville is the director of Museum Workshop Ltd. The torsos were made from acrylic (polymethyl methacrylate) to meet conservation requirements and passed the "Oddy test," an accelerated corrosion test developed to assess the potential impact of display materials on museum artifacts (Tímár-Balázsy and Eastop 1998:345–46). Testing was carried out at Tyne & Wear Museums by conservator Rachel Metcalfe. Historic Royal Palaces at Kensington Palace, the Royal Collections, and the Fashion and Style Gallery, National Museum of Scotland, Edinburgh, have since adopted this style of mount.

16. This process was carried out off-site, but the customization of each torso was done on-site by Mandeville and his assistants. Mandeville and Wood have since developed a twentieth-century female form and two male torsos.

17. Manufactured by the Italian company Arthema.

18. An international workshop on the museum display of dress took place at the Bowes Museum on April 26, 2013, as part of the Humanities in the European Research Area (HERA) program *Fashioning the Early Modern*, accessed August 3, 2015, http://www .fashioningtheearlymodern.ac.uk/workshops/workshop-6/.

19. Museums Heritage Award, "Highly Commended," permanent exhibition category, 2011, accessed August 3, 2015, http://www.museumsandheritage.com/show/awards/hall-of -fame/2011-award-winners/.

REFERENCES

Flecker, Lara. 2013. *A Practical Guide to Costume Mounting*. London: Routledge/V&A.

Hashagen, Joanna. 2007. "New Permanent Galleries for Textiles and Dress." May 31. Internal report.

Tímár-Balázsy, Ágnes, and Dinah D. Eastop. 1998. *Chemical Principles of Textile Conservation*. Oxford: Butterworth-Heinemann.

Watt, Melinda. 2010. "The Bowes Museum." *Textile Society of America Newsletter* 22 (3): 14.

AUTHOR BIOGRAPHIES

CLAIRE GRESSWELL completed a degree in communication design in 1982. After working for a publisher and a commercial exhibition design company, she joined the National Museum of Science and Industry, South Kensington, in 1985 as designer. In 1987 she was seconded to the National Media Museum, Bradford, where she focused on visitor interaction with displays and objects, assessing how well different design concepts worked. She learned how design solutions can accommodate constraints while still achieving project aims. In 1993 she established Blue, a design business that has undertaken projects from single graphic panels to exhibitions and galleries to complete museums, including many temporary exhibitions at the Bowes Museum.

JOANNA HASHAGEN has a BA in the history of art and a postgraduate diploma in museum and art gallery studies. She has been curator of fashion and textiles at the Bowes Museum, Barnard Castle, since 1981. Prior to this, she was assistant keeper, Gallery of Costume, Manchester. She has curated many temporary exhibitions with accompanying published catalogues, including *Royal Style: The Queen Mother's Wardrobe* (1992) and, with Santina Levey, *Fine & Fashionable: Lace from the Blackborne Collection* (2006). She led the project for the Fashion and Textile Gallery. Since 2011 she has delivered the temporary exhibition program, including *Vivienne Westwood Shoes* (2011) and *Stephen Jones: From Georgiana to Boy George* (2012). She organized *Style Is Eternal: Yves Saint Laurent* (2015), co-curated with Sandrine Tinturier, head of Collections, Fondation Pierre Berge-Yves Saint Laurent.

JANET WOOD has a BA in fashion and textiles. After her career in fashion design, she trained as a textile conservator with Historic Royal Palaces, United Kingdom. She was a member of the Conservation and Collection Care team, conserving tapestries, state beds, and costume (1994–2012). Since 2012 she has been a freelance consultant specializing in the conservation, interpretation, and display of historic dress and the design of training programs. She has worked on exhibitions at Kensington Palace; the Tower of London; the Fashion Museum, Bath; Buckingham Palace; and the Victoria and Albert Museum, London. In 2009–10 she served as consultant for the display of dress in the Museum of London's *Pleasure Garden*. She is a trustee of the Costume Society, United Kingdom.

11 | A DELICATE BALANCE
ETHICS AND AESTHETICS AT THE COSTUME INSTITUTE, METROPOLITAN MUSEUM OF ART, NEW YORK

Sarah Scaturro and Joyce Fung

The Costume Institute in the Metropolitan Museum of Art, New York, is renowned internationally for its spectacular, immersive fashion exhibitions. Grounded in scholarly research and rigorous curation, these exhibitions are elevated through the sensitive conservation and display of exquisite fashion objects. These often dramatic exhibitions are underpinned by a methodical approach centered on the close collaboration of the conservation, curatorial, and installation departments within the Costume Institute. This paper uses three case studies to introduce the delicate balance between ethics and aesthetics that the conservation and installation departments, both reporting to the curator-in-charge, must achieve in order to realize the Costume Institute's goal of presenting high fashion as an art form. These examples illustrate diverse approaches taken toward the conservation and display of historical, twentieth-century, and contemporary clothing.

THE COSTUME INSTITUTE'S HISTORY

To fully understand the aesthetic imperative underscoring each Costume Institute exhibition, it is critical first to address the department's development, especially in the context of its relationship to the fashion industry. The Costume Institute has thirty-five thousand objects, including the Brooklyn Museum Costume Collection, which was generously transferred in 2009. The institute's origins lie in a modest collection of historical and regional costumes started in 1915 by sisters Alice and Irene Lewisohn for use in theatrical productions by the Neighborhood Playhouse in New York's Lower East Side. By 1937, this collection was incorporated as the Museum of Costume Art, which Irene Lewisohn and Aline Bernstein (a costume designer) envisaged as a "source of authentic information and inspiration to stylists, couturiers, designers and manufacturers" with a program ambitiously focused on "the clothes of all ages and all peoples" (Koda and Glasscock 2014:22). Closely aligned with the fashion industry from its inception, its exhibitions were well attended. The collection grew through donations from members of New

York's high society, and it contained more than five thousand objects by 1944, when plans were initiated to merge the Museum of Costume Art with the Metropolitan Museum of Art. With the support of several fashion executives—including Dorothy Shaver, president of Lord & Taylor (the upmarket department store), and Eleanor Lambert, publicist and creator of the International Best-Dressed List and the twice-yearly New York City fashion weeks—successful integration within the Metropolitan Museum of Art was completed in 1946.

Uniquely within the Metropolitan Museum of Art, the Costume Institute was tasked with raising its own operating budget through contributions from the fashion industry, which it achieves primarily through the Party of the Year fund-raiser. This event is still the source of the department's funding, allowing it to benefit from the fiscal strength of the fashion system while maintaining the cultural authority of the museum. This funding structure underscores the requirement that the Costume Institute must continuously engage with designers, stylists, journalists, executives, and other creative professionals within the fashion industry and, thus far, the department has been able to do this by positioning itself as an inspiring and collaborative partner intent on framing high fashion as an art form.

From the start, the Costume Institute engaged the fashion industry and museum visitors with exhibitions that had contemporary relevance while being grounded historically. Utilizing the museum's collection of artworks spanning millennia, the exhibitions implemented the now long-standing practice of showing historical, ethnographic, and contemporary garments together to contextualize art historical themes. Typically, the mannequins were displayed in one of two ways: against a neutral background, or immersed in a period setting, when the goal was to achieve a didactic realism through head treatments, accessories, props, and artwork.

The appointment in 1972 of legendary fashion editor Diana Vreeland as special consultant consolidated the unique relationship between the Costume Institute and the fashion industry. Vreeland's tenure (1972–1989) marked the transition from realism to spectacle for the institute's exhibitions through fully designed, immersive experiences: some featured shocking colors, scents piped throughout the galleries, music, and fantastical props. One of her most effective contributions to the modern display of costume was the abstraction of mannequins. By knotting stockings over their heads and obliterating facial features, she established cohesion in the display of garments from disparate designers and time periods and set the art object apart from its former life as

a fashion object. This practice of abstraction continues today, as seen in the head treatments devised by Julien d'Ys and Guido Palau for the exhibitions *American Woman: Fashioning a National Identity* (2010) and *Schiaparelli and Prada: Impossible Conversations* (2012).

The importance of close dialogue between the fashion industry and the Costume Institute has been reinforced in recent decades, notably through the fund-raising efforts of *Vogue* editor and Condé Nast creative director Anna Wintour, an honorary trustee at the museum and chair of the Party of the Year. Proceeds from the fund-raiser have enabled renovations, such as new galleries with advanced technological capabilities; expanded collection storage; a research library; an installation and photography studio; and a state-of-the-art conservation laboratory. To acknowledge her support, the newly renovated area opened in 2014 was named the Anna Wintour Costume Center, while the curatorial department retains the Costume Institute name.

CRITERIA FOR COLLECTING AND EXHIBITING FASHION AT THE COSTUME INSTITUTE

The original collection included garments, accessories, and textiles from throughout the world and spanned five centuries and every socioeconomic sphere; however, within the last decade, the institute's remit has been clarified to focus only on the best examples of historical and contemporary Western high fashion. Factors such as provenance, significance, rarity, artistic achievement, and lacunae are all considered in the accessioning and deaccessioning processes. Another factor, which is just as important, is "exhibitability."

If an object cannot be exhibited to meet the artistic goals of the Metropolitan Museum (due, for example, to its condition, irreversible modern alterations, or even proportion and size), it may not be acquired or retained. Condition is of paramount importance in determining "exhibitability" at the Costume Institute. If an object has irreparable or untreatable condition issues that prevent it from being legible as an exceptional example of its type, it will not be exhibited, even if these issues do not affect its structural integrity. An object is rarely chosen if its poor condition means it must be displayed flat or in some other way that undermines the viewer's perception of it as a supreme exemplar of fashionable dress. Although flat display methods for non-Western fashions are used in other departments at the museum, where emphasis is typically on textile design, the prevailing philosophy of the Costume Institute is that Western high fashion is best understood when the object's relationship to the body and silhouette is clear.

The role of fashion as a visual medium, combined with the fact that the Metropolitan Museum is fundamentally an art museum and not a history museum, means that aesthetic considerations are fundamental when displaying dress at the Costume Institute. The exhibited artifacts must appear to be as close to the fashionable ideal as possible. As the following exhibition case studies show, this goal can present unique challenges in the conservation and display of garments. From the moment an object is selected for an exhibition, it undergoes a rigorous cycle of approval, examination, documentation, and treatment before it is mounted for display. The conservator's and installer's roles are as advocates for the object and enablers for the curator's aesthetic vision, mediating the physical requirements of the object against desired methods of display.

CHARLES JAMES: BEYOND FASHION (2014)
The opening exhibition of the Anna Wintour Costume Center was *Charles James: Beyond Fashion* (May 8–August 10, 2014). Celebrating the oeuvre of Charles James (1906–1978), a seminal mid-twentieth-century Anglo-American designer, the 123 objects in the exhibition came from the institute's collection, with a few strategic loans.[1] With so many iconic examples, the object list was streamlined to prioritize the garments in the best condition. However, even the selected garments had serious condition issues resulting from James's unique construction techniques. Issues included weakened fabrics at underarms, waists, and hems; and dresses with heavy, multilayered structural skirts that were deformed and collapsing, with consequent weaknesses at the shoulders and waists. Treatment requirements for the exhibition were so demanding that two temporary conservators were hired.[2]

The contrasting approaches taken for two of the objects selected for this exhibition illustrate the challenges the conservators faced in balancing aesthetic imperatives with conservation ethics, as well as the benefits of the depth of the institute's collection and its close connection with the fashion industry. The first example is a dramatic, flame-orange 1950 cocktail dress with silver metallic wefts (2009.300.181), a favorite of the curators for its stunning color and exemplification of James's "spiral" construction technique. Examination revealed that the dress was in very poor condition: the silver wefts were fracturing the weakened orange silk warps. The conservators determined that the dress could not be safely mounted for exhibition without an interventive adhesive treatment requiring it to be completely taken apart. The complexity of the dress's spiral construction, the lack of time for adequate adhesive testing

and treatment, and the potential for change in hand and drape, coupled with the availability of several other exemplary garments of this type (although not the same color), led the conservators to recommend that the curators select another version. After exhaustive condition documentation, this dress was returned to storage.

The treatment of a red-and-white gown worn for a fund-raising March of Dimes[3] ball (2009.300.2786) exemplifies the conservation department's advantageous relationship with New York City's fashion industry. The collection contains four such ball gowns in varying condition, all with an ivory-colored, pleated cotton organdy flounce. These flounces now have a dark brown, splotchy discoloration that diminishes the contrast of the ivory against the deep red velvet bodice and satin drapery. The dress in the best condition was chosen for exhibition, but the conservators realized that the discolored flounce prevented the gown from fully exemplifying James's artistic intent. Here, the challenge was caused by the mismatch between the ideal aesthetic vision and the surviving material evidence. While ascertaining an artist's intent is never straightforward, the department's conservators have to address aesthetic issues if garments that are intended to represent the fashionable ideal fall short of their iconic appearance.

The conservation team identified two options. The gown's construction made in situ treatment complicated, so one option was to remove the flounce, wet-clean, re-pleat, and then reattach it; a second option was to remove the flounce and replace it with a replica. No previous treatment documentation survived, but a professional publication revealed that flounces on two March of Dimes dresses, including the one chosen for this exhibition, had been removed, washed, bleached, and re-pleated in 1983.[4] This was reported to have improved the appearance sufficiently to meet curatorial requirements (Anonymous 1983:2). However, the discoloration appeared to have returned, indicating that further bleaching treatments could be similarly ineffective in the long term, especially without scientific testing. Staining at the pleated edges further complicated matters: should wet-cleaning fail to reduce the brown discoloration completely, the re-pleating process would be laborious and painstaking. These factors, and the compressed time schedule, resulted in the decision to work with a pleating company in New York City's garment industry to craft a new flounce (fig. 11.1). The original flounce was removed after documenting its position, and the new starburst-pleated cotton organdy flounce was temporarily attached.[5] The original flounce was reattached after the exhibition closed, and the replica was retained for future exhibitions.

FIGURE 11.1

An exhibition view of *Charles James: Beyond Fashion* (2014). In the foreground is the March of Dimes ball gown (2009.300.2786) with the reproduction pleated flounce. © The Metropolitan Museum of Art

The dressing of the objects for the James exhibition was similarly complicated. As the exhibition thesis focused on James's innovations in pattern making, draping, and construction, the garments themselves were the main focus, sublimating context and styling. Invisible mounts[6] were chosen for the display method to accentuate the sculptural quality of the costumes and their appearance as works of art *beyond fashion*. Each garment was fitted on a papier-mâché dress form on which the neckline was traced. The exposed neck area was subsequently cut away, creating a hollow form that would not be seen. Fabric matching the interior of the costume (which James often designed in a contrasting color) was used to drape the form to camouflage it and give the effect of looking into the costume. The success of these forms allowed the "body" to be invisible while practically and aesthetically preserving shape and silhouette.

These static and minimalistic mounts complemented the main conceit of the exhibition's designers, architectural firm Diller, Scofidio + Renfro. The designers utilized technology to highlight James's analytical, quasi-mathematical construction methods while maintaining a minimal approach to three-dimensional display. Animations showed two-dimensional fabric transforming into the displayed costumes, dissecting the structures and patterns of the garments and letting

the visitors see "through" the clothing. All technical information was supplied by the conservation team, thus expanding the conservation program to include treatments and research.[7] The garments were further probed by robots and lasers, emphasizing their three-dimensionality. In one gallery, live-feed cameras wove around day and evening wear, providing visitors with additional vantage points to appreciate the intricate dressmaking while introducing movement in a still gallery.

DEATH BECOMES HER: A CENTURY OF MOURNING ATTIRE (2014–15)
With the opening of the Anna Wintour Costume Center, the Costume Institute moved to producing two exhibitions per year. While the department has many resources at its disposal, time is not one of them. The twice-yearly exhibition schedule and other responsibilities, such as loans and collections care, result in the conservation and installation departments typically having fewer than nine months to prepare an exhibition. This means that the depth of the collection is of vital impor-tance in the curator's initial phase of object selection, especially for historical exhibitions such as *Death Becomes Her: A Century of Mourn-ing Attire* (October 21, 2014–February 1, 2015). Although the exhibition included loans, most of the 116 objects were from the department's collection. Because conservation treatments of historical garments are typically labor intensive, the conservators worked closely with the cura-tors to identify objects that had only minimal condition issues, while a few were singled out for more-intensive treatments. The nineteenth- and early twentieth-century mourning attire for *Death Becomes Her* was particularly fraught with condition problems. Most of the potential exhibits had at least one of two typical conditions: shattering and disintegrating black fabrics, and unstable embellishments, such as beads with glass disease. Fortunately, the richness of the collection allowed the curators to select objects that could be adequately treated within the time frame.

The treatment approach to three objects in *Death Becomes Her* illustrates what the institute's well-resourced conservation laboratory can achieve when mounting a historical exhibition with a compressed preparation period of approximately six months. Close examination of two French sequined demi-mourning gowns worn by Queen Alexandra following Queen Victoria's death in 1902 revealed each had already undergone several treatment campaigns, although no documentation was found. Both gowns had weak and unstable foundation fabrics, and the thread securing the metal and gelatin sequins was weak. The

conservators initially recommended these gowns not be displayed due to their poor condition. However, they recognized that these dresses were integral to the curatorial thesis, and the exhibition provided the best opportunity to treat them. There was only time and space for a temporary conservator to treat the mauve gown (C.I.37.44.1).[8] The goal was to support the skirt, shoulders, and sleeves, stabilize as many metallic sequins as possible, and compensate for sequin loss. Previous conservation treatments were left in situ, as removing them would cause further damage. It was impossible to stitch through every sequin in the time available; it was accepted that the dress would continue to shed sequins with major movement, although comprehensive photographic documentation was undertaken, and every single detached sequin was retained.

The only way the purple sequined dress (C.I.37.44.2a, b) could be sufficiently stabilized for display within the time frame was for it to be sent to an external conservation laboratory.[9] Both the temporary and independent conservators were directed to treat only the most significant condition issues. The goal was to replace distracting and poorly executed patches at the waist and bodice, support the skirt for further stability, and reattach and stabilize as many sequins as possible. Comparison with photographs of mid-twentieth-century exhibitions revealed that the back collar section was missing. In consultation with the curators, the missing portion was reproduced using new silk net and sequins that had already detached from the dress. The reproduced back collar was retained on the garment when the dress was returned to storage.

A third treatment focused primarily on distracting aesthetic issues, as the object was fundamentally stable. The black cotton Cluny lace on a black silk faille demi-mourning gown (2009.300.673a, b) was fragmentary and disintegrating, creating large blank areas. The conservators settled upon an innovative approach that, while costly, aimed at safely reproducing the scale, color, shape, and texture of the damaged lace. Through a collaboration with a New York City artist, high-resolution photographs were manipulated with computer-aided design (CAD) software. The resulting design was machine-embroidered in polyester thread onto a dissolvable substrate; when washed in deionized water, the reproduction "lace" was revealed. Several different kinds of embroidery patches were created, some mimicking lace for areas of loss and others corresponding to lace that had faded to dark brown. These patches were trimmed as needed to fill in the areas of missing lace. Where necessary, fragmentary areas of original lace were left in situ and covered by the reproductions (fig. 11.2).

These treatments illustrate typical conservation situations and deci-
sions in mounting historical exhibitions, and the conservation laboratory
staff could not have achieved successful treatment and mounting of
these three objects without sufficient budgetary and human resources.
The conservators relied on their close ties with New York City's fashion
and art communities to treat objects creatively and effectively. After
their stability and aesthetic issues had been successfully addressed,
these historical objects were transferred to the installation studio
for mounting.

To illustrate the evolution of mourning attire between 1815 and 1915,
fully accessorized and fully visible mannequins were chosen, as they help
the public better visualize the social imperatives of this sartorial custom.
Three styles of the historical mannequin manufactured by Nanasai, origi-
nally developed by the Kyoto Costume Institute (KCI) with input from
the Costume Institute, were used. The ability of the KCI mannequins to
achieve the correct silhouette with ease is unsurpassed. Small-size his-
torical garments do not readily fit the robust bodies of contemporary
mannequins. The corseted body of the eighteenth- to early twentieth-
century woman is built into the shaping of the KCI mannequins' bustline
and modifiable waist. Latch-on arms facilitate dressing, while height is
adjustable. Properly mounted on such mannequins, historical costumes

FIGURE 11.2
An exhibition view of
*Death Becomes Her: A
Century of Mourning
Attire* (2014–15)
showing mannequins
in customized poses.
The demi-mourning
dress (2009.300.673a,
b) on the left has the
reproduction black lace
trim. © The Metropolitan
Museum of Art

are more convincing, because they manifest the appropriate body ideal and posture. For *Death Becomes Her*, great care was taken with each mannequin's pose and gesture, extending the scope of the rotating head and basic arms so that the figures appeared to be engaging with one another. One vignette, set at a ball, showed a guest in demi-mourning moiré pondering her next partner, with *carnet de bal* (dance card) held close and a fan to her chin. Another scene included grieving women, one with consoling arm around another sobbing into a handkerchief. Specialty poses were achieved through simple mechanisms, such as hinged Ethafoam, and by collaboration with a mannequin refurbishment company, which cut and repositioned fiberglass arms.

Heat-set wigs specially created for each ensemble by theatrical designer Paul Huntley gave each mannequin a heightened sense of individuality. Mirroring the expanding skirts and falling bustlines, the synthetic hair was parted, braided, curled, and puffed in a myriad of historically accurate styles. Additional accessories from installation materials, such as feather aigrettes, pearl chokers, and folding fans, were added as finishing touches in the mise-en-scènes.[10] Only the mannequins' deathly white pallor, along with their stark white hairstyles, maintained a distance from realism.

ALEXANDER McQUEEN: SAVAGE BEAUTY (2011)

This illustrates a third type of Costume Institute exhibition consisting of contemporary objects, mostly loans (Bolton 2011). These exhibitions typically relieve the conservators from having to undertake complex treatments, because their work is focused on unpacking the loans and documenting their condition. The installation department, however, is tasked with dressing the mannequins—a difficult job due to smaller-size garments borrowed directly from fashion-house archives composed of runway samples (fitted on increasingly slimmer models), as well as avant-garde designs born of the *défilé* spectacle rather than wardrobe practicality. Current fashions rival those of the nineteenth century and New Look in terms of difficulty of fitting on a mannequin. On the body of a runway model, flesh is constricted and displaced by boned bodices and leather carapaces, but such distortive properties are not shared by the fiberglass body of a mannequin.

Mannequin selection is integral to the display of costume. In the case of nonhistorical costume, the supply of commercially available display mannequins is almost limitless and often customizable to the satisfaction of both curator and exhibition designer.[11] However, even though the standard measurements of a commercial mannequin can

work for many contemporary objects, just as often they do not. While a specialty KCI mannequin can suit the unique needs of a Victorian dress, no such mannequin exists for a Victorian-inspired dress by Alexander McQueen (1969–2010). The lack of a contemporary mannequin suitable for the extreme shaping of many new fashions is a significant problem in museum mounting. Without adjustment, not only can the garment be misaligned on the form, with proportion and designer's intent disrupted, but strain and poor fit can cause damage. A garment can be left half-zipped, but in-the-round display potential then becomes limited, and the integrity of a fully supportive mount is undermined.

When dressing *Alexander McQueen: Savage Beauty* (May 4–August 7, 2011), it became necessary to modify the mannequins drastically so they fit the clothes and shoes. Reversing the technique of making an invisible mount, the mannequin was traced not along the perimeter of neckline or armholes but around the curves of breast, waist, hips, and buttocks (a common area of reduction for a designer known for his "bumsters"). Like plastic surgery, extraneous shapes were cut away by spiral saw and sanded down.[12] The cavity was then spanned with archival pressure-sensitive tape or filled with smoothly carved Ethafoam

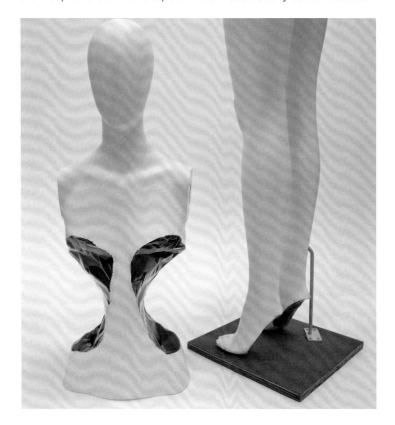

FIGURE 11.3
Mannequin components with cut-down torso and feet. © The Metropolitan Museum of Art. Photo: Joyce Fung

(closed-cell polyethylene foam), resulting in smaller body circumferences (fig. 11.3).

The trend of the ever-higher heel, culminating in the Armadillo shoe designed by McQueen, is always a challenge in dressing contemporary fashion. A difference in arch heights between the shoe and the mannequin's fixed foot means the toe of the shoe is inevitably upturned. If the shoe is perfectly level on the ground, the body would tip forward precariously. To ameliorate this, the sole of the foot is cut away at an angle, so that the body can sink into the high arch of the shoe. Such details, small in terms of dressing a full ensemble, are essential in maintaining the stability of the mannequin and the safety of the object, as well as the overall presentation.

CONCLUSION

The Costume Institute's conservation and installation departments are always guided by complete devotion to the objects and the exhibition narrative. Crafting a flexible yet ethical conservation program that allows an object to be presented as a fashionable ideal is an evolving process that reveals itself through each exhibition. Similarly, installation mounts are actively used for specific scenographic effects or sublimated to be invisible, whichever achieves the aesthetic objectives of curation.

The Costume Institute relies on its close connections with the fashion industry, not only for funding and resources but for inspiration. This relationship ensures that the museum's wide audience, ranging from fashion specialists to tourists, can expect exciting, groundbreaking costume exhibitions. Ultimately, it is the rigorous and ambitious approach to crafting visually arresting presentations, within the parameters of best museological practice, that sets apart exhibitions at the Costume Institute. The balanced relationship between the strict requirements of ethical museum practice coupled with the drive for compelling aesthetics—one never forsaking the other—is key to its blockbuster exhibitions and to the critical success of the Costume Institute's conservation and display of dress.

NOTES

1. The Costume Institute possesses almost all of Charles James's archives, due to the Brooklyn Museum Costume Collection transfer, along with a gift from Homer Layne, who was James's last assistant.

2. For an overview of typical condition problems found in James's garments, see Scaturro and Petersen 2014.

3. The March of Dimes Foundation supports mother and baby health. It was founded in 1938 by President Roosevelt to combat polio.

4. A 5% v/v hydrogen peroxide solution was used.

5. The flounce had been removed in the 1983 treatment, and thus this position might not have been original.

6. The production of the accompanying book *Charles James: Beyond Fashion* (Koda and Reeder 2014) predated the finalization of the exhibition design concept; consequently, a standard mannequin and traditional styling were used for catalogue photography.

7. For a discussion about the full scope of conservation, see Rachel High, "*Charles James: Beyond Fashion*—Interview with Conservators Sarah Scaturro and Glenn Petersen," Metropolitan Museum of Art, accessed November 13, 2015, http://www.metmuseum .org/about-the-museum/now-at-the-met/2014/charles-james-conservation/.

8. The treatment was carried out in the conservation laboratory over approximately six months.

9. The external conservator had previously worked in the conservation laboratory.

10. The Costume Institute has a rich collection of installation materials. Reproduction underpinnings consisting of petticoats, hoops, or bustles are the foundations of a period silhouette. Accessioned items, if unseen, are never used in the display of dress, including accessories that might be damaged during installation (such as close-fitting leather gloves, or shoes that must have holes drilled into the soles to accept the man-nequin base or flange).

11. A customized bone-colored cement finish was requested of the Bonaveri mannequin company for *Alexander McQueen: Savage Beauty*.

12. This technique was carried out and refined by Michael Downer, principal departmental technician.

REFERENCES

Anonymous. 1983. Lecture. *Textile Conservation Group Newsletter* 5 (5): 2.

Bolton, Andrew. 2011. *Alexander McQueen: Savage Beauty*. New York: Metropolitan Museum of Art.

Koda, Harold, and Jessica Glasscock. 2014. "The Costume Institute at the Metropolitan Museum of Art: An Evolving History." In *Fashion and Museums: Theory and Practice*, edited by Marie Riegels Melchior and Birgitta Svensson, 21–32. London: Bloomsbury.

Koda, Harold, and Jan Glier Reeder, eds. 2014. *Charles James: Beyond Fashion*. New York: Metropolitan Museum of Art.

Scaturro, Sarah, and Glenn Petersen. 2014. "Inherent Vice." In *Charles James: Beyond Fash-ion*, edited by Harold Koda and Jan Glier Reeder, 233–49. New York: Metropolitan Museum of Art.

AUTHOR BIOGRAPHIES

JOYCE FUNG is senior research associate, Costume Institute, Metropolitan Museum of Art, New York. She holds an MA (visual culture, costume studies) from New York University and a BS (apparel design) from Cornell University, where she worked in the Cornell Costume and Textile Collection. Fung has assisted with installations at the Costume Institute since *Goddess: The Classical Mode* (2003). She became primary dresser for the department in 2010 with *Alexander McQueen: Savage Beauty* (2011), her inaugural exhibition. Prior to

her position in installation, Fung worked in the Costume Institute's curatorial department, imaging and carrying out picture research.

SARAH SCATURRO is the head conservator, Costume Institute, Metropolitan Museum of Art, New York. She was formally the textile conservator and assistant curator of fashion at the Cooper-Hewitt, Smithsonian Design Museum. She holds an MA (fashion and textile studies: history, theory, and museum practice) from the Fashion Institute of Technology and a BA (summa cum laude, history and Italian) from the University of Colorado at Boulder. Scaturro coedited a special issue for the *Journal of Fashion, Style and Popular Culture* on "Curating Costume/Exhibiting Fashion." She is pursuing a PhD, with a focus on the history of fashion conservation, at Bard Graduate Center.

12 | FASHION AS ART
DRESSED TO KILL: 100 YEARS OF FASHION

Micheline Ford and Roger Leong

The focus of this paper is *Dressed to Kill: 100 Years of Fashion* (1993–94), a major exhibition of elite style at the National Gallery of Australia (NGA), Canberra, for which we were curator (Roger Leong) and textile conservator (Micheline Ford). This exhibition was, and remains, the largest and most ambitious display of the NGA's fashion collection, offering the opportunity to present fashion in the context of a gallery dedicated to the fine and decorative arts.[1] Our discussion focuses on the display and interpretative strategy designed to engage with three aesthetic dimensions of fashion: first, the relationship of clothing to the body; second, fashion as a sign of contemporaneity; and, third, fashion as a form of spectacle. Pragmatic understanding and theoretical insights by museum theorists and practitioners, including Elizabeth Wilson, Alexandra Palmer, and Lou Taylor frame the discussion. This paper considers display rather than textual interpretation; it does not discuss conservation parameters, as these are well known.[2] Our goals were to present items of dress held in the NGA collection as fashion and to create an exhibition in which fashion was presented as art. Interdisciplinary institutional collaboration was essential to achieve these goals.

DRESSED TO KILL: 100 YEARS OF FASHION
Dressed to Kill comprised seventy-five outfits, fifty accessories, and approximately one hundred works on paper. It included influential European, American, and Japanese couturiers and ready-to-wear designers, from Charles Frederick Worth (1825–1895) to designers from the 1990s, as well as key fashion illustrators and photographers. Rescheduled at short notice into the popular summer period, the exhibition gained a higher profile than originally expected; as a result, the project was given considerable institutional resources and a premium space, resulting in a theatrical presentation with high production values and dramatic staging, lighting, and multimedia components.

Critical writing on fashion display and interpretation in museums has developed considerably since the 1990s, alongside the growth of

fashion studies in academia.[3] Elizabeth Wilson's seminal work *Adorned in Dreams: Fashion and Modernity* (first published in 1985) addresses many of the themes that continue to engage fashion theorists today: "There is something eerie about a museum of costume. For clothes are so much part of our living, moving selves that, frozen on display in the mausoleums of culture, they hint at something only half understood, sinister, threatening; the atrophy of the body, and the evanescence of life" ([1985] 2003:1). Wilson argues that the essential character of fashion is change and spectacle (ibid.:58, 60). Alexandra Palmer, Lou Taylor, and Valerie Steele, drawing on their experience as curators, have written perceptively on the display of dress while remaining cognizant of the practicalities of working within an institution.[4]

In retracing the steps taken by the *Dressed to Kill* team, we acknowledge Diana Vreeland (1903–1989), so inspirational in the 1970s and 1980s, and the work of curator Stella Blum (1916–1985), both of the Costume Institute, Metropolitan Museum of Art, New York. Images of Vreeland's innovative displays and the two exhibitions associated with the Costume Institute that visited Sydney and Melbourne in the 1980s were certainly influential.[5] Our efforts to create a dynamic and affective experience were stimulated by Vreeland's focus on expressing the "creative talent of the fashion designer and the imagination of the given fashion world" (Melchior and Svensson 2014:8). As stated in our media release for the exhibition (November 30, 1993): "We have tried to capture and express the excitement, the drama, and the humor with which the very best fashion is associated, in order to communicate the designers' aesthetic and intellectual ideas" (quoted by Douglas 2010:142).

FASHIONING THE BODY

The relationship of clothing to the body is a critical attribute of fashion, as is the fashioning of bodies themselves as cultural objects (Entwistle 2000:12–16). Consequently, the absence of the human figure in fashion exhibitions is one of the greatest challenges for museums to over-come. Shortcomings in museum dress displays have been eloquently described. Wilson identifies the fading "evanescence of life" (2003:1), while Taylor notes the need to compensate for the lack of light, poise, and movement, highlighting the challenge to "revive" humanity in a set of clothes shown on a "static dummy" (L. Taylor 2002:24).

In *Dressed to Kill* we were faced with outfits designed for more than ten different body shapes. In selecting mannequins, we set-tled for a radical compromise: a standard dressmaker form for the

nineteenth- and early twentieth-century garments, and a range of mannequins with heads and limbs for the twentieth-century clothes.[6] Each type of figure was adapted for the requisite era, shape, and look (ibid.:29). The standard fiberglass dressmaker forms without heads or limbs were intended to act as neutral bodies. Many required specific modifications to their size, shape, and proportion. Our workshop team sliced away excess curves, while our conservation technician used polyester batting and stretch fabric coverings to perfect the shapes. Underpinnings (e.g., petticoats and crinolines) were constructed to support skirts and produce the required look. The dressmaker forms seemed most convincing with ensembles, such as a Worth visiting costume (ca. 1886) and evening dress (ca. 1903). These full-length outfits, with their substantial fabrics, extreme bustle shape, or S-bend silhouette had a sculptural presence on display.

Exhibiting the 1920s dance dresses was challenging because of their delicate fabrics, weighed down with heavy sequins or beaded fringes. The conservation team recommended display on sloped panels, but this conflicted with the curatorial preference for using mannequins. As a compromise, conservators devised individual supports for each dress using new inner "slips" to minimize the effect of gravitational pull. However, half the dance dresses were too small for the chosen mannequins and had to be displayed on dressmaker forms. Neither type of figure was completely successful. To achieve the contemporaneous look, such dresses require a body with the era's characteristic "curved spinal slouch" (ibid.:29), whereas the mannequins and dressmaker forms were too upright. To achieve a degree of Art Deco languor, the curator and conservators agreed not to pad the dress forms or mannequins to their full extent.

There were numerous inconsistencies in the use of mannequins and dressmaker forms; for example, some of the smallest and shortest 1920s and 1950s garments could not be fitted onto mannequins, so the exhibition's earlier sections featured both types. The incongruity was alleviated by treating the garments mounted on the dressmaker forms as if they were abstract sculpture. A Christian Dior (1905–1957) ball gown (1953), made with many meters of puffed and gathered ice-blue silk taffeta, and a Cristóbal Balenciaga (1895–1972) evening dress (1951), with its spiraling shawl of thick gold satin over a column of black wool, both held their own as sculpture (fig. 12.1).

Design and curatorial staff were keen to use dynamic poses to animate the display although, as expected, these were difficult, or even impossible, to achieve. Conservation staff provided extensive

FIGURE 12.1

An exhibition view of *Dressed to Kill* (left to right): a Cristóbal Balenciaga evening dress, 1951 (84.473.1-2); a suit, 1964 (93.708.1-2); a Gabrielle "Coco" Chanel suit, 1971 (87.1481.A-C); an Adrian suit, ca. 1945 (88.1525.1-3); and a Christian Dior ball gown, 1953 (87.1481.A-C). National Gallery of Australia, Canberra

FIGURE 12.2

An exhibition view of *Dressed to Kill*. In the center is the Vivienne Westwood "Salon" corset ensemble, 1992 (92.1586.1-5) and a man's ensemble, 1988 (88.1524.1-6). The close-up views on the left and right are jumpsuit and corset ensembles by Jean Paul Gaultier (88.1524.1-6; 93.429.1-2). National Gallery of Australia, Canberra

measurements of the garments, but dimensions alone cannot predict the amount of stretch required for a pose. A mannequin with its legs spread wide in a vaulting position, chosen for a Jean Paul Gaultier (b. 1952) man's jumpsuit ensemble (1988), provides an example. The ensemble is made of cotton jersey laminated with acrylic strips, and the conservators anticipated that the stress of dressing and undressing would cause the strips to cockle or possibly split. A mannequin in a simpler standing pose, with less body bulk and straight arms and legs, was used instead, thus reducing strain on the knitted fabric. This proved a better choice both for showing the design to its full effect and for preservation purposes. Conversely, a female mannequin with twisted legs and torso, which initially seemed unworkable, convincingly animated a Vivienne Westwood (b. 1941) Mini-Crini ensemble (1987), giving a suggestion of movement.

Like the dressmaker forms, nearly half the mannequins required customization. Fortunately, the NGA's workshop team at the time was skilled in fiberglass work and spray painting. Broad shoulders were cut to accommodate narrowly fitting clothes, and breasts, waists, and hips were also reduced in size. Garment lengths proved a challenge, so legs were shortened as required. The most radical alterations were for Westwood's "Salon" corset ensemble (1992) (fig. 12.2). Although the designer's eighteenth-century-inspired corsets had introduced the trend for the "pushed-up" breast look, this was not yet reflected in mannequin manufacture, so the figure's breasts were cut off and reconfigured. Westwood's infamous ten-inch platform shoes required a mannequin "foot rebuild" to accommodate their high angle. Another challenge was presented by the Westwood corset. Its Lycra sides were designed to stretch about ten centimeters. The conservators knew this would cause too much strain over the display period and recommended the purchase of a second, identical corset specifically for display. The original accessioned corset remained unused and undamaged.[7]

The creation of the "absent body" can be fraught, involving considerations of fit, pose, and proportion. Compromise was required to balance representation of the designer's original vision, to achieve a visually unified display, and to ensure the long-term preservation of the artifacts.

FASHIONING CONTEMPORANEITY

One of the main challenges of displaying historic dress as fashion is enabling visitors to see exhibits as stylish rather than as archaic curiosities. We addressed this in three ways: styling the dressmaker forms and

mannequins so the exhibits could be presented as fashionably contem-
poraneous; styling the garments by referencing contextual visual evi-
dence; and styling the space itself in terms of layout, color, and lighting.
We hoped that concentrating on our understanding of the designers'
original vision, and alluding to the contemporary impact of the gar-
ments, would establish them as modish in their own time, thereby imbu-
ing each historical object with the sensation of novelty and desirability
normally associated with fashion of the moment. We were again uncon-
sciously following Vreeland, who had an "intuitive awareness that the
clothing of the past was never 'costume,' but rather was the 'fashion' of
its day" (Steele 2008:11).

The first step in what we considered a "contemporization process"
was to style the supporting dressmaker forms and mannequins. The
dressmaker forms were presented in a manner intended to indicate
the historical status of the mounted garments. They were covered in
undyed Belgian linen fabric; turned, stained wooden finials and tri-
footed stands were attached. This pseudo-Victorian/Edwardian style,
contemporaneous with the nineteenth-century and turn-of-the-century
garments, suited the upright posture and the defined silhouette. How-
ever, this historicized look seemed to undermine the interpretation of
later pieces, such as the Mariano Fortuny (1871–1949) Delphos dresses
(ca. 1907–30) and a Madeleine Vionnet (1876–1975) dance dress (ca.
1925). This became apparent when our dressmaker forms were com-
pared to the unadorned, neutral forms used by the Kyoto Costume
Institute to display their loan of two Vionnet dresses and a cape by Elsa
Schiaparelli (1890–1973). What began as a decision to create design
continuity through the use of finials on the dressmaker forms became,
in hindsight, an interpretative encumbrance.

Another challenge in our choice of mannequins was the degree of
realism or stylization, recognized as a perennial question for museums
(L. Taylor 2002:36). Our initial attempts veered toward a level of real-
ism, aiming to reinstate an idealized image of the completely acces-
sorized fashion model. We used vintage or reproduction hats, shoes,
gloves, stockings, and occasionally jewelry to create what Palmer calls
the "ensemble effect" to "balance the garments and the silhouette," an
approach she learned from working with Blum (2008:35).

The hats looked odd resting on the bare heads of the off-white/
pink mannequins, so we added appropriately styled natural-hair wigs.
Management colleagues became increasingly dissatisfied with the
wigs' appearance; the director reminded us that the mannequins were
not real women. We were uncertain how to proceed until the deputy

director suggested asking the artist Marie Hagerty (b. 1964) to paint the mannequins' hair and faces. In her figurative work of the time, Hagerty was particularly interested in the Spanish painter Diego Velázquez. She also loved fashion. We showed her each garment and mannequin with associated picture research. Team members, including the deputy director, exhibition designers, and senior managers, visited Hagerty's studio to discuss the first trials. All agreed these were somewhat labored; Hagerty remembers how she "painted them like they had flesh like a painting."[8] Soon, however, she was customizing and personifying each mannequin with painterly bravado and economy; under low museum lighting, they came to life in a quite magical way. The strong gestural element of her brushstrokes invested many faces with a gritty glamour that was perfectly in tune with the early 1990s grunge, goth, and "heroin chic" trends. Hagerty's work lent the display an air of current fashion and an aura of contemporary art authenticity. Martin Margiela, one of the designers represented in the exhibition, noted that he was particularly impressed by Hagerty's painted faces.[9] However, for many visitors, these seemed to have been absorbed into the ambience of the exhibition, enhancing without drawing undue attention. This was welcome confirmation that we had successfully nuanced the display for the audience.[10]

Faced with the urgent task of photography for the exhibition catalogue, we found ourselves styling mannequins before determining the exhibition's overall design values. A number of changes in our decision-making meant that the catalogue stands as one approach to visual interpretation, while the exhibition took another path (fig. 12.3). Working through the catalogue photography enabled us to gauge the mannequins' limitations, fine-tune details of fit, and attend to other areas of weakness before display. It also allowed the exhibition designer and the executive team (notably the director and deputy director) to monitor progress.

The exhibition, presented in five interconnected, high-ceilinged rooms, was organized as a chronological narrative, from Worth in the late nineteenth century to Westwood in the early 1990s. This spatial arrangement supported the premise that fashion represents change and renewal over time. In each space, the experience of the objects was further animated through the display of contemporaneous illustrations (journals, photographs, and posters), providing the best way to show "how the garment would have been worn" (L. Taylor 2002:47).

The power of these graphic works was highlighted at the start of the exhibition with *La Rue* (1896), a color lithograph by

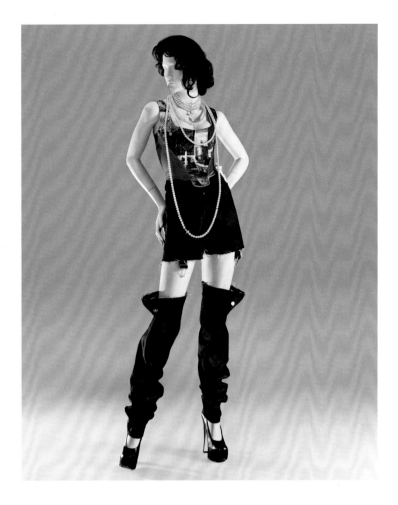

FIGURE 12.3
The Vivienne Westwood
"Salon" corset ensemble,
1992 (92.1586.1-5), as
depicted in the *Dressed
to Kill* catalogue (Leong
1993:69). National Gallery
of Australia, Canberra

Théophile-Alexandre Steinlen (1859–1923) that was placed behind
a group of nineteenth-century and turn-of-the-century haute cou-
ture ensembles, including a sumptuous tea gown (ca. 1892) by Emile
Pingat (1820–1901). The huge poster (more than 2 × 3m) depicts a
French street scene of well-dressed working- and middle-class men
and women. The color, movement, and sheer size of the imagery suc-
cessfully animated the space and conjured up the zeitgeist. The NGA's
collection of early twentieth-century photographs and fashion plates,
particularly those from the *Gazette du bon ton*, featured prominently
in the first two rooms.[11] These were given ample space so that visitors
could contemplate them as objects in their own right, and they created
an interpretative framework between actual garments and the idealized
fashion image (ibid.:46). The lively illustrations may have compensated
for the lack of animation in the dress forms used for some of the 1920s
ensembles. The use of large-scale blown-up photographs, such as the

iconic image of a Dior model climbing the steps of the Paris Opéra,[12] similarly heightened the theatrical effect of the 1940s and 1950s themed room.

A group of three ensembles lent by the designer Zandra Rhodes (b. 1940) and a suite of striking photographs and posters of Rhodes's work by Robyn Beeche[13] proved to be one of the strongest combinations of image and object (fig. 12.4). We worked closely with Rhodes to re-create the styling of her ensembles, even commissioning a reproduction pair of 1971 knee-high satin boots from Anello & David, the original British makers, for one of her iconic kaftan dresses. Hagerty painted one of the mannequins with bright orange hair, alluding to the designer's own colorful hairstyle. When Rhodes visited the museum to assist in finalizing the dressing of her works, she asked if Hagerty could paint an extra eyebrow on one of the mannequins. This complex web of collaboration

FIGURE 12.4

An exhibition view of *Dressed to Kill* (left to right): a Zandra Rhodes "conceptual chic" dress and sash, 1977; a quilted kaftan-style coat-dress in "frilly flower" and "button flower" print, 1977. National Gallery of Australia, Canberra

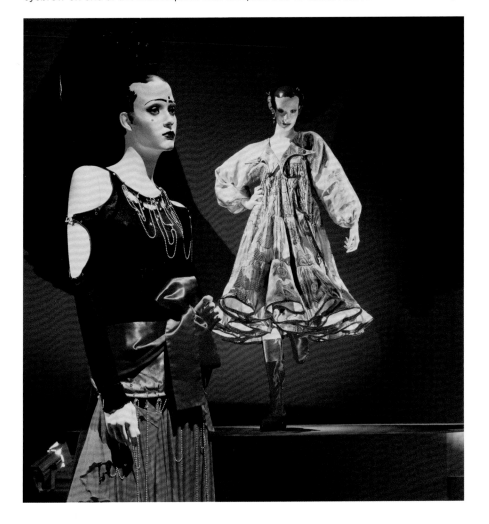

involving designer, artist, shoemakers, and the NGA team created one of the exhibition's most visually compelling tableau while also enhancing the sense of contemporaneity.

FASHION AS SPECTACLE

Fashion is a form of cultural spectacle. Mark Taylor argues that it "is mediated by multiple media ranging from print to cinematic, telematics, video, and electronic images" (1997:195) or, as Wilson defines it, "a mass pastime, a form of group entertainment" ([1985] 2003:60). Since the 1980s museums and galleries have become increasingly aligned with popular culture, particularly in "the American or Australian context where the aura of entertainment and leisure drives a large part of museum planning and marketing" (McNeil 2008:77). Recognition of high fashion as a type of performance, consumed through its simulations as much as through dress itself, motivated our exhibition team to adopt strategies to capture aspects of the experience of fashion as popular entertainment.

The *Dressed to Kill* exhibition designers played a key role in creating an immersive experience consistent with the popular image of high fashion; that is, runway presentations featuring glamorous models offering tantalizing glimpses of unattainable clothes. The runway show was adopted as a guiding principle of the design, and we decided to place most ensembles on open display. This allowed us to present garments in the round, with the freedom to adjust heights, positions, and groupings to maximize the sense of drama in the generous gallery spaces (over 1000m² and ceiling heights of 4–8m). All the figures were presented on plinths at least 0.5m high, appearing to meander obliquely through the five rooms, with each room having its own central highlight of either a single garment or group of garments on a higher plinth. The resulting conservation challenges (e.g., exposing garments and accessories to dust and potential invertebrate infestation) were resolved by regular insect checks and periodic dusting.[14] It was acknowledged that surface-cleaning the exhibits risked surface fiber loss for some of the more fragile silks and velvets.

The atmospherics of the display were important in heightening the theatrical effect. The walls of the first four rooms were painted a deep royal blue, which darkened the space considerably, giving the lighting designers ample scope to vary the lighting dramatically and to project patterns. The low, sometimes uneven theater-style lighting emphasized the shape and texture of the costumes while creating a sense of dynamism. Curatorial and conservation staff agreed that the uneven lighting

was not ideal from a preservation perspective but that the risk—for example, of color change or light-induced physical damage—was considered minimal given the overall low light levels. The lighting levels ranged from 30 to 40 lux for the early or very fragile costumes and up to 50 to 60 lux for the more contemporary pieces. This varied lighting created drama, while the floor was spotlighted for contrast and to allow safer access throughout the exhibition.

Fashion shows were featured regularly on Australian television in the early 1990s,[15] forming a vital part of the fashion experience. They provided "the paradigm of the modern spectacle which seduces us with the 'hyper-reality' of ravishing and perfect images" (Evans 2000:95), and we decided they should be integrated into the exhibition in the concluding display of contemporary fashion. We invested in the production of a continuous loop of fashion shows using DVD technology, then relatively new. The resulting huge (4m high) projection was clear when viewed from a distance but, at close range, gave a ghostly, shadowy, shifting light that subtly animated the space. The videos were combined with a music loop featuring an eclectic mix of Italian opera, contemporary jazz, and house music. The most memorable track was RuPaul's "Supermodel (You Better Work)" (1992), chosen to highlight two of fashion's defining qualities: artifice and camp.

CONCLUSION

The exhibition, a resounding success with visitors and the media, had healthy ticket and merchandise sales, sponsorship, and cross-marketing, generating a profit from the million-dollar-plus expenditure. Many factors and stakeholders contributed to these achievements, including an assistant director who became involved in staff support, procuring sponsorship and selecting music, and the coup of the NGA's public relations consultant in inviting Vivienne Westwood to attend the opening as the museum's special guest. The prime minister's wife opened the exhibition. The opening party, organized by *Vogue Australia*, attracted two thousand guests, including the cream of the Australian fashion industry. The *Sydney Star Observer* reviewed the show, unusual in the 1990s, when few Australian critics reviewed fashion exhibitions: "In terms of design and presentation it is probably the best fashion show held in Australia in the last decade. Low light levels are turned to dramatic effect. Costumes are arranged so that they can nearly all be viewed from all sides. Individual rooms are built around major central pieces. It has grandeur and opulence, wit and style; it has been put together with obvious love and care, it includes some great fashion."[16]

We acknowledge the importance of a close, constant, and respectful dialogue between conservation and curatorial staff to optimize display outcomes, encouraging the creativity and constructive compromise necessary when dealing with artifacts in public collections. Curators and conservators sometimes needed to go a step further; that is, the conservators tried to enable costumes to achieve their maximum impact, while the curators recognized the fragility of historic artifacts and respected the importance of preventive conservation strategies. Ideas drawn from museum practice and fashion theory, together with the skills, commitment, and imagination of our colleagues, enabled the creation of this popular and spectacular fashion exhibition. *Dressed to Kill* established that designer fashion could hold its own in a national art gallery. One male visitor said he felt a shiver down his spine when entering the exhibition.[17] This sensation, familiar to many art lovers, confirmed the success of our attempts to convey an experience of fashion as art.

ACKNOWLEDGMENTS

The success of *Dressed to Kill* depended on an activated team of hundreds of NGA staff members at all levels, in addition to external support and stakeholders, each of whom contributed positively to the outcome. We thank them all. We also thank Kylie Budge, Suzanne Chee, Marie Hagerty, Allison Holland, Peter McNeil, Andrew Montana, Thi Nguyen, Nick Nicholson, and Debbie Ward for their help with this paper.

NOTES

1. Since the mid-1970s, the NGA has collected and exhibited fashion within the broader context of art production. A Fashion and Textiles department was established in the 1980s, later merging with Theatre Arts. In 1990, the international fashion and theater arts collections were incorporated into the department of International Decorative Arts and, in 2002, within the department of Decorative Arts and Design. The 2005 vision statement declares the NGA's broad remit to "include exhibitions containing different media, not just painting but sculpture, photographic media, prints, drawings and the decorative arts"; see Ron Radford, "A Vision for the National Gallery of Australia," accessed July 3, 2016, http://nga.gov.au/AboutUs/DOWNLOAD/NGAvision2005.pdf/.

2. Display options were underpinned by conservation ethics. "Ethics and Reconciliation Statement," Australian Institute for the Conservation of Cultural Material (AICCM), 2002, accessed August 5, 2015, http://aiccm.org.au/about/code-ethics-and-reconciliation/. Our aim was to provide the best support while minimizing physical strain upon the costumes, with protective barriers between the museum artifacts and the fiberglass mannequins. Experience gained from *Dressed to Kill* allowed us to develop approaches and techniques that gave us greater control over the care of the collection.

3. For example, Melchior and Svensson 2014.

4. *Exhibitionism*, the 2008 special issue of *Fashion Theory*, features essays by volume editors
 Valerie Steele and Alexandra Palmer, as well as by Christopher Breward, Peter McNeil, and
 Patricia Mears.

5. *Fabulous Fashion 1907–67* (1981), curated by Stella Blum, and *Yves Saint Laurent
 Retrospective* (1987), curated by Hector Pascual and designed by Stephen de Pietri,
 a former Vreeland assistant.

6. The fiberglass mannequins and dressmaker forms were from Mei and Picchi, mannequin
 manufacturers for Australia and New Zealand since the 1930s (http://www.meipicchi.com
 /home/products/mannequins/).

7. The Westwood display corset is an auxiliary element linked to the ensemble; it is still used
 when displaying the outfit.

8. Marie Hagerty, email to authors, April 12, 2015.

9. Conversation between Roger Leong and Martin Margiela at the designer's studio, Paris,
 May 1994.

10. Visitor feedback was overwhelmingly positive, except for complaints about insufficient
 lighting of object labels, a matter that was addressed shortly after the exhibition opening
 (Robert Macklin, "A Capital Life," *Canberra Times*, January 1, 1994).

11. Including works by photographers such as Adolf de Meyer (1868–1946), Edward
 Steichen (1879–1973), and Horst P. Horst (1906–1999).

12. A 1948 photograph by Clifford Coffin (1913–1972).

13. Robyn Beeche (1945–2015), an Australian photographer active in London in the 1980s and
 India from the 1990s.

14. The environmental conditions of the NGA and exhibition space were 20–22°C and RH 53%
 ±3%.

15. In the early 1990s, cable television stations were airing programs such as *Style with Elsa
 Klensch* and *Fashion TV*. Excerpts of fashion parades were featured more regularly in news,
 current affairs, and arts programs on free-to-air stations.

16. Leigh Raymond, "Brushstrokes with Leigh Raymond: Queer as Frock," *Sydney Star
 Observer*, December 22, 1993, 36.

17. Unidentified visitor, personal communication to Roger Leong after an exhibition floor talk,
 December 1993.

REFERENCES

Douglas, Craig. 2010. "The Spectacle of Fashion: Museum Collection, Display and Exhibition." In
 Australian Fashion Unstitched: The Last Sixty Years, edited by Bonnie English and Liliana
 Pomazan, 127–50. Cambridge: Cambridge University Press.

Entwistle, Joanne. 2000. *The Fashioned Body: Fashion, Dress and Modern Social Theory*. Cam-
 bridge: Polity Press.

Evans, Caroline. 2000. "Yesterday's Emblems and Tomorrow's Commodities: The Return of the
 Repressed in Fashion Imagery Today." In *Fashion Cultures: Theories, Explorations and Anal-
 ysis*, edited by Stella Bruzzi and Pamela Church Gibson, 93–113. London: Routledge.

Leong, Roger. 1993. *Dressed to Kill: 100 Years of Fashion*. Canberra: National Gallery of Australia.

McNeil, Peter. 2008. "'We're Not in the Fashion Business': Fashion in the Museum and the Acad-
 emy." *Fashion Theory* 12 (1): 65–81.

Melchior, Marie Riegels, and Birgitta Svensson, eds. 2014. *Fashion and Museums: Theory and
 Practice*. London: Bloomsbury.

Palmer, Alexandra. 2008. "Untouchable: Creating Desire and Knowledge in Museum Costume and Textile Exhibitions." *Fashion Theory* 12 (1): 31–63.

Steele, Valerie. 2008. "Museum Quality: The Rise of the Fashion Exhibition." *Fashion Theory* 12 (1): 8–30.

Taylor, Lou. 2002. *The Study of Dress History*. Manchester, UK: Manchester University Press.

Taylor, Mark C. 1997. *Hiding*. Chicago: University of Chicago Press.

Wilson, Elizabeth. (1985) 2003. *Adorned in Dreams: Fashion and Modernity*. London: Virago.

AUTHOR BIOGRAPHIES

MICHELINE FORD is senior textile conservator, National Gallery of Australia, Canberra (NGA). She graduated from the University of Canberra, School of Applied Science, in materials conservation in 1987. In 1984 she joined the NGA textile conservation section, and in the past thirty-one years she has worked on all major textile exhibitions, including *Dressed to Kill*; *Sari to Sarong: 500 Years of Indian and Indonesian Textile Exchange*; *Ballets Russes: The Art of Costume*; and *Gold and the Incas: Lost Worlds of Peru*, documenting, treating, researching, and designing display supports for works of art. Ford has traveled overseas, installing exhibitions and treating textile works. She has been active in textile conservation education and training and lectures in Australia and internationally.

ROGER LEONG is senior curator, Museum of Applied Arts and Sciences, Sydney, Australia. He was previously assistant curator of International Decorative Arts, National Gallery of Australia, Canberra (1990–2001); lecturer, College of Fine Arts, University of New South Wales (2002); senior curator at Mornington Peninsula Regional Gallery (2003–4); and curator of International Fashion and Textiles, National Gallery of Victoria (2004–14). Leong has curated and co-curated seventeen exhibitions, including *Mad Hatters: Stephen Jones and Kirsten Woodward*; *From Russia with Love: Costumes for the Ballets Russes 1909-1939*; *William Morris and Friends*; *Sneakers: Classics to Customs*; *Black in Fashion: Mourning to Night*; *Persuasion: Fashion in the Age of Jane Austen*; *ManStyle*; *Ballet & Fashion*; and *Exquisite Threads: English Embroidery 1600s–1900s*.

13 | RADICALIZING THE REPRESENTATION OF FASHION
ALEXANDER McQUEEN AT THE V&A, 1999–2015

Claire Wilcox

This paper explores transgressive exhibiting of fashion at the Victoria and Albert Museum (V&A), London, by examining three performative events held between 1999 and 2001, known as *Fashion in Motion*, and the exhibitions *Radical Fashion* (2001) and *Alexander McQueen: Savage Beauty* (2015). The emotionally luxurious work of the late British designer Alexander McQueen (1969–2010) links these. Another significant feature is a commitment to re-present the performative aspects of runway fashion in novel ways, viewing the museum not only as a site of custodial responsibilities, of curation and conservation, but as a performative space, and presenting dress in a museum as spectacular, ephemeral, and experimental.

"Models could walk in pairs, utterly silent, or with music, around the corridors of the museum, without explanation, at various points during the day. They would not interact with their audience and may not be noticed by everyone." This is an extract from "Contemporary Display/Performance in the V&A: Working Ideas," a document I drafted in March 1999.[1] Within two months, on May 19, 1999, I was on my hands and knees, sticking fluorescent strips onto the mosaic floors of the V&A, charting a route for a fashion performance: models wearing Swarovski-crystal Antony Price dresses and a series of soaring, elliptical hats by Philip Treacy would stalk the museum. The fluorescent strips functioned in much the same way as the color-coded lines used in hospitals to direct visitors toward different departments. It seemed a rational solution to a navigational problem, the V&A being a similarly huge, complex, and sometimes confusing building.

FASHION IN MOTION

The models did find their way around the V&A, and they *were* noticed. Within the environment of the museum, their appearance was striking. Their clothing and millinery were outlandish, their gait exaggerated, and their impassive faces were "made up," to utilize one of the many parataxes in the language of fashion. As the models drifted through

the sculpture galleries and Cast Courts of the V&A, the pageant took on an interactive quality surprisingly sympathetic to the historical milieu of the museum, with its numerous representations of the human form. Intuitively, the models paused before *The Three Graces* (Antonio Canova, 1814–17), lingered by *Eve Listening to the Voice* (Edward Hodges Baily, 1842) (fig. 13.1), and silently regarded the massive plaster cast (ca. 1857) of Michelangelo's *David*. Startled visitors glanced between model and object, wondering if this might be a film shoot, but soon joined the group of people swept along in the models' wake, led onward by the tapping of high heels on the marble mosaic floors.

Despite a leaflet handed out at a nearby train station (South Kensington) on the morning of that first event, information for visitors was scarce. For *Fashion in Motion*, there could be no labels by which to corral thoughts about material, technique, collection, or designer. The models were (as the name suggested) on the move, inspiring fanciful thoughts about their escape from the confines of the museum case: "now the museum is releasing the outfits from their static glass cases and sending them out on models in a live monthly catwalk show, just as they were meant to be seen."[2] The museum was quick to point out that the clothes were, in fact, loans from the designers' current collections rather than from the V&A's archive. In replicating the designer-specific

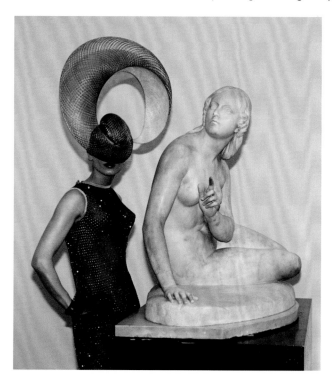

FIGURE 13.1
A model wearing a Philip Treacy headpiece and an Antony Price dress for *Fashion in Motion*, May 1999. Image: © Victoria and Albert Museum, London

accessories, hair, makeup, and, later, music and lighting, *Fashion in Motion* clearly drew on the language of the runway show. However, it still had a curatorial agency rooted in the V&A's mission "to make works of art available to all, to educate working people, and to inspire British designers and manufacturers,"[3] and a curatorial mind-set steadfast in its commitment to public service, funded by public subvention. This was despite contravening the norms of museum fashion display, utilizing the museum as venue rather than vitrine, and offending the dignity of the establishment by inadvertently removing a historical patina of dirt. As recalled in an oral history interview with senior research fellow Linda Sandino in 2005, when the fluorescent "stickers were peeled off the next morning [after the first event], they revealed beautiful, clean, white arrows. They'd sort of cleaned the floor as they were lifted off, and the museum then had to spend a lot of money cleaning the rest."[4] The ghostly traces of the stickers lingered for months, leaving material evidence of the models' ephemeral walk through the galleries.

During its original phase (1999–2001), *Fashion in Motion*'s demand on museum resources was not gallery space but time space: "we talked a lot about…the liminal spaces, and so it was the idea of making space where there was no space before. And the point about *Fashion in Motion*…was that there was no space for it, so it happened amidst spaces."[5] *Fashion in Motion*'s perambulations, among displays for which the Contemporary Team (a department then without a collection) had no curatorial responsibility, had a transgressive quality. Some might have argued that it lowered the tone in its juxtaposition of the customary inert museum mannequin with the enacted spectacle of *Fashion in Motion*. Such "wayfinding" creates "a dynamic relationship to the space" (Huelat 2007). The pageant-like quality of *Fashion in Motion* disrupted the notion that objects should be static, encouraging an active, mobile spectatorship. This fit well with an increasing awareness that the museum had an economic imperative and outreach objective to attract a younger generation of visitors. A new Friday Late program of events, talks, music, and happenings (involving practicing artists and designers) was introduced in 2000. This sanctioned a different, more dynamic kind of engagement with visitors. The museum became a site of attraction as well as of knowledge about the material evidence of historical and contemporary design practices and products and their preservation and presentation.

Sandino has argued that "in accordance with their role, curators are oriented to 'think historically,' not just about the past but also towards the future, embodying and sustaining the collective memory

that binds them to their *lieu de mémoire* [i.e., the V&A]" (2012:91). Such historical thinking tends to privilege the materiality of objects rather than preserving or presenting enactive aspects of dress and fashion. *Fashion in Motion*'s staging within the museum, described by Sandino as a "building [that] itself performs an important continuity function quite apart from the archival character of museums as repositories of the past for the future" (ibid.), engendered connectivity between previous and present. This nexus was enabled by the living flesh and blood of the models and activated by the gaze of each viewer. The edifice of the museum provided an aesthetic/aestheticized and contextual backdrop to *Fashion in Motion*, while the models' liveliness drew attention to the static beauty of the objects on display: history, through each model's gaze, could be seen afresh.

Although such events could be "missed," for they were temporal and fleeting, the traces they left behind nonetheless became part of the museum's history; for example, images of the events used on postcards and publicity materials, or films of the performances and interviews with designers uploaded to the V&A's website. *Fashion in Motion* also built relationships, increased understanding of how fashion houses worked, and fostered a greater awareness of the museum's archives as an accessible resource for practitioners. Offers of donations compensated for the fact that the garments worn in *Fashion in Motion*, unlike accessioned museum objects or even loan objects with temporary museum status,[6] lacked a catalogued history or "place," residing on the threshold of the collections but not *of* the collections. This created the walkway as a liminal space between the public sphere (with visitors wearing their everyday clothes) and the museum cases (with mannequins wearing historic dress or accessioned items of more recent fashion).

Each of the original, pageant-like *Fashion in Motion* performances had a distinct identity within the V&A. This distinctiveness promoted an overt subjectivity, unlike the permanent Fashion Gallery display that had, since the early 1960s, exhibited collectively agreed-upon and suitably conserved and mounted items of fashionable dress and accessories, presented as an accurate record of historical, elite Western taste and sensibility. *Fashion in Motion* instead privileged the designer, allowing each to show artistry and imagination in a series of fleeting, dynamic performances, sidestepping the plight of curators (forced to create static fashion displays using mannequins) and demonstrating what everyone already knew: that fashion looked best in movement.

This tension between old and new, movement and stasis, specifically appealed to the British designer Alexander McQueen. His

orthodoxy-challenging shows drew on the energy of the Young British Artists (YBA) movement, described as "full of youthful and innocent confidence and ambition. Their attitude, expressed in their work of that time, was the take-no-prisoners, hell-bent stance of those who genuinely have nothing to lose" (Craig-Martin 2015:215). McQueen's coming-of-age took place in an atmosphere of rebellion against conformity and safety, both artistic and sexual. It was perhaps no surprise to discover that McQueen's first studio in Hoxton was next door to that of the Chapman Brothers, and that he once created miniature clothes for their sculptures. McQueen's work had an impressive attention to facture (the act of making), with its extraordinary detailing and raw materials that included leather, shells, feathers, glass, carved wood, and metal. These were manipulated into staggeringly inventive forms, harmonizing with the imaginative properties of the historical paradigms materialized in the artifacts within the museum and the museum space itself.

The second *Fashion in Motion* event in June 1999 featured McQueen's No. 13 collection, which, appropriately for the V&A, had been inspired by the Arts and Crafts movement. The materiality of embroidered hessian dresses, balsa wood skirts, winged bodices, and rigid, molded leather carapaces looked exquisitely beautiful against the marble-clad grand entrance of the V&A and the terracotta fascia of the courtyard garden. This perhaps raised an awareness in McQueen's mind of heritage, the possibility of his own work forming part of the archives that he had so frequently studied, for he later stated, "I want to create pieces that can be handed-down, like an heirloom" (Bolton 2011:106). Some of the models were fitted with miniature cameras that filmed their promenade, capturing the incredulity of the visitors who fell back as the models surged through the museum, becoming the avant-garde army that McQueen encouraged them to be.

The last freewheeling *Fashion in Motion* took place in 2001, also with McQueen, in alliance with jeweler and collaborator Shaun Leane (b. 1969).[7] This event was intimidating. Photographs taken backstage in a corner of the museum's Ironwork Gallery, appropriately, show McQueen's assistant, Sarah Burton (then Heard, b. 1974), and Leane wielding screwdrivers as they encased the models in metal corsets, inserted mouthpieces that bared the models' teeth, and fitted bejeweled, hooded garments made of chain mail. White "war paint" obliterated eyebrows and eyelashes and turned the models into humanoids. Allowing McQueen into the museum suddenly seemed charged and dangerous. Suitably armored and plated, the models faced off the huge crowds while the museum guards and the curators stood by.

RADICAL FASHION

In 2001, the same year as the McQueen/Leane *Fashion in Motion*, the V&A staged *Radical Fashion*, a group exhibition featuring eleven contemporary fashion designers, each of whom could be described loosely as operating at the extremities of fashion.[8] As the curator, my first iteration of the exhibition proposal stated that it should consist of "a multi-media bank of experiences (visual, audio, digital, kinaesthetic and interactive) rather than a traditional presentation of museum objects and captions."[9] This goal was reflected in the high-tech ambience of various working titles, such as "Liquid Experience: Fashion 2000–2005," a reference to the mutability of the emerging digital landscape. Unsurprisingly, the proposal was rejected by the Exhibitions Advisory Committee: "There cannot be a V&A exhibition without objects."[10]

The final exhibition included individual tableaux, devised in collaboration with each designer. Many incorporated film elements; most, but not all, included clothing, often as a conceptual statement. Yohji Yamamoto, for example, showed a single wedding dress multiplied by infinity mirrors. Hussein Chalayan suspended flower-like dresses from the ceiling, alongside a computer-generated film depicting dresses first being shot to pieces and then the shards of the dresses reassembling. Helmut Lang's work did not arrive from New York because of the 9/11 terrorist attacks in 2001, so his installation consisted simply of a bench with an infinity film of all the catwalk shows he had ever presented, rendered in gray scale. Exhibition designer Arnaud Dechelle (then with the exhibition design group Event Communications) recalled:

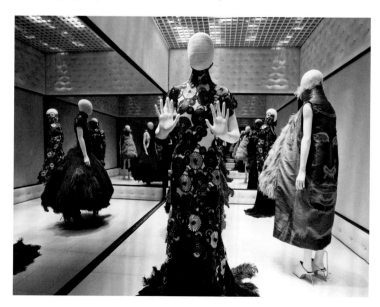

FIGURE 13.2
An installation view of *Savage Beauty*, 2015, re-creating the vitrine-like presentation Alexander McQueen used for his Voss collection in 2001. Image: © Victoria and Albert Museum, London

I think the biggest challenge for *Radical Fashion* was to create a coherent 'whole' while respecting the individuality of each designer. I believe we achieved this with the entrance 'eye,' the neutral 'in between' black spaces, the perspectives on the *Changeling* projection[11] and the standard approach to the entrance doorways and graphics. This allowed visitors to follow a clearly curated path but then also immerse themselves in the unique creative vision of each designer in their dedicated space.[12]

McQueen's installation was the only vitrine, based on his spring/summer 2001 collection Voss, which had been presented within a vast glass case, a conceit happily familiar to the museum albeit not on such a large scale. The demented models inside the two-way mirrored vitrine, padded like a psychiatric cell, could not see the audience, only their own reflections. This was reenacted in the *Radical Fashion* and *Alexander McQueen: Savage Beauty* exhibitions by museum mannequins with bound heads, their hands pressed against the glass (fig. 13.2).[13] McQueen noted that the performance/installation "was…to show that beauty comes from within" (Bolton 2011:142).

SAVAGE BEAUTY
Musings on the nature of beauty and mortality were articulated in *Savage Beauty* in its 2015 reincarnation at the V&A (Wilcox 2015).[14] An anteroom was added that featured a projection based on one of McQueen's show invitations. It depicted his face slowly morphing into a skull and back again, essentially proclaiming the entire exhibition to be an elaborate, complex, and theatrical memento mori: "Alexander McQueen was, like the Jacobean playwright John Webster, much possessed by death" (Sherman 2015:243). He died, only forty years old, in 2010. McQueen's peers had shown what death looked like in the form of embalmed animals, had staged the consumption of a skull by breeding flies, had frozen their own blood, and had filmed rotting fruit.[15] McQueen's response was to create dresses covered with real flowers that withered and died as they fell onto the catwalk.

The hologram of model Kate Moss wearing a diaphanous gown evoked the ephemeral. Museum visitors stood before a large, empty, transparent pyramid set in a dark space. A spark appeared at the pyramid's center and slowly grew into Moss's ghost-like form, rotating barefoot in her multilayered dress. After a while, she began to shrink, fading into darkness. This manifestation was immaterial; the transient image, the effect, and the soundscape is what mattered. McQueen took

a nineteenth-century piece of trickery—the "Pepper's Ghost," which at the time was believed to conjure up the dead—and utilized its evocative beauty as a commentary on the transience of fashion, and life.

The pathos of the uninhabited garment as a metaphor for death has long haunted writers and curators. Christopher Breward wrote of his own McQueen suit:

> Unbuttoning the jacket from the front to reveal an ice-white silk lining, edged like Victorian mourning stationery in a neat black border, produces a sensation not unlike that of a surgeon peeling muscle back from the sternum to the posterior ribs. When I place the discarded jacket over my arm I am reminded of those engravings attributed to the sixteenth-century scientist Andreas Vesalius: the cadaver presenting his flayed skin to the world. Suit as memento mori. (2015:39)

McQueen perhaps unconsciously tapped into such anxieties, with the hems of garments dipped into flesh-like latex and the insertion of human hair into the linings of his early garments, along with labels made from a lock of hair. Later constructions involved skulls, bones, and feathers. This sense of the "uncanny" may explain the garments' power and our sense of them still being remarkably activated, as has been seen in the numerous emotional responses to *Savage Beauty*. This was perhaps also a result of the level of McQueen's own emotional investment, for many of the pieces in the exhibition were hand cut or draped by him rather than being "editions," as his ready-to-wear pieces would be. "The ambition to be an artist, which is so evident in McQueen's runway shows [is] strongly brought out by the performance-cum-installation of the luxurious mise-en-scène at the V&A" (Warner 2015:25).

DISCUSSION

In the context of *Refashioning and Redress*, which explores the interaction of conservation and curation, *Fashion in Motion* was radical in having runway models wearing garments walking through the museum—a new form of re-presentation.[16] The museum's conservation responsibilities were restricted to the fabric of the building (removal of the sticky residues left by the tape). In the case of *Radical Fashion*, the radicalizing aspect of the display was welcoming contemporary designers who each "curated" their own work in a distinctive style. From the conservation perspective, the focus was on mounting near-contemporary dress on mannequins that ranged from invisible Perspex forms (in the case of

Azzedine Alaïa and Junya Watanabe's displays) to more conventional figures. For *Savage Beauty*, the goal was to evoke McQueen's driving preoccupations through the thematic room displays, each of which had a different mood and aesthetic (fig. 13.3).

Conservation is widely understood as managing change; issues of change, loss, and ephemerality are central. Here, the main conservation responsibilities were preventive conservation, notably costume mounting. The garments in *Fashion in Motion*, *Radical Fashion*, and *Savage Beauty* were not artifacts accessioned by the V&A; they were available for exhibition because the designers and owners were prepared to lend them on a "temporary" basis. Novelty in presentation is often important in museum display; in these examples, the obligation to present the effect of high fashion could be prioritized over traditional obligations for long-term preservation of accessioned collections.[17] The mannequins were dressed by the V&A's highly skilled conservation team to achieve appropriate fit and look without damage. This was a challenge in *Savage Beauty*, because most of the figures were too big, necessitating that the waists be cut and rebuilt. It was only in the specially commissioned mannequins for the final section (dedicated to Plato's Atlantis, McQueen's final fully realized collection) that conservators could control the size of the figures, thus reducing time and effort involved in mounting the costume.

FIGURE 13.3
Savage Beauty at the Victoria and Albert Museum, London, 2015. Image: © Victoria and Albert Museum, London

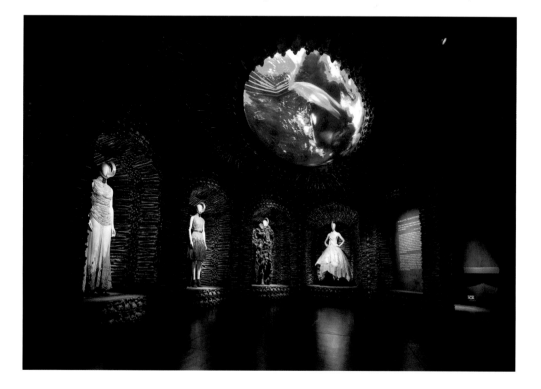

All of those involved in *Savage Beauty* learned from McQueen about conveying drama, either through working with him, attending his collections, or by having assiduously studied and collected his work. McQueen's work, viewed as the apotheosis of a new "spectacularity" in fashion, was informed by his rigorous training on Savile Row in traditional men's tailoring, his education at Central Saint Martins (a famous London school of art and design), his interest in nature, the broader context of 1990s British art, developments in the digital manipulation of imagery and film, and, in his later work, the production of digitally engineered textiles. McQueen's work offered a multilayered set of possibilities for interpretation. Perhaps the greatest lesson was that opening up the V&A to experimentation—whether curatorial, practical, emotional, or theoretical—enabled drama to ensue. With drama came risk, but also rich rewards.

The act of re-collecting a history of curatorial agency captured by Sandino's oral history recordings fostered reflection on key issues in curating fashion in the V&A.[18] The question for curators of contemporary fashion may not be how the museum can continue to harness fashion's power while maintaining curatorial integrity. Such collective responsibility assumes a shared belief system, still very much in operation in the V&A today. The question might be more about how to balance the museum as a locus of archival, curatorial, and scientific knowledge while also allowing space for new kinds of fashion display that can compensate for the inert mannequin. This often necessitates transforming the glass case into a stage and providing new ways of considering fashionable dress. Both curatorial and conservation roles are contingent, responding to current needs and longer-term responsibilities. Deborah Landis has argued that the "role of the curator has evolved to that of an artistic director....creat[ing] kinetic production rather than a static exhibition, and an active engagement rather than passive spectatorship."[19] The museum curator's agency in the making and documenting of fashionable "taste" is perhaps less that of an artistic director and more an act of curatorial patronage that allows artists the opportunity to run free with their radical imaginations.

ACKNOWLEDGMENTS

I am pleased to acknowledge the advice of Professor Bill Sherman, head of research, Victoria and Albert Museum, London, and of Linda Sandino, senior research fellow, Camberwell, Chelsea, and Wimbledon Graduate School/Victoria and Albert Museum research department.

NOTES

1. This document was a response to a museum-wide "call to arms" some months before the formation of the V&A's new Contemporary Team.

2. Susannah Frankel, "Fashion: Art of Poise," *Independent*, June 8, 1999, accessed August 6, 2015, http://www.independent.co.uk/arts-entertainment/fashion-art-of -poise-1099044.html/.

3. "A Brief History of the Museum," Victoria and Albert Museum, accessed August 24, 2015, http://www.vam.ac.uk/content/articles/a/a-brief-history-of-the-museum/.

4. Claire Wilcox, oral history interview with Linda Sandino, 2005.

5. Ibid.

6. A short-term loan is defined as any object that we borrow for less than a year for either display or research purposes. Under the terms of the National Heritage Act 1983, the trustees are permitted to borrow items "for the purpose of exhibiting them, or of study or research." We are required to take out Government Indemnity Insurance (GIS) for all objects that we borrow from private individuals or institutions to display for the public benefit and to cover them for loss and/or damage while they are under our care. We are also required to carry out "due diligence" on loans to check that the lender has good title and that the object is of sound provenance.

7. After the McQueen/Leane performance, shows have been confined to a catwalk format in the Raphael Gallery. *Fashion in Motion* marked its sixteenth year in 2015.

8. The exhibition ran from October 18, 2001, to January 6, 2002, and featured Alexander McQueen, Hussein Chalayan, Helmut Lang, Martin Margiela, Rei Kawakubo, Yohji Yama-moto, Junya Watanabe, Jean Paul Gaultier, Issey Miyake, Vivienne Westwood, and Azzedine Alaïa. John Galliano, the twelfth designer, declined and was not replaced.

9. Claire Wilcox, proposal for *Radical Fashion*, 2000. For another example, see *Mood River* (2002), "a remarkable, wide-ranging exhibition that incorporates thousands of objects from the worlds of contemporary art and design," Wexner Center for the Arts, The Ohio State University, accessed August 6, 2015, http://wexarts.org /exhibitions/mood-river/.

10. Claire Wilcox, oral history interview with Linda Sandino, 2005.

11. The *Changeling* projection was a film created for *Radical Fashion* (Wilcox 2001) featuring model Daphne Selfe (then seventy-two) and Rachel Creek (then twenty-two), cast for their uncanny resemblance. Wearing the same dress, the two women appeared to morph into each other in an incessant conversion and reversion of type. The installation drew on the inaugural 1999 *Fashion in Motion*, where Philip Treacy had cast two models, one mature, one young, a detail only recalled years later through Sandino's oral history recordings.

12. Arnaud Dechelle, e-mail correspondence with author, July 8, 2015.

13. So important was this collection that the cube was created for a second time in the exhibition *Alexander McQueen: Savage Beauty* (Costume Institute, Metropolitan Museum of Art, New York) and again in 2015 in the V&A, complete with a projected backdrop of the denouement, a revealed tableau based on Joel-Peter Witkin's pho-tograph *Sanitarium, New Mexico, 1983*, depicting a masked life model surrounded by fluttering moths.

14. This retrospective, curated by Andrew Bolton—including the original gallery title and text—was first shown at the Costume Institute, Metropolitan Museum of Art, New York, in 2011. The V&A exhibition (March 14–August 2, 2015) was viewed by 493,043 visitors.

15. See works by Damien Hirst, Marc Quinn, and Sam Taylor-Wood.

16. For a brief exploration of initiatives in presenting the "contemporary" at the V&A,
 see Lambert 2000.

17. Preventive conservation approaches, which are now standard practice in museums, were
 implemented and monitored (e.g., controlling the light exposure, checking for insects
 and other invertebrate pests, and regular, systematic condition-checking of exhibits
 during the exhibition), a shared responsibility of curatorial and conservation staff.

18. Claire Wilcox, oral history interview with Linda Sandino, 2005; see Sandino 2012.

19. Guy Trebay, "At the Met, Andrew Bolton Is the Storyteller in Chief," *New York Times*,
 April 29, 2015. Deborah Landis is costume designer, founding director, and chair of the
 David C. Copley Center for the Study of Costume Design, School of Theater, Film and
 Television, University of California, Los Angeles. She curated *Hollywood Costume* (2014)
 at the V&A; for conservation approaches, see Gatley and Morris 2015.

REFERENCES

Bolton, Andrew. 2011. *Alexander McQueen: Savage Beauty*. New York: Metropolitan Museum
 of Art.

Breward, Christopher. 2015. "Su[i]ture. Tailoring & the Fashion Metropolis." In *Alexander
 McQueen*, edited by Claire Wilcox, 37–49. London: V&A Publications.

Craig-Martin, Michael. 2015. *On Being an Artist*. London: Art Books Publishing.

Gatley, Sam, and Roisin Morris. 2015. "Striking a Pose: The Display of *Hollywood Costume*."
 Costume 49 (1): 75–90.

Huelat, Barbara J. 2007. "Wayfinding: Design for Understanding." A position paper for the
 Center for Health Design's Environmental Standards Council. Accessed July 9, 2015.
 https://www.healthdesign.org/chd/research/wayfinding-design-understanding.

Lambert, Susan. 2000. "Contemporary V&A." *Conservation Journal* 34: 5–7.

Sandino, Linda. 2012. "A Curatocracy: Who and What Is a V&A Curator?" In *Museums and
 Biographies: Stories, Objects, Identities*, edited by Kate Hill, 87–99. Martlesham,
 UK: Boydell & Brewer.

Sherman, Bill. 2015. "Ghosts." In *Alexander McQueen*, edited by Claire Wilcox, 243–45.
 London: V&A Publications.

Warner, Marina. 2015. "At the V&A." *London Review of Books* 37 (11): 24–25.

Wilcox, Claire. 2001. *Radical Fashion*. London: V&A Publications.

———, ed. 2015. *Alexander McQueen*. London: V&A Publications.

AUTHOR BIOGRAPHY

CLAIRE WILCOX is senior curator, Department of Furniture, Textiles and Fashion, Victoria
and Albert Museum, London, with responsibility for the twentieth-century and contemporary
dress collections, and professor of fashion curation, London College of Fashion, University of
the Arts London. She has curated numerous exhibitions, including *Radical Fashion* (2001),
Vivienne Westwood (2004), *The Golden Age of Couture: Paris and London 1947–1957* (2007),
and *Alexander McQueen: Savage Beauty* (2015). Wilcox was also the lead curator of the
redisplay of the V&A's permanent fashion collection (2012) and lead curator (V&A) for the
Europeana Digital Fashion Project. Wilcox has published widely. She is a member of the AHRC
Peer Review College and an editorial board member of the journal *Fashion Theory*.



14 | PEOPLING THE *PLEASURE GARDEN*
CREATING AN IMMERSIVE DISPLAY
AT THE MUSEUM OF LONDON

Beatrice Behlen and Christine Supianek-Chassay

In 2003 the Museum of London began preparing to update half of its permanent displays, by then more than twenty-five years old. Its Galleries of Modern London, opened in May 2010, tell the story of the capital and its inhabitants from the Great Fire of 1666 to today. This paper relates the development and installation of the *Pleasure Garden*, still on display at the time of writing, which is part of the first of the three main gallery sections (Miles 2013). Pleasure gardens emerged in the late seventeenth century on the fringes of London. Occupying vast, predominantly outdoor areas, these new urban spaces allowed members of different, if not all, strata of society to mingle while listening to music, eating, drinking, watching spectacular entertainments, or simply promenading. By creating a new type of museum display, we hoped to evoke in museum visitors the excitement and wonder once inspired by these amusement parks.

The museum's *Pleasure Garden* was envisioned as an immersive experience, a *Gesamtkunstwerk* (a total artwork), within the relatively restricted space available (83m^2), and different modes of presentation were exploited. An afternoon and evening in the late 1780s was condensed into a fourteen-minute drama for an audiovisual (AV) display. The resulting films are projected life-size onto two opposite walls of the gallery, so that visitors share the same space as the films' cast. The *Pleasure Garden* also includes a pavilion, real tree trunks, and park benches. The people who would have frequented such gardens in the past are represented in three ways: by filmed actors wearing reproduction dress; by six mannequins in replica clothing that visitors can touch; and by sixteen mannequins in two glass-fronted cases wearing historic clothes from the museum's collection (fig. 14.1). This paper focuses on the third form of representation: the presentation of historic garments and accessories from the 1740s to the 1840s. The appropriate historic headwear held at the museum was too fragile to be displayed, so contemporary hats were commissioned to convey the impact of high fashion, essential to the appeal of London's pleasure gardens.

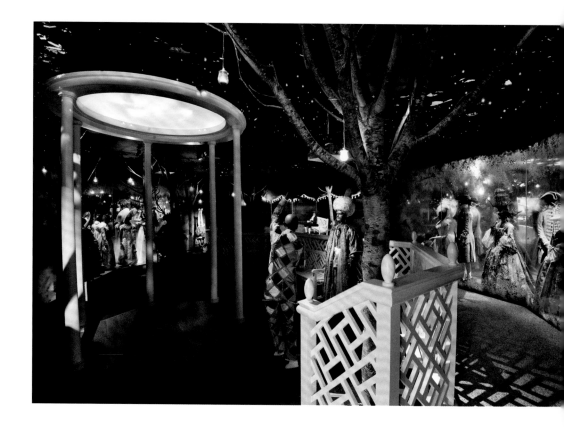

FIGURE 14.1

A view of the *Pleasure Garden* showing the pavilion, trees, mannequins wearing replica dress, and glass-fronted cases with mannequins wearing historic dress from the Museum of London collections.
Photo: © Museum of London

Although there were many specialists involved in the creation of the *Pleasure Garden*, the core team was as follows: the lead curator for this section of the gallery; two fashion curators (assisted by volunteers); three in-house textile conservators; a consultant specializing in mounting historic garments; one designer for the two-dimensional components, and three designers for the three-dimensional components; the film's director and the scriptwriter; a team from the mannequin manufacturer; a sculptor making wigs; and two milliners (theatrical and contemporary design) creating the mannequins' new hats and masks.

Written by Beatrice Behlen, one of the fashion curators, and Christine Supianek-Chassay, a textile conservator, this paper is further informed by the observations of numerous professionals who were involved in the *Pleasure Garden*'s creation. This approach reflects the project's collaborative nature—the informants are from curatorial, conservation, design, and education—and enabled us to capture the diversity of professional viewpoints and present them in an engaging way. In early 2015, we solicited observations via questionnaires, through in-person or telephone interviews, and recorded, transcribed, and edited them following established guidelines (McGuire 2007). We analyzed

these sources and selected quotations for this account, focusing on the main themes that emerged. Each informant is introduced in full, including his or her job title/role at the time of the project, at first mention. Additional quotations are accompanied by the informant's surname and title. The views of museum visitors, sent via e-mail or recorded on comment cards provided at the museum, are also represented. This paper presents only a small selection of the recorded material.

IMMERSIVE SPACE

The display aimed to accommodate the narrative ambitions of the curators, the learning aspirations of the education team members, and the aesthetic visions of the designers and artists, while being mindful of the conservators' concerns and the constraints of time and budget. Director Jack Lohman and Darryl McIntyre, group director of Public Programs, then both relatively new to the museum, had strong ideas about how museum displays should not be traditional "things in cases, they had to be more theatrical, more dramatic."[1] Alex Werner, lead curator of the *Pleasure Garden*, was keen to include "an immersive space. We know that things which are about mood and atmosphere and lighting and sound tend to be what people remember after their visit." His approach "was informed by new academic work, especially Miles Ogborn's *Spaces of Modernity* (1998) where he describes these new places in the city, what they meant and what they offered." Initially, two immersive spaces were discussed: a coffee house and a pleasure garden. Cathy Ross, head of the History Department and curatorial lead for the Galleries of Modern London project, noted that the latter was selected because it "would enable us to display costume. And also, in the coffee house the story was about finance and commerce, which just wasn't as glamorous as the 'dangerous liaisons' that went on in the pleasure gardens."

Said Ross: "In the old ways of doing things, the curators would get the story, and then the designers would come along and put the curators' story into 3-D, and then at the very last stage the education people would come on and see what they could find for children. And this was consciously done in a very different way [for the whole of the Galleries of Modern London project, including the *Pleasure Garden*]: right from the beginning, Learning, curators, and designers were equal voices in the decision-making."[2] Frazer Swift, head of Learning, noted that the display's design "supports a constructivist view of learning by enabling visitors to choose their route and by not being didactic in the way we expect people to engage with or learn from the display. We wanted the

space to support 'dynamic learners' who tend to learn by feeling and doing, enjoy imaginative trial and error, prefer hands-on experience and look for hidden meaning." Lead designer Gail Symington wanted visitors to enter "into something magical and wonderful."

Rob Payton, head of Conservation and Collections Care, was lead conservator for all of the Galleries of Modern London: "We approached the design concept with an attitude of making it work and only suggesting changes if the original ideas would have caused direct harm to the objects." Collections Care conservator Adrian Doyle agreed that people in his profession "are not there to stop people doing things. They're to say, 'Look, don't do it this way, do it that way.'" Ross thought that "conservators felt a bit that they were left out and could have contributed more at an early stage. But once we got the thing mapped out, Conservation was in very, very early."

DESIGN

Symington, the lead designer, was clear: "We didn't want a highly engineered showcase that was very rectilinear, and very obvious and very museum-y; we wanted that blurred boundary between visitor and exhibit. We worked with Conservation right from the beginning to develop cases that were much cheaper than they would have been if they'd been engineered showcases. Instead we worked with our setworks [display structures] contractor to build them in as part of the set, which felt much more integral." Helen Ganiaris, conservation manager, Objects, explained that the large cases were "made of a metal framework, glass, and MDF [medium-density fiberboard]...prepared to conservation specifications to reduce possible harmful emissions. Tested paints were used. The case construction was well sealed using extruded silicone and physical barriers." Ganiaris pointed out that it was necessary to check and maintain the cases, as "it is difficult to achieve the same level of air tightness with large setworks cases; silicone can shrink and shift."

Lead curator Werner remembered previous costume displays: "We have done things as a time period but not with any scene setting, just a row of costume...we'd never attempted anything quite so ambitious, actually setting it in a particular locality over a hundred years in time span." According to Edwina Ehrman, senior curator, Fashion and Decorative Arts (until 2007), the "outfits were chosen to tell this [the *Pleasure Garden*'s] story and to offer visitors some information about the history of textiles and fashion during this period. The clothes are made of some of the principal fabrics available at the time....The women's eighteenth-century clothes include a sack-back [see fig. 14.2] dress,

and closed and open robes, and the men's garments show the evolu-
tion of the cut of the suit. The nineteenth-century garments enabled us
to show the dramatic change in the fashionable silhouette in the early
years of the century."

Eleonora Rosatone, a 3-D designer, recalled that the "mannequins
were probably the biggest challenge ever! Because we wanted to have
the mannequins talk to one another, and not only that but talking to the
visitors, talking to the surroundings, talking to the AV. We wanted them
to pose, but we had original costumes and there was not enough move-
ment, for example, in the shoulder." According to conservator Supianek-
Chassay, the "biggest challenge was to find the right technique of
mannequin-making. The look of the mannequin had to work with the
design requirements, materials had to comply with conservation speci-
fications, and the realization had to be achievable." Said Rosatone: "We
didn't want the mannequins to stand out. Black and white we tended to
avoid. Grey seemed the right choice…[mannequins] had to be expres-
sive, but not realistic." Visitor perception varied: "England was a largely
white society. Why are all the models black? It's political correctness
gone mad" (visitor, Oct. 4, 2010).

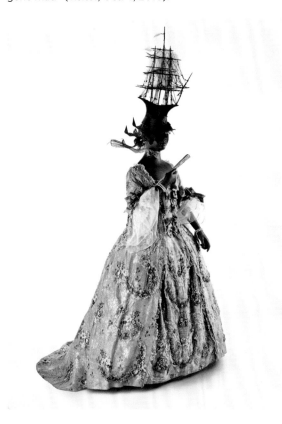

FIGURE 14.2

A mannequin wearing
a gown from the 1760s
(A12413) with the Philip
Treacy "galleon" hat.
Photo: © Museum of
London

There was much discussion "about whether the mannequins should have heads," said designer Symington. Also, according to curator Behlen, the designers and curators were concerned "about the mannequins' faces. We wanted something stylized, ideally additionally hidden underneath a mask. The mask idea led us to Philip Treacy (fig. 14.2), who also made our hats, mainly for the women [mannequins]. Jane Smith's hats for the men were reproductions rather than 'interpretations,' but Treacy made it clear from the start that he would not replicate historic styles. It was he who suggested that multimedia artist Yasemen Hussein should make metal wigs."[3]

MOUNTING HISTORIC DRESS

Mounting historic dress is challenging and time-consuming. Fashion curator Hilary Davidson stressed that the "physical processes of fitting, making, checking, adjusting, and rechecking the mannequins before production against fragile historic garments of wildly varying size and shape was very difficult logistically." Conservator Supianek-Chassay said: "For each outfit the mannequin-maker provided us with a stock figure (made of an upper body part and a separate hip piece), adjustable in height, based on object measurements. From that moment a complex system of fittings started. Once the correct parts were found, sometimes ready-made parts had to be adjusted, and the figure was sprayed and off-gassed at the factory before delivery to the museum. At this point, the final mounting started: preparing underpinnings, adjusting them to the desired fit and correct historical look." According to curator Behlen, the "mannequins went backwards and forwards between us [Museum of London] and the mannequin-maker, and each time they had to be unpacked, then wrapped up again. We had to write down what had to be changed, and later we filmed what didn't work. All of that took a lot of time."[4]

Curator Davidson explained that "Beatrice and I put together a character sheet (fig. 14.3) for each mannequin with name, age, background, etc., and selected an image that best represented the final look we were trying to achieve (fig. 14.4). This helped in having a goal to work towards when making decisions about accessorizing the garments both from our collections and with replicas. It also made it easier to convey the style to the wig- and hat-makers." Artist Yasemen Hussein recalled: "My favourite bit was that every single mannequin had a name and a profile. I loved them. Every single one I opened was like a present."

Contract conservator Janet Wood acknowledged that it is "hard to capture in words the intuitive. I think my main aim was that the figures

Closed mantua, 1743-50 (A7567) **target date: 1750**

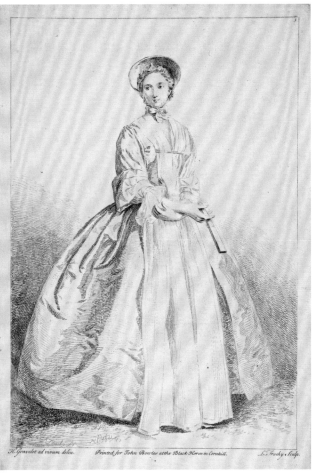

Charlotte Corkhill, 20
Landed gentry, family is prosperous, does not come to Pleasure Gardens often from the country estate, is normally somewhat shy but feels very good in her new dress and is posing.

Charlotte needs:
1. hair
2. cap and straw hat
3. mask

Outfit
Closed mantua of yellow silk brocaded with polychrome flowers.

FIGURE 14.3
A character sheet created for the representation of a gown of 1743–50 (A7567). The engraving (1744), published by John Bowles after Gravelot, is also in the collection of the Museum of London (2002.139/441). Photo: © Museum of London

FIGURE 14.4
The mid-eighteenth-century gown (A7567) as mounted for display with reproduction cuffs, fichu, and a contemporary Philip Treacy hat. The character sheet for fig. 14.3 was the starting point for this presentation. Photo: © Museum of London

should look relaxed and confident of their identity, like they really had just walked into the *Pleasure Garden*. Capturing their identity in the creation of the underpinnings, etc., was part of this aim and came down to very subtle differences."[5] Textile conservator Kate French confirmed that underpinnings "are essential for the provision of adequate support . . . [but] . . . few will realize what lies beneath." For textile conservator Gabriella Barbieri, "the challenges were the usual ones of trying to get mannequin arms into tight armholes and small shoulders! Sometimes three people were needed to get the costume on!" The final appearance of the dressed mannequins rested with the curators. Said Behlen: "The

conservators would pad the mannequin, and either Hilary [Davidson] or I or both of us would check it. I felt that it was up to us to decide when an outfit was finished, but the conservators had to be happy as well."

INSTALLATION

Said Behlen: "I remember the initial layout. We marked out the case on the floor, mounted the outfits on figures we had, and put them roughly in date order. Immediately there seemed to be connections between some of them, and we decided who was part of a family, who was alone trying to pick someone up." The final layout was roughed out using people as stand-ins for the mannequins. "This allowed the curators and designers to work out poses and relationships between the figures more easily," said curator Davidson.

Payton, head of Conservation, was responsible for organizing the installation each week. Conservator Supianek-Chassay recalled: "For each zone and case, he pulled together a team, which usually included a curator, technician, conservator, as well as the liaison conservator for that section of the gallery. We had additional help from volunteers and curatorial interns." The dressed mannequins "were very tall and heavy with their new hats, and the entrance to the gallery space was just about high enough to let them pass. Fitting the costumes in the show-case with a minimum of two to three people was challenging."

Everything had to work together. Designer Rosatone said: "We spent a lot of time dressing showcases: first, the costumes had to talk to each other, so there was this relationship with the immersive experi-ence and the visitors. But we also wanted to make sure we showed the costume from the best angle, and that people saw the details on the back. There were three or four stages: First you put them in, and then you make them talk, you put them in a pose; then you get out of the showcase, and you're by the glass and you see what the relationship is between you and them when you're close and when you're farther away, maybe with the surroundings, and then, even farther away, look-ing at the mirror [in the showcase]."

Lighting was a key element. Curator Werner said: "The designers wanted to test what you could do if you had a light that moves, how that might give mood through throwing shadows. It wasn't really involving the costume at that point, it was more about light falling on the ground. Can you give some sense of trees and leaves, and could there be a feeling of time passing within a day?" Swift, head of Learning, said: "We also wanted to make the lighting controllable, so that it could be adjusted when we run drama and storytelling

activities in the space." Designer Symington noted that "we worked with a lighting designer and with conservation and the curators to develop how much light the costume would be subjected to. And that was not your standard: it has to be 50 lux over a constant period of time for eight hours a day. It was much more: over the course of the year it couldn't be exposed to more than X amount of light, but you could have no light on at one point and then you could be blasting it with light at another point, so we had show-control on the lighting." Conservator Payton explained that "traditionally, we would have recommended a 50 lux exposure level; however, this was not possible with this type of display. Instead, I worked on the light exposures for each costume based on readings taken during a complete loop of the AV show. I determined the minimum and maximum acceptable exposure levels based on cumulative lux levels [duration of exposure multiplied by lux] (with near zero UV radiation), enabling the case lights to be controlled accordingly. As the ambient light levels for this gallery are low, the net effect of the low lighting in the case is not noticeable, and the results were very acceptable" for both atmosphere and long-term preservation.

AUTHENTICITY AND INTERPRETATION

The *Pleasure Garden* was designed "to evoke a look and feel of the new spirit of leisure and consumerism. The whole display is as much about ideas as about the authenticity of the material culture," said Ross, curator, and head of History. Matt Schwab, a 3-D designer, recognized that it was "essential to have the real objects within the space, to provide legitimacy and historical realism. Without the dresses and other costumes, the space would have been a fairly generic and perhaps weak attempt at recreation." Ross continued: "In any form of museum display, even the trad [traditional] ones, it's a theatrical walk-through experience, and if your aim is to get people to engage and to think, sometimes it's best done through bending the rules a bit and re-creation. [...] Any mannequin is an artificial construct anyway..." Lead designer Symington stated that including modern elements was important: "We looked at [the 2006 film by] Sofia Coppola, *Marie Antoinette*—at the contemporary references. It was something the public was already aware of and already experiencing in film, and we wanted to have an essence of that in the display."

According to lead curator Werner, pleasure gardens were "about having fun and dressing up, and there were masquerades. There is a tradition of absurd things happening in the pleasure gardens. I think that's why it [mixing old and new] was OK. I wasn't going to say 'no,

I don't want it,' and stand up for being very purist, because we were trying to do something new and different, so why not?" Conservator Barbieri agreed: "I have no problem mixing original objects with reproductions of historic objects, as long as the label states which objects are reproductions. Often it is possible to glean this anyway, as the reproduction is much plainer than an original would have been…This compromise works very well, I think, as it allows an overall complete 'interpretation' of the costume of the period" (fig. 14.4).

Curator Davidson said: "I have heard a few visitors assume that the actors in the film were wearing either clothing from the collection, or the clothing in the display cases. It is an interesting issue of audience interpretation, and perhaps accidentally sends out the wrong messages about how historic clothing in collections is used." From a visitor (Oct. 29, 2014): "On a visit to the pleasure gardens exhibit today I was distressed to see the mannequins wearing Philip Treacy hats which were clearly not contemporaneous with the dresses the women wore. I like the hats and was interested to see them but it seemed entirely wrong to place them in the exhibit where they would be viewed as copies of authentic period headgear. Unless we missed a notice explaining that the hats had no relationship with the period/clothes. I think it's very misleading historically and I think you should be clear that this is a bit of fun but not historically accurate. Historical accuracy is what we expect in a museum! Can we trust any other of your exhibits???"

Captions and text panels were seen as disrupting the immersive effect (e.g., Ross 2011). Said designer Symington: "We felt as soon as you saw printed text on the wall, the experience, the magic would be lost. You could write a book on the wall and not get the same amount of information that you could get just from looking, listening, sitting, and observing." Curator Werner: "The graphic panel outside—I'm not sure how many people read that. For an ideal visitor who is spending a lot of time in there, it probably works; for the person who doesn't have a lot of time and is rushing through the displays, I'm not sure." Swift, in Learning: "From observation, visitors do not seem to follow the story set out in the film, which I think is too long and complex. Ideally, it would also be easier for visitors to read the handheld guides (and visitors tend to miss them as they enter the space)." Said Ross: "It just seemed obvious [to us] that the historical data should live on a web database. Right from the beginning we decided that our captions would be just enough for the visitors walking round to enjoy it [the display], to root things to give them a little bit of information and to underline that these objects are authentic. Looking back, probably we were a bit idealistic."

RECEPTION

According to an evaluation report, "the majority of people....considered the *Gardens* to be the highlight of the gallery, and it was one of the most popular exhibits in 'Expanding City' [part of Galleries of Modern London]. Many commented that the *Gardens* offer an immersive experience to the visitor and create an atmosphere that is distinct from the rest of the gallery" (Creative Research 2010:130). Comments from the public included the following: "The best bit was the Pleasure Gardens" (June 2, 2011); "the place called Pleasure Gardens is amazingly fabulous!" (June 8, 2010); "'Vauxhall' garden's magical" (Dec. 28, 2010); "The Pleasure Garden was really spectacular!" (July 20, 2014); "Good to see some of the stored costumes have come out, the Pleasure Garden's particularly good. Somebody's excellent idea about the hats!" (Dec. 14, 2011). According to lead designer Symington: "When we were creating the displays, the construction manager said to me: 'Of all the places in the new galleries, I'd probably come to this one. I don't really like going to museums, but actually the Pleasure Gardens, that's something quite special, quite different.' And for me, the meaning that that [space] would make for him, someone who is not a museumgoer and actually connects with our display and our design in a way that he would never have done before, that was something really special."

Hannah Greig, lecturer in early modern history, University of York, said:

> As a historian of eighteenth-century London, I know Georgian London's most famous pleasure gardens—Vauxhall and Ranelagh—very well through contemporary texts and images. For me, the museum's immersive installation captured the spirit of the gardens brilliantly and creatively. It is incredibly difficult to communicate something that felt so innovative and modern in the 1700s.... By trying to re-create some of that experience, the gallery does far more justice to that history than would be possible through a more traditional exhibition of images and objects. The use of modern and dramatic millinery in the gallery also reminds us that, for the eighteenth-century visitor, the pleasure gardens were themselves modern and were famously frequented by the leaders of the fashionable world.[6]

ACKNOWLEDGMENTS

We would like to thank everyone who contributed to the display and those who responded to our questionnaire.

NOTES

1. As reported by curator Cathy Ross, who led the Galleries of Modern London project as the head of the History Department, Museum of London.
2. For more on this approach, see Ross 2011.
3. Philip Treacy (http://www.philiptreacy.co.uk/) is a London milliner for haute couture and ready-to-wear hats. Jane Smith (http://www.janesmithhats.co.uk/) provides hats for film and theater.
4. For more information on the choice of mannequins, see Supianek-Chassay and Behlen 2012.
5. Beatrice Behlen, "When all is said and done," *Museum of London* (blog), June 7, 2010, accessed March 29, 2015, http://blog.museumoflondon.org.uk/when-all-is-said-and -done/.
6. Hannah Greig, e-mail to Beatrice Behlen, February 17, 2015.

REFERENCES

Creative Research. 2010. "Galleries of Modern London: Survey, Summative Evaluation Find-ings," vol. 2. Unpublished internal document.
McGuire, Mary. 2007. "Ethical Guidelines for Editing Audio." *J-Source: The Canadian Journal-ism Project*, September 17. Accessed March 21, 2015. http://j-source.ca/article/ethical -guidelines-editing-audio.
Miles, Ellie. 2013. "'A Museum of Everything': Making the Pleasure Gardens inside the Museum of London." *London Journal* 38 (2): 151–65.
Ogborn, Miles. 1998. *Spaces of Modernity: London's Geographies 1680–1780*. New York: Guilford Press.
Ross, Cathy. 2011. "When Is a Story Not a Story?" In *Museum Narrative & Storytelling: Engag-ing Visitors, Empowering Discovery and Igniting Debate*, edited by Gregory Chamber-lain, 1–12. London: Museum Identity.
Supianek-Chassay, Christine, and Beatrice Behlen. 2012. "Die Frage nach der richtigen Figur: Neue Figurinen für die 'Galleries of Modern London'" [The question of the right shape: New mannequins for the "Galleries of Modern London"]. *Restauro* 2: 28–35.

AUTHOR BIOGRAPHIES

BEATRICE BEHLEN studied fashion design in Germany before moving to London in 1989. After gaining a postgraduate degree in the history of dress from the Courtauld Institute, Behlen worked as curatorial assistant at Kensington Palace. She then taught the history of fashion and design at several art colleges before working at a contemporary art gallery. In 2003 Behlen returned to Kensington Palace, where she curated and co-curated exhibitions on coronation robes, the queen's hats, Mario Testino's photographs of Diana, princess of Wales, and the influence of Princess Margaret on fashion. Since 2007 Behlen has been senior curator of Fashion and Decorative Arts, Museum of London, where she has worked on the Galleries of Modern London, curated displays on jewelry and fashion photography, and coordinated Show Space, a monthly changing display. She is also an associate lecturer for the BA Fashion History and Theory course at Central Saint Martins.

CHRISTINE SUPIANEK-CHASSAY trained as textile conservator in Germany, working in international textile conservation studios, including the Deutsches Textilmuseum (Krefeld), the Musée des Tissus et des Arts Décoratifs (Lyon), and the Textile Museum (Washington, D.C.). Supianek-Chassay graduated in 2007 from Cologne University of Applied Sciences

(diplom textile conservator) and then worked for five years as textile conservator at the Museum of London. She conserved and mounted many objects for display, focusing on three-dimensional object conservation and mannequin-making. She is an ICON-accredited textile conservator (ACR). Since 2013 Supianek-Chassay has been a freelance conservator based in her hometown of Erfurt, Germany, where she works for regional churches and museums and develops her expertise in digital mapping.

15 | DRAMATIC EFFECTS ON A STATIC STAGE
CANTONESE OPERA COSTUMES
AT THE HONG KONG HERITAGE MUSEUM

Evita So Yeung and Angela Yuenkuen Cheung

Cantonese opera is regarded as a distinctive intangible cultural heritage in Hong Kong, with many of the intangible qualities of performance achieved through props, especially costumes, which are noted for their eye-catching embellishments and colorful embroideries. In addition to being art objects, these costumes have intrinsic cultural significance and convey important information about the sociocultural history of Cantonese opera in Hong Kong. This paper introduces the conservation and display of costumes belonging to the Hong Kong Heritage Museum (HKHM).

Traditional Chinese opera combines singing, music, dialogue, acrobatics, and martial arts with complicated costumes and makeup. It dates from the Tang dynasty (618–907), when Emperor Xuanzong (r. 712–56) founded the Pear Orchard Academy, the first known royal acting and musical academy in China; artists are commonly called "children of the Pear Orchard" (Dolby 1983:15). Chinese opera evolved into 350 regional forms with unique melodies and specific dialects, the best known of which are Beijing and Kunqu opera (Yung 1989:1–11).

CANTONESE OPERA IN HONG KONG

Cantonese opera flourished in the Pearl River Delta of China in the southern province of Guangdong (formerly Canton) and in Guangxi. Popular in Hong Kong and Macau, it spread to other Cantonese-speaking regions. A blend of various operatic styles, it adopted elements of Western performing arts, including musical instruments, scenery, and costume, in the early twentieth century (Yung 1989). It has flourished in Hong Kong since the late nineteenth century, reaching its pinnacle in the early twentieth century, and Hong Kong and Guangzhou were considered major centers of the art (Hong Kong Heritage Museum 2004:15). From 1920, the singing language gradually shifted from Guilin dialect (a variation of southwestern Mandarin) to Cantonese, the local dialect (Li 2014:xix). A popular entertainment, Cantonese opera also imparts moral values and has an important function in ritual performances (*shengongxi*) or worship, such as celebrating the birthdays of Chinese gods. In

2009, Cantonese opera was placed on UNESCO's Representative List of the Intangible Cultural Heritage of Humanity, the first such designation in Hong Kong (UNESCO 2009; Chau 2011).

THE CANTONESE OPERA COLLECTION
AT THE HONG KONG HERITAGE MUSEUM

The HKHM is dedicated to preserving and promoting this ephemeral art form, and its collection includes around twenty thousand items, including librettos, posters, photographs, costumes, stage equipment, musical instruments, and sound recordings. A permanent exhibition gallery, the Cantonese Opera Heritage Hall, is designated for its public display. The costumes, mostly early twentieth century, were generously donated by Cantonese opera artists, scholars, and local residents.

Extravagant, colorful, shimmering costumes are a spectacular feature of the performances, portraying the status, role, and personality of the characters and indicating plot, events, and seasonal context. Early Cantonese opera costumes are thought to have imitated Ming dynasty (1368–1644) dress, while later designs were influenced by the Beijing opera (Hong Kong Heritage Museum 2005:13–24). Traditional Chinese opera costumes are made of embroidered or brocaded fabrics; since the 1930s, these have been embellished with imported sequins and beads. Under stage lighting, this creates a visual opulence that is greatly appreciated by audiences (Liu 1995).

These costumes may include many diverse materials, ranging from metal threads and buttons to manufactured materials such as rayon, nylon, and polyvinyl chloride (PVC). Their previous theatrical use, as well as tailoring techniques and materials, can lead to issues such as splits, holes, stains, detached embroidery threads, fragile sequins, and metal corrosion (Johnson and Morrison 1997), which must be dealt with by conservators.

DISPLAYING CANTONESE OPERA COSTUMES

In addition to informing audiences about the characters, the costumes reflect the personal styles of individual performers. They also facilitate expressive movement. The extended cuffs of so-called water sleeves, for example, enable the exaggerated gestures used to express a character's mood (Siu and Lovrick 2014:154–60). Appropriate dress is essential, evident in the Cantonese proverb "Wear torn clothes rather than the wrong clothes" (Su 2014).

Curators prefer to display complete ensembles, as they would have been worn onstage. This presents conservation challenges, because

most costumes consist of multiple pieces, including upper garments, skirts or trousers, belts, outer garments or sleeveless jackets (vests), and front and back leg flaps. Displaying them as worn means that each costume has to be assembled, layer by layer, with the inevitable strain on materials and construction stitching; moreover, the sequins, beads, and other decorations make the costumes very heavy, resulting in considerable stress when they are mounted. When displaying the costumes, conservators must reconcile preservation guidelines with curatorial requirements for "museum staging."[1]

The following case studies explore creative approaches that balanced the desire to show the dramatic and cultural significance of the costumes while preserving them for posterity. To highlight the performative effect of the costumes, the curators and designers re-created a traditional bamboo-framed theater in the Cantonese Opera Heritage Hall. This theater, which reproduces a classic Cantonese opera scene on the stage, encourages visitor participation and exploration. It also conveys intangible elements of the art form, such as the meaning of hand gestures and the roles represented by the costumes. The backstage area depicts associated activities such as dressing and applying makeup.

The scene selected for the onstage display (fig. 15.1) was from *Joint Investiture of a Prime Minister by Six Kingdoms*, a well-known opera about a renowned politician, Su Qin, who persuaded the monarchs of all six states to form a union during the Warring States period (475–221 BC). It is one of the standard ceremonial pieces that every Cantonese opera troupe presents at the grand opening of any sequence of

FIGURE 15.1

A scene from the opera *Joint Investiture of a Prime Minister by Six Kingdoms*. Reproduction garments give visitors a sense of the drama and splendor of the costumes onstage. © Hong Kong Heritage Museum

performances. Nearly every artist in the troupe participates, enabling the whole company to display stylistic skills and stage movements.

Initially, the costumes were going to be on mannequins, posed with accurate gestures and facial makeup, creating a scene that would convey the excitement of an actual performance. However, conservators did not recommend putting the costumes on open display for the following reasons: with the lighting set to imitate stage effects, excessive light would fall on costumes, causing irreparable damage (color changes and structural instability); dust or dirt would be trapped on the costumes, with the additional risk of insect damage (such as silverfish, cigarette beetles, and clothes moths); frequent mechanical surface-cleaning would be needed, placing the numerous beads and sequins at risk; and posing the mannequins could result in physical damage, such as stress and abrasion.

The conservators raised their concerns with the curators, who deliberated further. A compromise was achieved when research showed that Cantonese opera costumes are still made today, albeit with modern materials and techniques. The primary objective of the reconstructed theater is to illustrate stage performance and costume genres, headdresses, and footwear; therefore, the mannequins could be dressed in newly made costumes. The re-created scene achieved the intended theatrical effect, vividly demonstrating the characters' ranks and social status. Although the modern costumes do not have the same cultural/historical significance, and their handiwork is less fine, they present the essential features of the performance of Cantonese opera.

THE ARTISTS' CORNER IN THE CANTONESE OPERA HERITAGE HALL
The iconic costumes of eminent Cantonese opera artists—displayed in a separate area with glazed showcases called the Artists' Corner[2]—are crucial for depicting the artists' achievements by illustrating their various roles. Visitors first view the scene from *Joint Investiture of a Prime Minister by Six Kingdoms*. They then enter the "backstage" area before concluding their tour in the Artists' Corner. The displays in the Cantonese Opera Heritage Hall are various. There are electronic projections and other Cantonese opera artifacts such as documents and librettos. Text panels, photographs, and video clips of performances are used to introduce Cantonese opera in the gallery. Moreover, visitors can play facial makeup games and listen to Cantonese opera musical instruments. The following examples illustrate approaches to conservation and display.

Painted costumes worn by Soo Chow Mui

The costumes of Soo Chow Mui, a principal artist in Cantonese opera in the early twentieth century, are unusual in that their painted decoration includes microglass beads to enhance the glittering effect onstage. They were designed by her friend, the well-known Chinese painter Bao Shao-you,[3] and Soo wore them when she returned to the stage for a charity performance in 1938. These painted costumes are extremely fragile, perhaps because they were intended to be worn only for a single performance. The painted microglass beads are delicate and vulnerable to flaking, and it is unclear whether effective consolidation can be undertaken, as locating precise areas of flaking paint is difficult. In-depth research is required to address the consolidation concerns (Cheung, Tsang, and Sam 2012). Due to their unique significance, the curator was keen to display these costumes. Both the curator and the designer agreed that the condition of the garments should be the prime criterion in decision-making. The most robust object was chosen for interim display, and it was monitored continuously for any adverse effects. A T-bar mount was used, which supported the robe's sleeves while showing off the detailed motifs. (Mounting materials are discussed below.) The costume was displayed alongside a photograph of Soo Chow Mui (fig. 15.2).

FIGURE 15.2
The Artists' Corner. The pink, painted costume (1996.82.10) is accompanied by a photograph of Soo Chow Mui, the Cantonese opera artist who wore the garment. Collection of Hong Kong Heritage Museum; donated by Mr. Ma Chiu-kei and his family. © Hong Kong Heritage Museum

A sequined, reversible palace costume worn by Fong Yim Fun

This costume was worn in 1957 by Fong Yim Fun, a famous Cantonese opera star, during a performance of *The Marriage of Hung Luen*. Its front and back are densely covered with delicate gelatin sequins, making it extremely heavy (over 15kg). The costume symbolized the magical power of Hung Luen (played by Fong) in the scene when she transforms into a fairy goddess to protect her husband and son. Fong first wore the costume with the yellow sequined side outermost; after her transformation, she flipped the sleeves and turned the costume inside out, making the red side visible.

The reversible costume would be a star attraction in the inaugural exhibition of the Cantonese Opera Heritage Hall. However, to illustrate the spectacle of transformation, both sides of the costume had to be displayed at the same time. Neither a T-bar mount nor a mannequin was a viable option, and the limited space in the predesigned cases meant that flat display was not feasible either. It was decided to display the costume on a slightly inclined platform, which would reduce gravitational stress (Baker 2008:10). Part of each sleeve and the edges of the front openings were turned back to reveal the reverse. The sleeves were supported on a padded Perspex rod, which held the weight of the costume. The folds of the turned-over sleeve ends and front edges were supported with soft rolls of polyester batting covered with color-matched fabrics. The display was limited to six months, and the exhibition environment was controlled and closely monitored. The already vulnerable sequins were later found to contain cellulose nitrate, so controlling display conditions is vital for retarding further deterioration (Cheung 2005; Paulocik and Williams 2010).

DEVELOPING MOUNTS FOR MULTIPART COSTUMES

It is a challenge to conserve and display multipart costumes, because conservators need to take curatorial and design perspectives into consideration as well. Designers envisage a wide range of displays to create the lively, innovative, and attractive ambience appropriate to an exhibition's theme. The conservator considers the condition, construction, and size of the costumes in order to devise display mounts that are appropriate to the conservation strategy (McCloskey 2011; Lister 1997) while supporting and presenting the costumes. Modified stainless steel T-shaped mounts, which fully support shoulder areas, were used for most of the costumes (Morrison 2002). The mounts are adjustable in height and sleeve length to suit different costumes. Mannequins were used for lightweight costumes and to enable "action" postures.

Custom-made mounts were used to exhibit special features of certain costumes, including those in the most vulnerable condition.

A green sequined costume worn by Ng Kwan Lai

Ng Kwan Lai, a renowned and versatile Cantonese opera artist, generously donated to the HKHM over three thousand personal items associated with her career. This green sequined costume, which Ng wore in the play *Dream of the Golden Well in the Red Chamber* in 1960, is described as a "minor ancient costume" and is typical of those worn by young unmarried female characters. It has five pieces: an upper garment with flowing "water sleeves," a sleeveless jacket, an underskirt, an outer skirt, and a belt.

Comparatively lightweight, the garment is made of viscose rayon decorated with lace trimmings and sequins. Overall, it was in fair condition except for large, noticeable, yellow perspiration stains and a tear near the bottom of the upper garment. Thorough discussion about the stains' evidential significance took place, because cleaning is irreversible (Eastop and Brooks 1996). These costumes are seldom washed because of their heavy embellishment, noncolorfast dyes, and starch-sized fabrics. In consultation with the curators, it was decided to treat the perspiration stains to improve the costume's aesthetic appearance and reduce long-term chemical and physical damage. As the upper garment, made of a double layer of a white viscose rayon overlaid with green transparent nylon gauze, is decorated with sequins, spot-cleaning was the only practical option. The stains were spot-cleaned with Orvus WA (sodium lauryl sulfate, an anionic surfactant) paste and then lightly bleached with hydroxide peroxide using a suction table; the stains became only slightly fainter, so this treatment was not very effective. The torn area was reinforced by stitching with an infill of silk crepeline that matched the texture and feel of the original semitransparent fabric.

The upper garment with the sleeveless jacket (worn on the exterior) was placed on the upper section of the T-bar. The T-bar was padded at the waist in order to display the skirts, with the belt secured on the top. No extra support was added, because the skirts are lightweight and designed to drape naturally. The "water sleeves" were also allowed to hang freely. Some abrasion and/or creasing was anticipated where the skirts overlapped, so padding was added to minimize these risks.

Sequined grand armor worn by Ng Kwan Lai

Ng Kwan Lai wore grand armor in 1964 for her role as a general's wife (the female martial role) in *How Leung Hung Yuk's War Drum Caused*

the Jin Army to Retreat. Grand armor features a round collar, narrow sleeves, a "belly" (a padded, paper-stiffened middle section slightly broadened at the front), and a sleeveless jacket and trousers. The costume also features four triangular pennants in a fan-like position, each attached to a bamboo pole slotted into an embroidered bag that the performer ties on like a backpack. (These pennants are stage devices intended to emphasize the general's gallantry; real armor does not include pennants.)

There was considerable wear and numerous tears on the armor and sleeveless jacket, as might be expected for a heavy costume worn in a martial play. The armor is made of a silk/viscose rayon blend lined with a cotton fabric, and wear on the fabric had resulted in horizontal splits, probably due to the weakening of silk yarns. There was marked splitting across the shoulder area of the unlined jacket, and this was reinforced by stitching and supported with dyed, color-matched silk patches wherever feasible. Splits in the rigid "belly" piece were supported using patches of adhesive-coated support fabric where stitching was not possible. The reinforced shoulder area remained fragile even after treatment; because the jacket was worn under the armor and had no special features that would have appealed to visitors, the curators and conservators decided not to exhibit it. The grand armor is so heavy that an additional T-bar mount was placed behind the standard T-bar mount. The "backpack" was supported with polyethylene foam and fastened onto the T-bar stand, which held the pennants in a balanced, upright position.

Lightweight armor with dragon motifs worn by Yu Kai

This men's armor from *Beauty from the South Meets the Han Emperor* (1960) shows how a performer's acting style can affect the design of the costume. Yu Kai chose painterly, calligraphic Gu embroidery[4] to decorate the costume, rather than the sequins commonly used in the 1950s and 1960s; this greatly reduced the armor's weight, enhancing the actor's ability to perform fight scenes. The armor includes a "cloud" collar, scarf, leg flaps, and pennants. It is in generally good condition, although some couching threads securing the silver-wrapped metal threads of the embroidered motifs had broken; these were stabilized with stitching.

Yu Kai is famous for his martial roles, and both the curator and designer wished to present the armor on a dramatically posed mannequin. Varying the methods of display would also add visual and spatial diversity to the exhibition. The major challenge was mounting

the fanned-out pennants. The pennants are supposed to be fastened directly onto the figure's back, but this would have created stress, added weight, and changed the mannequin's center of gravity, making it unstable and causing it to lean backward. Moreover, the mannequin's arms would need to be bent to create the pose, also inducing stress. Several factors, including the short duration of the exhibition, enabled conservators to reach a compromise on its display. The costume was in robust condition and comparatively lightweight, with embroidery that was sufficiently flexible to withstand slight distortion. Padding eased areas of stress, and a commercial torso was modified and equipped with detachable, bendable arms. The chest areas were thickly padded using a "vest," which provided enough support for the structure with the pennants to be fastened onto the mannequin's back (fig. 15.3).

FIGURE 15.3

Cantonese opera artist Yu Kai chose painterly, calligraphic Gu embroidery for his armor (2010.10.88) for *Beauty from the South Meets the Han Emperor* (1960), here mounted on a mannequin. Its light weight enabled the actor to perform fight scenes. Collection of Hong Kong Heritage Museum; donated by Mr. Chak Yu-kai. © Hong Kong Heritage Museum

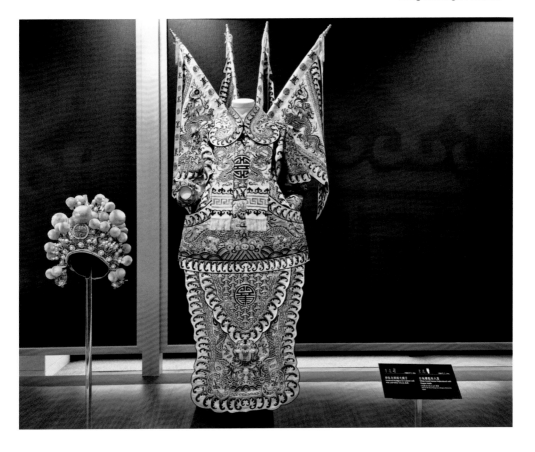

CONCLUSION

Cantonese opera costumes are complex structures with fragile components, and special display procedures may be required to effectively convey their theatrical impact. Each costume selected for exhibition in the Cantonese Opera Heritage Hall needed significant attention to reconcile the needs of long-term preservation and effective presentation. Preventive measures are required to ensure each costume's preservation because of the instability of the materials used in their construction. Good mounting serves as a preventive measure by protecting the costumes while also enhancing their aesthetic and performative values (White 1994) and revealing their beauty. As much as possible, the display retains the original vertical presentation of the costumes as worn, and padded mounts enable them to convey their theatrical characteristics. Nevertheless, the costumes present challenges for display, and close collaboration between curators, designers, and conservators is important: all parties should be equal players, especially in organizing exhibitions. The curator's focus is to ensure that the costumes can be well understood by visitors, the designer's mission is to integrate the display aesthetically, and the conservator's responsibilities are safe access and long-term preservation. With professional expertise and mutual respect, these exquisite costumes can be brought to the static stage of a museum exhibition in a way that reflects and respects their first lives in the performance of Cantonese opera.

NOTES

1. For example, "Textiles," AIC Wiki, American Institute for Conservation of Art and Historic Works, accessed June 7, 2015, http://www.conservation-wiki.com/wiki/Textiles; Museums & Galleries Commission 1998; Robinson and Pardoe 2000.

2. The controlled ambient environment is set at RH 60% ±5% at 20°C ±1°C in winter and 23°C ±1°C in summer; lux levels below 80 with UV content below 10⊠W/lumen.

3. Bao Shaoyou specialized in Chinese paintings of the Lingnan school.

4. For more about Gu embroidery, see "Traditions: Folk Handicraft: Gu Embroidery," Cultural China, accessed March 1, 2015, http://www.cultural-china.com/chinaWH/html/en/16Traditions1729.html.

REFERENCES

Baker, Marjorie M. 2008. *Caring for Your Textile Heirlooms*. University of Kentucky Cooperative Extension Service. Accessed March 1, 2015. http://www2.ca.uky.edu/agc/pubs/fcs2/fcs2707/fcs2707.pdf.

Chau, Hing-wah. 2011. "Safeguarding Intangible Cultural Heritage: The Hong Kong Experience. Intangible Cultural Heritage and Local Communities in East Asia." In *Proceedings of the International Conference on Intangible Cultural Heritage and Local Societies in East Asia, Hong Kong Heritage Museum, December 4-6, 2009*, edited by

Tik-sang Liu, 121–33. Hong Kong: South China Research Center, Hong Kong University of Science and Technology/Hong Kong Heritage Museum.

Cheung, Angela. 2005. "A Study of Sequins on a Cantonese Opera Stage Curtain." In *The Future of the 20th Century: Collecting, Interpreting and Conserving Modern Materials*, edited by Cordelia Rogerson and Paul Garside, 122–27. London: Archetype.

Cheung, Angela, Alice Tsang, and Louise Sam. 2012. "Glittering Decorative Art: Reflective Cantonese Opera Costumes." In "24th Biennial IIC Congress: The Decorative: Conservation and the Applied Arts," special issue, *Studies in Conservation* 57, Supplement 1: S346–47.

Dolby, William. 1983. "Early Chinese Plays and Theater." In *Chinese Theater: From Its Origins to the Present Day*, edited by Colin Mackerras, 7–31. Honolulu: University of Hawai'i Press.

Eastop, Dinah D., and Mary M. Brooks. 1996. "To Clean or Not to Clean: The Value of Soils and Creases." In *Preprints of the 11th Triennial Meeting of ICOM Conservation Committee, Edinburgh, Scotland, September 1–6*, edited by Janet Bridgland, 2, 687–91. London: James and James.

Hong Kong Heritage Museum. 2004. *A Synthesis of Lyrical Excellence and Martial Agility: The Stage Art of Ng Kwan Lai*. Hong Kong: Leisure and Cultural Services Department.

———. 2005. *Cantonese Opera Costumes*. Hong Kong: Leisure and Cultural Services Department.

Johnson, Elizabeth L., and Darrin Morrison. 1997. "Exhibiting Historical Costumes from a Living Tradition: Cantonese Opera in Canada." In *Symposium 97—Fabric of an Exhibition: An Interdisciplinary Approach, Preprints, NATCC*, 113–18. Ottawa: Canada Conservation Institute.

Li, Siu-leung. 2014. "Hong Kong Cantonese Opera, Fong Yim Fun, and the Female Subject." *Anthology of Hong Kong Cantonese Opera: The Fong Yim Fun Volume*. Hong Kong: Infolink Publishing.

Lister, Alison. 1997. "Making the Most of Mounts: Expanding the Role of Display Mounts in the Preservation and Interpretation of Historic Textiles." In *Symposium 97—Fabric of an Exhibition: An Interdisciplinary Approach, Preprints, NATCC*, 143–50. Ottawa: Canada Conservation Institute.

Liu, Aiwen. 1995. *A Study on the Dates of Early Designs of Cantonese Opera Costumes*. Accessed March 1, 2015. http://www24.atwiki.jp/nsga/pages/81.html. In Chinese.

McCloskey, Allison. 2011. "Supports for Textile Display: Overview and Strategies for Flat Objects." *Art Conservator* 6 (1): 19–22.

Morrison, Darrin. 2002. "Mounting Methods for Cantonese Opera Robes, Dresses and Suits." In *Museum Mannequins: A Guide for Creating the Perfect Fit*, edited by Margot Brunn and Joanne White, 25–28. Edmonton: Alberta Regional Group of Conservators.

Museums & Galleries Commission. 1998. *Standards in the Museum Care of Costume and Textile Collections*. London: Museums & Galleries Commission.

Paulocik, Chris, and R. Scott Williams. 2010. "The Chemical Composition and Conservation of Late 19th- and Early 20th-Century Sequins." *Journal of the Canadian Association for Conservation* 35: 41–61.

Robinson, Jane, and Tuula Pardoe. 2000. *An Illustrated Guide to the Care of Costume and Textile Collections*. London: Museums & Galleries Commission.

Siu, Wang-ngai, and Peter Lovrick. 2014. *Chinese Opera: The Actor's Craft*. Hong Kong: Hong Kong University Press.

Su, Lianer. 2014. *Embroidery Features of Cantonese Opera Costumes in Guangzhou*. Accessed
March 1, 2015. http://guangdong.kaiwind.com/yyfh/201412/29/t20141229_2211189_1
.shtml. In Chinese.

UNESCO. 2009. "Yueju opera." Accessed May 30, 2015. http://www.unesco.org/culture/ich
/index.php?lg=en&pg=00011&RL=00203#identification.

White, Sarah. 1994. "The Role of Costume Mounting in Preventive Conservation." *Preventive
Conservation: Practice, Theory and Research*, edited by Ashok Roy and Perry Smith,
228–32. London: International Institute for Conservation.

Yung, Bell. 1989. *Cantonese Opera: Performance as Creative Process*. Cambridge: Cambridge
University Press.

AUTHOR BIOGRAPHIES

ANGELA YUENKUEN CHEUNG has an MSc (material science), University of Hong Kong;
certificate (archaeological conservation), University College London; and BSc, University
of Hong Kong. She is assistant curator I of conservation, Conservation Office, Leisure and
Cultural Services Department, Hong Kong Special Administrative Region Government.

EVITA SO YEUNG has a postgraduate diploma (management studies), Chinese University
of Hong Kong; MSc (environmental management), University of Hong Kong; postgraduate
certificate (archaeological conservation), University College London; and BSc, University
of Hong Kong. She is the head of conservation, Conservation Office, Leisure and Cultural
Services Department, Hong Kong Special Administrative Region Government.

16 | CONSERVING DAMAGE

CLOTHING WORN BY INDIRA GANDHI AND RAJIV GANDHI
AT THE TIME OF THEIR ASSASSINATIONS

Kristin Phillips

On the morning of October 31, 1984, Indira Gandhi, prime minister of India, walked from her home at 1 Safdarjung Road, New Delhi, to her adjacent office at 1 Akbar Road to meet Peter Ustinov, the actor and filmmaker. She was dressed in an orange sari and black *chappals* (sandals) and carrying a handwoven shoulder bag from Nagaland. As she walked past the connecting gate, two of her Sikh bodyguards opened fire. She was shot in the abdomen by one of the guard's handguns and, after she had fallen to the ground, by thirty rounds from a Sten gun fired by the other guard. Indira Gandhi was declared dead at the All India Institute of Medical Sciences that afternoon. The assassination was in retaliation for the Indian army quashing the Sikh separatist uprising at the Golden Temple, Amritsar, in June 1984. Gandhi's assassination triggered widespread civil unrest.

On May 21, 1991, Indira Gandhi's oldest son, Rajiv Gandhi, was killed by a suicide bomber during his campaign for reelection as prime minister. He arrived at a campaign rally in Sriperumbudur, in the state of Tamil Nadu, wearing, as always, a pair of white cotton trousers, a long, white Indian-style shirt, white sneakers, and two pairs of white cotton socks. As he walked to the dais, he greeted well-wishers, Congress Party members, and schoolchildren, who presented him with garlands. When Rajiv Gandhi approached Thenmozhi Rajaratnam, also known as Dhanu, she bowed down to touch his feet and detonated an explosive device in her belt. The blast killed Gandhi and his assassin instantly, together with twelve bystanders. Dhanu was a member of the Liberation Tigers of Tamil Eelam (LTTE), which was fighting against government forces in Sri Lanka. Gandhi had stated he would disarm the LTTE if reelected, and the LTTE hoped his death would prevent the Congress Party from regaining power. Although the election process was delayed, the Congress Party swept to victory in June 1991 (see Mehta 1994).

The garments worn on those two fateful days now form part of the exhibition at the Indira Gandhi Memorial Museum (New Delhi), created from her house and office, which have been preserved by the

Indian government. The Indira Gandhi Memorial Trust and the museum were both established in 1985 to preserve, protect, and display objects, publications, and photographs connected with the prime minister. The museum now incorporates both display areas and rooms of the house, which are still decorated as they were when it was the Gandhi family home. Several rooms devoted to Rajiv's life were opened in 1992. The damaged garments, as intensely personal and poignant reminders of these violent deaths, are central to the museum and are on continuous display. They are pivotal objects in the family narrative: the fatalities and the memorialization transformed everyday clothes into relics. Displaying the damage is of the greatest importance, and the conservation treatments were developed with this as the principal objective.

DEVELOPING THE CONSERVATION APPROACH

Artlab Australia conservators Kristin Phillips and Justin Gare, working as part of an AusHeritage team led by its chair, Vinod Daniel, traveled to New Delhi to carry out the treatments.[1] The project costs were supported by a grant to AusHeritage from Australia's Department of Foreign Affairs and Trade. Indira's sari and Rajiv's trousers were examined in 2008. Treatments took place over two two-week periods in December 2009 and January 2011. Conservation work was done at the museum using materials and equipment brought to India by the conservators. Suman Dubey had been Rajiv's personal aide and was with him on the day of the assassination; now secretary of the Memorial Trust, he provided curatorial assistance and other help.

It is widely accepted that the overriding principle of conservation is to preserve an object's significance; therefore, determining this is pivotal in formulating a conservation approach (Marquis-Kyle and Walker 2004:16). Many different aspects of an artifact are explored, including researching its history and provenance, consulting custodians, exploring context, and undertaking analysis and comparisons (Russell and Winkworth 2009:10). In this case, the conservators played a key role in assessing the significance of the garments. Textile conservation can involve the repair or disguise of damages and stains. In this case, however, the damage and staining is primary evidence of the assassinations (Eastop and Brooks 1996). With these factors in mind, the conservators developed the following statement:

- each garment exhibits evidence of decisive moments in modern Indian history;

- the evident damage is highly evocative of the violent deaths of Indira and Rajiv Gandhi. (Artlab 2008)

It was clear that the damage caused by the shooting and the bomb blast—including bullet holes, shrapnel, carbon residue, human biological remains, and, to a lesser extent, the holes and marks from the postmortem forensic tests—have become crucial components of the objects and of primary significance. The conservation of this damage was therefore a priority.

Biological hazards were assessed before treatment began, and potential risks were considered low because of the age of the biological material. Conservators wore gloves except when this was impractical (for example, during stitching treatments) and washed their hands before and after all contact. A protocol was developed for needle threading.[2]

THE SARI AS RELIC

Handwoven in Orissa, the orange sari was made of hand-spun cotton thread and included decorative black borders. The *pallu* (the loose end of a sari that drapes over the shoulder) was further embellished with black stripes and a pale green and cream woven pattern. The sari would have been worn with pleats at the front; this pleating was loosely re-created in the original display at the museum. In the display case, the sari was folded in half, pleated across its width, and draped over a raised marble plinth, with the shoulder bag and sandals alongside.

Dubey stated that the sari had not been washed after the assassination. There is extensive blood staining, including solid dark areas and more diffuse areas with "tide lines" at the edges, along with other soiling and darker black stains. The blood has not affected the sari's flexibility. The lack of heavily infused areas of blood staining strongly suggests that Indira Gandhi died quickly.[3] Two signatures, possibly those of the forensic examiners, are written in pen at one end of the sari. Forensic examiners routinely attach labels to document the custody chain; the unusual act of writing signatures directly on the fabric may reflect the prominence of the sari and its wearer.

Damage to the sari comprised numerous small bullet holes. Reports stated that thirty bullets entered the body and twenty-three passed through the pleated sari, resulting in more than eighty bullet holes (Gupte 1985:49). There was some tearing associated with the bullet holes, but it is not known when or how this occurred.

With the overriding principle that any residue and damage resulting from the assassination was of primary significance, the objectives of the conservation treatment were identified as:

- documenting the sari's condition;
- selecting the best approach to preserve evidence of the shooting, including the stains and bullet holes;
- providing an effective system for handling;
- improving the display method; and
- encouraging the provision of suitable environmental conditions.

The presence of blood is normally considered to be detrimental to the long-term preservation of cloth, increasing the risk of insect attack, fungal growth, and deterioration of the fabric. However, in this case, the significance attributed to the staining and other biological remains overrides any potential risks of an increased rate of deterioration. The stains are now an integral part of the artifact. Preserving bloodstains has been considered by other conservators (e.g., Sanyal 1989; Buenger 2000, 2003). In this case, no consolidation was required; the staining was diffuse and well absorbed and did not affect flexibility. It was decided not to treat the sari with either aqueous or inorganic solvents, which might have affected these residues. This is consistent with the ethical precept of nonintervention best serving the needs of preservation (Australian Institute for the Conservation of Cultural Material 2002:9). However, to reduce the risks of deterioration, the provision of good environmental conditions is fundamental.

The bullet holes manifest the circumstances of the assassination and are considered of primary significance, but they also increased the risk of damage because they weakened the fabric's structure. It was therefore considered important to provide physical support to all holes, particularly where the cloth was torn. To provide support without disguising the holes, each bullet hole was patched with washed white cotton voile (fig. 16.1). These patches were cut to size and stitched behind the hole (or holes) as required, and couching stitches were worked using a fine, commercially dyed polyester thread (Tetex). This stabilized the losses but, unusually in textile conservation practice, did not camouflage them. In fact, when the sari is on display, the bullet holes are highlighted because a white fabric was selected as the underlying display material.

The pleats were re-created for the redisplay of the sari. To eliminate sharp creases, each fold was gently padded using a card-stiffened 10mm diameter polyethylene foam rod covered in orange fabric (to blend with the orange sari). The sari's support board served two functions: effective display, and easy and safe handling around the museum. Constructed from lightweight honeycomb aluminum board, it included

FIGURE 16.1

Indira Gandhi's sari undergoing treatment; the bullet holes are being supported but not camouflaged. Photo: Justin Gare, Senior Objects Conservator, Artlab Australia

painted wooden dowels to soften the hard edges and was covered with washed cotton flannelette; white cotton fabric was secured to the back. When on display, the support board is placed on a gentle slope.[4]

These articles needed to be conserved in situ, so the support work was carried out within a tight schedule of two weeks. This necessitated longer stitching periods than normally desirable, with little opportunity to rotate tasks. Occupational health and safety is an important consideration for any conservation treatment and, in this case, there were the added risks of working in an unfamiliar environment. A portable, sloped stitching surface that had been conceived, designed, and constructed prior to leaving Australia was used throughout the treatment.[5] The work was completed without injuries or discomfort.

FRAGMENTARY TROUSERS AS RELICS

When first inspected, Rajiv Gandhi's trousers were attached to a piece of translucent muslin using hand- and machine-stitching. Thus lined, the trousers had been hung vertically in a display case in front of a narrow window overlooking the location where Indira Gandhi had been shot. This intentional positioning is considered an important part of the display, and the museum wanted this relationship to be retained.

The trousers have a waistband with belt loops, two inset flat back pockets, and two side front pockets. There is no maker's label, and Dubey reported that they were tailor-made for Rajiv Gandhi.[6] Made in Andhra Pradesh, the fabric is hand-spun and handwoven *khadi*, a plain-weave cotton. Rajiv's choice of *khadi* demonstrates his sensitivity to the symbolism that cloth and clothes have in Indian society,

transmitting holiness, purity, and pollution. Because of its association with the campaign to remove India from British colonial rule, *khadi* has been described as the "fabric of Indian independence" (Bean 1994). Mahatma Gandhi (no relation to Rajiv or Indira) revived a powerful "self-sufficiency" campaign called *swadeshi* (literally, "indigenous goods") that encouraged people to boycott imported, British-made cottons (Tarlo 1996) and support local production and consumption of *khadi* instead. Cloth's porous, absorbent properties are widely recognized in India: first, for absorbing moisture and thereby controlling the temperature of the wearer's body (biochemical), and second, for its ability to absorb purifying or polluting qualities (moral) (Bayly 1986:285).

Rajiv's bomb-blasted trousers have absorbed both tangible matter and intangible properties, making them very powerful relics. Only a part of the trousers remains, completely infused with biological material, and preserving this evidence informed treatment decisions. Although the upper back, most of the back left leg, and part of the front left leg are relatively intact, large sections are missing. The proper right leg is almost completely lost below the thigh. Edges are torn and extremely tattered, and there are numerous holes. Many of the small holes were caused by shrapnel, and fragments of metal remain in the cloth. Holes with jagged, frayed edges are assumed to have been caused by the blast.

The biological material is likely to include blood, fat, and other bodily remains, and the resulting staining is yellow brown and has a greasy feel. There is also black, sooty staining caused by the bomb. The metal shrapnel fragments have rust stains. The museum has experienced periods of high relative humidity (RH), attributed both to Delhi's high temperatures and humidity and to the presence of many visitors in the museum, frequently thousands per day. High RH had caused the biological material in the trousers to migrate into the display muslin, resulting in unsightly brown haloing. Green, powdery mold was present at the top of the trousers.

Marking and sampling is common practice during forensic examination, particularly in a bombing, because the samples are tested to characterize the type of explosives or detonators. It is therefore assumed that, where the edges are sharp and appear cut, the trouser fabric was removed for forensic purposes. Pen marks made during the forensic examination included ringing around particular areas of damage, handwritten notes, and numbers.

The treatment objectives were the same as those for the sari: conserve the damage as evidence of the assassination as well as the

fabric itself. The stitching securing the trousers to the lining muslin was released, and the muslin was removed and packed for archival storage, as it now also contains biological material. A new lining of fine polyester plain-weave fabric was prepared; it was similar in size and appearance to the original muslin but reduced the risk of a recurrence of migration of the staining (fig. 16.2).

As with the sari, the decision was made not to treat the staining. The presence of the biological material makes the trousers feel greasy to the touch but has not stiffened the fabric. However, the mold caused by the high RH was not only damaging and unsightly but, more importantly, was unrelated to the assassination. Options for treatment were limited. Liquids and solvents might have affected the biological material and could not be used. The risk of continued mold growth after treatment was considered very low, because the trousers were to be displayed in a case with a controlled environment. The mold was therefore carefully removed using gentle vacuum suction, but no other remedial treatment was undertaken.

FIGURE 16.2
Rajiv Gandhi's trousers undergoing treatment. Photo: Justin Gare, Senior Objects Conservator, Artlab Australia

The question of how to align the trouser fragments arose. A conventional textile conservation approach would be to return the fabric and threads wherever possible to their presumed original position. However, the trousers had been subject to violent change and were no longer an item of clothing but a resonant and poignant relic. The damage powerfully conveys the violence of the bomb blast, and the treatment approach therefore made conserving that damage the core objective. Would attempting to align the trousers and frayed threads to their original positions affect the visual impact of the damage and remove aspects considered of primary significance? Equally, would attempting to position the trousers as they might have been after the blast assist in preserving damage but place the remaining fragments under undue physical stress and thus accelerate their deterioration? Also, would this approach be misleading, as there is no way to ascertain the exact positioning of the trousers after the blast?

The final alignment aimed to achieve a balance between conserving the damage as evidence of the bomb's impact while reducing the physical stress on surviving threads and fabric. In most places, the fabric fragments or threads were aligned to their original positions as part of a tailored garment. For example, the remaining front section of the left trouser leg had been previously displayed so that it could be seen, and this had necessitated flipping it down from its original position. As a result, the threads at the sides of this section were under considerable strain; they had been twisted and distorted to achieve this position, one which was also confusing to the viewer. The decision was made to untwist this section, returning it (as closely as possible) to its original position in front of the remaining back of the left trouser leg.

Some areas, such as the tattered remains of the top edges at each side of the trousers, were left folded out flat. This was not their original positioning, but it did not put threads under any undue stress or distortion. Such repositioning also helped to convey the impact of the blast, highlighting aspects considered most important. Frayed threads at the edges were aligned approximately to their original location, taking care not to realign fabric distorted by the blast. This was guided by the significance assessment, which recognized that aligning the threads in the original position was not necessarily the most appropriate approach in this case. Nevertheless, it was difficult to resist ingrained professional practices of neatness and order, and likewise hard to overcome concerns that a drop in "neatness" might be interpreted as a lack of professionalism.

The final alignment was discussed with the museum staff. The trousers were then sewn to the polyester backing using a combination

of running stitches and couching over damaged areas. A beige polyester thread (Skala) was used throughout. As with the sari, this treatment was carried out within a two-week schedule using the sloped work-support mentioned earlier.[7] Once the stitching was completed, the trousers were rehung in the original display location overlooking the site of Indira Gandhi's assassination (fig. 16.3). The long-term preservation of the textiles has been enhanced by optimizing the environmental conditions, which will slow the rate of deterioration caused by the presence of biological and metal residues.[8]

FIGURE 16.3

Visitors viewing Rajiv Gandhi's trousers at the Indira Gandhi Memorial Museum. Photo: Justin Gare, Senior Objects Conservator, Artlab Australia

DISCUSSION

It is the palpable evidence of these damaged garments that makes them such powerful documents and highlights their primary importance as material evidence.[9] Neither written accounts nor images are as emotive and visceral as looking at (or in the case of the conservators, handling) the physical objects caught up in such calamitous events. Preserving evidence of the assassinations is essential; these garments must continue to tell the story of momentous events in modern Indian history. They cannot be separated from their power as relics. The often dramatic reactions of visitors, many of whom come almost as pilgrims paying homage, clearly indicate the garments' ongoing importance. The long-term preservation of the sari and the trousers is a challenge that the museum has actively embraced. The conservation treatment and provision of the environmentally controlled cases are important steps in the continuing efforts to preserve and present these violently damaged garments.

ACKNOWLEDGMENTS

I thank the Gandhi family for their support in undertaking this project. I also thank Suman Dubey, secretary of the Indira Gandhi Memorial Trust, for assistance in Delhi and providing information for this article; Jaideep Thakur, administrative officer, for invaluable assistance and guidance at the museum; and Associate Professor Neil Langlois and Edmund Silenieks, biology evidence recovery, Forensic Science South Australia, for advice on health and safety when dealing with human biological materials. I thank my AusHeritage colleagues, in particular the chair, Vinod Daniel. I also thank the staff at Artlab Australia, including Andrew Durham, director; Sarah Feijen, Helen Weidenhofer, and Heather Brown, assistant directors; and colleague Mary-Anne Gooden; and I give particular thanks to my fellow project member Justin Gare for his assistance in writing this paper.

NOTES

1. AusHeritage (http://www.ausheritage.org.au/) is a network of Australian cultural heritage management organizations, established by the Australian government in 1996 to facilitate the overseas engagement of the Australian heritage industry.

2. Sewing threads were licked only once and were not licked again after they had been passed through the reliquary fabric. If rethreading was necessary, the thread was dampened with water.

3. Neil Langlois and Edmund Silenieks, biology evidence recovery, Forensic Science South Australia, e-mail to author, 2015.

4. A cloth cover, secured to the back of the support board with hook and loop fastening, was made to hold the sari securely when it is moved from the display case.

5. Artlab conservators worked with an ergonomic physiotherapist to develop sloped work surfaces. These have proved effective in reducing neck flection and therefore lowering the risk of musculoskeletal disorders (Phillips, Gare, and Bills 2013:1); "Best Solution to an Identified Work Health and Safety Issue," Artlab Australia, SafeWork SA, accessed August 9, 2015, https://www.youtube.com/watch?v=2-8sWGiQDNI&index =6&list=PLo4mf6efyi_FROIiLL8jrSKqE8Rax-KK5/.

6. Suman Dubey, personal communication to author, 2008 and 2014.

7. In this case, the sloped surface was extended, enabling conservators to sit on both sides at the same time and increasing work efficiency.

8. The Indira Gandhi Memorial Museum, with assistance from AusHeritage, monitored the museum environment. This led to the choice of free-standing, climate-controlled, conservation-standard display cases with ultraviolet filtered glazing produced by Glasbau Hahn, Germany. The internal environment is set at 20°C and 50% RH with 99% nitrogen to reduce the risk of mold growth, insect attack, and oxidation. The slight overpressure provides protection from airborne pollutants and dust. The display areas are now air-conditioned to control RH. Windows have been fitted with reflective ultraviolet-absorbing film, and artificial lighting was reduced to a minimum.

9. Because the tragic deaths of Indira and Rajiv Gandhi are so clearly evident in the textiles, the treatment of these garments was an intensely moving and sometimes emotional challenge for the conservators. The trouser fragments in particular invoked a strong emotional response, reminding the conservators of the garments' history by their grim physicality.

REFERENCES

Artlab. 2008. "Significance Assessment and Condition Reports, Indira Gandhi Sari and Rajiv Gandhi Trousers for the Indira Gandhi Memorial Museum, New Delhi." Unpublished report.

Australian Institute for the Conservation of Cultural Material (AICCM). 2002. "Ethics and Reconciliation Statement." Accessed February 2, 2015. http://www.aiccm.org.au/about /code-ethics-and-reconciliation/.

Bayly, Christopher A. 1986. "The Origins of Swadeshi Home Industry: Cloth and Indian Society." In *The Social Life of Things*, edited by Arjun Appadurai, 285–321. Cambridge: Cambridge University Press.

Bean, Susan S. 1994. "Gandhi and Khadi: The Fabric of Indian Independence." In *Cloth and Human Experience*, edited by Annette B. Weiner and Jane Schneider, 355–76. Smithsonian Series in Ethnographic Inquiry. Washington, D.C.: Smithsonian Institution Press.

Buenger, Nancy. 2000. "Wet with Blood: The Investigation of Mary Todd Lincoln's Cloak." In *Conservation Combinations: Preprints of a Conference; North American Textile Conservation Conference 2000, Asheville, North Carolina, March 29–31*, 40–51. Asheville, NC: Biltmore House Textile Conservation Staff.

———. 2003. "Connective Tissues: Ethical Guidelines for Biohistorical Research." In *Objects Specialty Group Postprints*, vol. 10, edited by Virginia Greene, David Harvey, and Patricia Griffin, 22–32. Washington, D.C.: AIC.

Eastop, Dinah D., and Mary M. Brooks. 1996. "To Clean or Not to Clean: The Value of Soils and Creases." In *Preprints of the 11th Triennial Meeting of ICOM Conservation Committee,*

Edinburgh, Scotland, September 1–6, edited by Janet Bridgland, 2, 687–91. London: James and James.

Gupte, Pranay. 1985. *Vengeance: India after the Assassination of Indira Gandhi*. New York: W. W. Norton.

Marquis-Kyle, Peter, and Meredith Walker. 2004. *The Illustrated Burra Charter: Good Practice for Heritage Places*. Canberra: Australia ICOMOS (International Council on Monuments and Sites).

Mehta, Ved. 1994. *Rajiv Gandhi and Rama's Kingdom*. New Haven, CT: Yale University Press.

Phillips, Kristin, Justin Gare, and Jo Bills. 2013. "'Table Talk': The Development of Modified Work Systems to Reduce the Risk of Work-Related Musculoskeletal Disorders from Conservation Treatment." In *Contributions to "Contexts for Conservation," the Australian Institute for the Conservation of Cultural Material National Conference 2013, October 23–25, Adelaide, South Australia*. Canberra: Australian Institute for the Conservation of Cultural Material. Accessed June 19, 2015. https://aiccm.org.au/sites/default /files/docs/NatConf_2013/NatConf_2013PubsFinal/17.%20%20Phillips_Gare_Bills _Table%20Talk.pdf.

Russell, Roslyn, and Kylie Winkworth. 2009. *Significance 2.0: A Guide to Assessing the Significance of Collections*. Rundle Mall, South Australia: Collections Council of Australia.

Sanyal, D. K. 1989. "Preservation of Blood Stains on Fabric." *Conservation of Cultural Property in India* 22: 112–15.

Tarlo, Emma. 1996. *Clothing Matters: Dress and Identity in India*. London: Hurst.

AUTHOR BIOGRAPHY

KRISTIN PHILLIPS, Bachelor of Applied Science, Conservation of Cultural Materials, University of Canberra, is president of South Australia/Northern Territory, Australian Institute for the Conservation of Cultural Material (AICCM). As principal conservator of textiles, Artlab Australia, she manages the Textiles Laboratory, providing services for the Art Gallery of South Australia, South Australian Museum, History SA, State Library of South Australia, and Carrick Hill, as well as private clients in Australia and overseas. She provides preventive conservation training for regional museums. She is also involved in school programs, for example, "The Wrap on Mummies: Lord Carnarvon and Lady Evelyn and Tutankhamen's Tomb," which introduces students to art and science. With a master knitter, she recently published a knitting pattern replicating the balaclava worn by Sir Douglas Mawson, a famous Australian Antarctic explorer.

17 | MOVING FORWARD TOGETHER

Bianca M. du Mortier and Suzan Meijer

Unlike any other type of object in a museum's collection, dress has to be manipulated to achieve its ultimate shape. A garment on a hanger is a limp object. Mounting costume is time-consuming and therefore costly; the specialized mannequins and display cases weigh heavily on the average—usually quite tight—budget. Although always popular with visitors, dress exhibitions can be less popular with budget holders. With preparation time frequently limited, close cooperation between curatorial and conservation staff is of utmost importance, as is adopting a pragmatic stance. The evolution of this approach toward costume displays in the Rijksmuseum and its precursor over the last 140 years is introduced below, drawing on historic examples and more recent case studies.

DISPLAYING DRESS AT THE RIJKSMUSEUM

The Rijksmuseum costume collection is the oldest in the Netherlands, originating in the Nederlandsch Museum van Geschiedenis en Kunst in the 1870s in The Hague. The Annual Reports after 1877 give a clear picture of the acquisition policy for costume as well as approaches toward its display. It was not until the opening of the grand building in Amsterdam in 1885 that several state-owned collections were brought together in a new national museum, the Rijksmuseum. With regional dress rapidly disappearing in the last quarter of the nineteenth century, the Dutch government commissioned twenty-five life-size figures dressed in "different national costumes" for display at the 1878 Exposition Universelle in Paris.[1] Upon the return of the costumes, the minister of trade and industry decided that they should be displayed at the Nederlandsch Museum van Geschiedenis en Kunst. The museum's director reported his dismay in 1880, when it seemed that this costume display was the most likely reason that visitor numbers doubled that year (Ministry of the Interior 1880:24–25). Not only were the costume mounts (made of plaster, straw, cotton wadding, and burlap) problematic, but moths (*Lepidoptera*) caused so much damage that some costumes had to

be discarded. In 1882, the display was dismantled and visitor numbers dropped. The director wrote: "It is difficult to determine the cause of this decline. It would be distressing, if the disappearance of the figures [dressed in regional dress], the least important part of the Museum, would be the cause" (Ministry of the Interior 1882:19, 21). However, the costume collection grew extensively through donations and purchases (Ministry of the Interior 1901:3).[2]

The remaining costumes from the Paris exhibition were permanently displayed in the new Rijksmuseum; after May 1900, when a Costume Room was opened, they were exhibited with fashionable costume and that worn by famous and royal personages, as well as "the highly important [new] collection of contemporary Dutch regional dress" (Ministry of the Interior 1901:3).[3] Much of the Rijksmuseum's collection, like that of the Victoria and Albert Museum (V&A), London, was intended for the "use and betterment" of artists, art lovers, collectors, and students of history and the history of art, as well as the general public. Museum objects were often taken to the adjoining School of Drawing and the School of Applied Arts.[4] Although public interest in costume remained high, resulting in a growing collection, all large costume exhibitions in the early twentieth century were held outside the Rijksmuseum and involved both public and private participation. "Curatorial" work was done by the director, and "conservation" was relegated to volunteer ladies of independent means.

DEVELOPING CONSERVATION EXPERTISE
In 1937, H. S. Bloedhouwer, who trained at the Manufacture des Gobelins, Paris, established the Tapestry Conservation Workshop; the next year, he was joined by four other employees, including his French wife, A. Bloedhouwer-Ducrot. Seventy-eight conservators and dozens of interns have since worked on the Rijksmuseum's collection. The first reported costume conservation treatment appears in the 1966 Annual Report (Rijksmuseum 1966:70). Due to the lack of systematic conservation training in the Netherlands, costume treatment was undertaken by ladies with a background in needlework or dressmaking. Little is known of their approach, as no records other than the Annual Reports survive from this period.

A trained head of Textile Conservation was appointed in 1980, and the first formally trained costume conservator was appointed in 1981. Initially, the conservation studios were under the authority of the curatorial department, consisting of one curator for textiles and one for costume. In 2008 a new independent department, Conservation

and Research, was established, with Dr. Robert van Langh as head. Conservators' job descriptions changed, with up to 20 percent of their time devoted to collection research, enabling greater emphasis on technical and scientific pursuits. Conservators and curators now operate at the same hierarchical level.

The Costume and Textile Conservation Workshop has spacious quarters with adjoining office space and work space. Two full-time and two part-time conservators, assisted by local and international students and interns, are responsible for the conservation of all types of textiles, costume, and accessories (approximately 13,500 objects). Funding is available to contract specialized conservators or scientists for specific projects; for example, a specialist in color analysis was hired to identify dyes in selected costume and accessories.[5]

EVOLVING EXHIBITIONS

As early as 1920 the Rijksmuseum had a freelance costume curator, Johanna Henriëtte der Kinderen-Besier (1865–1944), who was also a trained art historian and an accomplished illustrator and writer. Her 1921 article on the mounting and display of costumes emphasized the importance of historical knowledge and extensive research of actual garments, inside and out, before even considering the mounting process. She argued that mounting could only be successful with proper underwear, with additional shaping achieved using tissue paper. Der Kinderen dismissed the use of twentieth-century busts or wax figurines, believing that contemporaneous posture and ideals of beauty had to be taken into account when choosing a mannequin (1921:5).[6] For the 1923 permanent display *De Kleeding onzer Voorouders 1700–1900* (The dress of our ancestors), der Kinderen put her theory into practice, using custom-made, headless plaster mannequins modeled and finished by sculptor Abraham Hesselink (1862–1930). She was well aware of the rigidity of this material but opted for a historically correct body shape.[7] The costumes were presented in closed glass showcases with contemporaneous portraits above (fig. 17.1). The display was a huge success, and der Kinderen was commissioned by the Rijksmuseum to write an accompanying catalogue with line drawings and some patterns (1926). The display and book are early examples of excellent practice and research.

In 1962, costume and textiles curator A. M. Louise E. Mulder-Erkelens (1915–1984), with graphic designer Dirk Cornelis Elffers (1910–1990), designed a Costume Court, a series of period rooms built in one of the museum's courtyards. The rooms were decorated with museum furniture, wallpaper, lighting, mirrors, and other items. Mulder-Erkelens

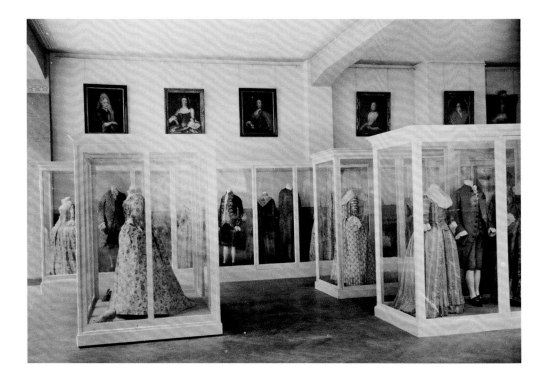

FIGURE 17.1

The 1923 costume display curated by Johanna Henriëtte der Kinderen-Besier, with figures by Abraham Hesselink. Image © Rijksmuseum, Amsterdam

commissioned theater designer Metten Koornstra (1912–1978)—whose window displays for the Amsterdam department store De Bijenkorf were renowned—to make lifelike figures in a variety of poses. These were plaster over a frame of bamboo with naturalistic heads, topped with wigs, including one original wig from the collection (fig. 17.2). Each glass-fronted case had thin wooden walls, a cotton fabric "ceiling," and white fluorescent lighting installed in a recess at either side. Over the years, the unfiltered light, dust, and building materials that gradually accumulated on the fabric ceiling damaged the costumes, especially because cleaning the rooms was difficult and it was done infrequently. When Bianca M. du Mortier (b. 1956) became the new curator of costume in 1980,[8] it was recognized that the exhibition no longer met conservation standards. However, it took until the late 1980s to convince the directors that the public's favorite gallery would have to close after almost thirty years, leaving only one smaller room for costume display.[9]

In 1996 the museum opened a new, purpose-built Costume and Textiles Gallery in its south wing. This introduced a continuous series of thematic presentations from the collection on a biannual rotation, with each presentation orchestrated by a different Dutch designer. The designers came from varying backgrounds—styling, interior design, architecture, and theater—and some had previous experience working

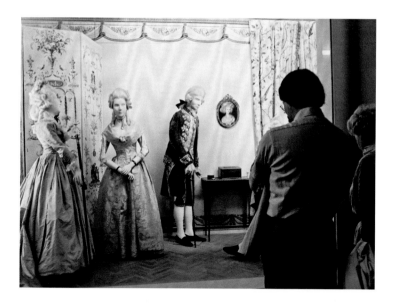

FIGURE 17.2
The 1962 costume display
in period room settings
curated by A. M. Louise E.
Mulder-Erkelens, with
figures by Metten
Koornstra. Image ©
Rijksmuseum, Amsterdam

FIGURE 17.3
The 2002 presentation
Finishing Touches,
Accessories 1550–1950,
curated by Bianca M. du
Mortier in the Costume
Gallery in the south wing.
Image © Rijksmuseum,
Amsterdam

with historic costume, while others were completely unaware of con-
servation requirements and needed careful guidance. Their approaches
varied: some installed modern pieces of furniture and art with the cos-
tumes to bring past and present together, and others painted the gallery
walls in stripes that matched the colors of displayed garments. With
these external factors impacting the process, close cooperation between
the curator and the Conservation Workshop was imperative, with prag-
matism remaining key. This was especially critical because some exhi-
bitions were accompanied by publications that required advance object
photography. This involved working with well-established or emerging
Dutch photographers who had backgrounds in fashion rather than in
historic dress; once again, clear parameters had to be set (fig. 17.3).

FASHION DNA: THE RIJKSMUSEUM IN THE NIEUWE KERK (2006)
During the Rijksmuseum's closure for refurbishment (2003–13), two experimental exhibitions took place in the Nieuwe Kerk in central Amsterdam. This sixteenth-century church had been transformed into a cultural events venue in 1980 and had already hosted many exhibitions. With costumes and accessories not viewable by the public until the Rijksmuseum reopened, it was decided that one of the Nieuwe Kerk exhibitions would feature items from this collection, allowing new ways of display to be explored in preparation for the New Rijksmuseum.

The main aim was to attract a broader audience—anyone over fourteen, and especially those who had never visited the Rijksmuseum—and to transform the museum's image from rather old-fashioned and stuffy into contemporary and vibrant. The museum had not tackled a large-scale project like this before, and the schedule was tight, but the team of one curator and three conservators (one part-time) started work. Inspired by Agnes Brooks Young's book *Recurring Cycles of Fashion, 1760–1937* (1937), as well as frequent references to historical dress and accessories in contemporary fashion design, the curator proposed to combine exhibits from the Rijksmuseum with contemporary pieces from both "off-the-rack" retailers and famous European fashion houses. The exhibition's starting point was the body as the connection between past and present, demonstrating changing ideals of beauty and their effect on the shape of the dressed body, that is, the effect of garments on the body and vice versa.

The Dutch fashion brand Mexx became the project's main sponsor, and the title *Fashion DNA* was chosen together. Mexx, in addition to acting as a sounding board, had its in-house designers produce the exhibition graphics.[10] Milanese architect Italo Rota (b. 1953)—who had worked for Florence's *Pitti Immagine* trade fair, for fashion designer Roberto Cavalli, and for museums in Italy and abroad—was asked to be the designer, mainly because of his experience with historic buildings. However, it became apparent that Rota, having worked in the fashion world, where budgets were sizable, was accustomed to grand gestures that the Rijksmuseum could not afford. Unfortunately, downsizing became inevitable; for example, a proposed tailor's table was never made. This table was designed with a recess in which an object was displayed flat, covered with a transparent digital screen that, when activated, would show enlargeable images of the back, inside, and details of the garment as well as additional information. Rota's proposed alternative to standard cases, the form-following "blister" case, proved technically challenging. Inspired by the packaging of Barbie doll clothes,

the blister case allowed visitors to view the garments extremely closely without touching them (fig. 17.4). Ideally, the "blister" would have been extended, with an extra vertical panel with a screen, allowing the visitor to see moving images (e.g., newsreels, films, music clips) relating to the garment. One blister case was ordered for the Rijksmuseum's 1.8m wide wedding dress (1759), but due to lack of experience with the required technology—shaping a synthetic material around a 3-D scan of a garment was then largely unknown in the Netherlands—the result was very disappointing and little appreciated by visitors.

With the budget running out, display cases or Barbie boxes had to be standardized and therefore could not be fitted to every costume. Such setbacks led to many meetings, with the curator and conservators feeling caught in the middle. Although the result was not as interesting or as different as the team had wished, the exhibition was a huge success. The mixture of old and new, with some cases displaying products readily available at mass-market retailers, attracted visitors of all ages. Many bought the accompanying "magalogue," a catalogue in the form of a fashion magazine that was available at kiosks nationwide.

FIGURE 17.4
The "blister" case designed by Italo Rota for the 2006 exhibition *Fashion DNA* at the Nieuwe Kerk, Amsterdam, curated by Bianca M. du Mortier. Image © Rijksmuseum, Amsterdam

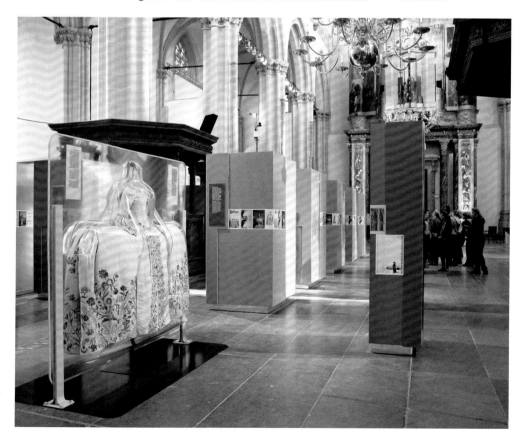

ACCESSORIZE! (2008)

The period between 2006 and the reopening of the Rijksmuseum was designated for updating and completing registration, documentation, and photography of the museum's collection. It was decided to use the resulting digital images for a web-based exhibition in Dutch and English called *Accessorize!*[11] The first of its kind in the Netherlands, it showcased 250 accessories presented as high-resolution images with detailed text information and related games; it was searchable by type, period, material, and color. Graphic designer Joost van Grinsven's approach was highly stylized, referencing advertisements in glossy magazines and websites such as Net-a-Porter, which are analogous to museum presentations in that they also try to "sell," that is, communicate their objects to their audience. Yet again, time pressure demanded a pragmatic choice of objects. Only those in mint condition were selected; this was also important because the high level of zoom meant that details normally invisible to the naked eye could be seen.

COSTUME DISPLAY IN THE NEW RIJKSMUSEUM
(2013 TO THE PRESENT)

Because costume display is so popular with museum visitors, and because the New Rijksmuseum display ethos is to mix historical and contemporary art pieces, the initial plan was to include a costume in each of the exhibition rooms of the main visitor circuit. Both the curator of costume and the conservators opposed this idea for the following reasons:

- the maximum light level in the designated rooms would be 200 lux (as opposed to the recommended 75 lux);
- it would be very difficult to design cases that could hold the varying silhouettes within a designated century (sometimes too large for one garment or too small for two);
- the limitations of the costume collection (several periods are abundantly represented, while others are not);
- not all costumes are in a condition to be displayed and would require much interventive conservation; and
- there are limited staff resources for biannual rotations.

In 2011 one of the vaulted basements was designated for the display of special collections; that is, objects that were missing from (or only partially displayed) in the main circuit.[12] As three painted columns, original architectural elements of the building, prevented

the construction of small display cases, it was decided to make one large case (5 × 10m) for costume displays. The result is far from ideal: the height is limited to 3.25m, and two of the three heavily decorated columns stand in the middle of the case. Consequently, full views are blocked from certain angles, and creating an attractive display is challenging.

As most of the biannual presentations are based on or around the Rijksmuseum costume collection, the process starts with the selection of one to three topics that are related to current affairs or to fashion developments, which can be linked to an object or group of objects in the collection. This choice is made collectively and pragmatically, considering curatorial and conservation workloads. The first step is a close inspection of the selected object by the conservators, who report their findings and treatment proposals to the curator. Extensive treatment is of course carried out if necessary, but as both staff and time are limited, minimal intervention is preferred where possible. This may mean that a particular costume cannot be displayed because more time is needed to stabilize it, or because previous alterations make it unsuitable. Following selection, costumes are photographed from all angles on a mannequin. The Rijksmuseum's professional photographers have a background in advertising and were trained in costume photography by V&A colleagues. They work with the curator; conservators are involved as needed. Although extremely time-consuming, this gives good results: the photographer is able to concentrate on technical aspects of image capture, and the curator, on achieving the correct silhouette.

COSTUME MOUNTING

Preparing textiles for photography and research and organizing the biannual costume display rotation leaves limited time for interventive conservation. Extensive treatment is therefore only carried out when absolutely necessary to prevent further damage from handling and exhibition. As a result, the emphasis is on accurate mounting to ensure garments have appropriate support during display. Toiles are not used: they are time-consuming to prepare, and none of the staff is a trained pattern cutter. Information on the correct shape of the garment is gathered from the museum's large collection of costume prints and paintings as well as from specialist publications. These sources are discussed extensively with the curator and compared with the evidence provided by the actual garment until the optimum result for that particular garment is achieved. This process may take up to two days, because the costume has to have the correct appearance from all angles.

For displaying women's dress, Japanese Nanasai (formerly Wacoal) mannequins, often described as Kyoto mannequins, are used whenever possible. The museum had been acquiring them since the 1980s and now has approximately sixty mannequins in a variety of shapes and sizes.[13] They have been spray-painted in matte light gray (RAL 7047), because the New Rijksmuseum's interior designer considered this color sympathetic to old or discolored fabrics. The legs are seldom used, nor are the heads, as they require wigs. Using headless mannequins also follows the "abstract tradition" of presenting costumes initiated in the 1920s by der Kinderen. The emphasis is on the garment itself, and costumes are not displayed with accessories.

If the smallest mannequin is still too big, copies of the Wacoal torso are made with paper tape, buckram, or etamine (starched cotton), cut to size, and covered with synthetic jersey. A plywood base allows the Wacoal metal stand to be used, while the Wacoal arm fittings are inserted into the shoulders for attaching the original arms and hands. This is considered an acceptable solution, because the arms provide good support for a garment's shoulder area and sleeves. If the mannequin arms are too short or too thick, the hands are attached to a piece of metal rod inserted into the arm fittings; however, this is less satisfactory, and improvements are still being sought. Of course, these copies are not as well finished as the originals, but for shorter displays, they serve their purpose. Using measurements supplied from their respective collections, the Metropolitan Museum of Art, New York, and the Kyoto Costume Institute collaborated on the design of the Nanasai mannequin torso, meaning the mounted costumes usually only need a little additional padding.[14] The mannequins do not have a diaphragm, and corsets and supporting underwear are added to create the right shape.

Until recently, the museum lacked appropriate mannequins for twentieth-century dress. Unfortunately, Nanasai does not supply twentieth-century mannequins, or any for the period between 1840 and 1880. Experience has shown that 1840–80 costumes do not fit well on a "regular" nineteenth-century mannequin, because the shoulders have an extreme slope, or on a belle époque form, because the mono-bosom is far too large. Therefore, standard polystyrene torsos were used, cut to size and covered with jersey in a color matching the Nanasai and Wacoal mannequins. In 2014, several headless twentieth-century mannequins were ordered from the Italian firm Bonaveri; the company still uses molds dating back to the 1940s, which have the right size and shape of breasts. Most commercial mannequins today have pert, pushed-up breasts with clearly visible nipples, making them unsuitable

for historic costume. These Bonaveri mannequins fit most dresses from the 1920s to the 1960s and are available with a variety of arms (straight, bent, or placed on hips).

The few garments in the collection predating 1725 are mainly male dress. Although the Rijksmuseum bought Wacoal male mannequins in the 2000s, and the torsos had the desired measurements, they nonetheless did not meet the museum's needs. The male mannequins are less user-friendly than the female figures. They seem heavy and have a tendency to tilt to one side, and attaching the hands and legs requires that screws be tightened by reaching inside sleeves or trousers, which can easily cause damage. For this reason, torsos for seventeenth-century male garments are made by cutting down modern polystyrene torsos and covering them with jersey. This forms the base support for a thick felt copy of the actual garment, which provides an additional layer of support using the Pietsch method (Pietsch and Stolleis 2008:138–43).

CONCLUSION

Cooperation between the Textile Conservation Workshop and the curator of costume has intensified since 2000 for a number of reasons: the proximity of their offices; the growing number and scale of interdisciplinary projects (e.g., research, biannual rotation exhibitions, and publications); the closeness of storage; the increasing number of visits by museum professionals, university students, and other researchers; and, most of all, mutual respect for one another's knowledge, experience, and opinions. Consultation is embedded in the daily routine and allows for freedom of movement and trust across disciplinary boundaries. The curator "temporarily" moved into the Conservation Workshop in 2012 for the costume mounting for photography (and later for display) and has not yet left. Although some colleagues within and beyond the museum do not see this arrangement as obviously beneficial—and even frown upon it—it has proven very beneficial to all involved and has resulted in a refreshing cross-pollination of knowledge and ideas. We recommend that all curators and conservators follow our example and move in together—albeit "temporarily"!

NOTES

1. "Pays-Bas–D'abord, une exposition ethnologique de costumes populaires [...] Puis un salon de personnes riches...." (*Guide du visiteur à l'Exposition Universelle de 1878* 1878:64).

2. For instance, a major purchase of seventy-four mostly seventeenth- and eighteenth-century items of clothing and accessories in 1882 (Ministry of the Interior 1883:33–35).

3. This new collection of regional dress on life-size mannequins was donated to the museum on the occasion of the 1898 investiture of Queen Wilhelmina (Ministry of the Interior 1900:44, 52).

4. For the costume collection's history, see du Mortier 1995:43–56.

5. "Color" has become a multidisciplinary, cross-collection research project encompassing several museums. It is anticipated that initial results will be published in a book on the costume collection in 2016.

6. See Marcus-de Groot 2003:151–54.

7. Der Kinderen preferred plaster to linen and burlap figures, arguing that its firmness and resistance to moths or woodworm made it last longer and retain its shape and so was better for the costumes (Ministry of the Interior 1920).

8. When du Mortier trained as an art historian specializing in western European costume at Utrecht University in the late 1970s, the curriculum did not include museum skills. Accessioning, handling, mounting, and display were supposed to be mastered through practice. Therefore, from the beginning of her career at the Rijksmuseum, her contact and collaboration with the Costume and Textile Conservation Workshop has been close and frequent.

9. This also gave conservators more time to devote to improving storage and working on documentation.

10. Mexx won the Dutch Sponsor Ring in the art category (2006) for its exemplary sponsorship.

11. *Accessorize!* (https://www.rijksmuseum.nl/formats/accessoires) was launched at Modefabriek, the Netherlands' "Finest Fashion" fair, winning the Dutch Design Award (2008) for outstanding photography and design; see du Mortier and Bloemberg 2009. The website was designed by Joost van Grinsven, with animations by Cristina Garcia Martin.

12. In 1885 this area had been designed to house religious art; hence, the vaulted ceiling and painted columns replicating those of three important churches in the Netherlands.

13. The storage requirements of this large mannequin collection present problems; for example, explaining to management why so many mannequins are needed and why they should be stored near the workshop.

14. The only disadvantage is that metal fittings for the older Wacoal mannequins do not fit other versions. This means three different types of arm fittings, three different torso/hip fittings, and two different and noninterchangeable hip/stand fittings, making them much less flexible in use.

REFERENCES

der Kinderen-Besier, Johanna Henriëtte. 1921. "Over kostuumgeschiedenis en het opstellen van oude kostuums" [On costume history and preparation of old costumes]. *Oude Kunst: een Maandschrift voor Verzamelaars Kunstzinnigen* [Ancient art: a review for collectors] (January): 1–5.

———. 1926. *De Kleeding onzer Voorouders 1700–1900: De Kostuumafdeling in het Nederlandsch Museum voor Geschiedenis en Kunst te Amsterdam* [The dress of our ancestors 1700–1900: The costume collection in the Nederlandsch Museum voor Geschiedenis en Kunst]. Amsterdam: van Looy.

du Mortier, Bianca M. 1995. "'Om haar eigen artistieke waarde': de geschiedenis van de kostuumverzameling van het Rijksmuseum" ['To her own artistic value': the history of the costume collection of the Rijksmuseum]. In *Kostuumverzamelingen in beweging:*

Twaalf studies over kostuumverzamelingen in Nederland [Costume sets in motion: Twelve studies of costume collections in the Netherlands], 43–56. Arnhem, Netherlands: Dutch Association of Fashion and Costume Regional Dress.

du Mortier, Bianca M., and Ninke Bloemberg. 2009. *Accessorize!: 250 Objects of Fashion & Desire*. Amsterdam: Rijksmuseum.

Guide du visiteur à l'Exposition Universelle de 1878. 1878. 6th ed. Paris: Chaix.

Marcus-de Groot, Yvette. 2003. *Kunsthistorische Vrouwen van Weleer: de eerste Generatie in Nederland vóór 1921* [Art history women: the first generation in the Netherlands before 1921]. Hilversum, Netherlands: Verloren.

Ministry of the Interior. 1880. *Verslagen omtrent's Rijks Verzamelingen van Geschiedenis en Kunst, II, 1879* [Reports on the national collections of history and art, II, 1879]. The Hague: Ministry of the Interior.

———. 1882. *Verslagen omtrent's Rijks Verzamelingen van Geschiedenis en Kunst, IV, 1881* [Reports on the national collections of history and art, IV, 1881]. The Hague: Ministry of the Interior.

———. 1883. *Verslagen omtrent's Rijks Verzamelingen van Geschiedenis en Kunst, V, 1882* [Reports on the national collections of history and art, V, 1882]. The Hague: Ministry of the Interior.

———. 1900. *Verslagen omtrent's Rijks Verzamelingen van Geschiedenis en Kunst, XXII, 1899* [Reports on the national collections of history and art, XXII, 1899]. The Hague: Ministry of the Interior.

———. 1901. "Verslag van den Hoofddirecteur B. W. F. van Riemsdijk" [Report of Chief Executive B. W. F. van Riemsdijk]. In *Verslagen omtrent's Rijks Verzamelingen van Geschiedenis en Kunst, XXIII, 1900* [Reports on the national collections of history and art, XXIII, 1900]. The Hague: Ministry of the Interior.

———. 1920. *Verslagen omtrent's Rijks Verzamelingen van Geschiedenis en Kunst* [Reports on the national collections of history and art]. The Hague: Ministry of the Interior.

Pietsch, Johannes, and Karen Stolleis, eds. 2008. *Kölner Patrizier- und Bürgerkleidung des 17. Jahrhunderts: Die Kostümsammlung Hüpsch in Hessischen Landesmuseum Darmstadt* [Cologne patricians' and citizens' clothing of the 17th century: The Hüpsch costume collection in Hessian Landesmuseum Darmstadt]. Riggisberg: Abegg-Stiftung.

Rijksmuseum. 1966. *Verslagen omtrent's Rijks Verzamelingen van Geschiedenis en Kunst* [Reports on the national collections of history and art]. Amsterdam: Rijksmuseum.

Young, Agnes Brooks. 1937. *Recurring Cycles of Fashion, 1760–1937*. New York: Harper.

AUTHOR BIOGRAPHIES

BIANCA M. DU MORTIER, MA, has been curator of costume at the Rijksmuseum since 1980, focusing on dress and accessories from the Netherlands, 1550–1950. She has been a board member of the international ICOM Costume Committee, the Dutch Costume Society, and the Koninklijk Oudheidkundig Genootschap (Royal Antiquarian Society). From 1996 to 2002 she organized biannual presentations in the museum's Costume and Textile Galleries. In 2006 the major exhibition *Fashion DNA* attracted large crowds. The web exhibition *Accessorize!* (2008) won the prestigious Dutch Design Award and the accompanying book, *Accessorize!: 250 Objects of Fashion & Desire*, was praised for its photography. She has written many articles, and her book about a selection of costumes from the Rijksmuseum collection is expected to be published in 2016.

SUZAN MEIJER is head of Textile Conservation at the Rijksmuseum, appointed 1997. She trained at the Dutch State Training School for Conservation (1988–92). She started working as a textile conservator at the Rijksmuseum in 1993, taking a special interest in furnishing textiles. She was a teacher at the Opleiding Restauratoren from 2002 to 2008, and, since 2011, has been assistant coordinator of the Textile Working Group of ICOM Conservation Committee.

Page numbers in italics refer to illustrations.

A

Abegg, Margaret, 79

Abegg, Werner, 79

Abegg-Stiftung, 79, 80–81, 86, 91n4, 91n9

 Hülle und Zier: Mittelalterliche Textilien im Reliquienkult, 88

accessories, 109, 111, 117, 145, 147, 149, 150, *150*, 160, 161, 168, 171n10, 173, 182, 189, 190, 199, 239, *241*, 242 246, 247n2

 exhibition on, 244, 248n11, 249

Adrian, suit, *176*

aesthetic movement, 107

Ainu, 33–48

Alaïa, Azzedine, 195, 197n8

Alexandra, Queen, 165

Amsterdam, 15, 237, 240, 242

Anderson, Ian, 59–60, *59*

Anello & David, 181

apartheid, 5

archaeological textiles, 8–9, 79–92, 121–22

Arnold, Janet, *Patterns of Fashion*, 133, 137

Art Deco, 175

Arthema, 157n17

artifacts, 2, 35, 36, 38, 43, 71, 94, 122, 137, 139, 146, 152, 157n15, 162, 184, 191, 195, 216, 228

 access to, 10, 43, 184n2

 conservation of, 34, 35, 43, 66, 226

 preservation of, 5, 7, 74, 122, 177, 226

Artlab Australia, 226, 235n5

Arts and Crafts, 191

Arts Victoria, 52

Ashmolean Museum, University of Oxford, 97, 99

assassinations. *See* Gandhi, Indira; Gandhi, Rajiv

Atkinson, Uncle Henry, 52, 54, 60, 63

Attfield, Judith, 21

AusHeritage, 226, 234n1, 235n8

Australia, 51, 61n10, 182, 183, 185n6, 185n13, 226, 229, 234n1

 Aboriginal peoples of, 49–50, 53, 54, 58, 60, 61n5, 61n10

Gunditjmara, 52, 55, 60n3

Wurundjeri, 52, 53, 57, *58*

Yorta Yorta, 51, 52, 53, 54, *56, 57*, 60n3

Melbourne, 52, 55, 174

southeast, 49, 50, 52, 60

Sydney, 174

Victoria, 51, 52, 54, 55

authenticity, 2, 15, 16n9, 66, 138, 159, 179, 207, 208, 209

B

Baily, Edward Hodges, *Eve Listening to the Voice*, 188, *188*

Balenciaga, Cristóbal, evening dress, 175, *176*

Banks, Joseph, 96

Bao, Shaoyou, 217, 222n3

Barak, Murrup, 57

Barak, William, 53

Barbieri, Gabriella, 206, 208

barkcloth, 94, 95, 97–98, 99, 100, 102

Baxandall, Michael, 1

Beeche, Robyn, 181, 185n13

Behlen, Beatrice, 200, 204, 206–7, 211

Bloedhouwer, H. S., 238

Bloedhouwer-Ducrot, A., 238

Blow, Isabella, exhibition on, 20–21, 29n3

Blue, 145, 148, 156n2, 157

Blum, Stella, 174, 178, 185n5

body, 10–13, 95, 153, 164, 167, 168, 170, 174, 204, 242

 absent, 1, 14, 19, 20, 21, 22–23, 25, 28, 174, 177

 clothing and, xiv, 8, 9, 11, 14, 19, 20, 21, 22, 28, 50, 70, 150, 152, 161, 173, 174–77, 230, 242

 forms, 21, 101, 117

 shapes, 102, 116, 151, 153, 174–75, 239

 as a term, 10

Bolton, Andrew, 12, 191, 193, 197n14

Bowes, John, 145, 156n1

Bowes, Joséphine, 145

Bowes Museum, 145

 Fashion and Textile Gallery, 14, 145–57, *148, 150, 154*

Glass Cube, 149, *149*, 151–52, 153, 155, 156n11

Bowles, John, *205*

Brazil, 133, 134, 135, 136, 137, 140–41, 142, 142n2, 142n6, 143n7

 coffee plantations, 133, 135, 136

Breward, Christopher, 185n4, 194

Briggs, Uncle Donnie, 54

Brighton Museum & Art Gallery, 29n7, 157n14

 Fashion & Fancy Dress, 22, 23, 29n9

Britain, 12, 25, 107, 110, 133, 137, 181, 187, 189, 190, 196, 230

British Museum, 97

Buckingham Palace, *xvi*, 1, 15n1

Bugge, Thomas, 97

Burne-Jones, Edward, 110

Burton, Sarah, 1, 191

C

caches, 3, 121, 123, 130–31

Cambridge, Duchess of (Catherine Middleton), wedding dress of, *xvi*, 1, 14

Canada, 43

Canova, Antonio, *The Three Graces*, 188

Casa do Pinhal, 133, 134, 135, 136, 138, 139

Cattermole, Charles, 110

Cavalli, Roberto, 242

Central Asia, garment from, 80, 84, *85*, 87, 91n9

Central Saint Martins, 29n3, 196

ceremonies, 56, 97, 99, 215–16

 cloaks used in, 10, 49, 50, 52, 53, 57, 74, 95

 mourning, 95, 104n6

 wedding, 6, 14

Chalayan, Hussein, 192, 197n8

Chanel, Gabrielle "Coco," suit, *176*

Chapman Brothers, 191

China, 36, 213, 214, 217, 222n3

Churchill, Lady Randolph, 110

Clark, Judith, xiv

Clarke, Maree, 52

Clavir, Miriam, 43, 44

cloaks, 94, 99, 100, 102, 110, 111, 115, 116, 117
 Māori, 5, 10, 21, 65–77, *68*, *69*, *73*, 74
 possum-skin, 5, 10, 49–62, *54*, *58–59*
 Lake Condah, a Gunditjmara cloak,
 52, 60n3
 Maiden's Punt (Echuca), a
 Wolithiga cloak, 52, 55, *55*,
 60n3
clothing/costume/dress/garments
 body and, xiv, 8, 9, 11, 14, 19, 20, 21, 22,
 28, 50, 70, 150, 152, 161, 173, 174–77,
 230, 242
 contemporary, 159, 161
 display of, ix, xiv, 1, 2–3, 5, 7, 14, 24, 28,
 133, 155, 157n18, 159, 160, 162, 168,
 170, 171n10, 173, 174, 183, 239
 fashionable, 4, 23, 25, 100, 122, 161, 190,
 196, 238
 as gifts, 27, 72
 historic, 4, 27, 111, 133, 145, 159, 160, 161,
 165, 167–68, 177–78, 190, 199, 200,
 200, 204–6, 208, 241, 252
 as trade, 50, 96, 97, 135
 Victorian, 151, 169, 178, 194
 See also conservation; preservation;
 replication; reproduction; *specific
 items of clothing and clothing types*
coats
 fragmentary/Maldon Cache, 3, 7, 121–31,
 122, *125*, *129*
 McQueen, 12, *13*, 15n5, 21
 tiputa (ponchos), 94, 98, 99, 102, 105n9
Cochet, Augustine, *Portrait of a Woman*,
 150
Colchester Castle Museum, 121
 Buried! Hidden Secrets from the Past,
 122
Colenso, William, 75–76n10
collaboration, interdisciplinary, 53–56,
 65–70, 74–75, 93, 101–2, 145–46, 152,
 184, 247
colonialism/colonization, 5, 14, 33, 65, 67,
 72, 74, 75n10, 230
computer-aided design (CAD) software,
 166
computer-aided drawings (CorelDRAW),
 139
Comyns Carr, Alice, 110, 111, 116, 118n8
Condé Nast, 161
conservation
 of artifacts, 34, 35, 43, 66, 226
 and display, xiv, 2–3, 7, 8, 11, 14–15, 65,
 90, 122, 159, 162, 170, 213, 216
 ethics/principles, 38, 43, 45, 45n5, 101,
 121, 162, 184n2, 222, 228
 and preservation, 2, 9, 20–21, 35–36, 49,
 57, 60, 69, 121, 128–130

 and restoration, 9, 34, 35, 37, 46n7, 65,
 67, 75, 109, 114, 117
 textile, ix, xiv, 100, 109, 133, 135, 139, 141,
 142, 173, 200, 206, 226–27, 228, 232,
 238–39, 247, 248n8
 Western conservation ethics, 34, 36,
 43, 45
 See also cultural property; preservation;
 replication; reproduction; *specific
 items and types of clothing*
Cook, Captain, 93, 96–97, 98, 104nn1–2,
 104nn5–6
Cooke, Alan, 101–2
Cooper, Uncle Wally, 51–52
Coote, Jeremy, 101
Coppola, Sofia, *Marie Antoinette*, 208
coronations, 23, 24
Costigliolo, Luca, 151
costumes, stage. *See* Hong Kong Heritage
 Museum (HKHM); Terry, Ellen
couturiers, 12, 159, 173
Couzens, Ivan, 52
Couzens, Vicki, 52, 53, 62
Craig, Edy, 107
Creek, Rachel, 197n11
crochet, 110–16
Crocker, Harriet Valentine, 22–23
Crowe, Lauren Goldstein, 20
cultural property, 7
 Japan's policy on, 5, 34–38, 42, 43,
 45, 46n7
curation
 ethics/principles, 27, 65–67, 101, 109,
 115–16, 121, 187–88, 222
 and preservation, 36, 49, 65–67, 69, 177,
 195, 215, 222
 and restoration 8–9, 40–41
 (reweaving), 113–16, 129–30 (replica)
Curzon, George (Lord Curzon), 24, 30n24
Curzon, Lady (Mary Leiter), 24, 30n21
 peacock dress of, 24–25, *26, 30*nn25–27

D
D'Alleva, A. E., 99
dalmatic. *See* Saint Godedard
Dancause, Renée, 137
Daniel, Vinod, 226
Darroch, Lee, 52, 53, 54, 55, 56–57, 63
Davidson, Hilary, 204, 207, 208
Davis, Megan, *59*
Daykin, William, 145
Dechelle, Arnaud, 192–93
de la Haye, Amy, xiv, 21–22, 24, 29n9
Deliberately Concealed Garments Project,
 3, 121, 123, 130–31
de Meyer, Adolf, 185n11
department stores, 160, 240

de Pietri, Stephen, 185n5
der Kinderen-Besier, Johanna Henriëtte,
 230, 239, 246, 248n7
designers. *See specific designers*
digital media/technology, 3, 9, 12, 123, 124,
 137, 142n5, 151, 192, 196, 242, 244
Diller, Scofidio + Renfro, 164
Dior, Christian, 181
 ball gown, 175, *176*
display/exhibition
 cases, 27, *27*, 42, 55, 101, 109, 128, *129*,
 151, 208, 227, 229, 235n4, 235n8, 237,
 242–43, *243*, 245
 conservation and, xiv, 2–3, 7, 8, 11, 14–15,
 65, 90, 122, 159, 162, 170, 213, 216
 of Māori cloaks, 70–74
 of a Tahitian mourner's costume,
 x
 of Terry's beetle-wing dress,
 107–19
 See also replication;
 representation; reproduction;
 *other specific items and types
 of clothing*
 designers, 116–17, 145–48, 182–83, 201–2,
 239–41, 242–45
 historical accuracy and, 93–105
 immersive, 4, 148, 159, 160, 182, 199,
 201–2, 207, 208, 210
 interactive, 53, 134
 lighting in, 42, 147, 156n8, 173, 178, 179,
 182–83, 185n10, 189, 201, 207, 214,
 216, 235n8, 239, 240
 online, ix, 3, 14, 134, 138–41, *140, 141*
 retail, 147
 See also dress/dressmaker forms;
 mannequins; mounting
Dommuseum Hildesheim, *87*, 88, *89*
 See also Hildesheim Cathedral
Doyle, Adrian, 202
dress/dressmaker forms, 21, 164, 174–75,
 177, 178, 180, 185n6
dresses
 coat-, *181*
 cocktail, 162–63
 "conceptual chic," *181*
 coronation, 23
 dance, 175, 178
 evening, 175, *176*
 flapper, 22
 mourning, 93, 133–34, *134*, 135–36,
 137–40, *140, 141*, 167–68, *167*
 petticoats, 3, 171n10, 175
 wedding, *xvi*, 1, 3, 6, *6*, 14, 30n17, 192,
 243
 See also gowns
Dubey, Suman, 226, 227, 229

dummies. *See* mannequins
du Mortier, Bianca M., 240, *241, 243,* 248n8
d'Ys, Julien, 161

E
East India Company, 19, 27
Easy Tiger Creative, 117, 119n12
Ebrecht, Caroline, 119n14
Edward VII, 24
Egypt, 8, 9, 14, 15
 silk tunic from, 79–80, 83–84, *83,* 87
 See also Petrie Museum of Egyptian
 Archaeology
Ehrman, Edwina, 202–3
Elffers, Dirk Cornelis, 239
Elizabeth, Queen, II, *xvi,* 1, 14
Elizabeth, Queen, Queen Mother, 156n1
Ellis, William, 95
England, 19, 107, 145, 203
ensembles, 4, 24, 31n29, 153, 168, 170, 175,
 178, 180, 182, 214–15
 corset, *176,* 177, *180,* 185n7
 man's, *176*
 mourner's, 3, 94, 98, 100, 101, 104,
 133–43
 Rhodes, Zandra, 180, *181*
Entwistle, Joanne, 19
ethnography, 72, 100, 160
Europe, 24, 31n29, 49, 50, 66, 70, 75n8, 122,
 135, 173, 242, 248n8
Evans, Caroline, 20
Evans, Edward, 99, 183
Event Communications, 192
"evil eye," 39
Ewer, Patricia, xiv
exhibition design. *See* display/exhibition

F
fashion
 as art, 4, 173–86
 as contemporaneity, 173, 177–82
 design, 12, 139, 141, 156n4, 174, 192, 242
 exhibitions, xiv, 156n5, 159, 174, 183, 184
 high, xiv, 4, 24, 159, 160, 161, 182, 195,
 199
 houses, 168, 190, 242
 industry, 4, 159, 160, 161, 162, 163, 170,
 183
 plates, 151, 180
 shows, 20, 183, 185n19
 catwalk/runway, 4, 11, 12, 13, 168,
 182, 186, 188, 189, 192, 193,
 194, 197n7
 as spectacle, ix, 168, 173, 174, 182–83
 See also couturiers; haute couture
feathers, 12, 15n5, 25, 94, 95, 96–97, 98–99,
 168, 191, 194

in cloaks, 70, 73, 74, 94, 99, 100, 102
Fenollosa, Ernest, 46n13
fine and decorative arts, 145, 173
Fitzwilliam Museum, *Silent Partners: Artist*
 and Mannequin from Function to
 Fetish, 20
Flecker, Lara, xiv, 157n14
Fong, Yim Fun, costume worn by, 218
Foote, John, *jama* of, 25–28, *27,* 31n28,
 310n30
Ford, Bruce, 55
Ford, Micheline, 173, 186
Forster, George, 93, 97, 98, 99, 104
Forster, Reinhold, 93, 94, 97, 98, 99, 104
Fortuny, Mariano, 178
French, Kate, 206

G
Galliano, John, 197n8
Gandhi, Indira, sari worn by, 4, 225–29, *229,*
 230–31, 233, 234–35
Gandhi, Mahatma, 230
Gandhi, Rajiv, trousers worn by, 4, 226–27,
 229–34, *231, 233,* 235n9
Ganiaris, Helen, 202
Gare, Justin, 226
Gariwerd National Park, 51
Gathercole, Peter, 98
Gazette du bon ton, 180
Godehard, Saint, dalmatic of, 79, 86–88,
 87, 89, 91n10
Godwin, Edward, 110
Gowers, H. J., 97
gowns, 25, 110–11, 163, 165–66, 180, 193,
 203, 205, 206
 ball, 25, 163, *164,* 175, *176*
 evening, *154*
Gravelot, *205*
Greig, Hannah, 210
Gresswell, Claire, 145, 146
Grieves, Genevieve, 54
Grimwade Centre for Materials
 Conservation (GCCMC), 57
Groarke, Carmody, 29n3
Grove, William, 111
Gunditjmara community, 52, 55, 60n3
Gurob sleeves, 8

H
Hagerty, Marie, 179, 181
hair, human, 94, 95, 99, 194
Hamilton, Samantha, 54, 63
Hamm, Treahna, 52
Harries, Rhiannon, 23
Harris, Jane, 9
Hashagen, Joanna, 145, 146
Hately, Tim, 29n8

haute couture, 138, 180, 211n3
Hay, Cathy, 30n27
headgear/headwear, 4, 14, 199, 20
 hats, 4, 9, 21, 178, 187, *188,* 199, 200, *203,*
 204, 207, 208, *209,* 210, 211n3
 headdresses, 23, 94, 95, 98–99, 100,
 104n7, 216, *221*
Heap, Val, 51
Heath, Shona, 21
Hesselink, Abraham, 239, *240*
H&H Sculptors, 116, 119n10
Hildesheim Cathedral, 79, 86
 See also Dommuseum, Hildesheim
Hirst, Damien, 198n15
Historic Royal Palaces, Kensington Palace,
 157n15
Hobbes, John Oliver (Pearl Mary Teresa
 Craigie), 25, 30n31
Hodges, William, 98, 104n6
Hoffmann, E. T. A., 29n1
Hong Kong Heritage Museum (HKHM),
 Cantonese opera costumes in, 12,
 213–24
 Artists' Corner, 216–21, *217, 221*
 Beauty from the South Meets the
 Han Emperor, 221
 Joint Investiture of a Prime Minister by
 Six Kingdoms, 215
Horsley, Jeffrey, xiv
Horst, Horst P., 185n11
Huntley, Paul, 168
Hussein, Yasemen, 204

I
identity, 22, 27, 43, 161, 207
 cultural, 51, 59, 60, 74, 75n2
immigrants, 50, 133, 135
India, 4, 24, 25, 31n30, 185n13, 225, 226,
 229, 230, 234
 Andhra Pradesh, 229
 Mughal, 19, 25, 27, 28
 New Delhi, 4, 24, 30n21, 225, 226, 230
 Orissa, 227
Indian Museum, Kedleston Hall, 25
indigenous cultures, ix, 5
 See also Ainu, Australia, Japan, New
 Zealand
Indira Gandhi Memorial Museum, 225–26,
 233, 235n8
Irving, Henry, 107, 109, 110, 111, 118, 118n1

J
jackets, 21, 194
 doublets, 79, 82–83, *82,* 84, 123, 131
 sleeveless, 215, 219, 220
Jahan, Shah, 25
James, Charles, 22, 170n1

exhibition on, 162–65, *164*, 170n1, 171n6

James, Henry, 107

Japan, 173, 246

 Ainu robes, 5, 33–34, 38–47, 40, 41, 42

 conservation/cultural property policy/

 principles in, 5, 34–38, 40, 42, 43,

 45, 45n5, 46n7, 46n13

 Yamato, 33, 34, 42, 43, 44

Jean Paul Gaultier, 197n8

 ensembles, *176*, 177

Jones-Amin, Holly, 57

K

Kaeppler, Adrienne L., 95

Kai, Yu, armor worn by, 220–21, *221*

Kamba, Nobuyuki, 33–35, 36

Kasina, Polina, 12, *13*

Kawakubo, Rei, 197n8

Kelly, Grace

 exhibition on, 22, 23–24, 30n11

 wedding dress of, 3, 30n7

khadi, 229–30

Kihara, Toshie, 34, 46n7

Kjellberg, Anne, 29n10

Kobayashi, Ayako, 37–38

Koorie Heritage Trust, 52

Koornstra, Metten, 240, *241*

Koumalatsos, Kelly, 52

Kyoto Costume Institute (KCI), 167, 169,

 178, 246

L

Lambert, Eleanor, 160

Landis, Deborah, 196, 198n19

Lang, Helmut, 192, 197n8

Leane, Shaun, 191, 192, 197n7

legal frameworks, 5–6, 34–39, 42–45,

 66–67

Lennard, Frances, xiv

Leong, Roger, 173

Lewisohn, Alice, 159

Lewisohn, Irene, 159

Liberation Tigers of Tamil Eelam (LTTE),

 225

Lister, Jenny, 23, 30n11

Logsdail, William, *Mary Victoria Leiter, Lady*

 Curzon, 25, *26*, 30n26

Lohman, Jack, 201

London, 185n13, 187, 211n3

 fashionable, 107, 147

 pleasure gardens, 199, 201, 208, 210

Love, Peter, *69*

Lucini, Carmen, 157n14

M

Macbeth, Lady, 107, *108*

Maddigan, Gayle, 52

majority world, 135, 142n4

Mandeville, Roy, 153, 157nn15–16

mannequins, xii, 5, 9, 11, 12, *13*, 19, 20, 21,

 22–24, 25, 28, 111, 113, 116, 119n10, 130,

 140, 155, 160, 167–69, 171n10, 174–75,

 177, 178–79, 190, 193, 194–95, 199,

 200, *200*, 203, *203*, 206–7, 208, 216,

 218, 220–21, *221*, 239, 245, 246–47,

 248n3, 248n13

 abstract/stylized, 12, 23–24, 117, 160–61,

 171n6, 178, 204

 Bonaveri, 171n11, 246–47

 character sheets for, 204, *205*

 customized/painted, 138, 157n16, *167*,

 168, 171n11, 177, 178–79, 181, 203, 237

 cutaway, 157n14, *169*, 169–70

 fiberglass, 116, 153, 157n14, 168, 184n2,

 185n6

 headless, 1, 14, 246

 as inanimate/inert/lifeless, 12, 20, 28,

 147, 151, 168, 189, 196

 Kyoto, 246

 Mei and Picchi, 185n6

 mimetic/realistic, 21, 22–23, 30n17,

 101, 168

 Nanasai (Wacoal), 167, 246, 247, 248n14

 transparent, 14, 152, 153–55

Manufacture des Gobelins, 238

Māori, 65–78

Margiela, Martin, 179, 197n8

Marshall, Shonagh, 20–21, 29n3

Martin, Caroline, 53–54

Martin, Cristina Garcia, 248n11

masks, 21, 94, 96, 98, 102, 103, 104, 197n13,

 200, 204, *205*

material culture, ix, xiv, 10, 53, 93, 207

materiality, 2, 24, 190, 191

Matshoba, Nikiwe Deborah, wedding dress

 of, 6, *6*

Maud, Queen, exhibition on, 22, 23

McAlpine, Romilly, 22, 29n8

McDermott, Catherine, 29n8

McIntyre, Darryl, 201

McNeil, Peter, 182, 185n4

McQueen, Alexander, 1, 21, 190–91, 194, 196

 exhibitions on, 13, 14

 Alexander McQueen: Savage

 Beauty, 12, 13, *13*, 168–70, *169*,

 171n11, 187, *192*, 193–94, 195,

 195, 196, 197nn13–14

 Fashion in Motion, 187–91, *188*,

 192, 194, 195, 197n7, 197n11

 Radical Fashion, 187, 192–93,

 194–95, 197n11

Mears, Patricia, 185n4

Mei and Picchi, 185n6

Melbourne, 52, 55, 174

Melbourne Museum, Museum Victoria

 (MV), 51–52, 60–61n3

 Bunjilaka Aboriginal Cultural Centre,

 First Peoples, 49, 53–54, 54, 56,

 56–57

Melchoir, Mary Riegels, xiv

memento mori, 28, 193, 194

memorialization, ix, 6, 21, 22, 133, 226

Messel family, collection of, 22, 23, 29n7

Metcalfe, Rachel, 157n15

Metropolitan Museum of Art, Costume

 Institute, 4, 159–62, 170, 171n10,

 174, 246

 Alexander McQueen: Savage Beauty, 12,

 13, 168–70, *169*, 171n11, 197nn13–14

 American Woman: Fashioning a National

 Identity, 161

 Anna Wintour Costume Center, 161,

 162, 165

 Charles James: Beyond Fashion, 162–65,

 164, 170n1, 171n6

 Death Becomes Her: A Century of

 Mourning Attire, 165–68, *167*

 Schiaparelli and Prada: Impossible

 Conversations, 161

Mexx, 242, 248n10

Michelangelo, *David*, 188

Miyake, Issey, 197n8

models

 fashion/runway, 12, 13, *13*, 20, 168, 178,

 181, 182, 183, 187–88, *188*, 189, 190,

 191, 193, 194, 197n11, 197n13, 203

 as a term, 11–12, 19–20

Mookherjee, Nayanika, 2, 6

Morena, Jill, 138

Moss, Kate, 193

Moulton, Kimberly, 53

mounting, xiii, xiv, 10, 25, 28, 29, 30n14, 36,

 73, 95, 98, 100–4, *101*, *103*, 116, 145,

 152–53, 167, 169, 194–95, 200, 204–6,

 217, 220–21, 222, 237, 239, 245–47,

 248n8

 acrylic, 152, 153, *154*, 155

 pressure, 4, 44, 79–92

 remounting, 91n4, 93, 99, 104, 117

mourning dress

 of Countess of Pinhal, 133–44, *134*,

 140, *141*

 exhibition on, 165–68, *167*

 Tahitian mourner's costume, 5, 93–105,

 97, *101*, *103*

muka, 68–69, 70–71, 72

Mulder-Erkelens, A. M. Louise E., 239–40,

 241

Munro, Jane, 20

museology, ix, xiv, 1, 170

Museu Afro-Brasileiro, Salvador, 135

Museum of Anthropology, University of British Columbia, 43
Museum of Fine Arts, Boston, 36
Museum of London, 29n8
 Galleries of Modern London, 199, 201–2, 210
 Pleasure Garden, 4, 199–211, *200*, *203*, *205*, *206*
Museum of New Zealand Te Papa Tongarewa (Te Papa), *Kahu Ora, Living Cloaks*, 5, 65–76, *68*, *73*
Museum of the City of New York, 22
Museum Workshop Ltd., 157n15
Museu Paulista, Universidade de São Paulo, 133, 135, 136, 142

N
National Gallery of Australia (NGA), 184n1
 Dressed to Kill: 100 Years of Fashion, 4, 173–86, *176*, *180*, *181*
National Heritage Act (1983, UK), 197n6
National Museum of Australia, 55
National Museum of Scotland, 157n15
National Trust, England and Wales, 30n20, 30n26, 107, 111, 115
Netherlands, 237, 238, 243, 244, 248nn11–12
Nettleship, Mrs., 110, 111
New Gallery, 116
New Look, 168
New York, 12, 30n21, 138, 159, 160, 163, 166, 167, 174, 192, 197nn13–14
New Zealand, 51, 53, 65, 67, 72, 74, 75n1, 75n8, 96, 185n6
 Māori cloaks, 5, 10, 21, 67–77, *68*, *69*, *73*
 See also Māori
Ng, Kwan Lai, armor/costume worn by, 219–20
Nicholson, Aunty Phoebe, 50
Nicholson, Mandy, cloak, 52, 57, 58, *58*, 59, *59*, 63
Nieuwe Kerk. *See* Rijksmuseum
Nijō, Motihiro, 45n4
North, Susan, 29n10

O
object-based research, 121, 123, 131, 133, 137, 140–41, 142
Ogborn, Miles, *Spaces of Modernity*, 201
Okakura, Tenshin, 36, 46n13
O'Neill, Alistair, 29n3
opera, 183
 Cantonese costumes, 12, 213–24, *215*, *217*, *221*

P
Pacific Rim, 93, 95, 96, 97, 104n1

Palau, Guido, 161
Palmer, Alexandra, xiv, 173, 174, 178, 185n4
parataxis, 11, 13, 14, 187
Paris, 23, 25, 145, 157n14, 181, 238
 Exposition Universelle, 237, 238
Parkinson, Sydney, 104n4
Pascual, Hector, 185n5
Pass Laws, 5
Pater, Walter, 118n2
Payton, Rob, 202, 207–8
Petrie Museum of Egyptian Archaeology, University College London, 8–9, 14–15
Philadelphia Museum of Art, 30n17
Phillips, Kristin, 226
Pingat, Emile, 180
Pinhal, Countess of (Anna Carolina de Melo Oliveira de Arruda Botelho), 134
 mourning dress of, 133–44, *134*, *140*, *141*
Pinhal, Count of, 136
Pinney, Christopher, 2
Pitt Rivers Museum (PRM), University of Oxford, Tahitian mourner's costume, 5, 93–105, *97*, *101*, *103*
Planché, J. R., 110, 118n6
Pointon, Marcia, 31n31
Polynesia, 72, 94, 95
 Bora Bora, 99
 Tuamotus, 95
postcolonialism, 5, 44
PowerPoint, 128–29, *129*, 130
pre-Raphaelites, 110
preservation, 2, 3, 5, 7, 35, 51, 53, 56, 84, 86, 87–88, 122–23, 142, 156, 183
 and access/display/presentation, 20–21, 66, 69, 79, 82, 121, 122, 136, 177, 189, 215, 222
 and conservation, 2, 9, 20–21, 35–36, 49, 57, 60, 121
 long-term, 57, 79, 93, 136, 177, 195, 207, 222, 228, 233, 234
Price, Antony, dress, 187, *188*
Pritt, Georgina, 24
Puketapu-Hetet, Erenora, 69
Pygmalion, 20

Q
Quinn, Marc, 198n15

R
Rajaratnam, Thenmozhi, 225
ready-to-wear, 173, 194, 211n3
redress
 Australia, 49–50, 52, 60
 Japan, 33–34, 42–45
 New Zealand, 65–70, 74–75
 South Africa, 5–6

refashioning, xii–xiv, 3–4
Rendell, Caroline, 152
replication, 22–23, 188–89, 204
 Replicar, 133–44, *140*, *141*
 replicas, 3, 4, 7 30n27, 52, 117, 129–30, 133, 134, *134*, 135, 137–38, 139, 140, 163, 199, *200*, 204
 See also reproduction
representation, xiv, 7–8
reproduction, 52, 70, 138, 151, *164*, 166, *167*, 171n10, 178, 181, 199, 204 *206*,, 208, 215, *215*
reversibility, xiv, 38, 128
Reynolds, Amanda, 54, 56, 63–64
Reynolds, Joshua, *Captain John Foote*, 25–27, *27*, 28, 31n28–29
Rhodes, Zandra, ensemble, 181–82, *181*
Rijksmuseum, costume collection, 15, 237–49, *240*, *241*
 Accessorize!, 244, 248n11
 Finishing Touches: Accessories, 1550–1950, *241*
 Nieuwe Kerke, 242
 Fashion DNA, 242–43, *243*
robes, 117, 203, 217
 Ainu (kimono), 5, 33–47, *40*, *41*, *42*
 jama, 25–28, *27*, *27*, 31nn30–31
Rosatone, Eleonora, 203, 207
Ross, Cathy, 201, 202, 207–8, 209, 211n1
Rosse, Countess of, 21–22, 24
Rota, Italo, 242–43, *243*
Royal Collections, London, 157n15
RuPaul, 183
Russia, 33

S
Saint Godehard, dalmatic, 79, 86–88, *87*, *89*
Salvador, 135
Sandino, Linda, 189–90, 196, 197n11
São Paulo, 135, 138
Sargent, John Singer, *Ellen Terry as Lady Macbeth*, 107, *108*, 109, 111, 116, 117
sari. *See* Gandhi, Indira
Sasaki, Toshikazu, 38–39, 45n2
Savile Row, 152, 196
Schiaparelli, Elsa, 178
 exhibition on, 161
Schwab, Matt, 208
Selfe, Daphne, 197n11
Shaver, Dorothy, 160
shells, 51, 94, 191
 mussel, 51, 70
 pearl, 94, 95, 96, 98, 102, 103, 104
Shimura, Akira, 40
shoes, 21, 86, 116, 169, 170, 171n10, 177, 178, 182
slavery, 133, 135

Slocombe, Emma, 109
Smallhythe Place, 107
 Terry's beetle-wing dress at, 3, 107–19, *108*, *112*
Smith, Jane, 204, 211n3
Somerset House, *Isabella Blow: Fashion Galore!*, 20–21, 29n3
songlines, 53, 61n10
Soo, Chow Mui, costumes worn by, 217, *217*
St. Léon, Arthur, 29n1
Stallybrass, Peter, 21
Staniland, Kay, 23
Steele, Valerie, xiii, xiv, 20, 174, 178, 185n4
Steichen, Edward, 185n11
Steinlen, Théophile-Alexandre, 180
Sundsbø, Sølve, 12, *13*
Supianek-Chassay, Christine, 200, 203, 204, 207
Svensson, Birgitta, xiv
Swift, Frazer, 201–2, 207, 209
Sydney Star Observer, 183
Symington, Gail, 202, 204, 208–9, 210

T
Tahiti, mourner's costume from, 5, 93–105, *97*, *101*, *103*
Tarkhan tunic, 8
Tarrant, Naomi, 22
Taylor, Lou, 137, 173, 174, 179
Taylor, Mark, 182
Taylor-Wood, Sam, 198n15
taonga, 65–67, 74–75
Te Roopu Raranga Whatu o Aotearea, 67
Terry, Ellen, beetle-wing dress worn by, 3, 107–19, *108*, *112*
textiles
 conservation of, ix, xiv, 100, 109, 133, 135, 139, 141, 142, 173, 200, 206, 226–27, 228, 232, 238–39, 247, 248n8
 historic, 35, 80, 142
 See also Bowes Museum; *specific textiles*
Thompson, Aunty Zeta, 54, 56
Thompson, Eleanor, 22, 29n9
Tinker, Zenzie, 109, 111
Tissot, James, 151, 156n9
Tokugawa, Yorisada, 33, 45n4
Tokyo National Museum (TNM), Ainu robes in, 33–34, 36, 38, 39, 42–43, *42*, 45nn3–4, 46n16
trade, 33, 75n8, 226, 237
 clothing as, 50, 96, 97, 135
Treacy Philip, 197n11
 hats, 187, *188*, *203*, 204, *206*, 208, 209, 211n3
Treaty of Waitangi, 66
trousers, 215, 220

worn by Rajiv Gandhi, 4, 226–27, 229–34, *231*, *233*, 235n9
Trumble, Angus, 25
tunics, 110
 Egyptian silk tunic, 79–80, 83–84, *83*, 87
 Tarkhan Tunic, 8
Turner, Uncle Alf "Boydie," 54
Tyne & Wear Museums, 157n15

U
Uden, Jeremy, 93, 104n2
UNESCO, 43, 214
University of Melbourne (UoM), cloak at, 10, 49, 53, 57–60, *58*, *59*
Ustinov, Peter, 225

V
van Grinsven, Joost, 244, 248n11
van Langh, Robert, 239
Velázquez, Diego, 179
vestments. *See* dalmatic
Victoria, Queen, 165
Victoria and Albert Museum (V&A), 13, 30n24, 31nn29–30, 100, 198n19, 238, 245
 Alexander McQueen: Savage Beauty, 187, *192*, 193–94, 195, *195*, 196, 197nn13–14
 British Galleries, 148
 Fashion in Motion, 187–91, *188*, 192, 194, 195, 197n7, 197n11
 Grace Kelly: Style Icon, 22, 23–24, 30n11
 Radical Fashion, 187, 192–93, 194–95, 197n11
 Style and Splendour: Queen Maud of Norway's Wardrobe 1896–1938, 22, 23, 29n10
Viollet-le-Duc, Eugène, 110, 113
Vionnet, Madeleine, 178
Vogue, 161, 183
Vreeland, Diana, 160–61, 174, 178, 185n5

W
Wakka, Ekashi, 33, 45n3
Watanabe, Junya, 195, 197n8
weaving, 36, 40, 44, 84, 133, 139
 Māori, 67–68, *68*, 69, 70, 75, 75n7
websites, 3, 133, 139, 140–41, 151, 190, 244, 248n11
 hotsites, 134, 138–141, *140*, *141*, 142, 142n2, 143n7
Webster, John, 193
"Welcome to Country" ceremony, 50
Werner, Alex, 201, 202, 207, 208, 209
Westminster Abbey, 14
Westwood, Vivienne, 22, 177, 179, 183, 197n8

corset ensemble, *176*, 177, *180*, 185n7
White, Allon, 21
Whitworth Art Gallery, *Clothing Culture: Dress in Egypt from the First Millennium AD*, 9
wigs, 22–23, 168, 178–79, 200, 204, 240, 246
Wilde, Oscar, 110
Wilkinson, Chris, 101
Wilson, Elizabeth, 20, 173, 174, 182
Wintour, Anna. *See* Metropolitan Museum of Art, Costume Institute
Witkin, Joel-Peter, 197n13
Wolithiga. *See* cloak, Maiden's Punt
Women's Jail, Johannesburg, exhibition of dress in, 5–6, *6*, 12
Wood, Janet, 145, 152, 157n16, 158, 204–6
Worth, Charles Frederick, 25, 173, 175, 179
Wurundjeri, 52

X
Xuanzong, Emperor, 213

Y
Yale Center for British Art, *Edwardian Opulence: British Art at the Dawn of the Twentieth Century*, 25, 30n22
Yamamoto, Yohji, 192, 197n8
York Art Gallery, *27*
York Castle Museum, 24
York Museums Trust, 27
Yorta Yorta, 52
Young, Agnes Brooks, *Recurring Cycles of Fashion 1760–1937*, 242
Young British Artists (YBA), 191
Yunupingu, Galarruy, 60